The Houses of
VERANDA
The Art of Living Well

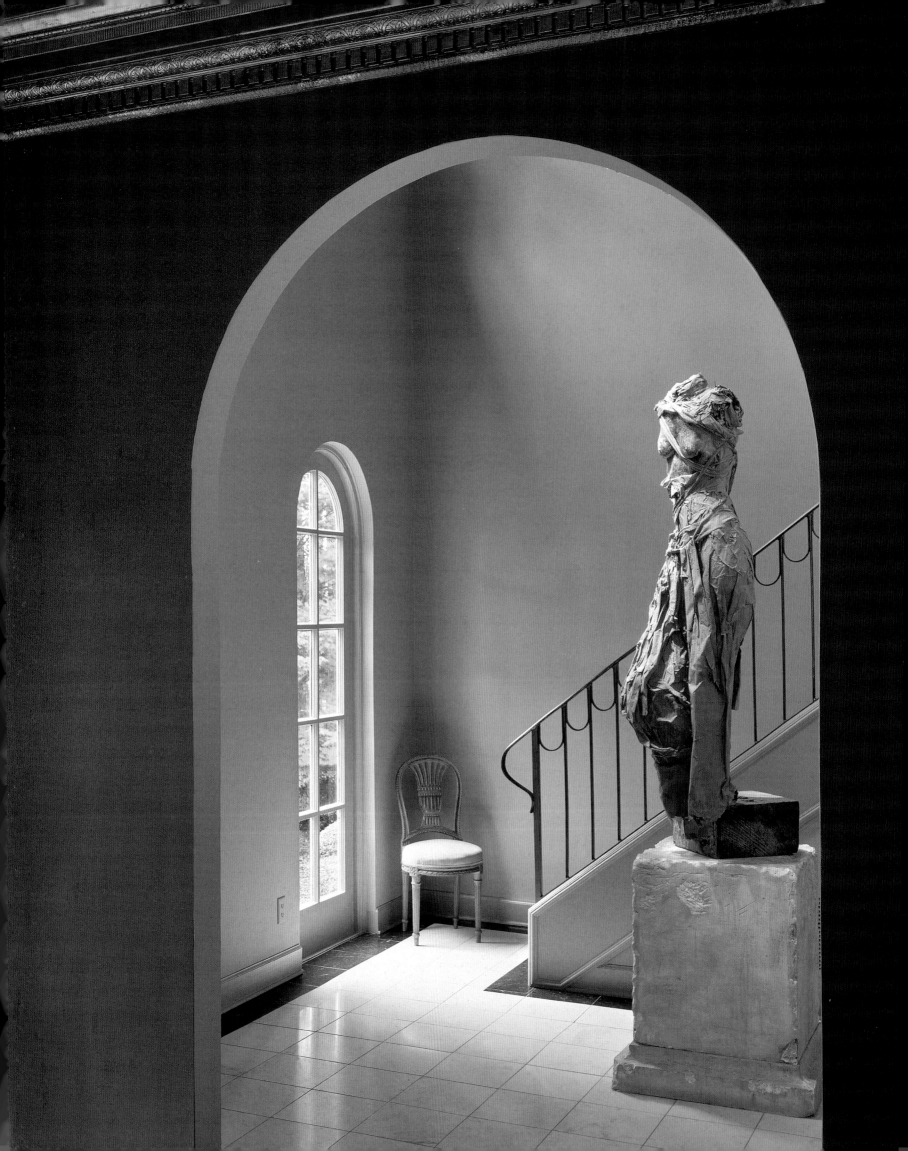

The Houses of
VERANDA
The Art of Living Well

LISA NEWSOM

HEARST BOOKS

New York

HEARST BOOKS
New York

An Imprint of Sterling Publishing
387 Park Avenue South
New York, NY 10016

ISBN 978-1-58816-927-3 (hardcover)
ISBN 978-1-58816-958-7 (ebook)

Designer: Doug Turshen
Layout Artist: David Huang
Photo Editor: Martha Corcoran
Writer: Mario López-Cordero
Copy Editor: Stephen Singerman
Project Editor: Sharyn Rosart
Project Manager: Tom Woodham
Publisher: Jacqueline Deval

Library of Congress Cataloging-in-Publication Data

Newsom, Lisa.
 The houses of VERANDA : the art of living well / Lisa Newsom.
 p. cm.
 Includes index.
 ISBN 978-1-58816-927-3
 1. Interior decoration—Themes, motives. I. VERANDA. II. Title. III. Title: Art of living well.
 NK2110.N49 2012
 747--dc23
 2011041051

Distributed in Canada by Sterling Publishing
c/o Canadian Manda Group, 165 Dufferin Street
Toronto, Ontario, Canada M6K 3H6
Distributed in Australia by Capricorn Link (Australia) Pty. Ltd.
P.O. Box 704, Windsor, NSW 2756, Australia

For information about custom editions, special sales, and premium and corporate purchases, please contact Sterling Special Sales at 800-805-5489 or specialsales@sterlingpublishing.com.

Manufactured in China

10 9 8 7 6 5 4 3 2

www.veranda.com

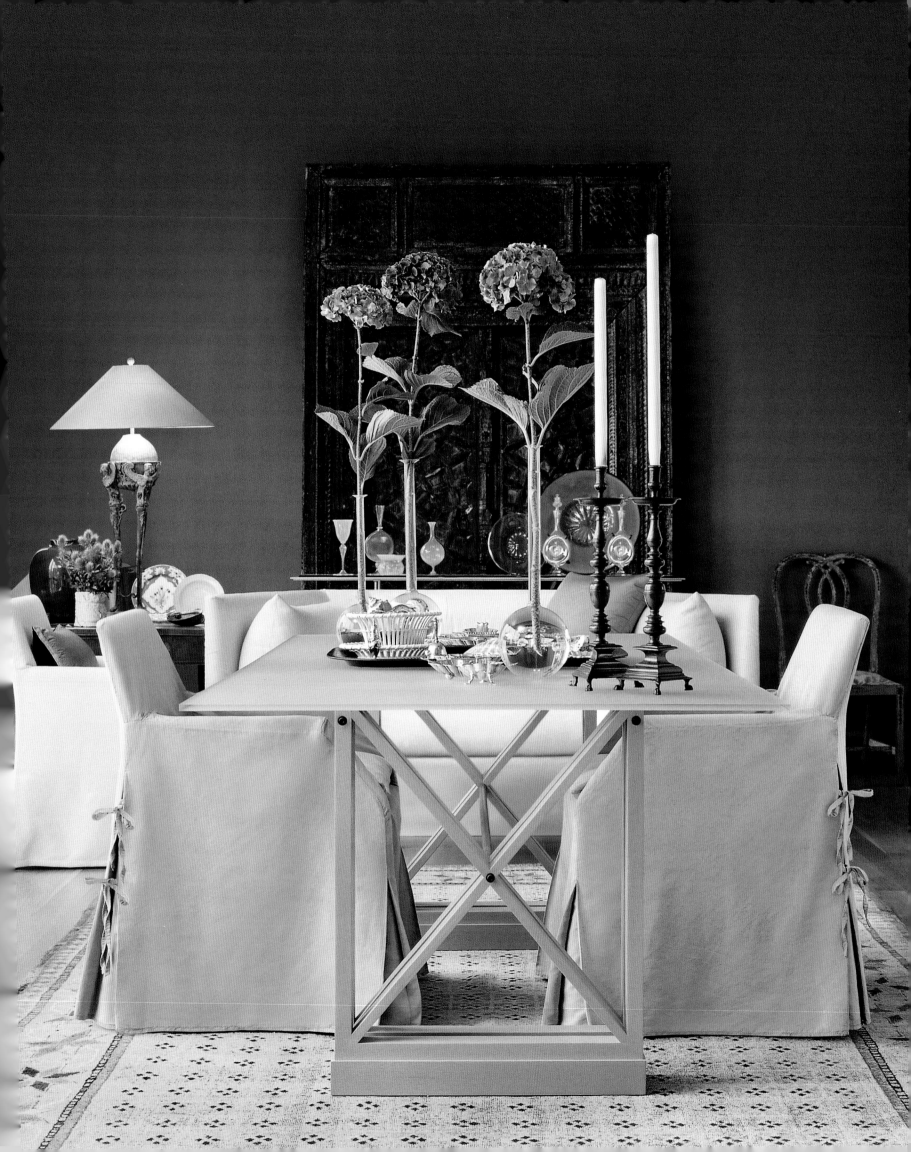

Preface by Dara Caponigro
page 8

Introduction by Lisa Newsom
page 10

Classic Houses
page 14

Modern Houses
page 94

Romantic Houses
page 150

Artful Retreats
page 212

Dedication & Acknowledgments
page 282

Credits
page 284

Index
page 286

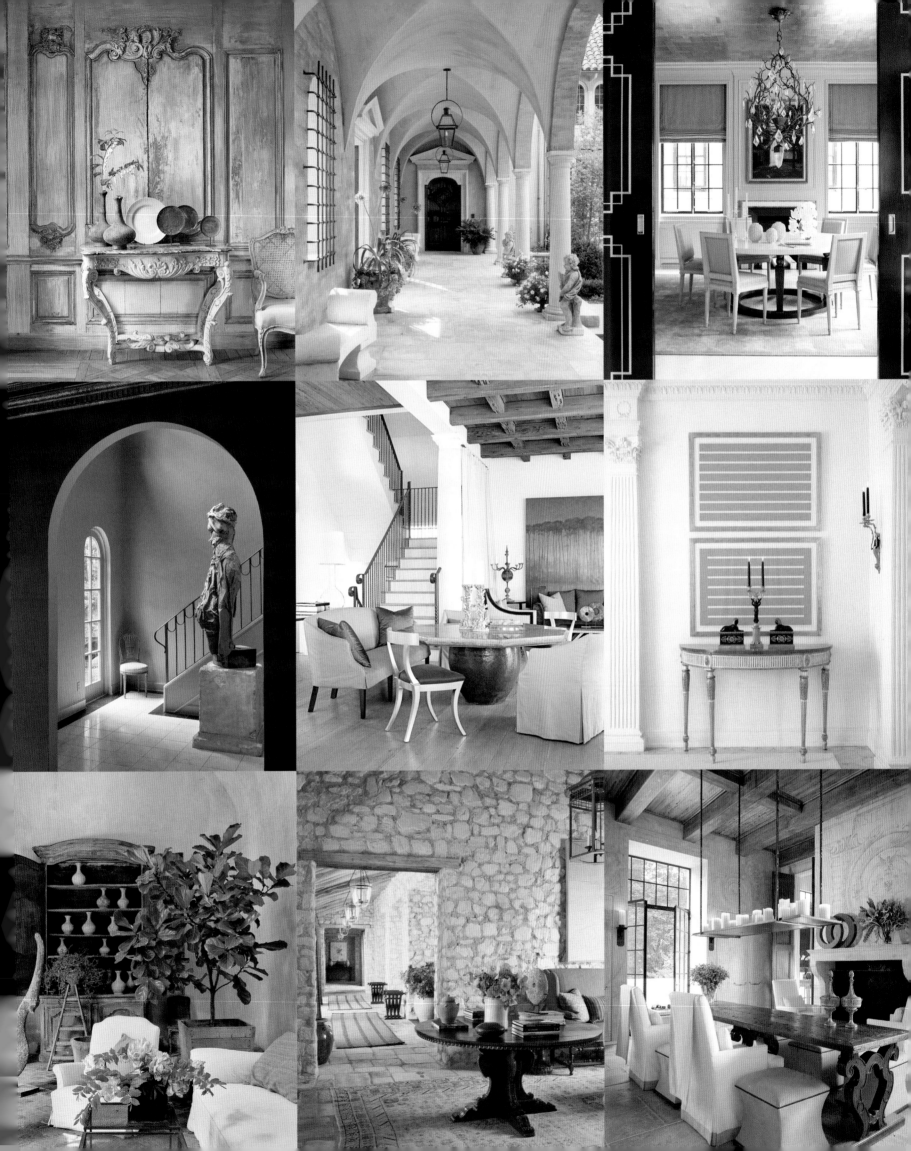

PREFACE

I've always believed in the idea that a simple thing done well is worth a million complicated embellishments. It's true in food, fashion, language and, of course, in decoration. It happens to be true with magazines, too.

Before I ever stepped foot in the offices of VERANDA, I'd admired this aspect of the enterprise that Lisa Newsom created from scratch—with will, determination and an unfailing sense for the beauty in our everyday surroundings. Setting aside the pluck and perseverance it took to create a magazine that has grown to be such a success, I was in awe of Lisa's extraordinary attention to detail, to the simple little things that add up to create a magnificent whole. Quality was always her guiding principle: only the best paper, only the best photography, only the best art direction.

And then there were the houses. Where every other decorating magazine seemed to embrace rooms that were often excessively styled and propped, Lisa's houses looked like places where people actually lived. Yes, they were sometimes grand. Yes, they were sometimes located in far-flung locales. Yes, they often represented the pinnacle of a certain style or genre. Even so, they were always authentic. Whether it was a castle in the Belgian countryside or a beach house on the Florida coast, you always got a sense for the people who inhabited these graceful spaces. You also always felt they were happy to share their homes.

Maybe its VERANDA's Southern roots. More than anyone I've ever met, Lisa Newsom embodies the legendary sense of warmth and hospitality for which the region is well known, and this spirit has always suffused the pages of the magazine. It inflects every room ever featured, whether or not that room actually happens to be in the South.

In my final analysis, I think that's truly what has made the magazine such a success. It's the simplest task of all, and Lisa mastered it from the very beginning. One can pursue the world's best decorating, sumptuously photograph it and showcase it on the finest grade of paper, but none of it will have a lasting impact if, in the end, looking at it leaves you cold. Making readers feel at home is Lisa's lasting legacy, and it has made all the difference.

—Dara Caponigro, Editor-in-Chief

INTRODUCTION

Dreams do come true. The book you are holding is a collection of some of the most beautiful interiors featured in VERANDA and the culmination of my life's work as an editor. The journey has been rewarding, challenging, exciting and humbling. I've met and become friends with some of the most interesting and talented people in the industry.

It all started with my one-room playhouse in Thomasville, Georgia, where books and magazines were my windows to the world. My favorite daily activity was rearranging every piece of furniture in that tiny space. I was learning an important lesson: A room in which we surround ourselves with the things we love not only makes us comfortable but also becomes a means of expressing ourselves, of establishing our personal sense of style. My love affair with interior design had begun.

When my husband, Neal, established his medical practice in Atlanta, I became involved in social activities but also wanted to take advantage of my training in art and design. One day in Jane Marsden's antiques shop on Peachtree Road, I saw a brochure for the launch of a magazine featuring Southern houses. It was a great idea, since at that time, many people outside the region seemed to think we lived either by the railroad tracks or at Tara!

When I was told the magazine had been canceled for lack of interest, I volunteered to draw up a list of potential subscribers from my personal contacts and help get it started. That magazine was *Southern Accents*, and its first issue in 1977 sold out. I joined the staff and eventually became editor-in-chief. After almost a decade there, the magazine had become so popular that I realized I could start my own home design publication.

In the spring of 1987, I founded VERANDA at my dining room table. Not long after, I rented a two-room office and asked Charles L. Ross, former art director of *Architectural Digest*, to join me. VERANDA's reputation for lavish visuals was set from the beginning. Gifted interior designers were soon sending us some of their most outstanding projects. As editor-in-chief, I made it my mission to showcase their work with the reverence it deserved, and I engaged first-class photographers, editors and writers.

I was experienced in editorial work but knew little about advertising and circulation. I learned quickly! My children—Bradley, Leslie, Andrew and Ansley—and their friends targeted neighborhoods and stuffed brochures into mailboxes as part of the initial effort to attract subscribers. To sell ads, I hired Lola Battle and Penny Coppedge, two Atlanta Junior Leaguers who never took no for an answer. The premiere issue exceeded our expectations, with thirty pages of ads in its 112 pages. All ads were paid because I didn't know that many new magazines offer discounted ads just to produce a thick first issue.

By the mid-1990s, California was one of the states with the most VERANDA readers, and we had not yet even featured a house there. This validated my belief that the beautiful design, gracious hospitality and sense of place embodied by the homes in VERANDA had universal appeal. In 1997, I turned over my responsibilities as publisher to Sims Bray. Two years later, I began featuring houses outside the South, even outside the country, and decided to publish six issues each year. By 2001, VERANDA's audited circulation was approaching 400,000, and it had the most affluent readership of any shelter magazine in America.

VERANDA caught the eye of several large New York publishing groups that wanted to acquire it. In 2002, it was Hearst—led by Frank Bennack, Victor Ganzi, Cathie Black and Mark Miller—that I entrusted with the magazine I still think of as "my baby." Their mandate was to continue featuring the best of the best of interior design. I accepted the invitation to stay on as editor-in-chief, making frequent trips to the Hearst Tower and guiding my hard-working and wonderful team in both Atlanta and New York. In 2010, the very talented Dara Caponigro became editor-in-chief, bringing to VERANDA her sense of elegance, heartfelt grace and refined style.

When I look back, I can hardly believe it has been twenty-five years. One of the great things about working in magazines is that one's efforts are always well documented. I can go to my bookshelf, open an issue, and suddenly I'm there again, on that photo shoot, in that stunning room, surrounded by a skillful designer's glorious vision.

Only a small fraction of the houses in VERANDA are presented in this book, and limiting the selection was very, very difficult. After all, to have appeared in VERANDA in the first place meant the homes were exceptional examples of their particular genres. One of the most exciting aspects of being an editor was discovering designers whose remarkable work had never been published, and seeing them rise to national prominence. At the same time, respected designers who had already attracted international acclaim generously offered their projects to us. Thus each issue—and now this book—combines their talents and styles in a lush, visually engaging manner.

We have taken great pleasure in presenting beautiful homes in VERANDA and in sharing them with you in this book. I hope you, too, will find them to be a source of inspiration and joy.

—Lisa Newsom, Founder and Editor-in-Chief, 1987–2010

1.
Classic rooms take the best traditions and make them relevant for today—soulful, sophisticated and, above all, comfortable.

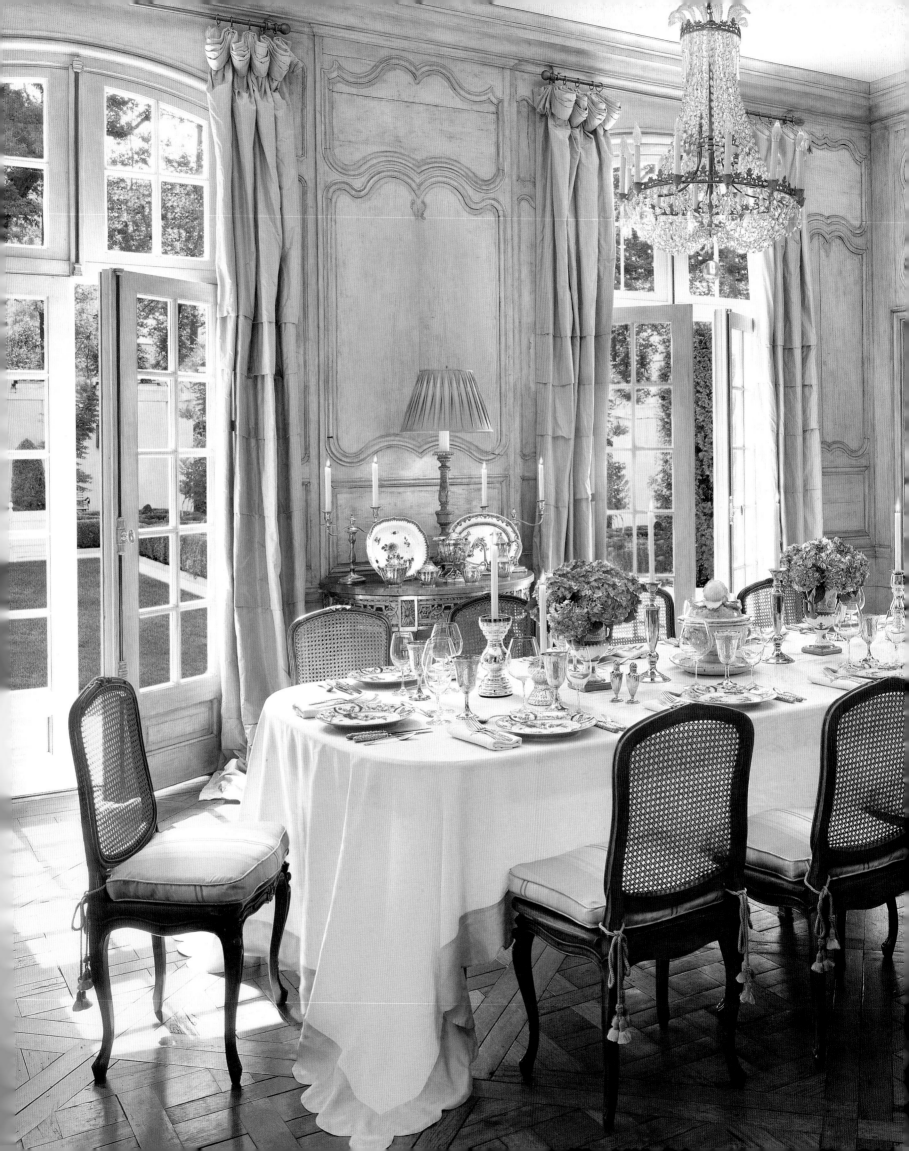

Classic Houses

When you use the word *traditional* to describe a room, you can sometimes conjure images of grand and imposing spaces. You might think of ornate mahogany furniture, heavy drapes, acres of ruffles and jabots. There's nothing wrong with any of these things, of course—ruffles and jabots and noble mahogany furniture all have their place in decoration. But VERANDA's take on traditional has always nodded to real life. We've always tried to ask how people actually live in the spaces we feature. Where will they put their feet up when they get home after a long day? Where will they set down their cocktail or cup of tea? Where will they curl up with a book—or our magazine?

The "traditional" houses that appealed to us the most were those that looked like they could accommodate the rigors of daily life. They take certain touchstone principles like symmetry, scale and proportion and combine them with the tried-and-true building blocks of traditional design, such as elegant antiques and architectural elements like millwork and parquetry, to create something that looks to the past while simultaneously embracing the present day and the future.

Classic is a much better word to describe such spaces. How else could you categorize a living room in a former eighteenth-century hunting lodge designed by couturier Edouard Vermeulen, where gorgeously weathered boiserie envelops a seating arrangement anchored by plush sofas and armchairs slipcovered in simple Belgian linen? Or a Palm Springs estate by master designer John Saladino that features an open-plan configuration of Doric columns and curving arches cleverly and artfully separated by gauzy scrims and louvered screens? Inside the famed castle of iconic *antiquaire* Axel Vervoordt, the grandeur of the historic Belgian property is downplayed by a collection of Asian artifacts scattered throughout the rooms in a worldly—and very contemporary—way. Similarly, Southerner Dan Carithers uses a soft, monochromatic palette of beiges and creams to temper a regal Provençal-style Atlanta house that might otherwise have come across as too somber. Italian-born textile designer Piero Castellini Baldissera uses color in very much the opposite way at his Tuscan farmhouse, employing simple graphic shapes and vibrant pops of color to give his spaces all the striking presence of a Rothko painting.

What all these rooms have in common is a wonderful livability that relies on timeworn ingredients deployed in inventive, irreverent and, yes, trailblazing ways. Most of all, they are comfortable, and they are timeless. In a word, classic.

PAST PERFECT
An elegant estate adroitly balances its history with the rhythms of daily life.

"A lovely outfit doesn't need a lot of accessories," says Belgian couturier Edouard Vermeulen. "A beautiful house doesn't need too much decoration, and a good dinner doesn't need too much preparation. Good ingredients are my policy for everything. Keep it sober, simple and refined." This is not just a design ethos for Vermeulen. It's a philosophy for living—one that's borne out at his estate near Brussels. Built in the eighteenth century, the former hunting lodge has rich verdigris boiserie and antique Versailles oak parquets tempered by stark ivory silk curtains and furniture wearing plain white linen slipcovers.

This yin-yang aesthetic can be difficult to pull off, and the deftness with which it's displayed here reflects true talent. In a former life, the fashion designer—known for dressing such Low Country royals as Princess Mathilde of Belgium and Princess Máxima of the Netherlands—was a decorator, and he crafted these interiors himself. He managed to create a home grounded in the current age that still retains an appropriate sense of historicism.

When Vermeulen purchased the property, parts of which date back to 1780, he discovered it had been modernized with false ceilings and spotlights. He commissioned architect Raymond Rombouts to restore its original proportions and brought in elements that would eloquently set the scene. Along with the boiserie and parquets, he commissioned a curving limestone staircase to dominate the entry hall. Together they yielded a lived-in, patinated background against which Vermeulen placed contemporary accents, such as a minimalist painting by Michel Mouffe in the entry hall and a streamlined metal coffee table in the living room. Textiles are uniformly white, with nary a pattern in sight. There are cross-cultural references, too: Han dynasty bronzes and Thai and Khmer pottery share space with eighteenth-century French and Swedish antiques.

All of it comes together in a seamless expression that reads neither too grand nor too humble, but completely beautiful and elegantly livable.

Edouard Vermeulen says the antique boiserie installed at his home, which was restored by architect Raymond Rombouts, has the presence of furniture, so he complements it with lighter pieces that lack heft, such as a scrolling 18th-century console. The bronze Chinese vases and age-darkened mirrors are from the Han era.

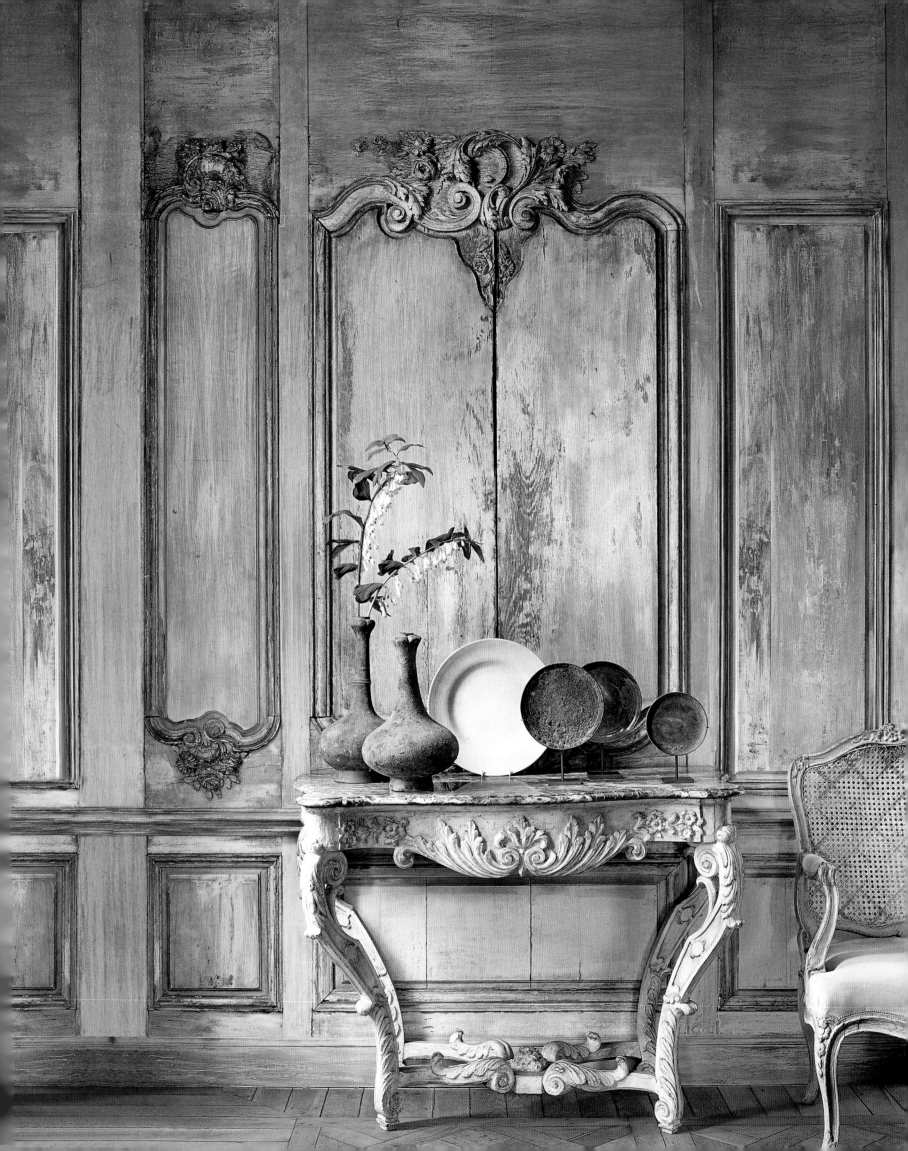

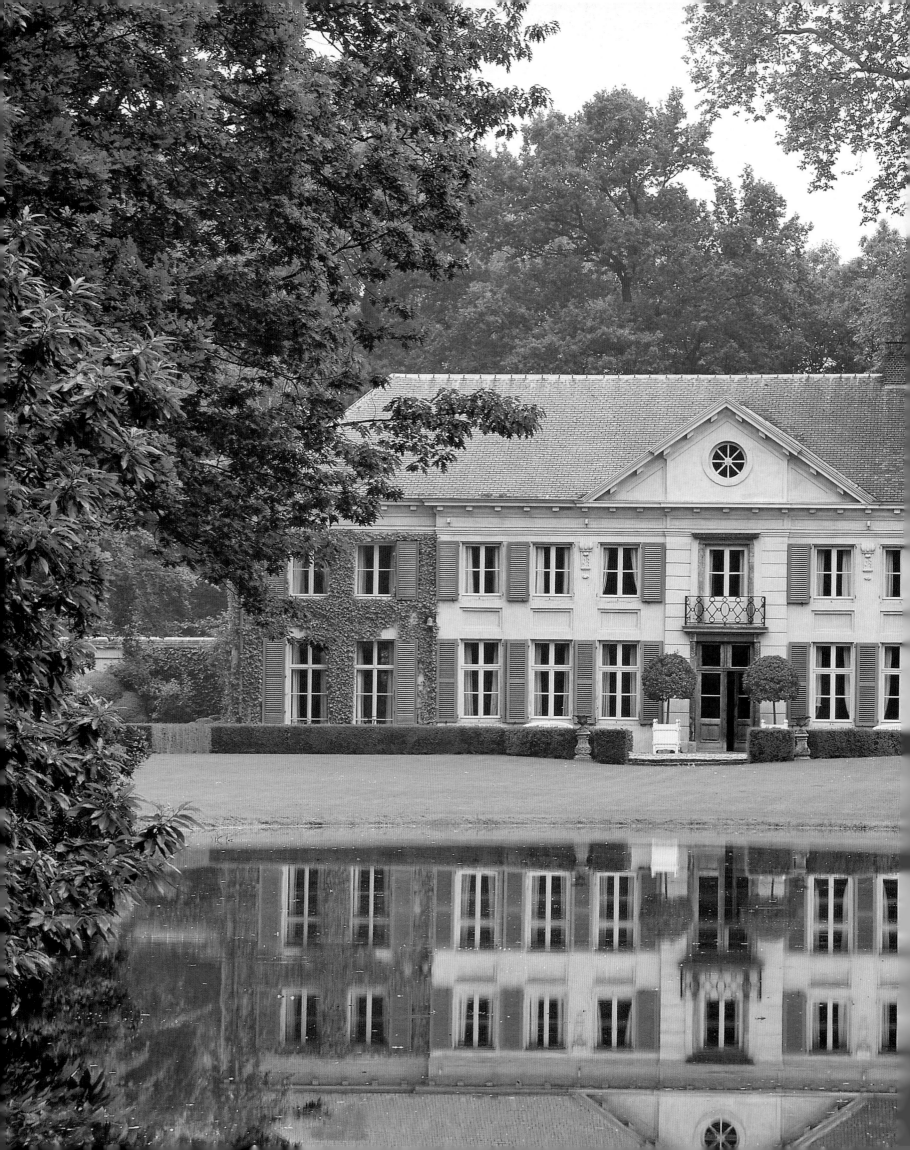

The formality of the richly paneled, parquet-floored living room is offset by simple and surprisingly modern pieces, like a clean-lined metal coffee table and a slipcovered sofa and chairs. Pinch-pleated silk curtains adorn the floor-to-ceiling windows. Swedish demilune tables from the 18th century share space with a Louis XV–style cane-back fauteuil and a Louis XV side chair. PRECEDING PAGES: The 18th-century hunting lodge was restored to its Directoire elegance.

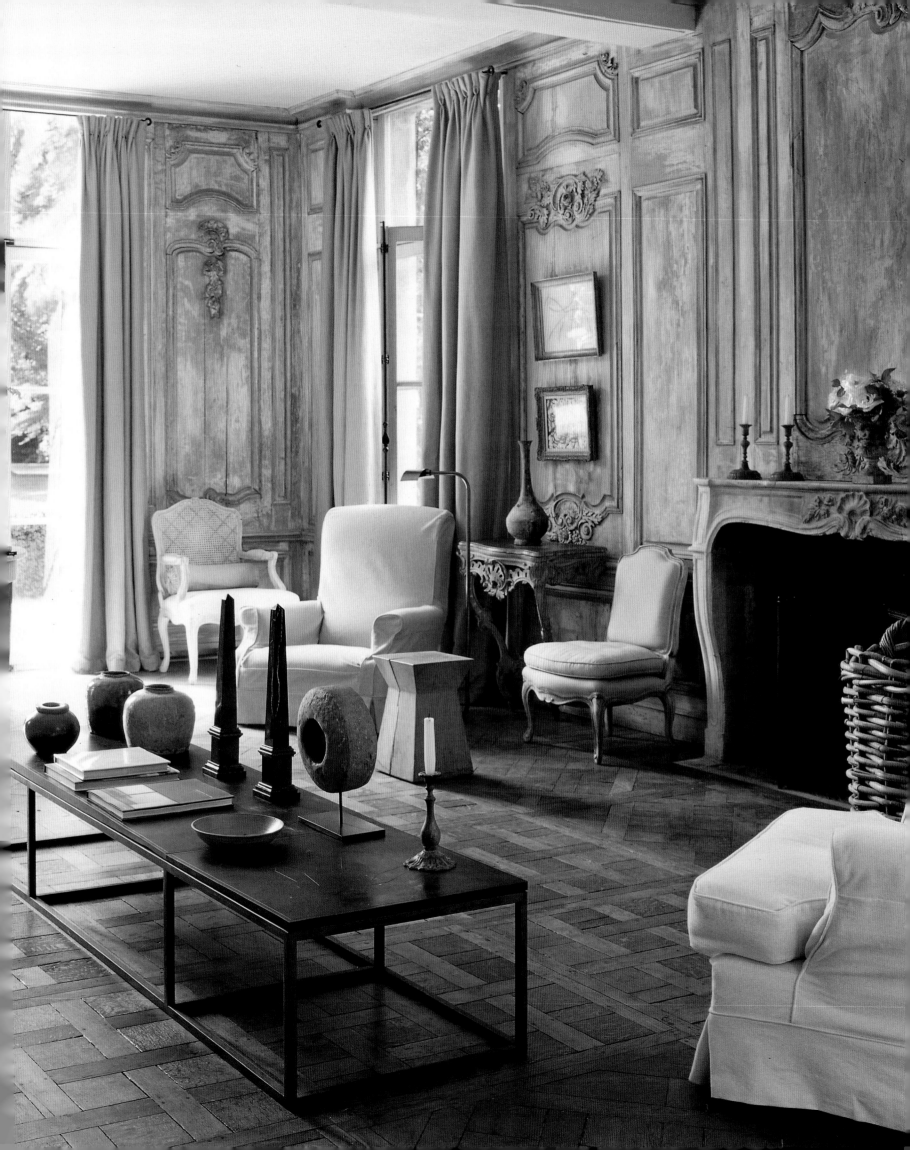

A modern sensibility includes cross-cultural references. ABOVE: Thai and Khmer vases from the 16th and 17th centuries adorn a country table in a guest room; one has been converted into a lamp. OPPOSITE: A large cabinet in the vaulted orangerie holds a collection of Han pottery. A Thai architectural relic is displayed as sculpture. The terra-cotta floor is original.

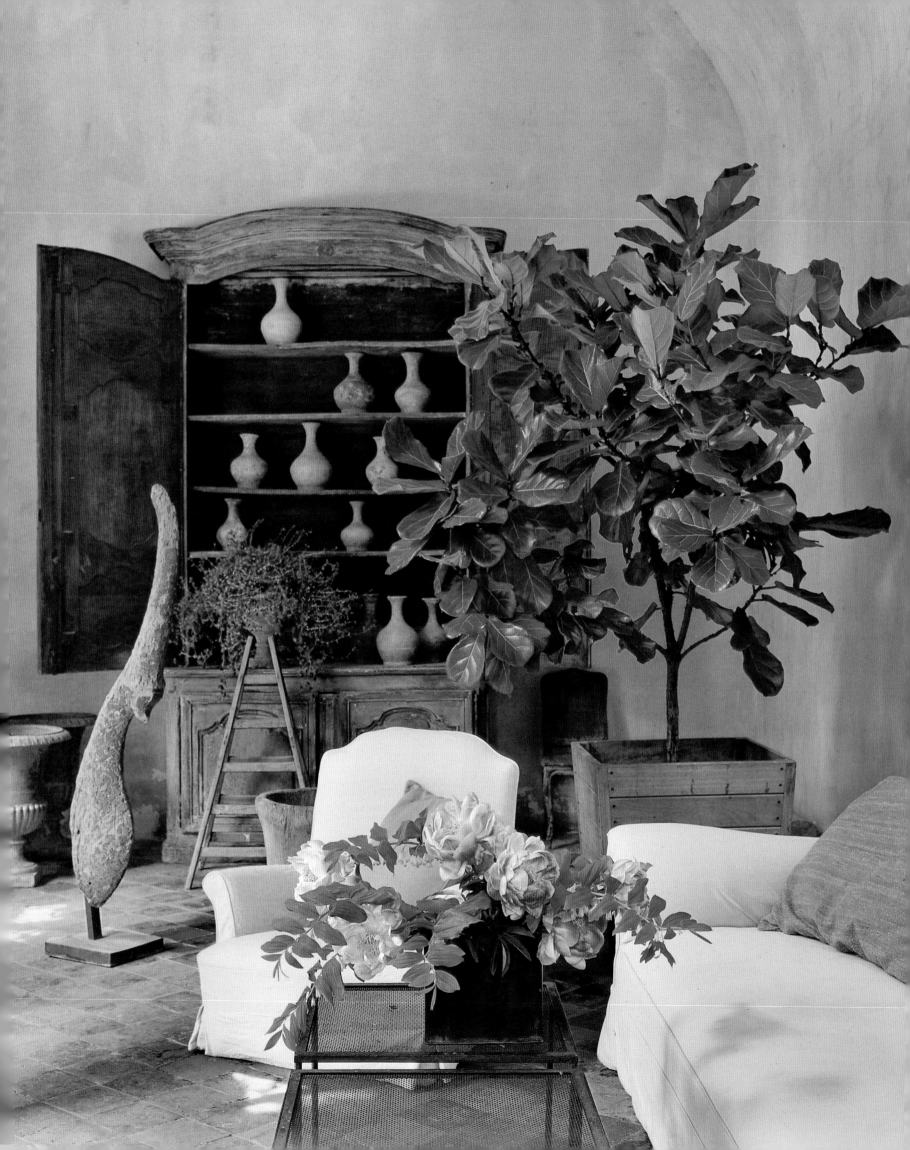

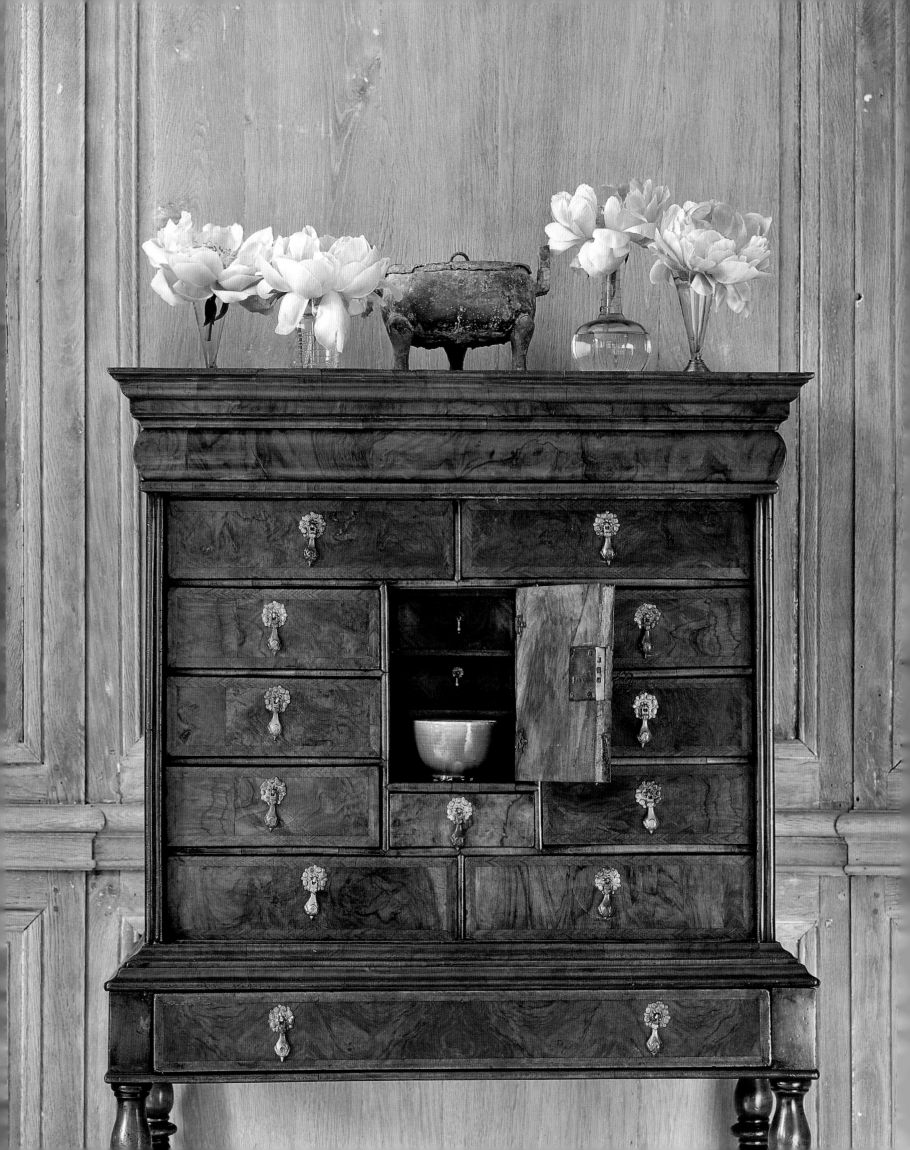

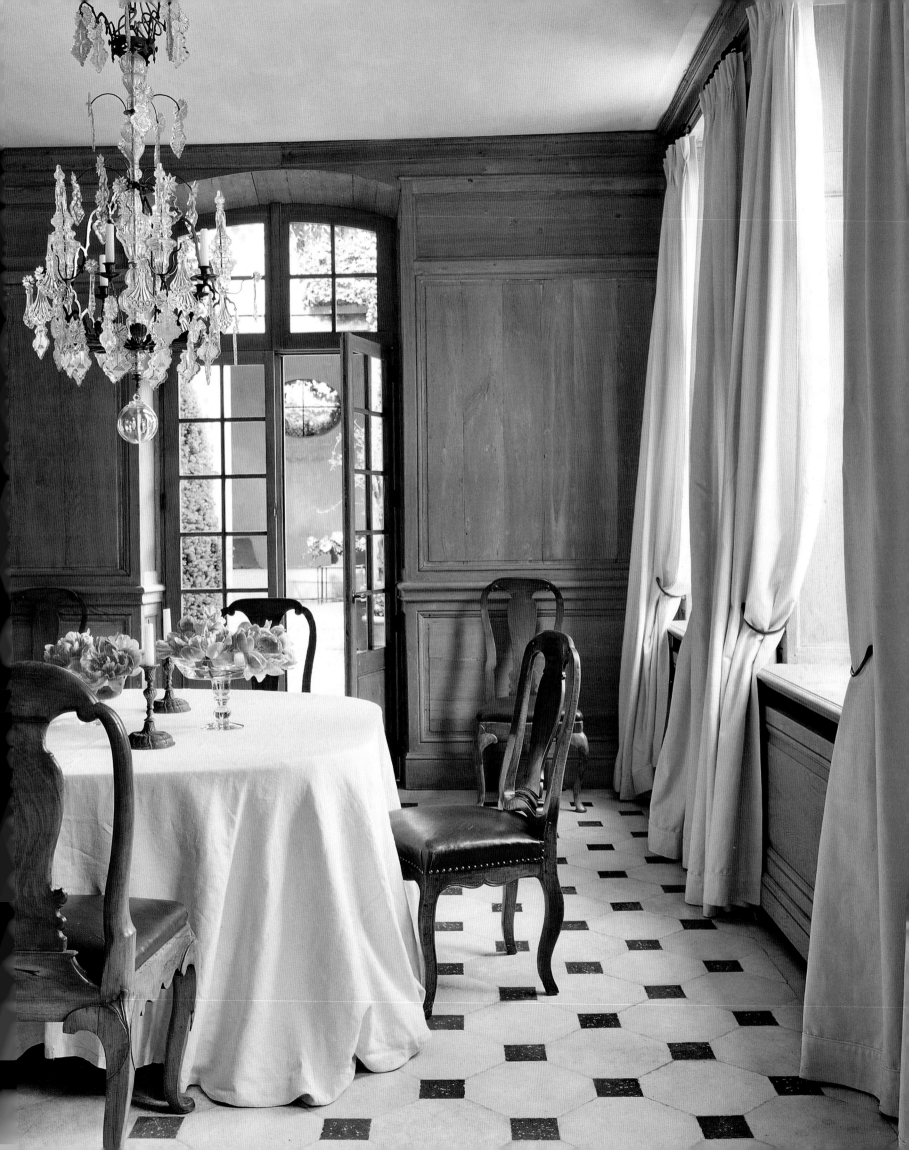

Chalky finishes impart a spare aesthetic. ABOVE AND OPPOSITE: Paint in the master bedroom and bathroom is textured to resemble limestone. The oak vanity's open shelves add a contemporary note. PRECEDING PAGES: The dining room cabinet is from the 17th century. Plain linen tablecloth and curtains pair well with 18th-century Dutch dining chairs and an elaborate crystal chandelier.

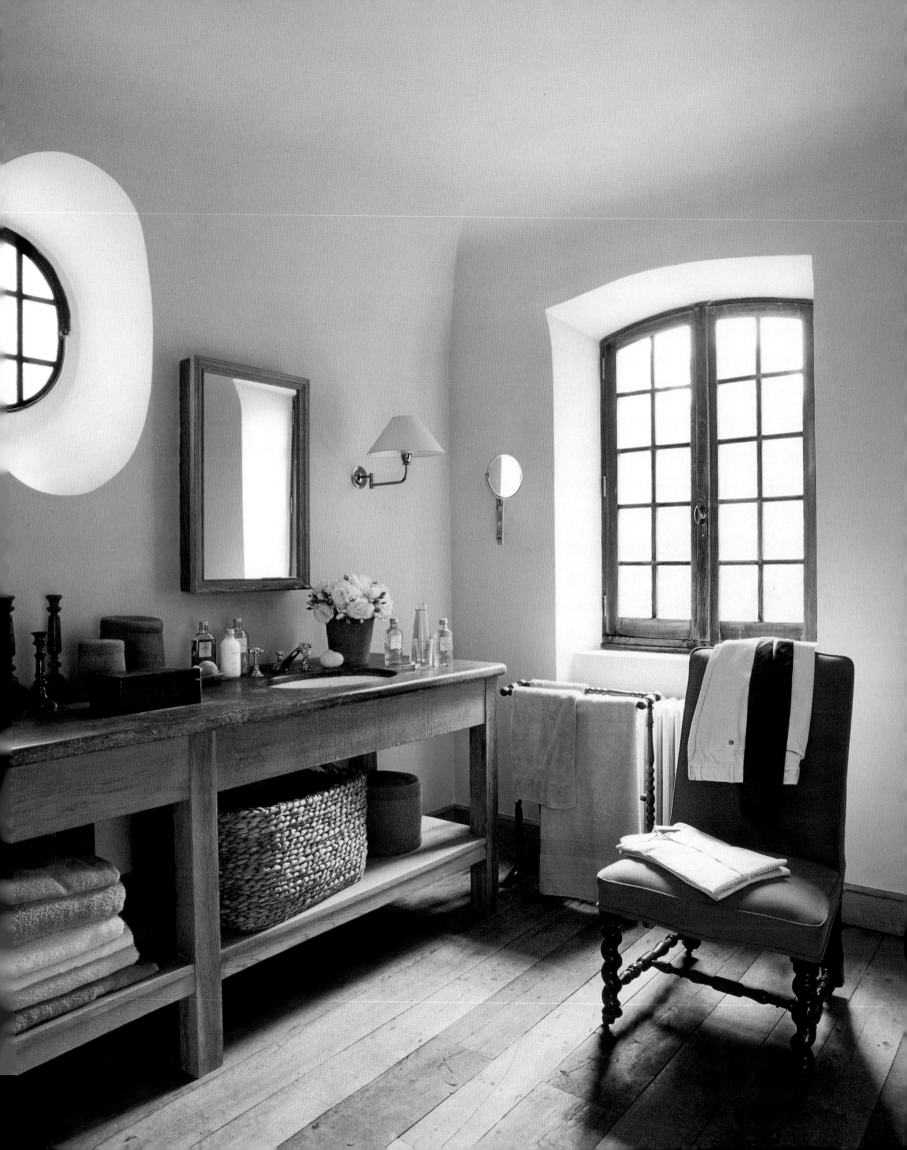

INSIDE STORY

A master designer focuses his gaze within a
grand enfilade of rooms.

What do you do when an otherwise grand house lacks the dramatic punch of sweeping
mountainside views or expansive oceanfront vistas? You create them indoors. Which is exactly what
designer Dan Carithers and architect Peter Block did at this Provençal-style house that sits on an awkward
corner lot in Atlanta.

The centerpiece is a regal parade of rooms that places a heavy emphasis on sight lines. From the
entry hall, indoor panoramas stretch as far as the eye can see, taking in attention-grabbing elements like
a chalky limestone fireplace in the far-off kitchen and a charmingly painted screen in a nearby powder
room. Outside, Block adapted the property—originally built in a ranch style in the '50s and updated in the
'90s with a second story and the look of a stately rural retreat—with a new driveway, a pool and a leafy rear
courtyard with a latticework brick wall.

To match that characterful exterior, Carithers furnished rooms with a traditional bent in neutral
tones, offset by weathered and humble touches. In the kitchen, an eighteenth-century monastery table
serves as an island, custom cabinets are crowned with Gothic arches, and a cushy armchair in blue and
white toile is tucked into a sunny corner. Throughout, there is enough faience, jasperware, creamware,
Delft and Spode hanging on walls or displayed on shelves to cater a wedding banquet. In the living room,
beams were painted and scraped for a flaking, storied effect—they look as if they'd held up the eaves for
centuries. And for a household that includes three dogs and a cat, Carithers brought in such hard-living
materials as walnut parquet floors refinished in a sand color that hides wear, as well as sturdy sisal rugs that
disguise stains. They help ensure that, in this house, the only thing liable to cause drama is design.

An 18th-century French limestone mantel is the focal point of this
sitting room in Atlanta. Antique candelabra on brackets and
Rockingham lions on side tables flesh out the symmetrical arrangement.

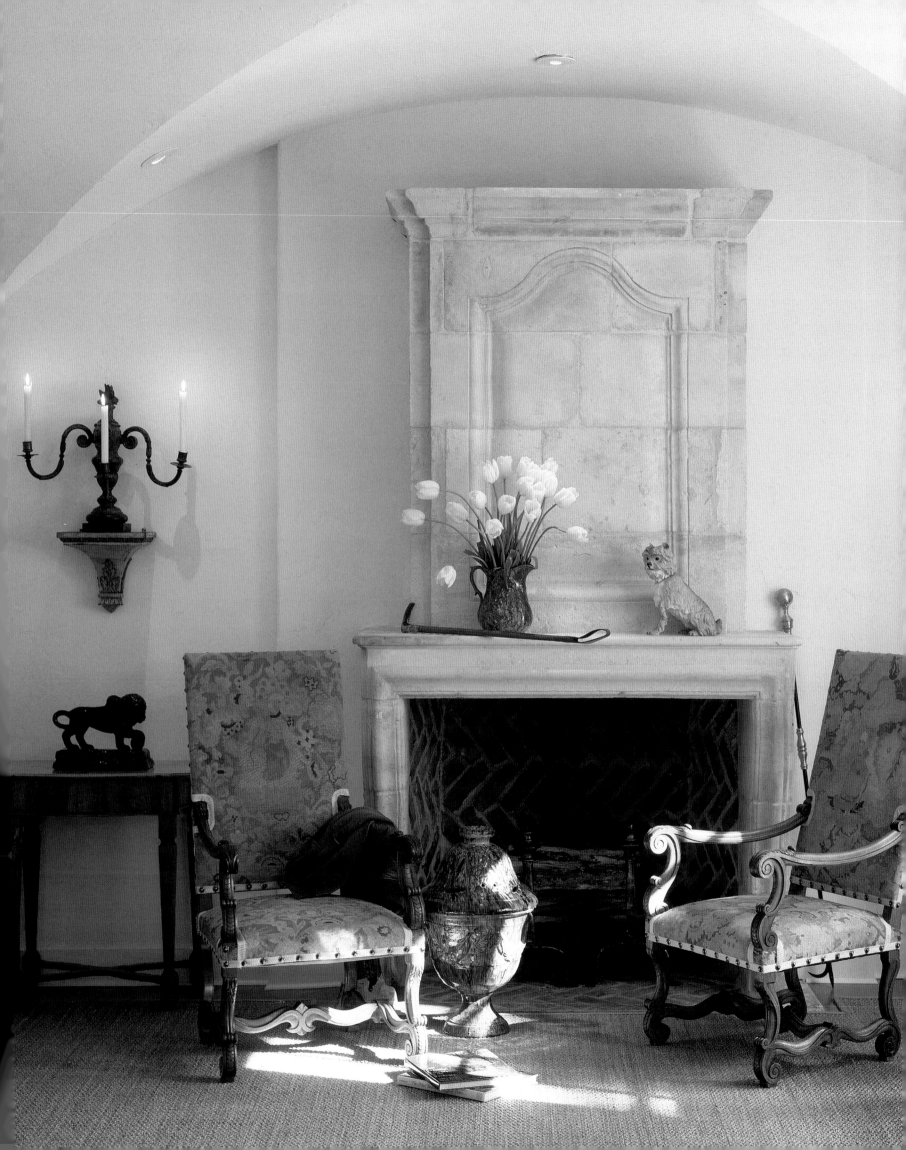

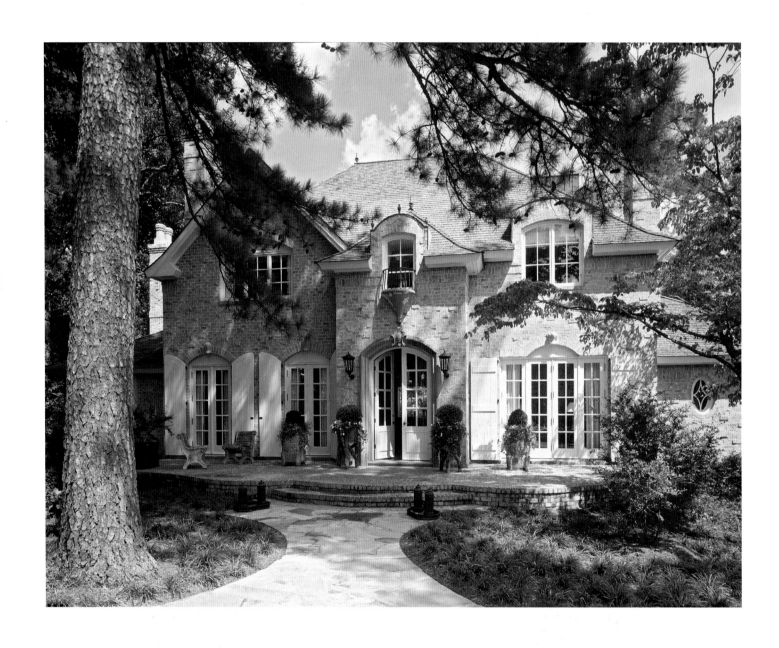

ABOVE: Designer Dan Carithers and architect Peter Block created drama for this Provençal-style house by refining proportions and incorporating authentic elements. OPPOSITE: Living room beams were treated to look antique. The Louis XV chest is made of myrtle wood.

The tall proportions of the antique limestone mantel draw the eye upward—all the better to showcase artfully vaulted ceilings. Antique tapestry chairs, French lavender urns and a 19th-century English leather desk chair share similar tones and are grounded by the sisal rug, which unifies the space.

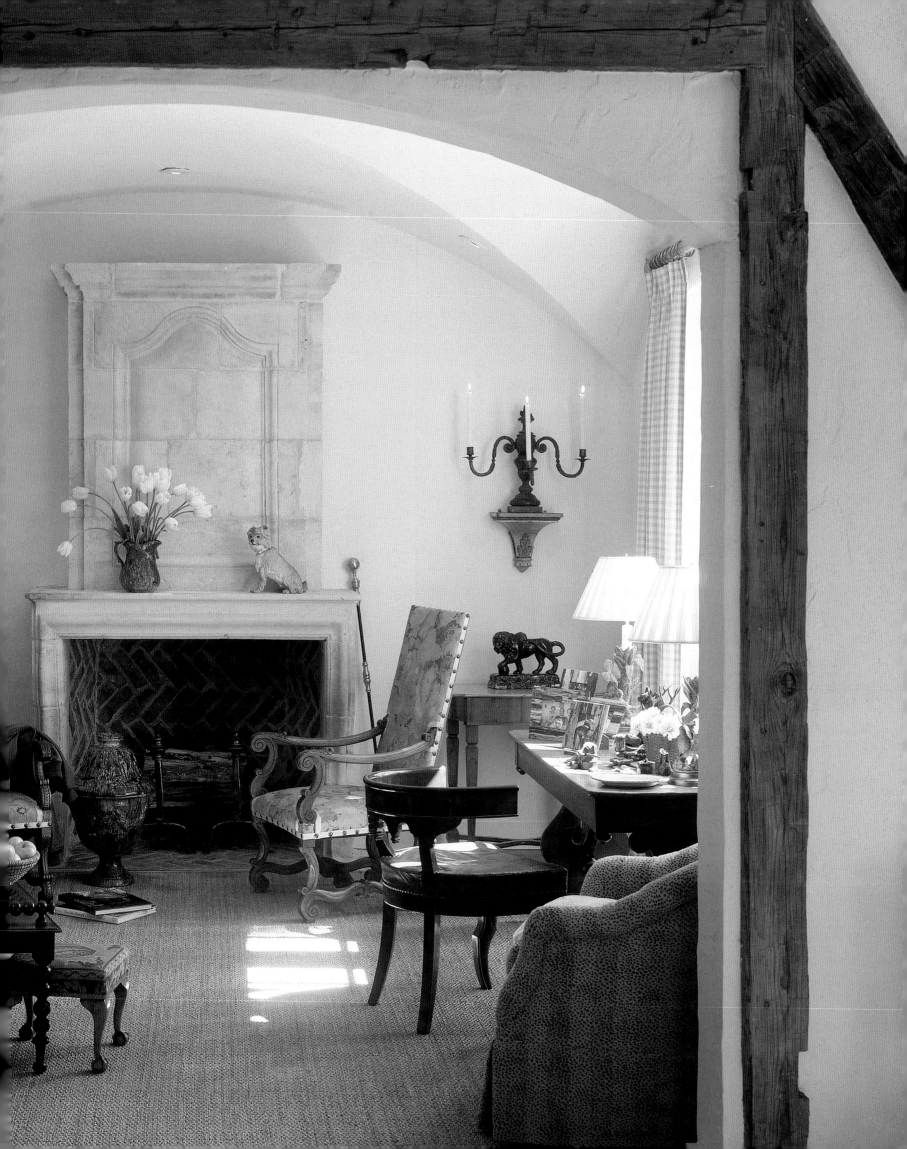

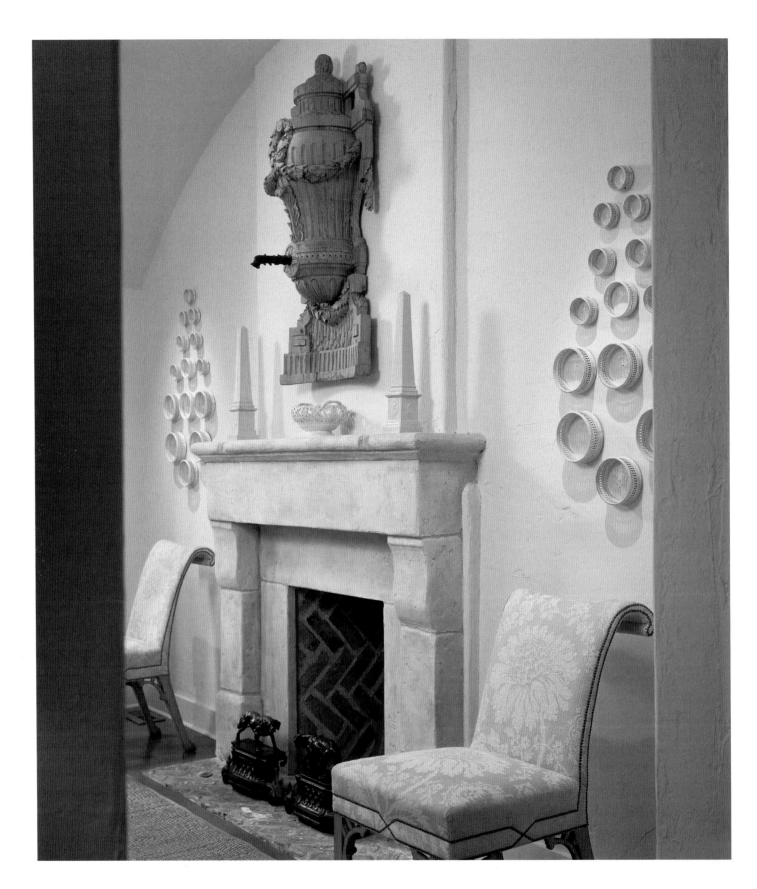

ABOVE AND OPPOSITE: An arrangement in the dining room is a study in neutrals and shapes.
A French carved wood lavabo is flanked by rare 18th-century creamware obelisks, which are in turn
bracketed by a collection of antique wine coasters displayed on the walls. Mix-and-match
dining chairs—in leather and raffia or damask with nailhead trim—give the space a less formal flair.

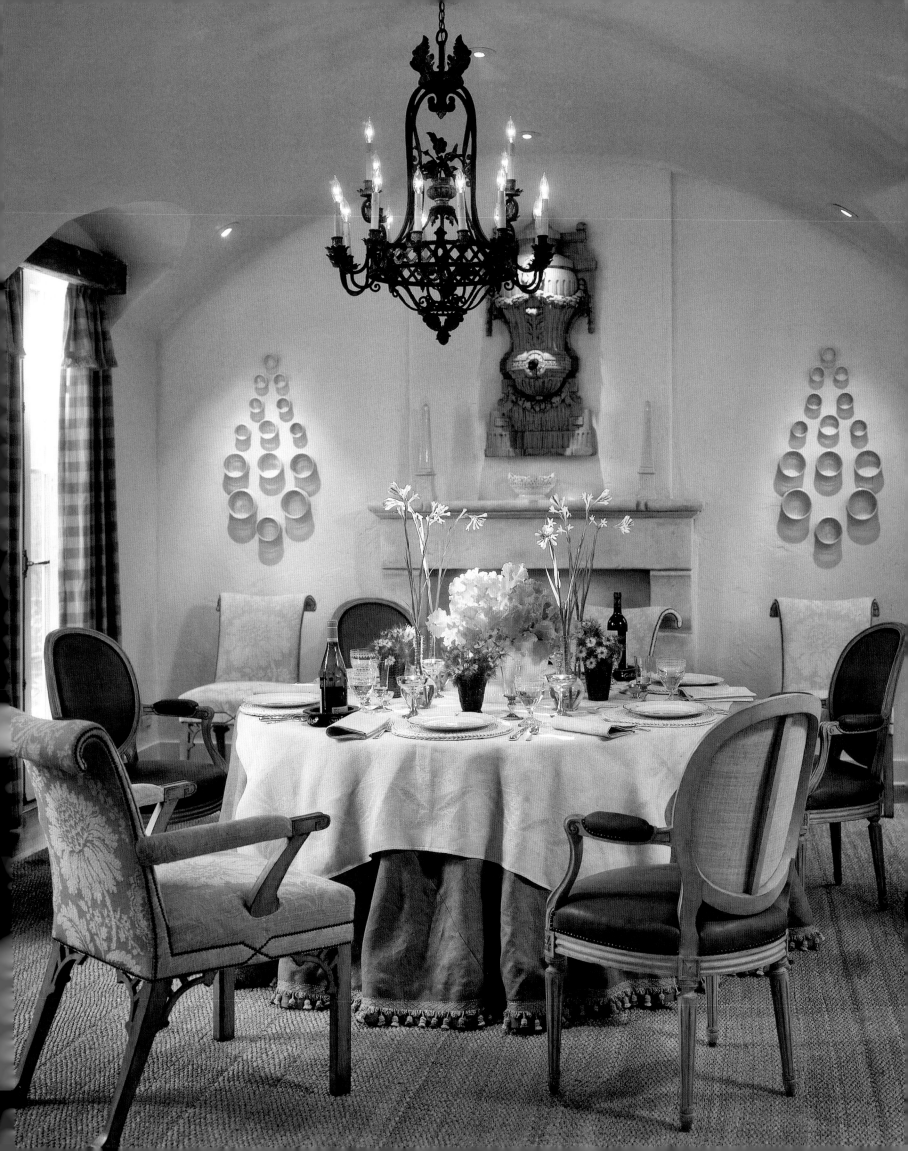

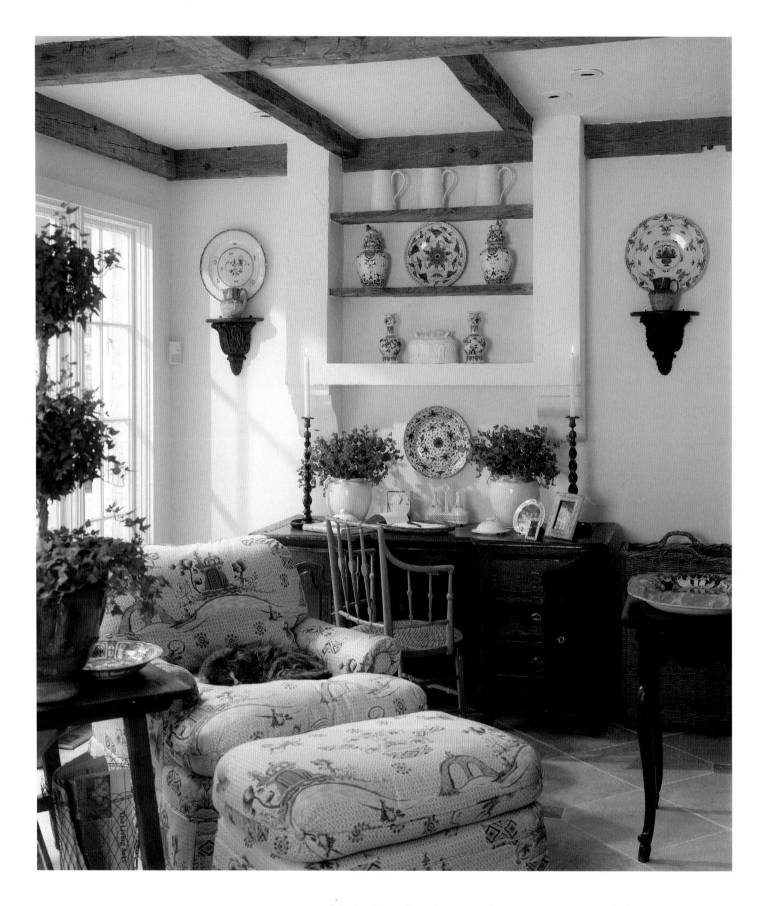

ABOVE: A corner of the kitchen takes advantage of a sunny exposure and feels more like a sitting room. Antique Delft and creamware are displayed above a painted English Regency chair.
OPPOSITE: A monastery table suits casual dining. The Louis XV–style bench is covered in raffia.

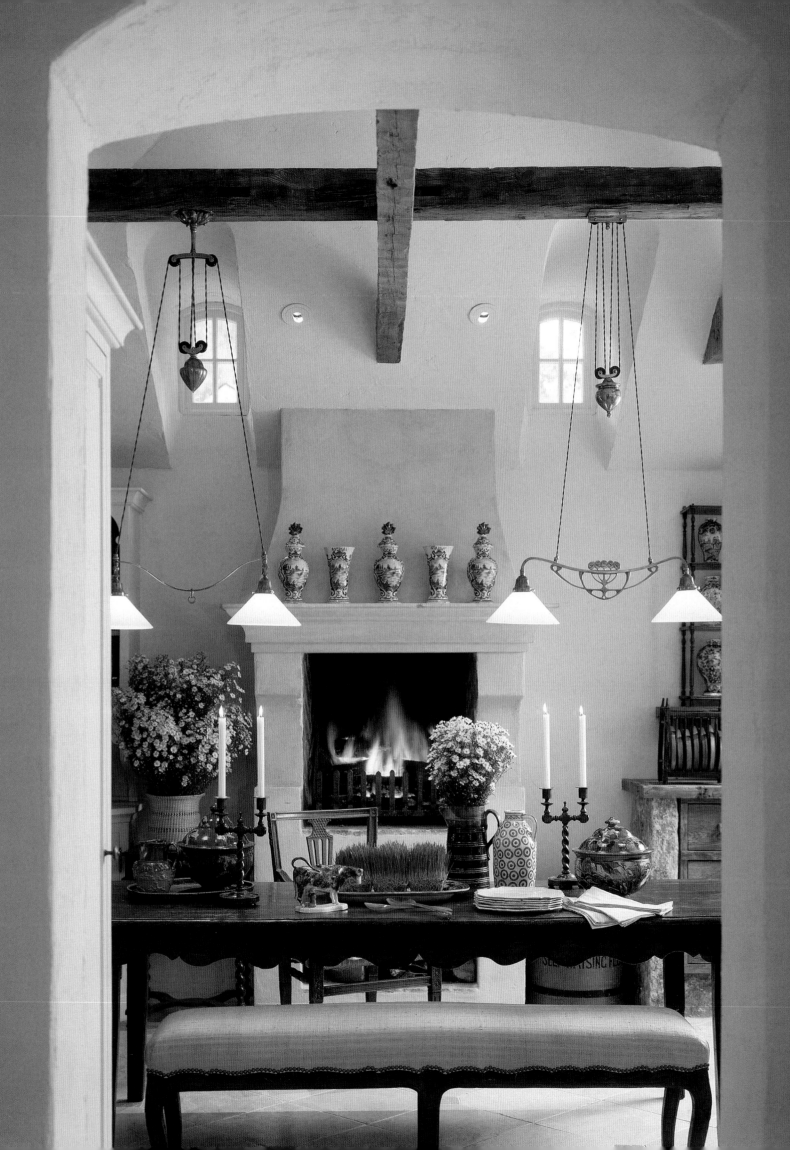

VISUAL SYMPHONY
Achieving sublime results through the expert use of color and classical proportions.

John Saladino focused on the big picture when he created the interiors of this sprawling house near Palm Springs. "I abstracted all the elements—sofas, lamps, tables and chairs—into geometric shapes," says the New York–based designer, whose work is known for its serene beauty. "Once I introduce color, it's as if I'm painting a still life."

The exteriors of the stone-clad house conformed to the arid brown tones of the desertscape, and on his first site visit, Saladino quickly developed a thirst for color. He proposed a daring blend of pinks, magenta, cream and mustard yellows. "They're unusual colors to use together in a living room," he says. "But I knew the desert light would extract some of their intensity and power." Used in slipcovers and upholstery on chairs and sofas, the pinks echo the bougainvillea on the property and the deep hues that halo the mountains at sunset. Mustard, duplicated from a native blossom, crops up on throw pillows, passementerie and antique fauteuils.

The clients initially likened their expansive living room to an auditorium, so Saladino warmed the large space by painting its walls a rosy taupe and zoning it into three "rooms." In what the owner calls the "Casablanca corner," a screen sections off a bridge table and chairs. In another area, a sofa and armchairs cluster around a fireplace. "I introduced a sense of procession," Saladino says. He savors the dramatic tension achieved by playing with scale and sequence. His furniture juxtapositions are dynamic: baroque with modern, primitive with refined, vibrant with subdued. They assure a feeling of intimacy in the large space, illustrating his consideration for the way a room will actually be used, as well as his canny sense of where to draw the line. Saladino knows how to edit. "What you omit or hold back is just as important as what you include."

The lofty gallery of a house near Palm Springs has a human scale, thanks to John Saladino's seating arrangements and architectural elements that give the space structure. The wood sculpture is by Jerome Abel Seguin.

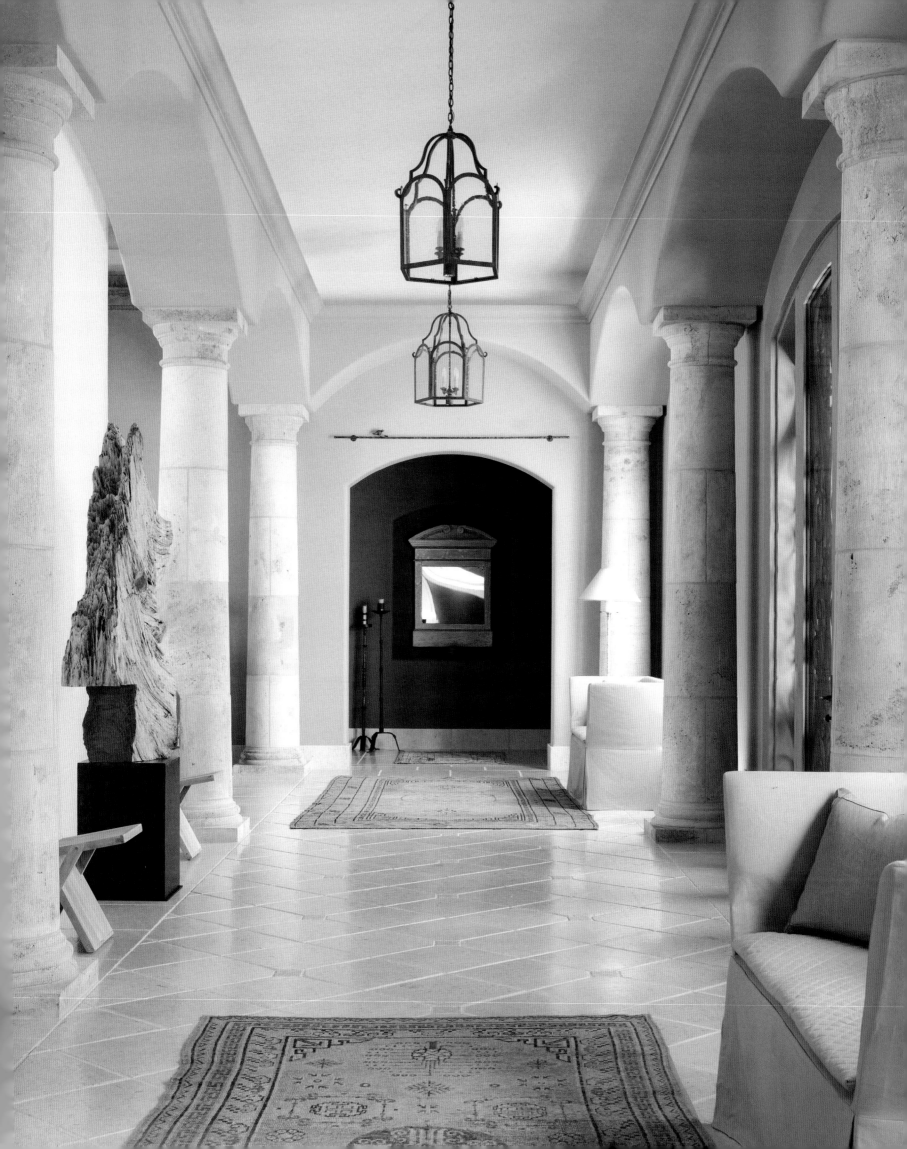

Fabric on walls and a quilted and skirted
banquette make for a cozy breakfast
nook that also includes contemporary
art by Robert Courtright, a French chair
and an antique table heavy on patina.
PRECEDING PAGES: Using a scrim panel
and a shuttered screen, Saladino created
separate seating areas to break down a
large living room that his clients had said
felt like an auditorium.

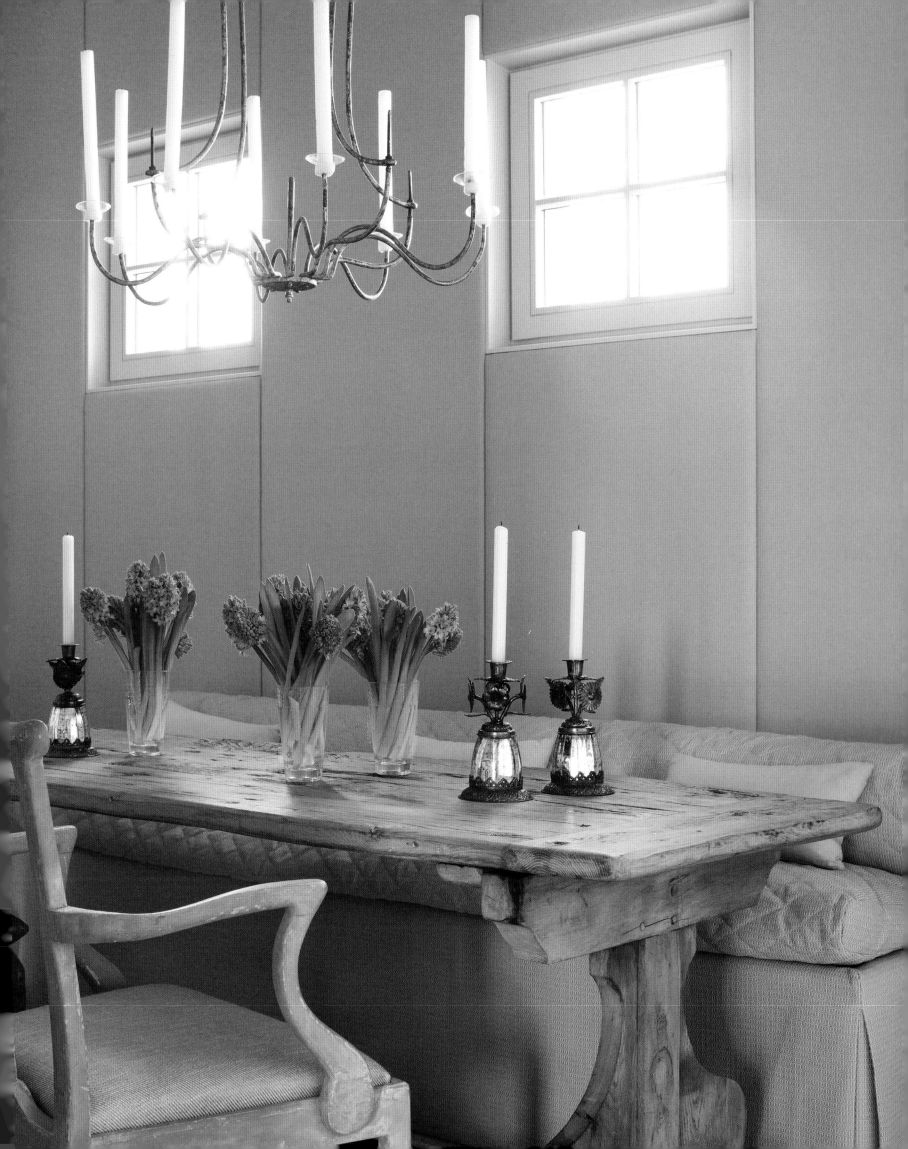

Textures and tones play off the light and have a cooling effect in an ethereal bedroom that includes art by Cy Twombly, a Belgian stone-top console and a custom wall hanging that conceals a television. The sitting area is separated from the sleeping area by more scrim panels.

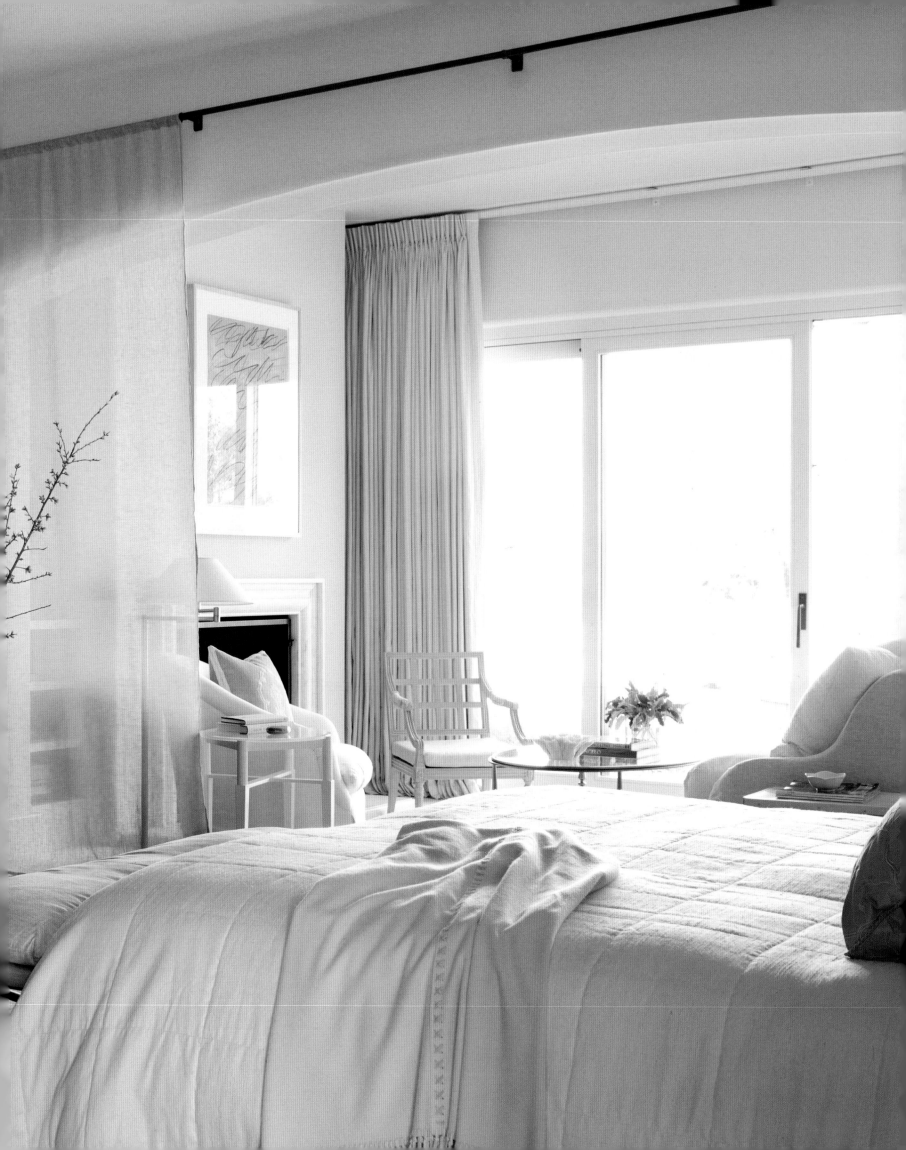

ANTIQUAIRE'S CASTLE
A centuries-old estate becomes a trailblazing
and influential testing ground.

A xel Vervoordt is an antiquarian who's something of an institution in his native Antwerp. In
1969, when he was just twenty-one, Vervoordt intervened to stop city authorities from tearing down a
row of crumbling sixteenth-century houses on the Vlaeykensgang, in the heart of the city. Vervoordt then
restored the eleven properties and set up his home and business headquarters there. Today, the regenerated
Vlaeykensgang, with its nest of restaurants and apartments, is one of the chicest addresses in Antwerp.

But Vervoordt has long since moved on. In the mid-'80s, he outgrew the location, and he and his
wife, May, moved to 's-Gravenwezel, a turreted and moated fifty-room castle that serves as both their
home and showroom in the Flemish countryside about ten miles outside town. It quickly became a staging
ground for Vervoordt's distinctive art, a talent for mixing items of disparate eras and pedigrees in spaces
that are at once grand, stylish and completely comfortable: "I juxtapose major pieces with more everyday
objects to retain a human dimension." There is gilt Italian paneling and a Gainsborough portrait in the
master bathroom, whitewashed alcoves and a humble painted pine secretary in a guest room. Vervoordt also
winningly assembles pieces from different cultures: ceramic Han horses in an eighteenth-century Belgian
cabinet, Ming blue and white porcelain and a Guatemalan silver chandelier from the 1700s. The entrance
hall blends eighteenth-century French consoles, English silver and Viennese lead reliefs.

It's as if Vervoordt were hosting a cocktail party and had invited the most interesting guests, regardless
of background—so long as they contribute something intelligent. "I adore mixing things, bringing objects
together in a way that you would people." The sentiment is incredibly apt. Interior design, at its best, does
have a way of feeling like a celebration.

Parts of 's-Gravenwezel, Axel and May Vervoordt's home and showroom, date
to the 12th century. It was rebuilt in 1740 by Jan Pieter van Baurscheit the Younger
to include a mix of 15th- and 18th-century architectural styles.

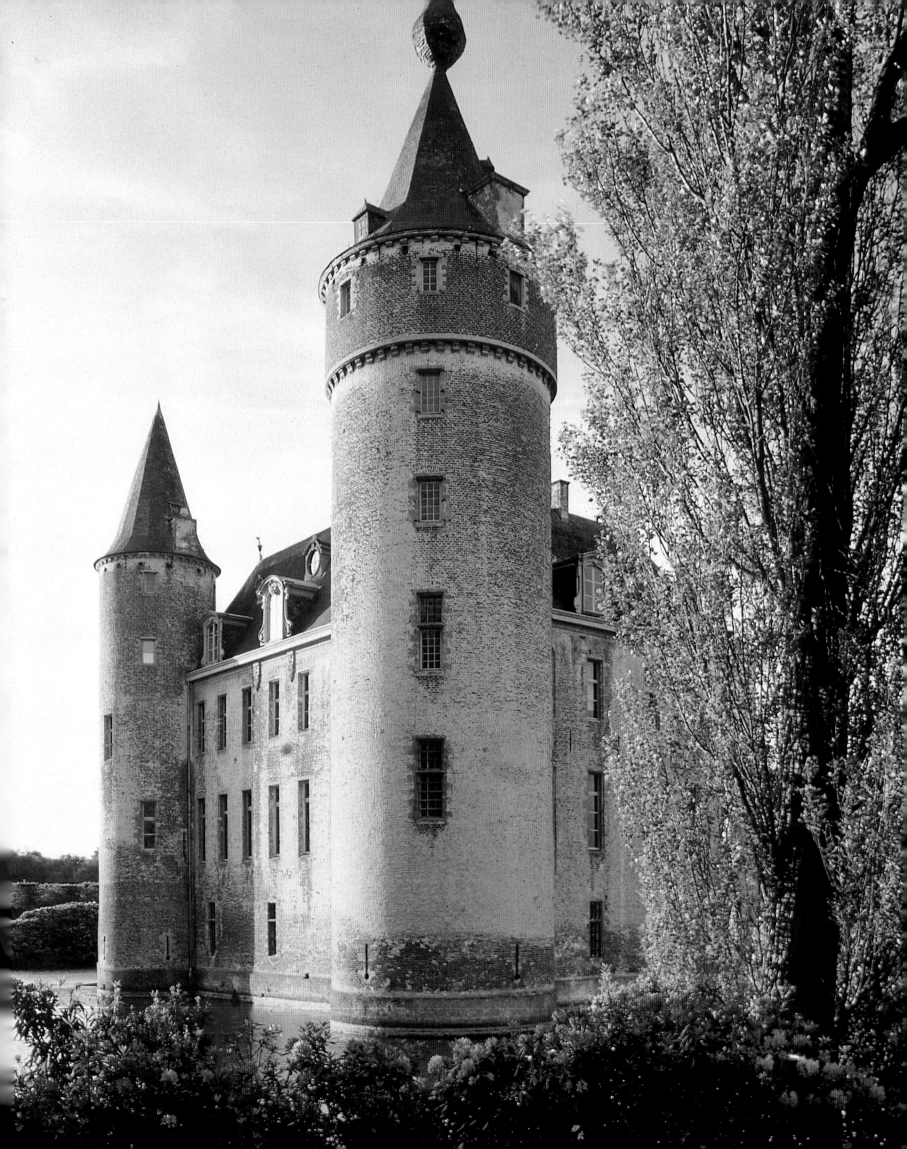

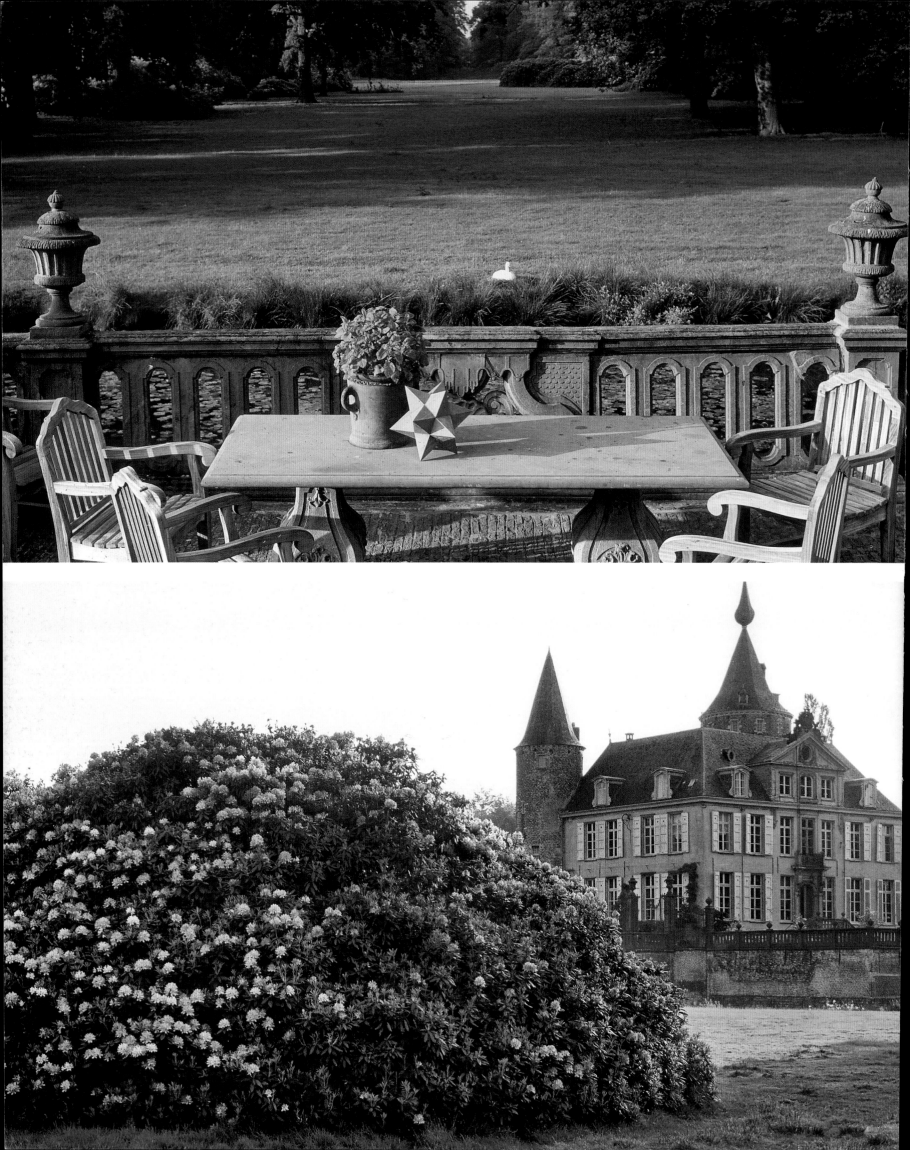

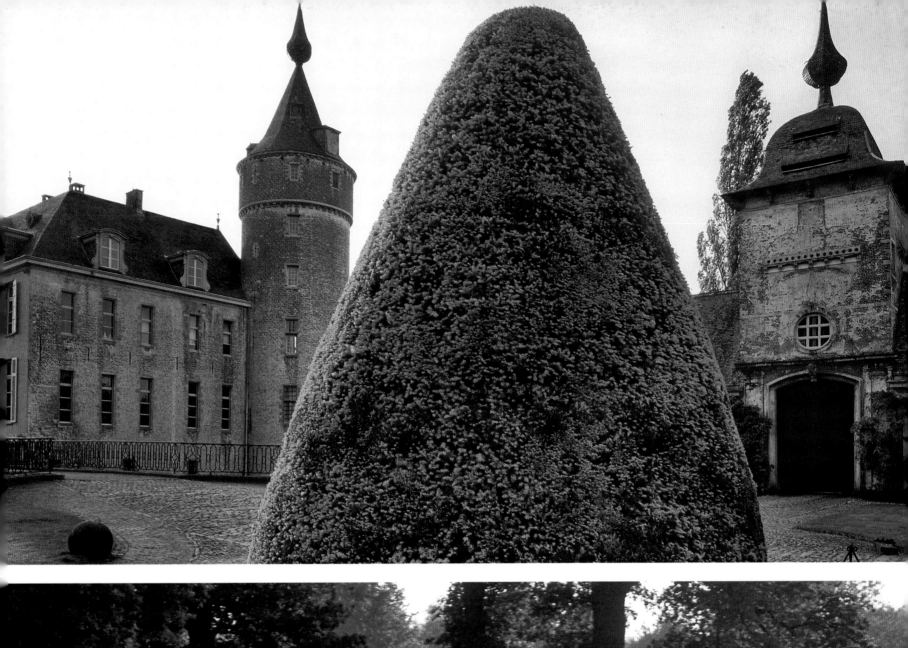

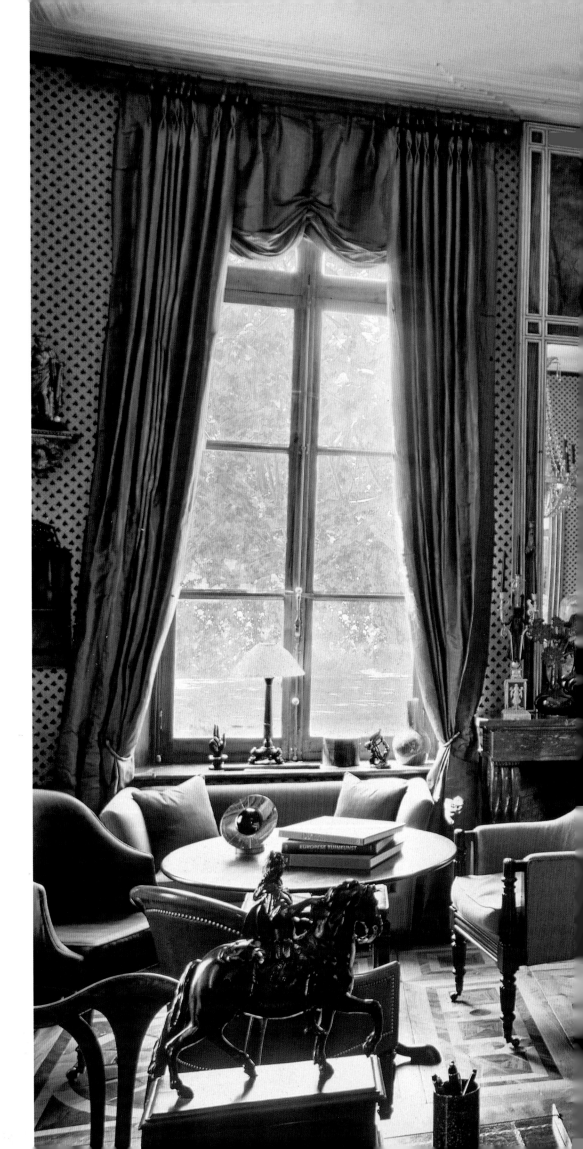

Contemporary furnishings, such as a sleek iron-and-marble cocktail table and upholstered chairs and sofas, mix with elevated elements like intricately patterned French parquet and 19th-century art and antiques to give Vervoordt's office a regal but not-too-precious air. PRECEDING PAGES: The estate's grounds, which had been allowed to return to wild growth when the Vervoordts purchased the castle, were restored by landscape designer Jacques Wirtz according to van Baurscheit's original plans.

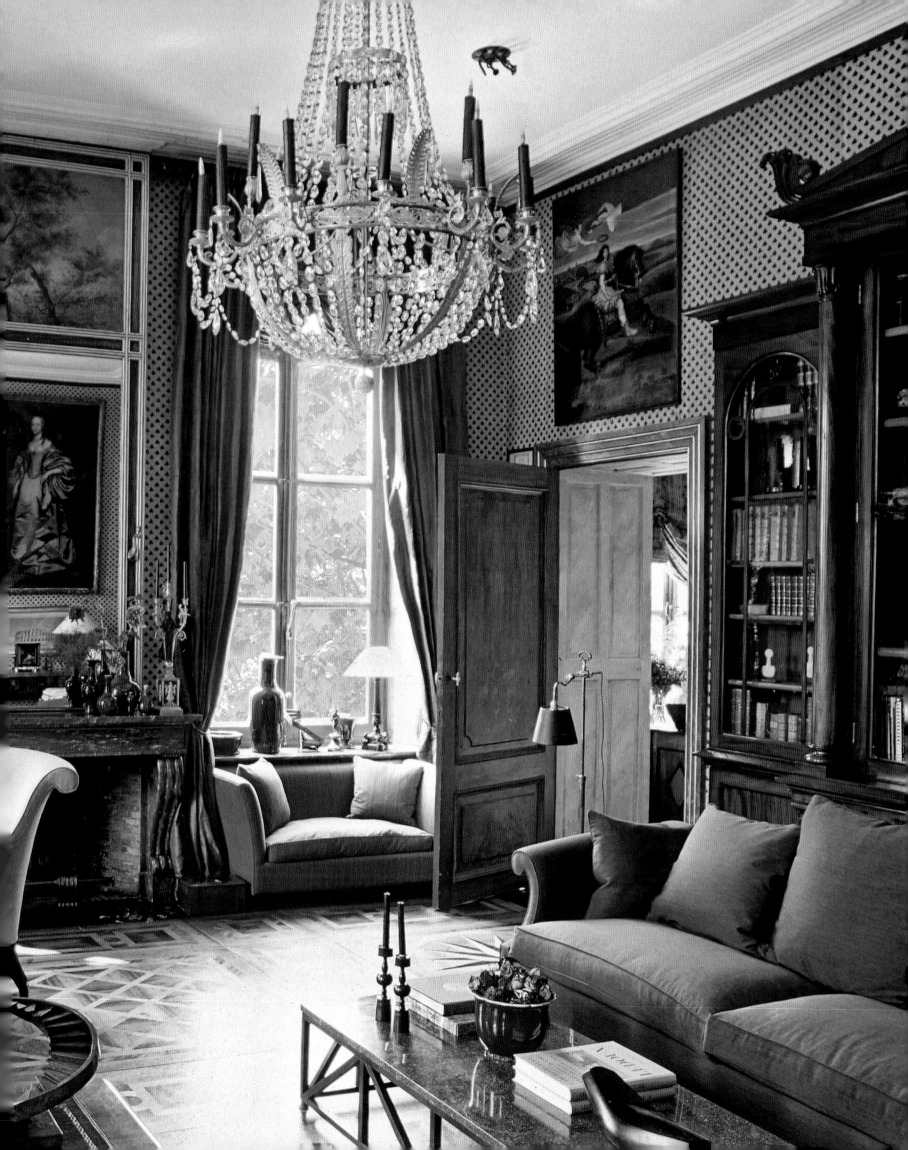

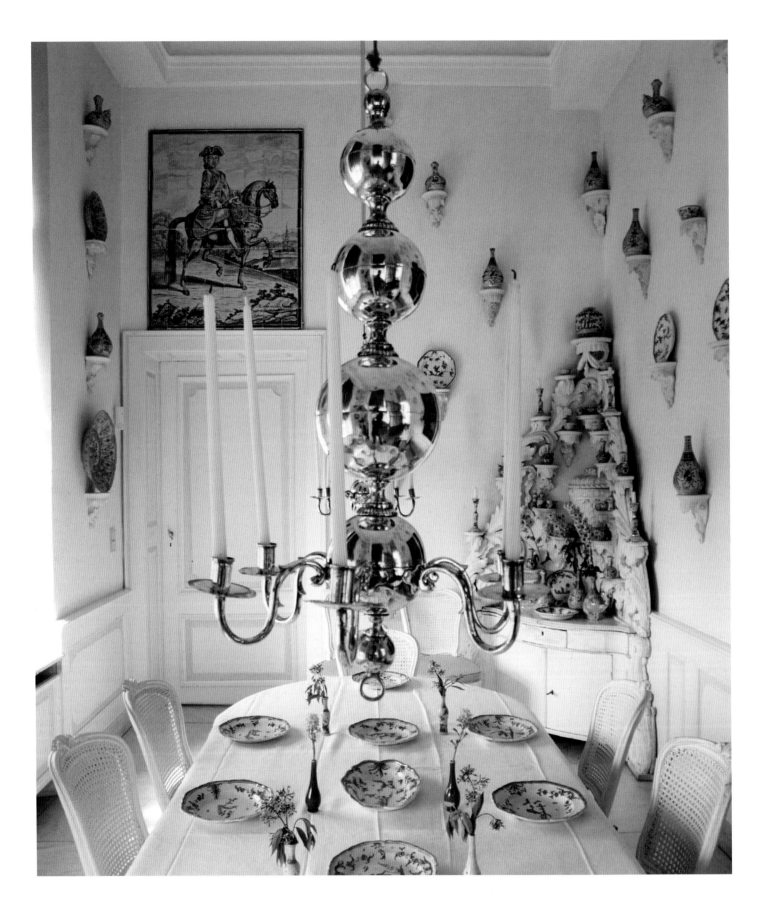

ABOVE: A Guatemalan silver chandelier made around 1760 hangs above a dining table set with a c. 1740 faience service from the South of France. OPPOSITE: The large collection of blue and white Ming china had been lost in a shipwreck for 350 years. The Louis XIV corner cabinet was made by Daniel Marot, who worked at the French court.

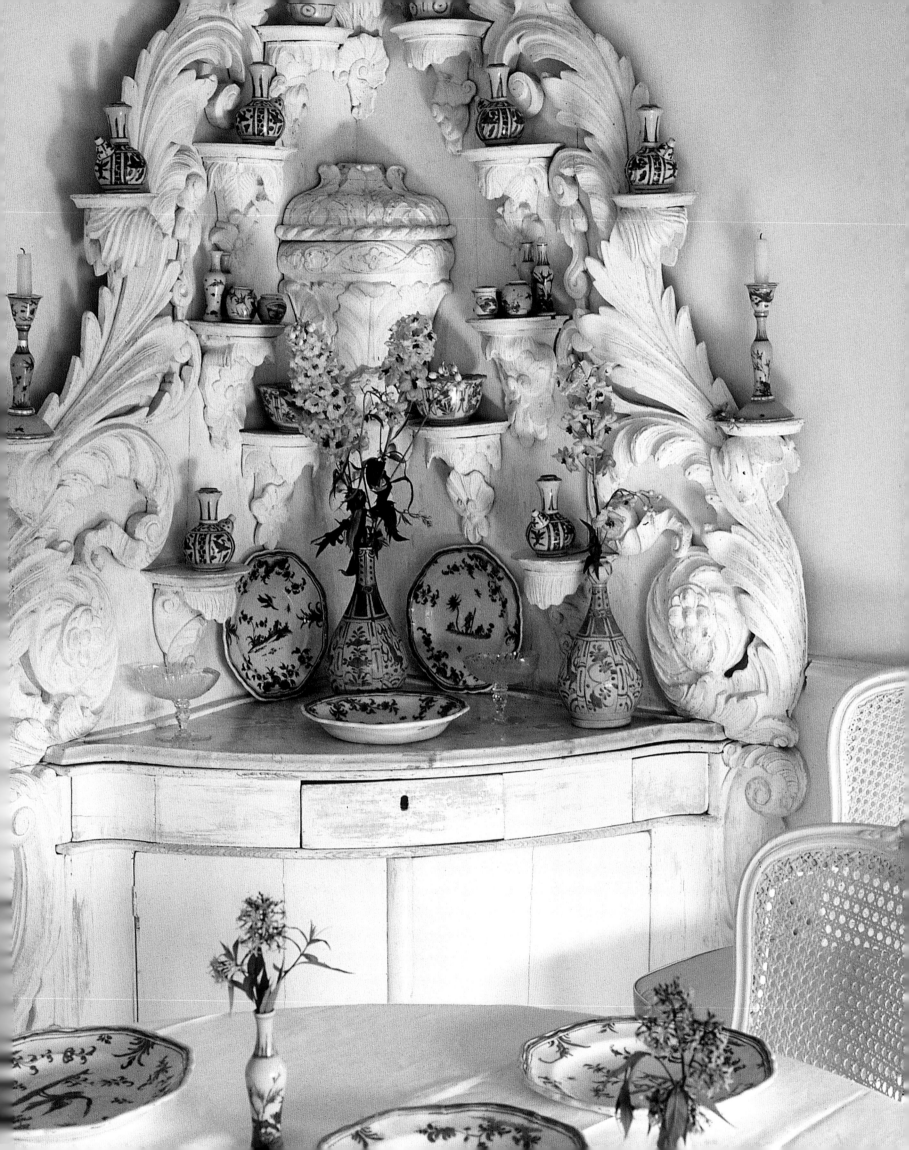

ABOVE: The orangerie, overlooking a flower-lined pool, is a modern addition. OPPOSITE: A silver gilt table and grotto chairs decorate the pool house. FOLLOWING PAGES: The master bathroom features 18th-century Italian gilt paneling and Thomas Gainsborough's *Portrait of the Daughter of George II* hanging in the bathtub alcove.

ALL THAT GLITTERS
Achieving artful results in timeless spaces from a precise use of tone and tint.

Just because a house has a classical background doesn't mean it can't have a modern edge. For Washington, D.C.–based designer Mary Douglas Drysdale, scrolling Greek key motifs, Corinthian columns and meticulously symmetrical proportions are merely a jumping-off point—an ideal assortment of decorative touchstones into which she can incorporate contemporary art and judicious punches of color to create interiors that are refined, serene and totally today.

In this particular project, Drysdale avails herself of a rich repertoire that includes regal architectural details, fine-boned furniture and ivory, gold and yellow tones—in a way that you could almost call minimalist. It's not as far-fetched as it sounds. By being very strict, she keeps all those rarefied elements from turning the rooms into period pieces and instead imbues them with gallery-like gravitas. Gold glints off the edges of mirror frames or from the swirling arms of sconces but never offers more than a whisper of glimmer. Yellow pops on seat backs, pillows and throws but is never more than an accent. Everything else, from the Louis XVI–style chairs to the acanthus leaf crown moldings and laurel wreath friezes, wears a mostly uniform shade you could match to a glass of milk.

The seemingly simple blueprint belies an amazing attention to detail. Furniture pieces were custom-painted on site to attain the most pleasing shade. "We observed the color at different times of the day and at night, then made adjustments," says Drysdale. "That's the way to achieve extraordinary results."

Another way is to thoughtfully pair elements you'd never expect to coexist peacefully, much less so stunningly: a graphic linear woodcut by Donald Judd and a gilt Neoclassical demilune table, gleaming gold urns and a geometric work by Frank Stella. Achieving spare and unstudied elegance from such unlikely ingredients and combinations: It doesn't get more extraordinary than that.

At a house by designer Mary Douglas Drysdale outside Washington, D.C., gold tones in frames, gilt furniture, candelabra and sphinx *objets d'art* have a unifying effect. They stand out against a rich, classically inspired background including such architectural details as acanthus leaf crown moldings.

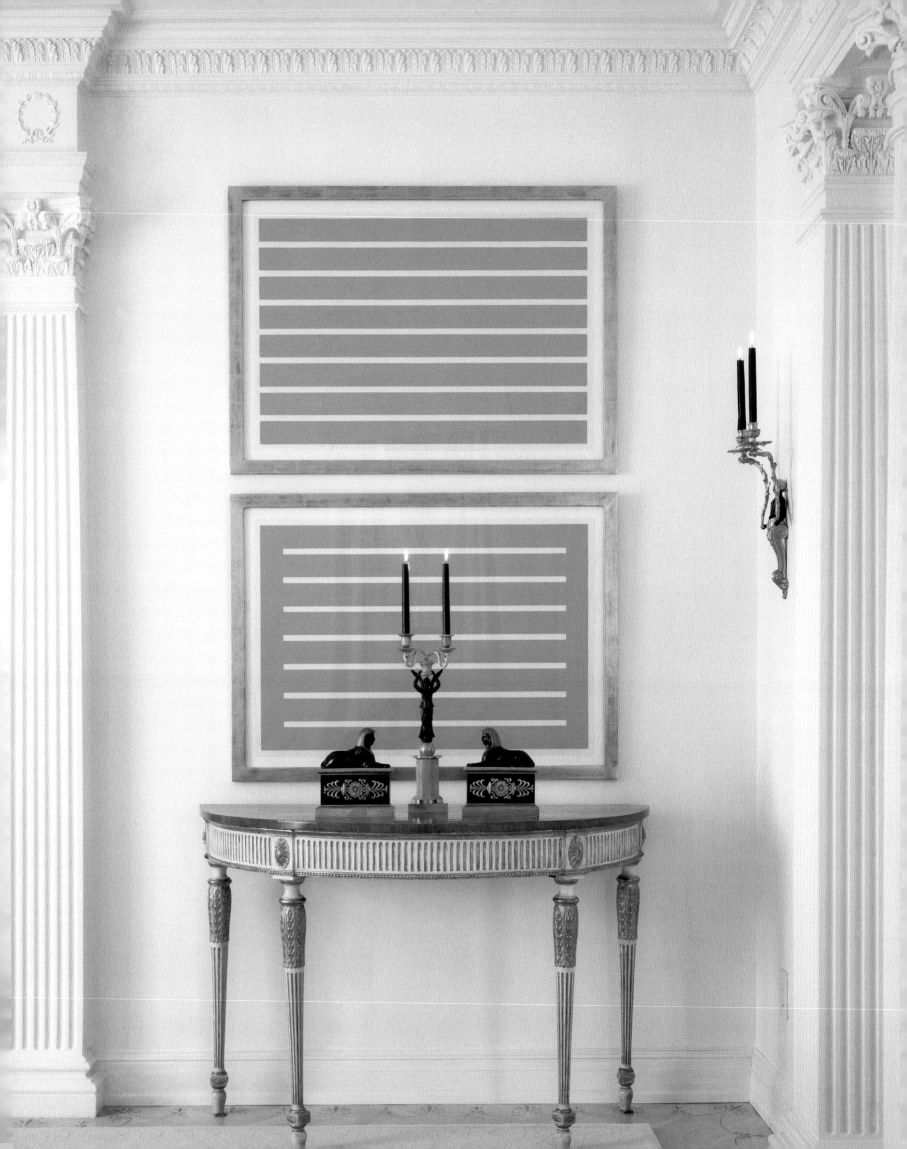

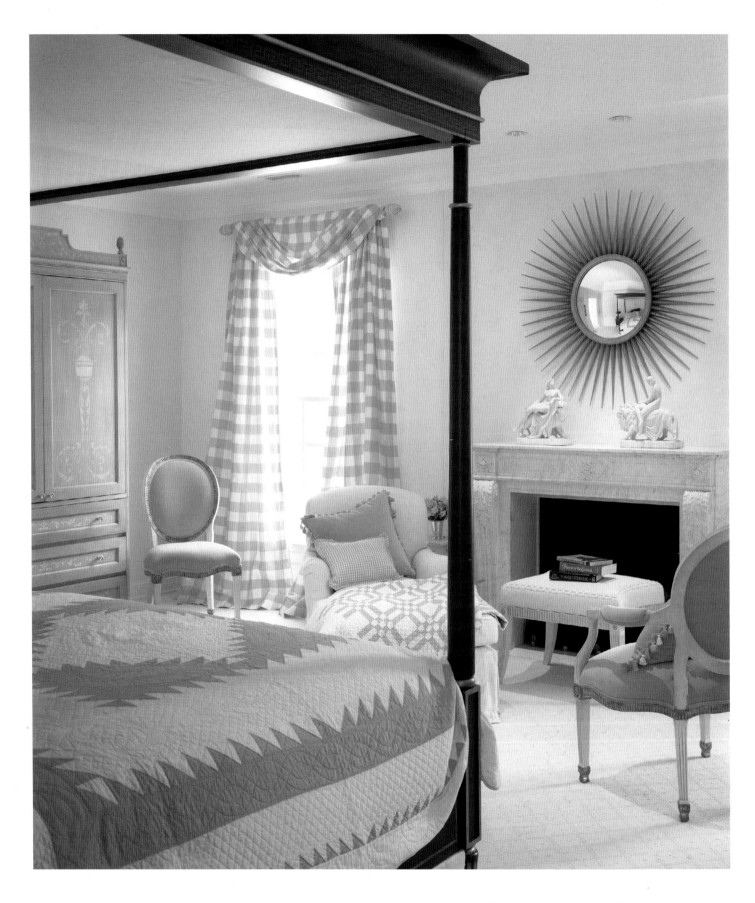

ABOVE: A starburst mirror becomes a graphic focal point above the bedroom mantel and echoes the geometric pattern in the quilt bedspread. OPPOSITE AND PRECEDING PAGES: The mostly white living room is divided into two spaces by pilasters and columns.

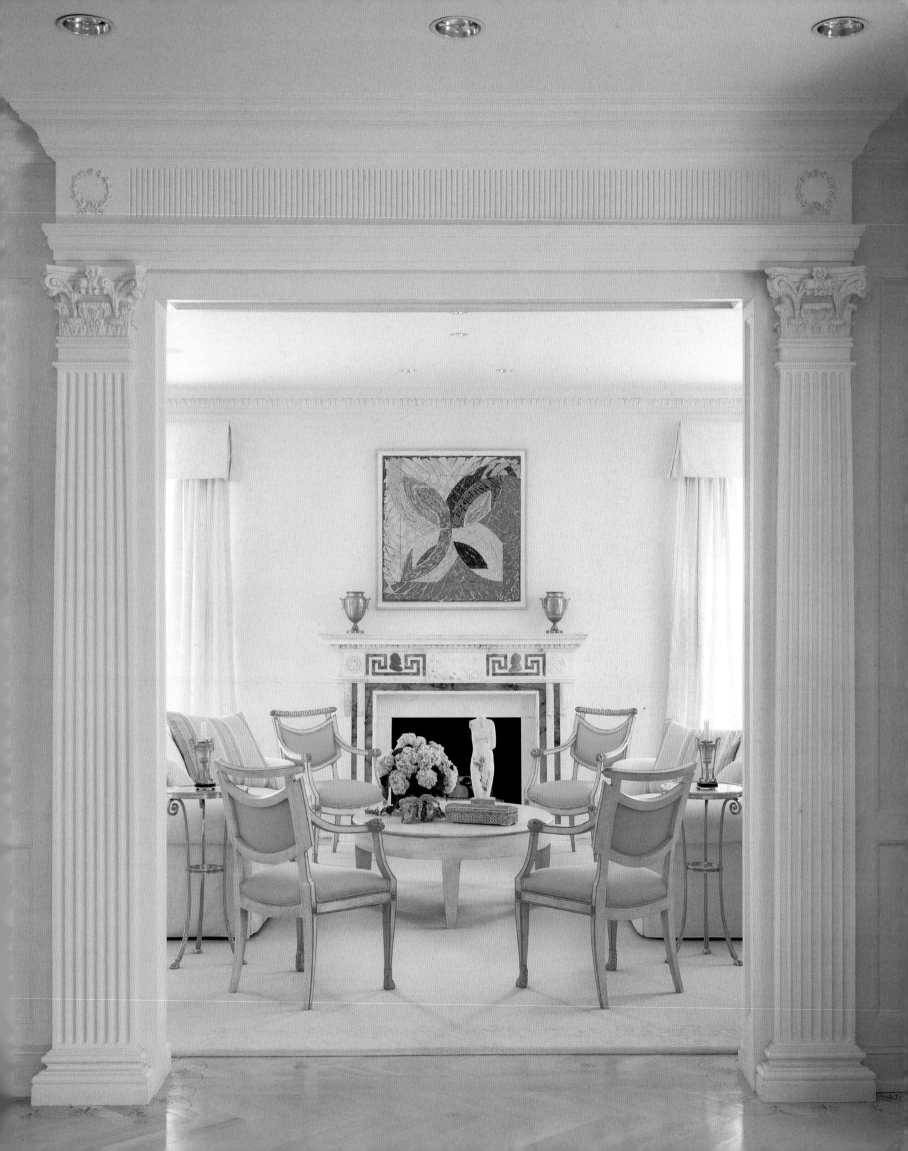

PROVENÇAL SPLENDOR
A recherché refuge in the South of France
recognizes both period and place.

Y ou already know the fantasy of the Provençal farmhouse, because its romance has been well documented in countless travelogues, memoirs and movies. The glowing plaster facades, the fields of sunflowers and lavender, tinkling glasses of rosé under the shade of plane trees. But Atlanta-based decorator Ginny Magher and her husband, Craig—who'd regularly spent time in France ever since their honeymoon and had long since fallen in love with the sun-kissed region in the country's south—didn't just want to read about that woozy dream or watch it unfold on the silver screen. They wanted to live it, and they were given the opportunity at the end of a winding rocky path in Paradou, an enclave in the Alpilles near Saint-Rémy.

When they found the object of their desire, it was only a shell with massive stone walls, large openings for doors and very few windows. But they were not deterred. They hired local architect Bruno Lafourcade to restore the *bastide*, or country manor house, according to strict French codes for building and restoration, while also adhering to the sensual visual vernacular for which the area has become so well known.

The two-year pursuit had the Maghers scouring flea markets everywhere, from nearby L'Isle-sur-la-Sorgue to Clignancourt in Paris, for chimneypieces, mantels and beams that would look and feel correct. Furnishings followed suit: A simple antique Louis XV–style writing desk and cane-back fauteuil in the entry hall were both found in Fontvieille, near Arles. The kitchen has traditional terra-cotta floors and bright cobalt tile backsplashes. In the master bedroom, a custom canopy bed overflows with a floral undulating with vines. Magher also used it to line the walls.

For the Maghers, the farmhouse furnishes the kind of romance that far exceeds that of any book or film, and as a second home, it perfectly suits its halcyon purpose. "We come here to entertain family and friends," says Ginny. "It's like an open house all the time."

An outdoor seating arrangement abuts a former dovecote on the estate of Ginny and Craig Magher in Provence. Ginny uses another dovecote on the property as a studio. FOLLOWING PAGES: Except for an existing row of plane trees, the gardens were redesigned by Dominique Lafourcade, the wife of project architect Bruno Lafourcade. The rattan furniture was purchased in nearby Saint-Rémy.

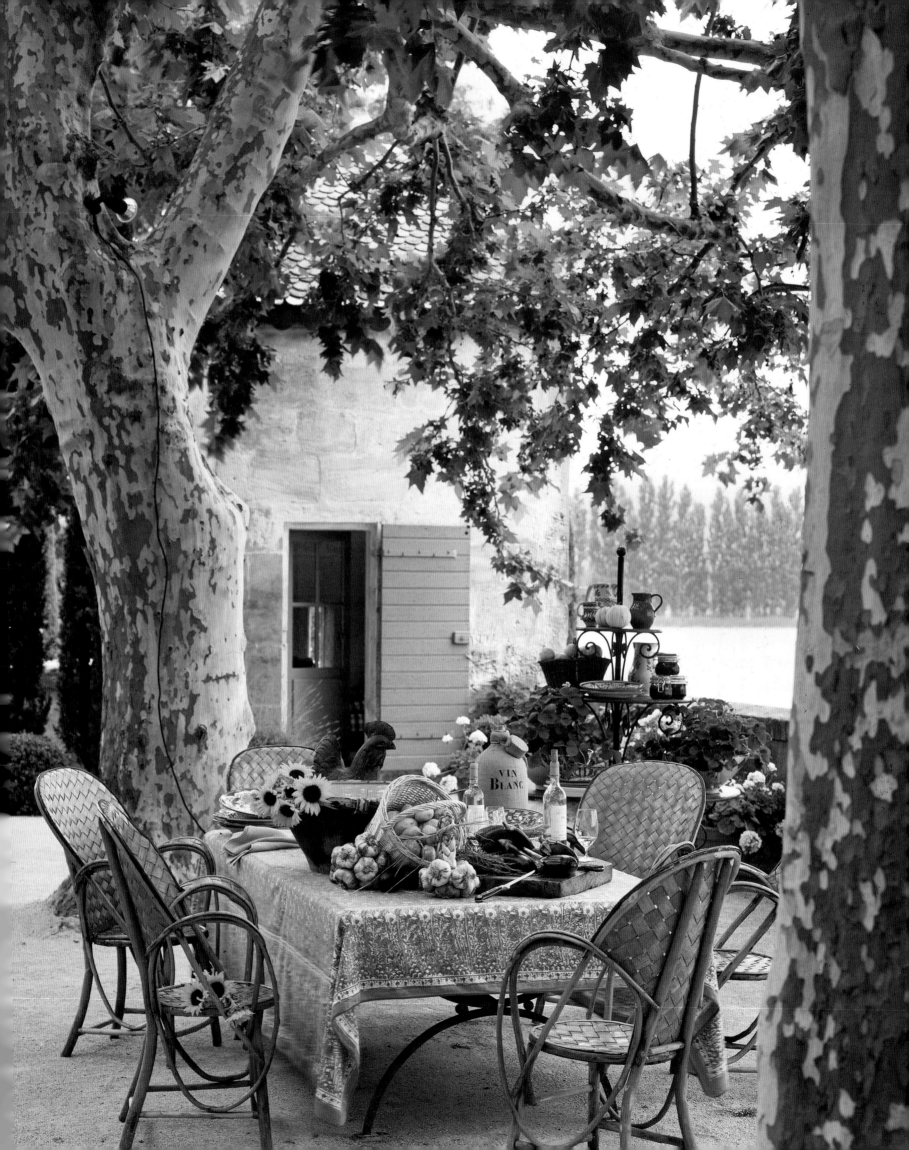

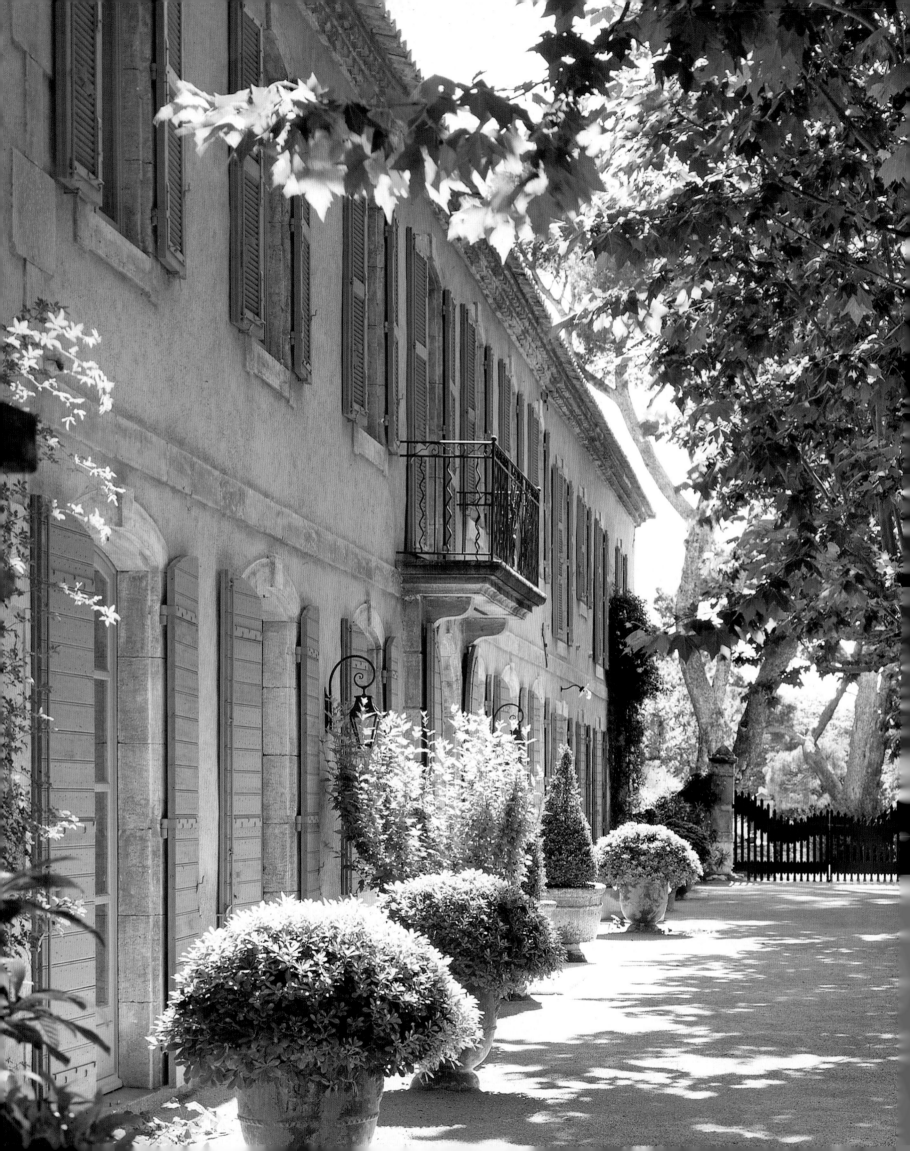

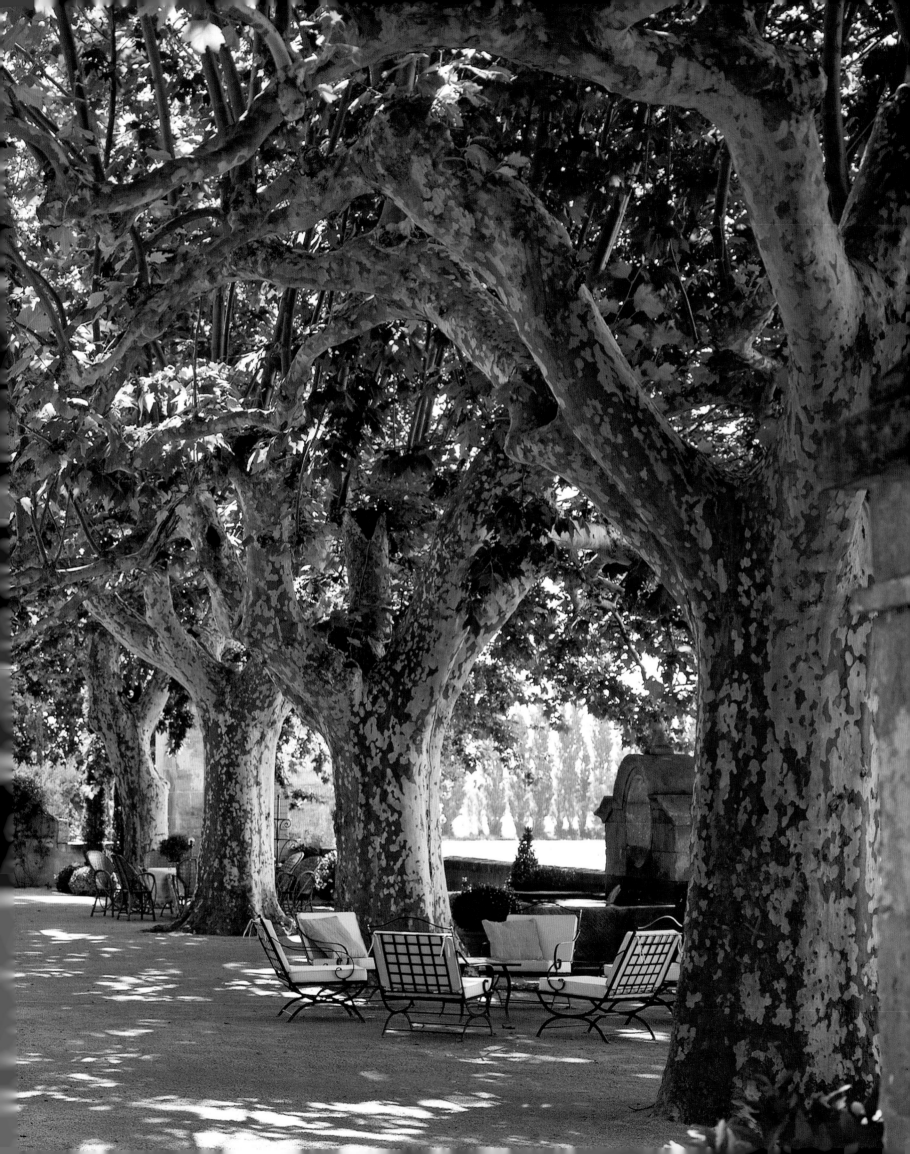

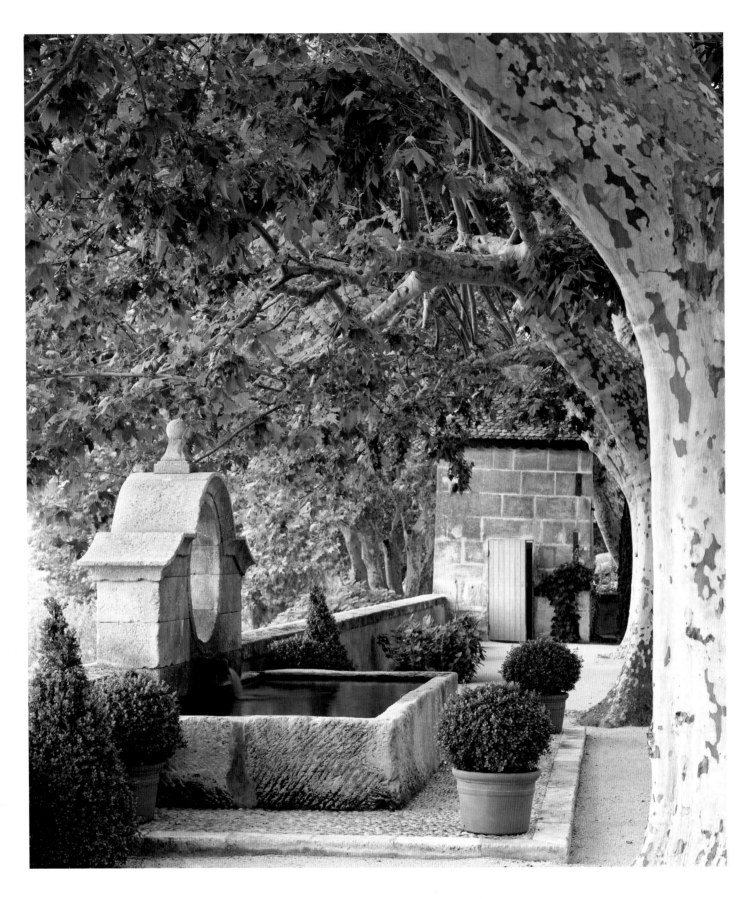

ABOVE: A moss-covered vintage fountain creates a soothing focal point in the garden.
Clipped boxwood globes and topiaries in terra-cotta pots add a layer of dimension.
OPPOSITE: An 18th-century sphinx stands at the landing of the staircase in the entrance
hall. A set of twenty Chantilly porcelain plates lines the walls.

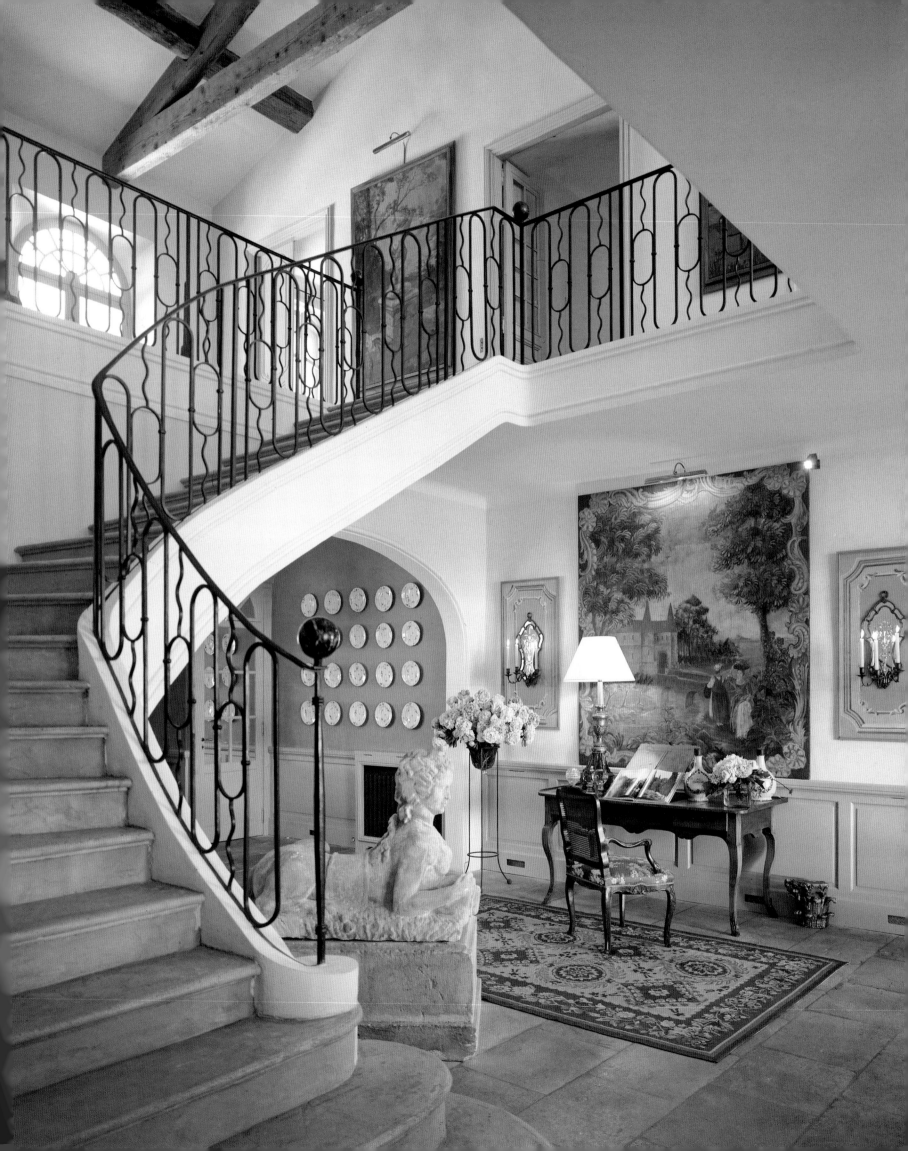

The dining room feels lush thanks
to a verdant shade on the walls
and leafy tapestry upholstery on
antique dining chairs. Magher
made art from wallpaper by
framing scenes from antique Zuber
fragments. The overmantel was
part of an 18th-century trumeau.

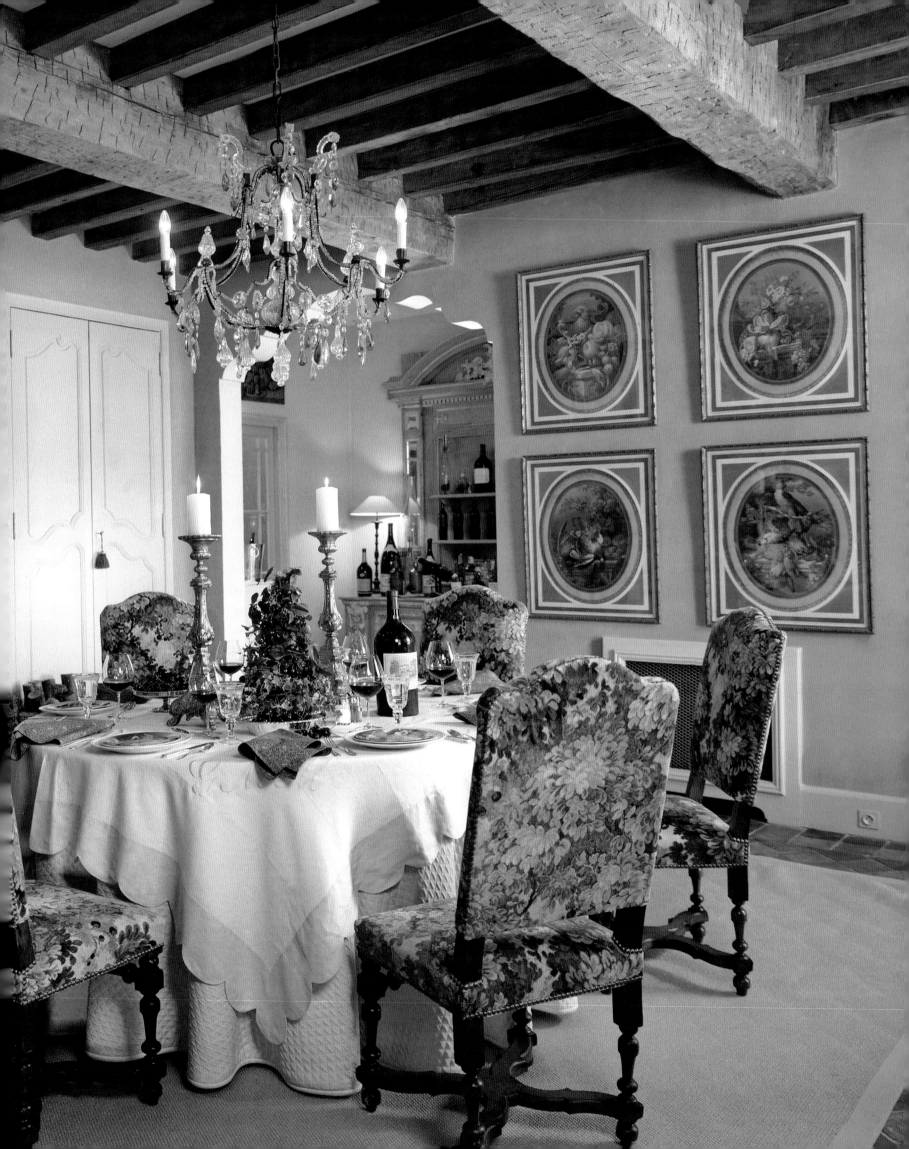

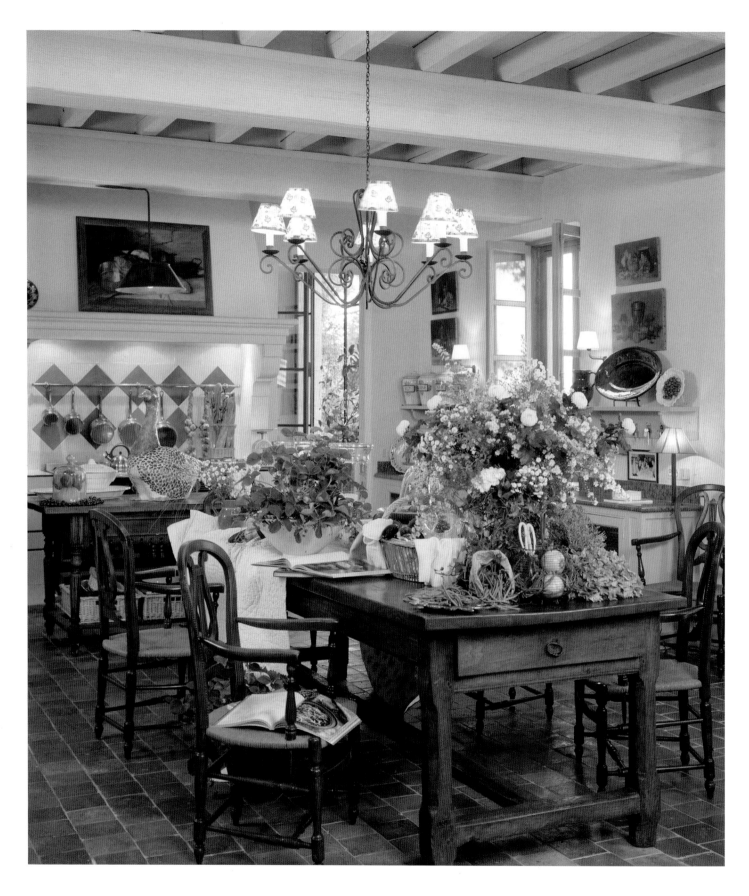

ABOVE: The kitchen is a casual space with reclaimed beams and terra-cotta floors. OPPOSITE: The old barn was converted into an orangerie. The dining table overlooks fields that bloom with sunflowers in June.

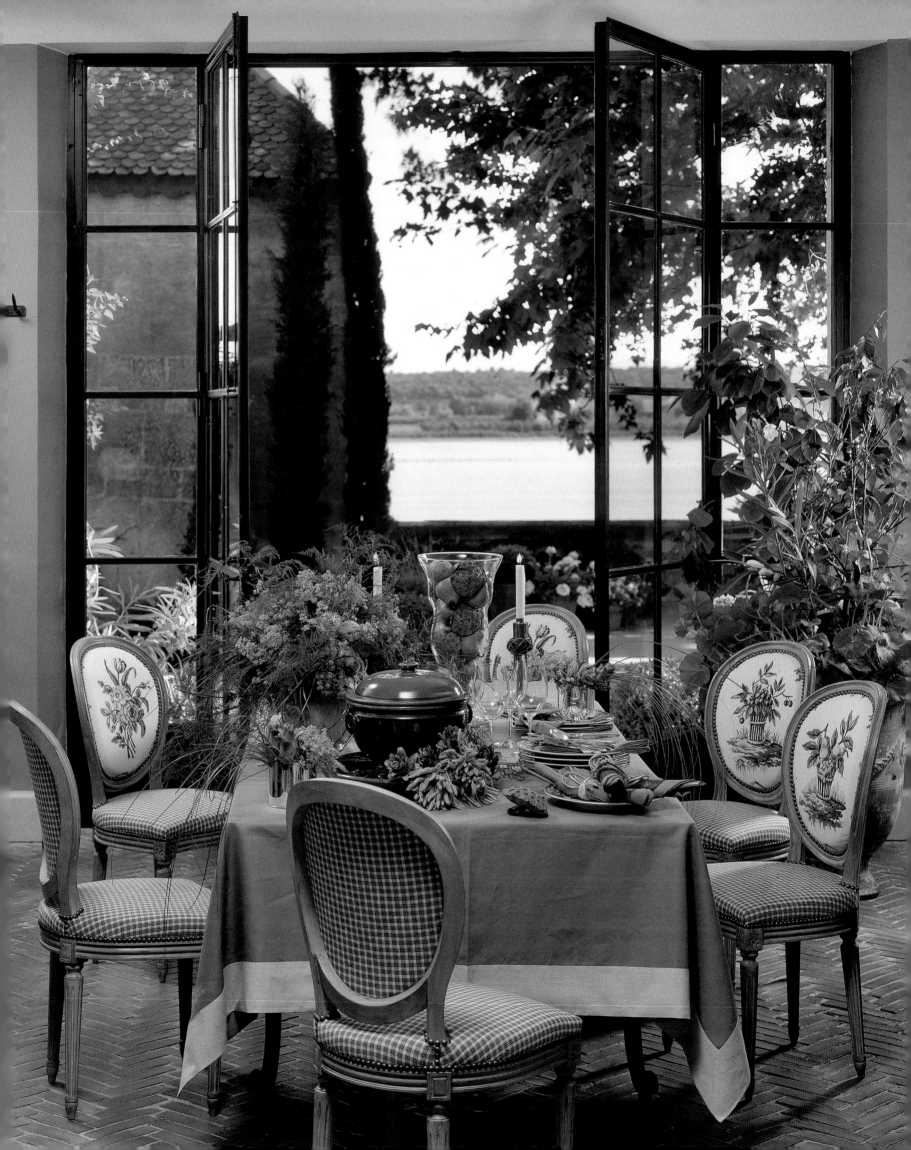

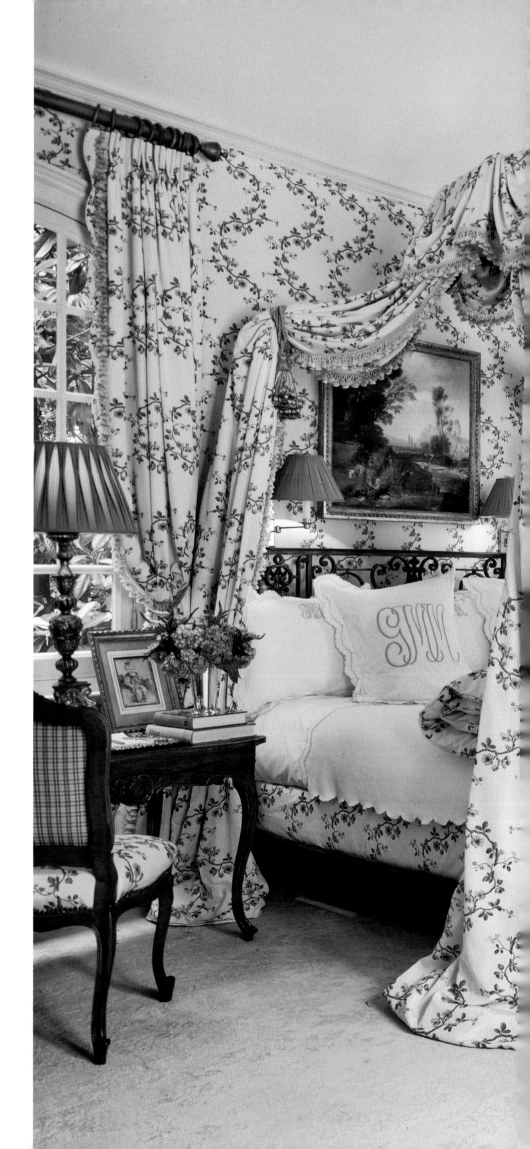

The master bedroom takes a twirling vine-and-flower pattern by Pierre Frey and repeats it to stunning effect: on the custom canopy bed, on the Louis XV–style suite of furniture and on the walls. The mantel is a reclaimed 18th-century original.

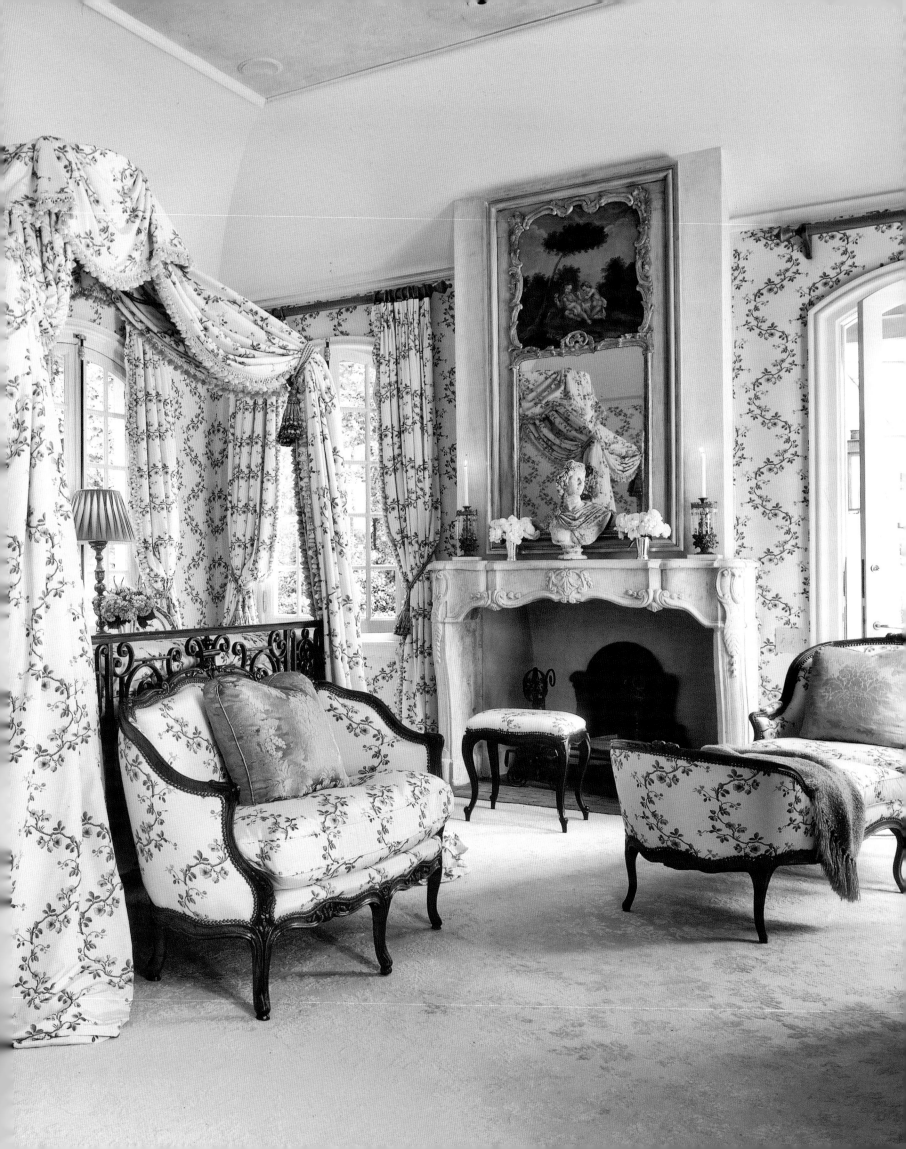

SWEEPING GESTURES

A house's grand appearance belies its intimate—
and surprisingly familial—scope.

This Mediterranean-style villa perched amid leafy oaks in Nashville makes a majestic first impression with its glowing stucco facade and steep roof clad in terra-cotta tile. As you make your approach, the drive winds through tall pillars capped by pediments and finials to a porte cochère of buff parged, or plastered, brick. But that baronial character begins to recede as you crunch across the ocher gravel and walk through the main entrance, which leads through a lushly planted courtyard to a vaulted loggia hung with gas lanterns and, finally, to the oak front door.

The house reveals itself in stages, like a Russian nesting doll, from sweeping statement-making spaces to ever more easeful rooms. The result of a collaboration by designer Landy Gardner and architects Bobby McAlpine and Greg Tankersley, it artfully combines grand structure and traditional interiors. Inside, the Mediterranean theme serves as a jumping-off point for worldly arrangements: Ground-floor public rooms are floored in concrete pavers and cocooned by ceilings that are paneled—in some places coffered—with pecky cypress, which McAlpine likes for its "ravaged" look. There are wrought-iron torches from San Miguel de Allende, a Spanish Baroque walnut library table, an eighteenth-century Italian candelabrum dripping with wax. In the salon, a favored retreat for the homeowners, weathered wooden shutters enclose a cozy chamber with two fireplaces, a cushy velvet-covered settee and an abaca rug underfoot.

There are also explicit nods to contemporary life. Despite the house's stately bearing, it lacks a proper dining room. The family prefers impromptu meals in alternative nooks furnished by Gardner: at a long table complete with stools in the gallery, at the sunny kitchen island, en plein air under a pavilion by the pool. So even though it has all the appearances of genteel formality, the house responds to the daily rhythms of ordinary modern life. First impressions, after all, can be deceiving.

A house in Nashville by designer Landy Gardner and architects
Bobby McAlpine and Greg Tankersley features classical elements such as Doric
columns and pediments above doorways for a regal Mediterranean effect.

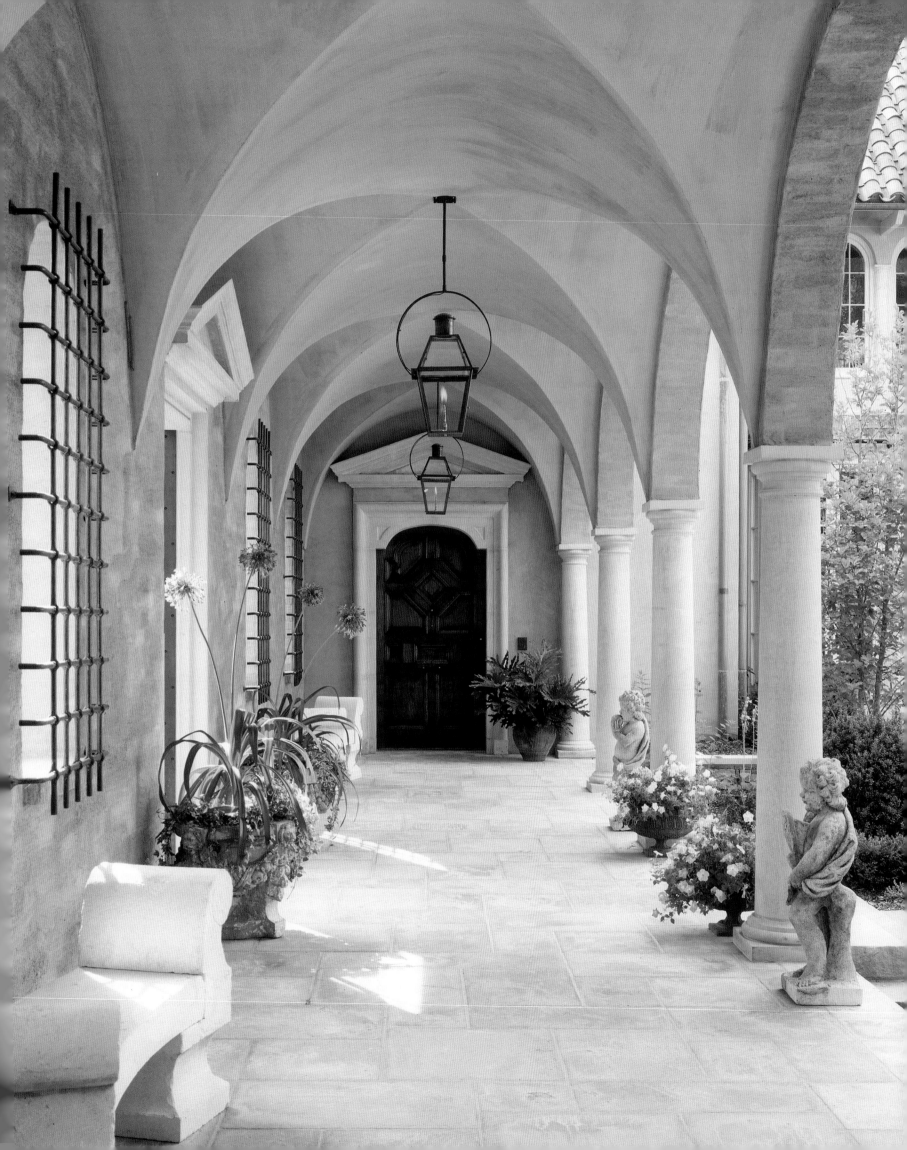

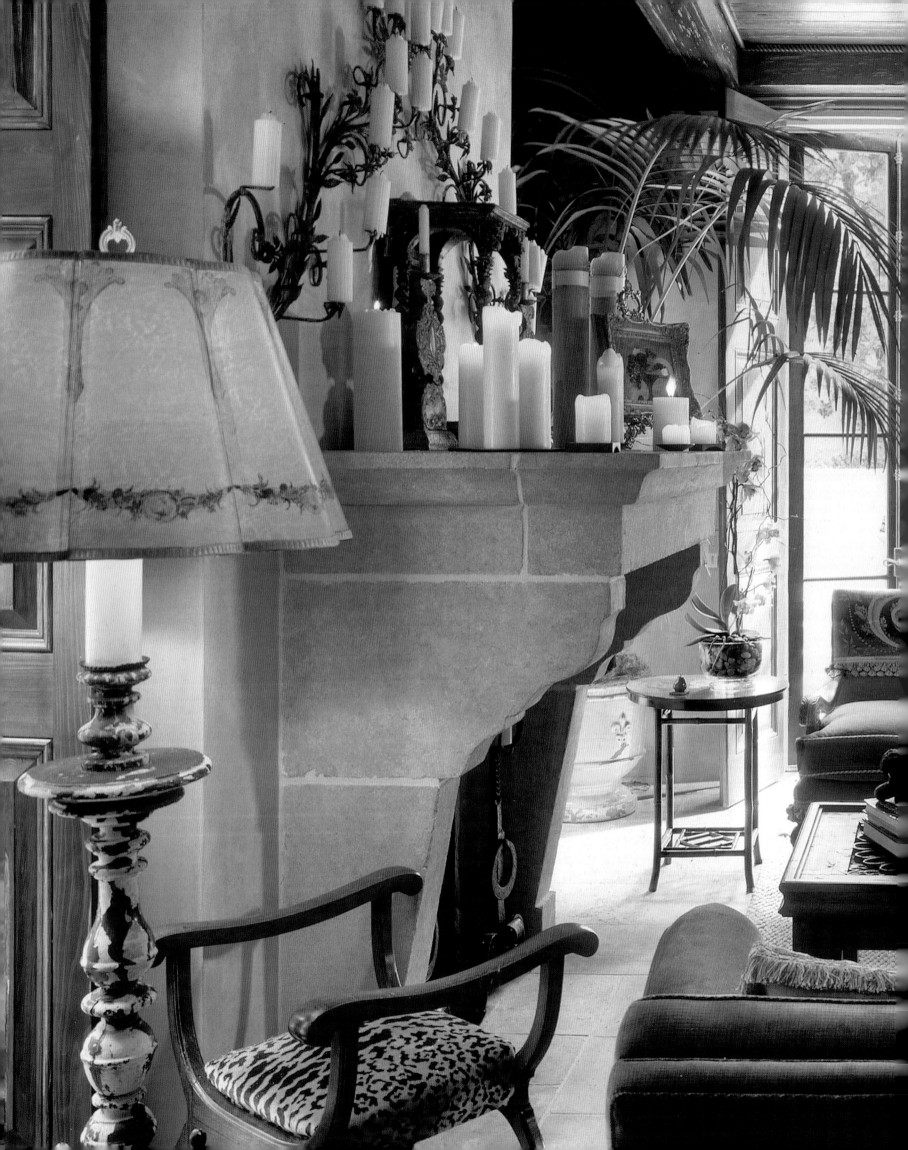

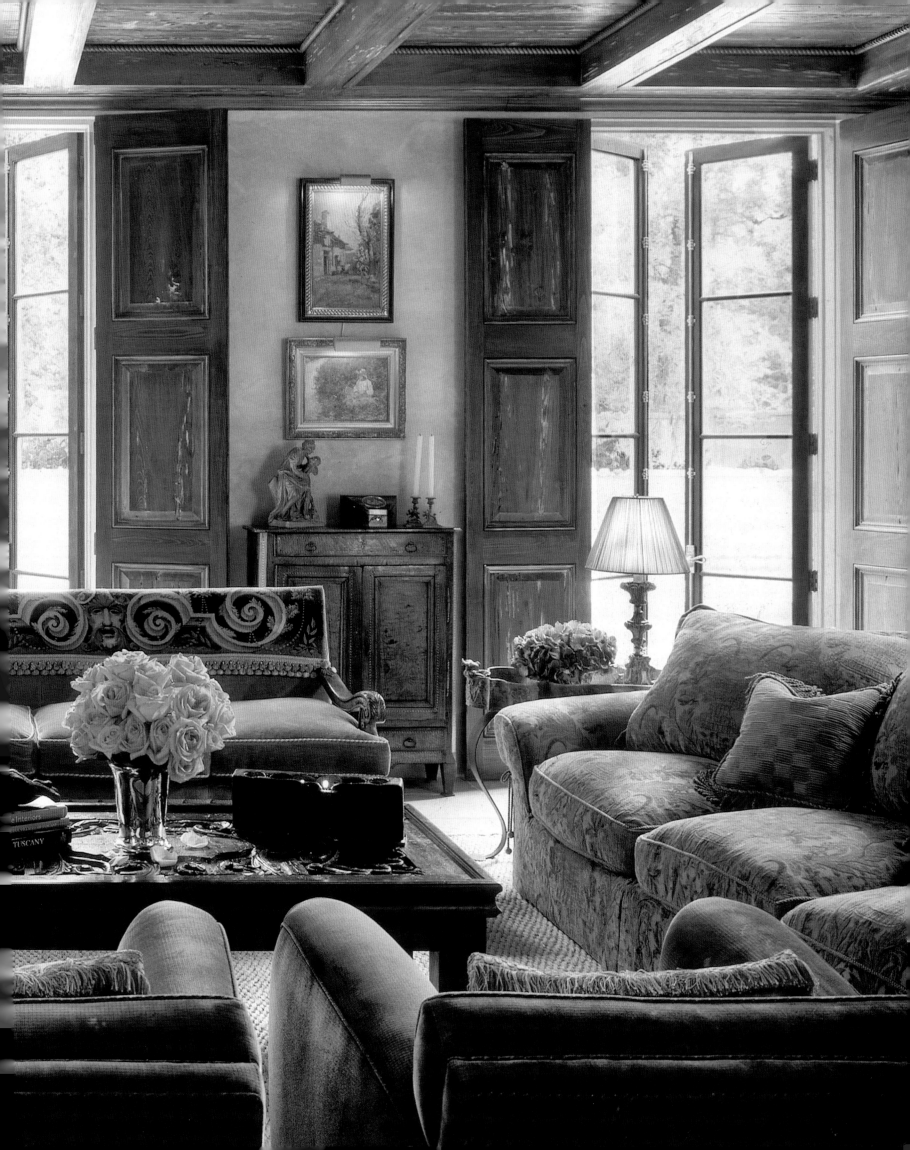

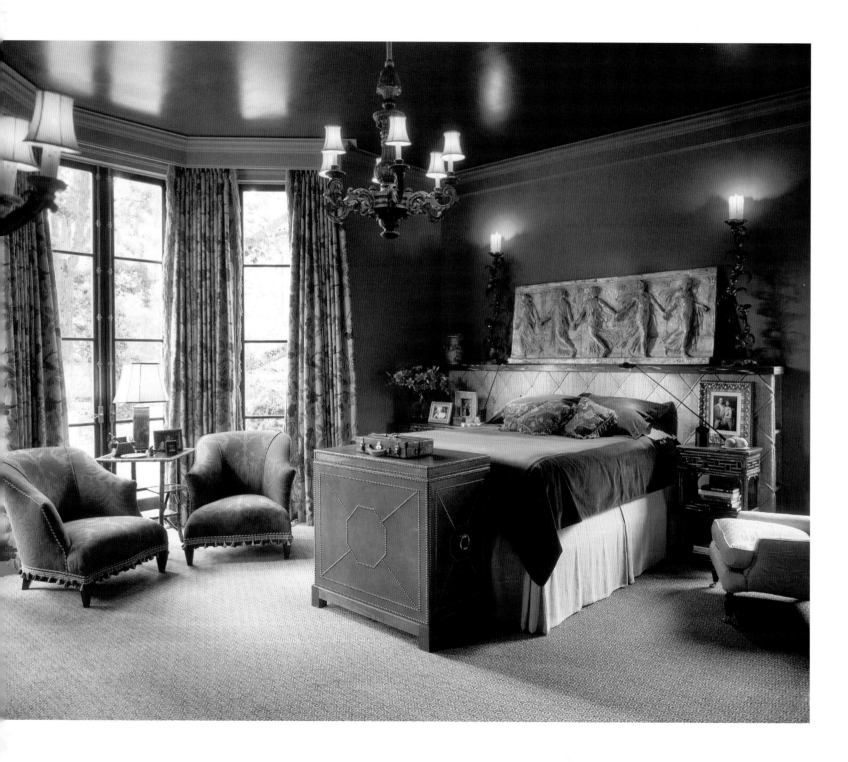

The color scheme mines a rich spectrum of honeyed mahoganies and burnished oak, giving the house a cozy cohesion. ABOVE: In the master bedroom, a custom leather cabinet hides the television. A classical-style frieze crowns the headboard. OPPOSITE AND PRECEDING PAGES: A fireplace punctuates each end of the large salon, which is divided into intimate seating areas. Upholstery on the 19th-century Italian settee was crafted from a salvaged tapestry.

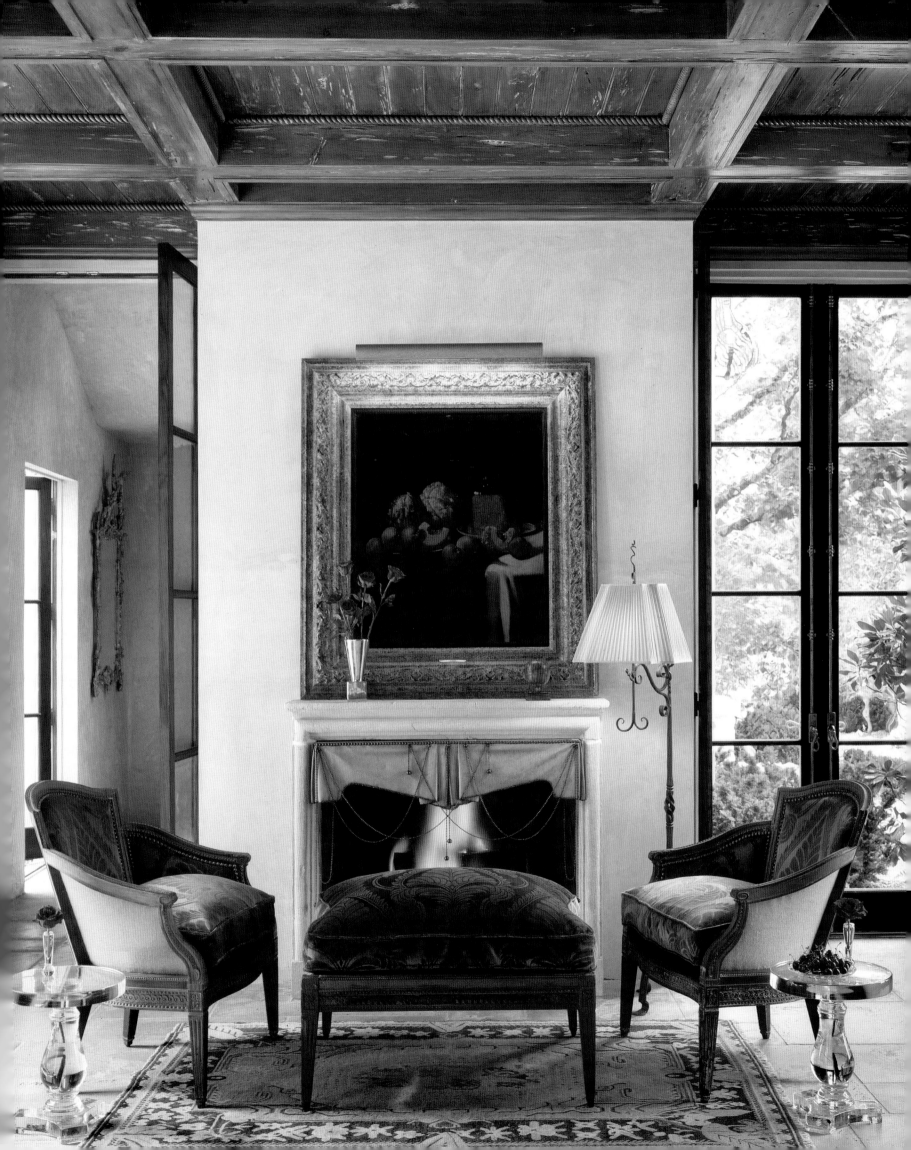

GLOBAL PERSPECTIVE

A worldly point of view colors a Tuscan farmhouse
in vivid and vibrant hues.

"I like disorder," says Piero Castellini Baldissera. "I put things together in ways that you're not supposed to, and in the end I find something perfect for me." What Milan-based Castellini Baldissera has arranged for himself in the Tuscan countryside between Montalcino and the Val d'Orcia is pretty perfect for everyone else, too. There, in a farmhouse dating back to the seventeenth century, bright ocher walls backdrop a diverse array of elements that hang together in an inimitably stylish way: cow horns from Maremma, a region renowned for its beef; Sicilian terra-cotta tile floors; Laotian windows turned into kitchen cupboards; an Indian howdah in the entry hall.

Not surprisingly, Castellini Baldissera cites travel as a major influence. But what brings everything together is a plethora of classic Continental touches. He combines ideas he picks up in India or North Africa with such pieces as a Louis XVI birdcage and corner cabinet. Elsewhere, ticking stripes and toile de Jouy adorn a gracefully arching canopy bed. Those ocher walls are richly textured and have been painted with wide stripes or geometric patterns. The whole of it, of course, is housed within the kind of rustic structure for which the region is well known, which gives everything an unstudied air. The dining room, for instance, where Moorish-inspired chairs wear Crayola shades of linen, was once a stable.

In a nod to these roots, Castellini Baldissera uses the estate to cultivate his own olives and grapes, two crops that have traditionally provided the area's rolling hills with its famed and picturesque allure. "It's the most beautiful place in the world," he says. "There are wonderful things in Tuscany: the trees, the vineyards, the castles. The country is dramatic. You can see such a lot of color and changing light. There is something magnetic about the region." Ditto for Castellini Baldissera's perch within it.

Piero Castellini Baldissera's Tuscan farmhouse, which dates from the 17th century, sits on
the edge of a large property in the hills between Montalcino and the Val d'Orcia.
FOLLOWING PAGES: Once used as stables, the dining and living rooms reflect a wealth of
worldly influences. The lampshade is made from an Indian sari, the coffee table is
Indonesian, and the backs of the dining chairs recall Moorish arches.

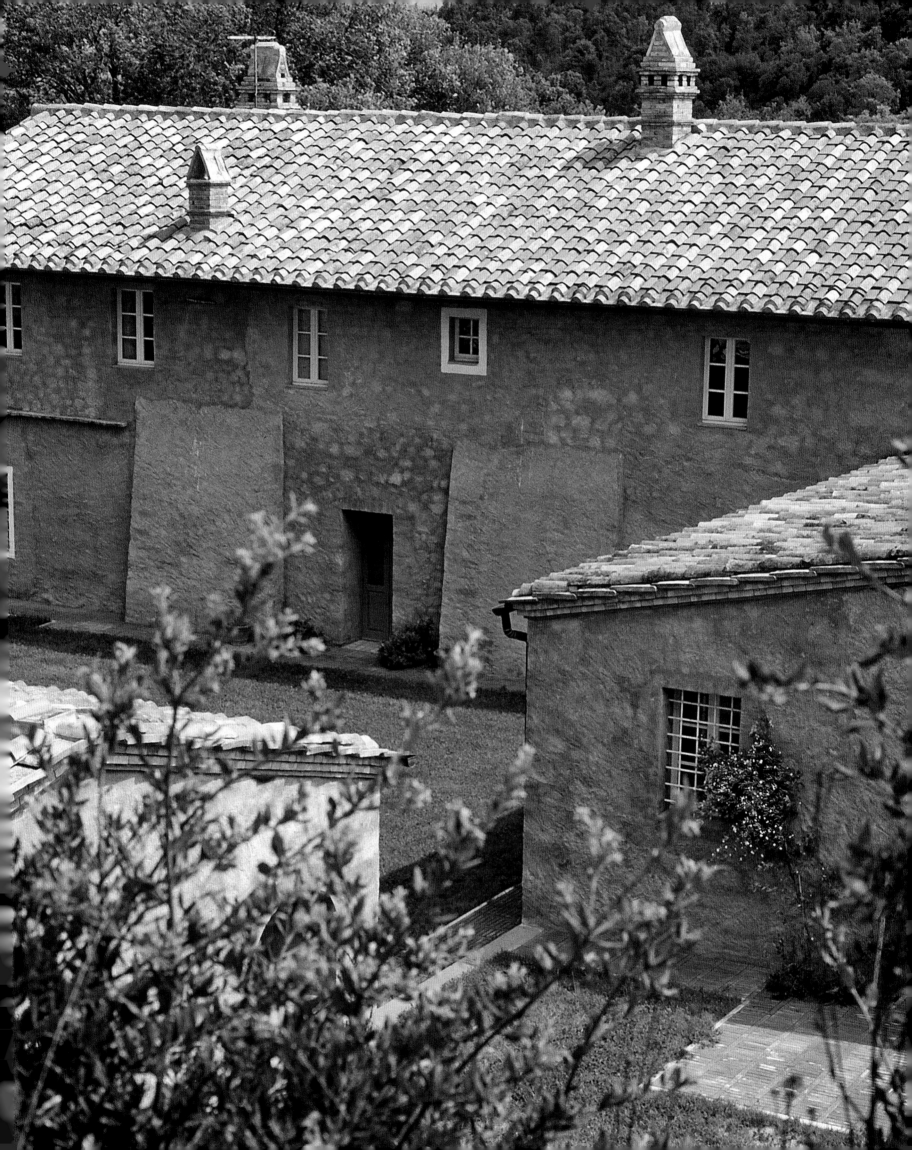

Walls were painted a bright ocher shade in stripes and geometric motifs. Castellini Baldissera designed the iron-and-wood table, and the countertops were made from local stone. PRECEDING PAGES: The farm overlooks vineyards of brunello, a grape for which Montalcino is renowned. A subtle palette of violet and gray dominates a guest room.

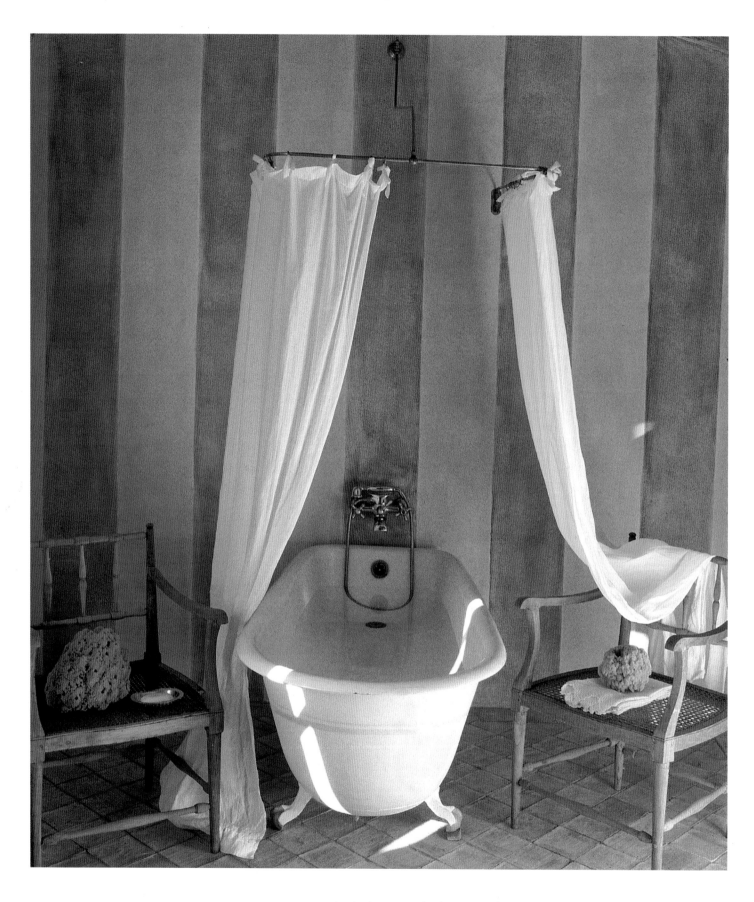

ABOVE: In the master bathroom, 19th-century Italian chairs flank a vintage tub.
OPPOSITE: Castellini Baldissera based his design for the master bedroom's canopy bed on an
18th-century original. The lamps were crafted from church candelabra.

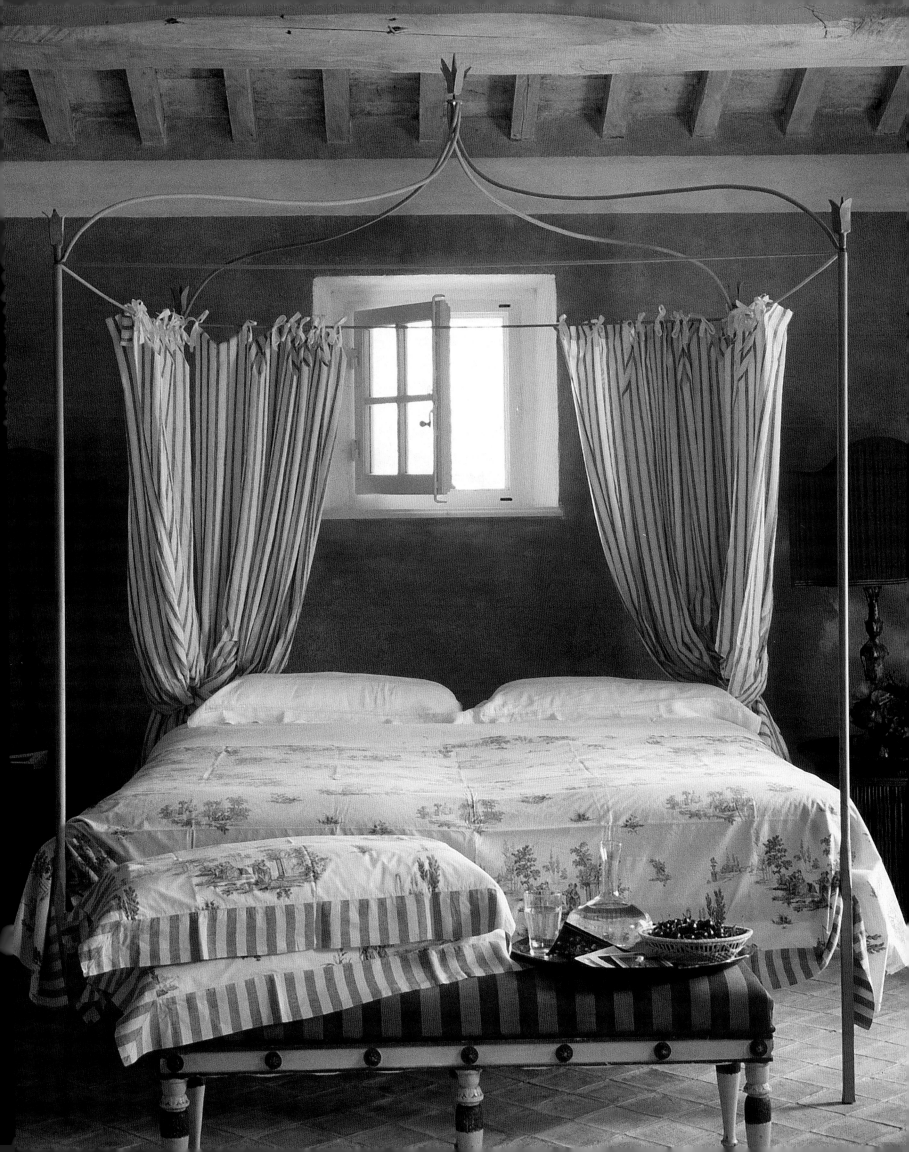

2.
Modern is just
a frame of mind—
paring basics down to
their essential forms
with light, space
and real depth.

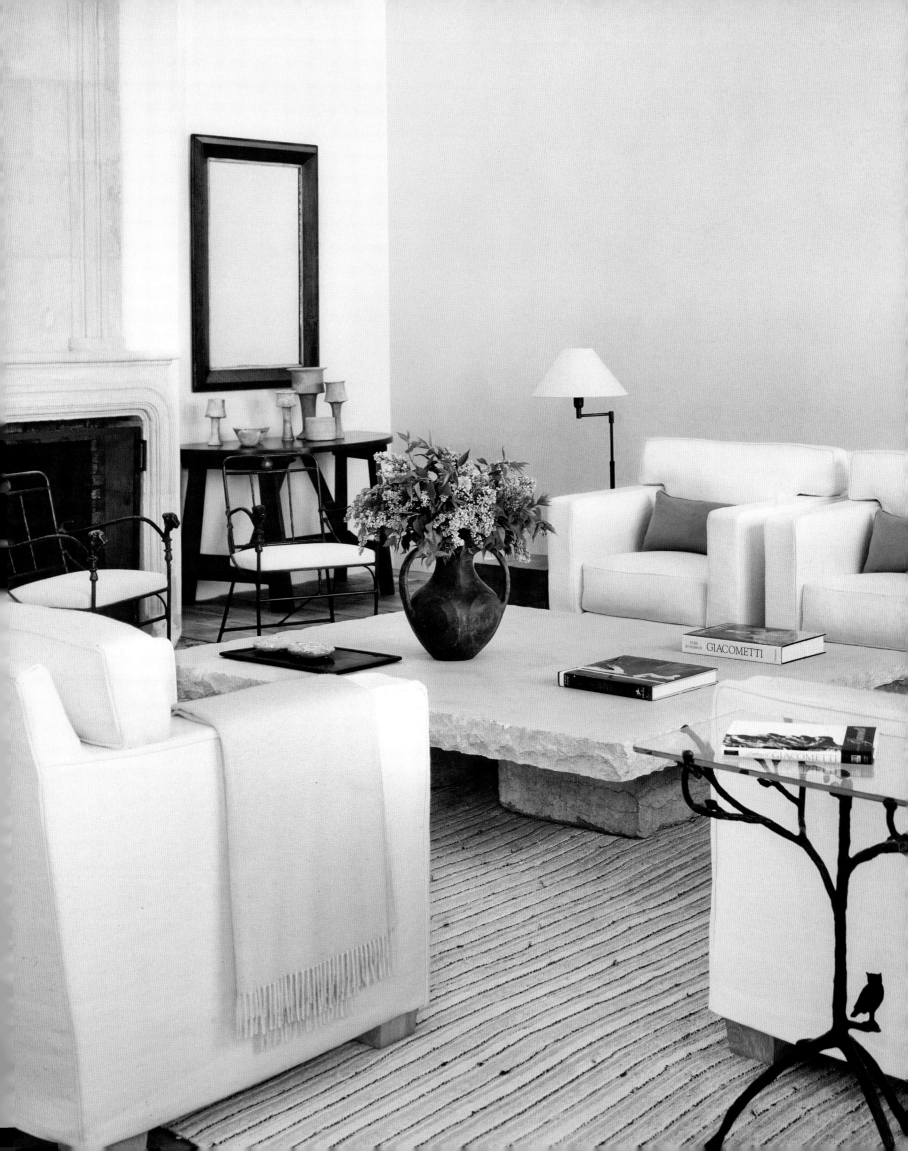

Modern Houses

As a design sensibility, modern doesn't necessarily have to coincide with the spare sobriety that often marks an interior as contemporary. It never has for VERANDA. As a matter of fact, contrary to what those unfamiliar with the magazine may have assumed over the years, there has always been a place in our pages for modern interiors, and this chapter provides ample proof. And really, it represents only a fraction of such spaces that we've published.

It's just that the modern aesthetic we embrace has never been cold. Maybe that's where the confusion arises. Because these rooms are warm and sensual, because they temper clean lines with a sense of artistry and craft, because they welcome a play of texture, because they seem collected and accumulated rather than installed, they don't feel modern in the typical sense of the word.

But they are indeed modern. They dial down ornament and overt decoration for the sake of visual composition. They employ color sparingly, if at all. They make ample use of light, often leaving windows bare or draping them with the simplest of curtains. They let architecture speak for itself. In many cases, the only bold strokes are collections of contemporary art, sensitively and skillfully incorporated into spaces where they necessarily become focal points—a task that is itself an art.

As any good designer will tell you, in the absence of all the bells and whistles, certain challenges come to the fore. Quality becomes paramount. Scale is everything. Details are key. Proportion reigns supreme. The tone of gray on cerused oak plank paneling can make or break a room. Place an armchair too squarely against a drinks table, and what might have looked inviting is suddenly severe. Use an excess of sheen—in the lacquer finish of a commode, on ebonized floorboards, on French polished doors—and things start to fall apart.

In other words, modern takes talent. Take one look at Barbara Wiseley's Santa Barbara living room and that much is abundantly clear. See the sunroom Richard Hallberg expertly drafted for a Los Angeles couple: all that sunshine, the greenery, the art! David Kleinberg and Peter Pennoyer's collaboration on a Park Avenue apartment for a young New York family takes the idea of modern glamour and brings it to life, in nickel and marble and a lusciously glossy French blue paint that nearly steals the show. The placement of the few objects that make up a dining room by Alexandra and Michael Misczynski is pure poetry—testament to the notion that even a two-hundred-year-old antique can be made to seem modern. It's a question of sensibility and nuance and the artistry of design.

WHAT'S OLD IS NEW
Two pros sensitively incorporate antiques into a clean and spare house.

"Our mantra for this whole project was using materials that are old and trying to make them feel modern," says Alexandra Misczynski, partner with husband Michael in Atelier AM, a Los Angeles–based design firm. Their client's Mediterranean-style house, set on eleven acres in Southern California, was built in the 1990s and updated by architects Marvin Herman, Drexel Patterson and Tony Crisafi with capacious rooms, soaring ceilings and steel sash windows and doors.

The trick for the Misczynskis was to bridge the gap between this clean-lined but fairly traditional structure and their client's preference for interiors with a modern aesthetic. That they managed to do just that is a testament to their genre-bending talent. It makes sense when you consider their professional backgrounds: Michael previously worked for modernist architect Richard Meier, and conversely, Alexandra logged stints with traditionalists Michael S. Smith and Naomi Leff.

Their solution involved gathering furnishings that paired sleek geometry with rustic honesty, in many cases deploying objects with pedigree and patina in unexpected ways. A twelve-foot-tall George III mahogany cabinet feels fittingly understated in the sober dining room. It brings a soulful but restrained grace to the space and served as a lesson for the client, who opposed its purchase while on a buying trip. "He said, 'It doesn't look modern. It will never look modern,'" says Alexandra. "Now he loves it."

Other boundary-breaking elements include Han and Ming vases recast as lamps, sharp custom sofas and chairs upholstered in plain and unfussy linen, and tactile coffee tables made from limestone slabs. To bring everything together, the Misczynskis devised a motif of antique French oak planks, cut into rectangles and used throughout the house in floors, paneling, doors and kitchen cabinets. "It's very clean and consistent."

A house set on eleven acres in Southern California horse country was updated by Alexandra and Michael Misczynski to bridge the divide between traditional architecture and modern interiors. The steel-and-glass front door suffuses the entry hall with sunlight.

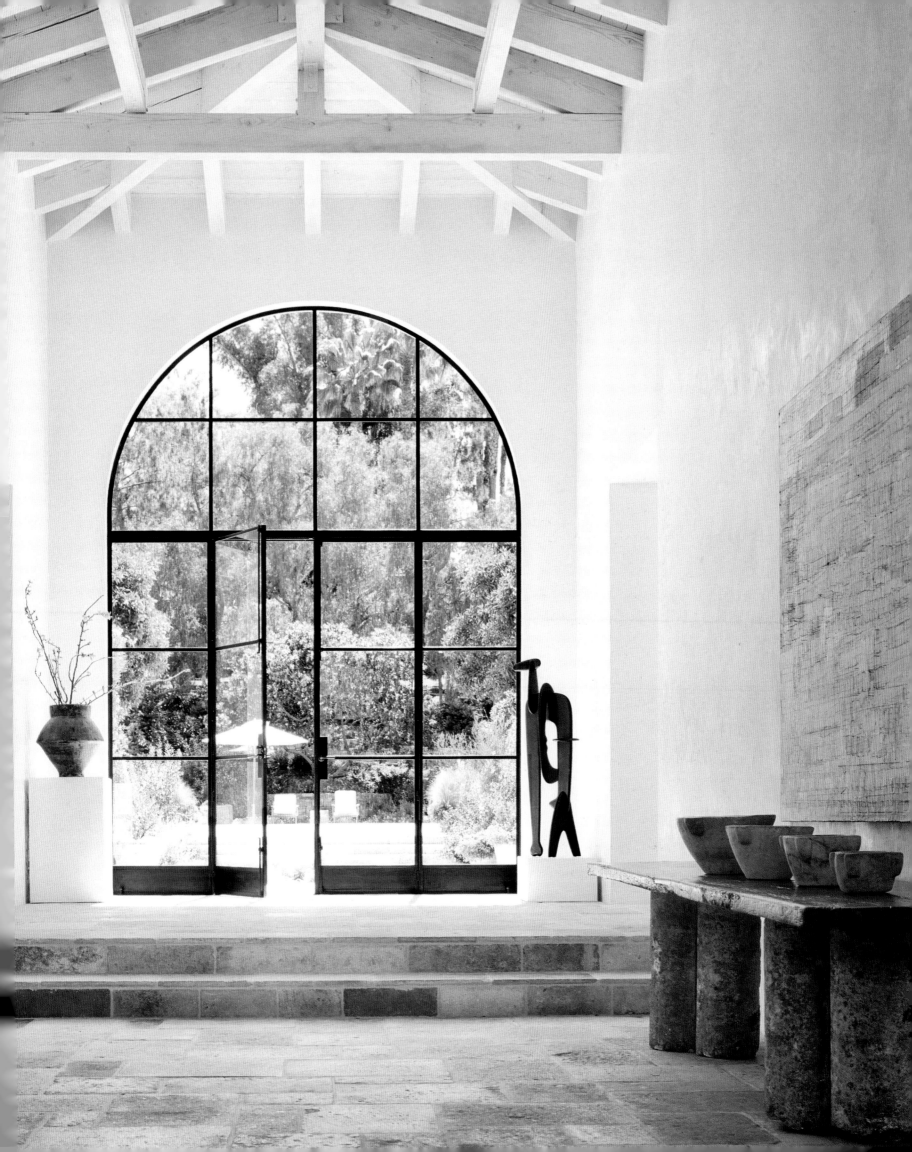

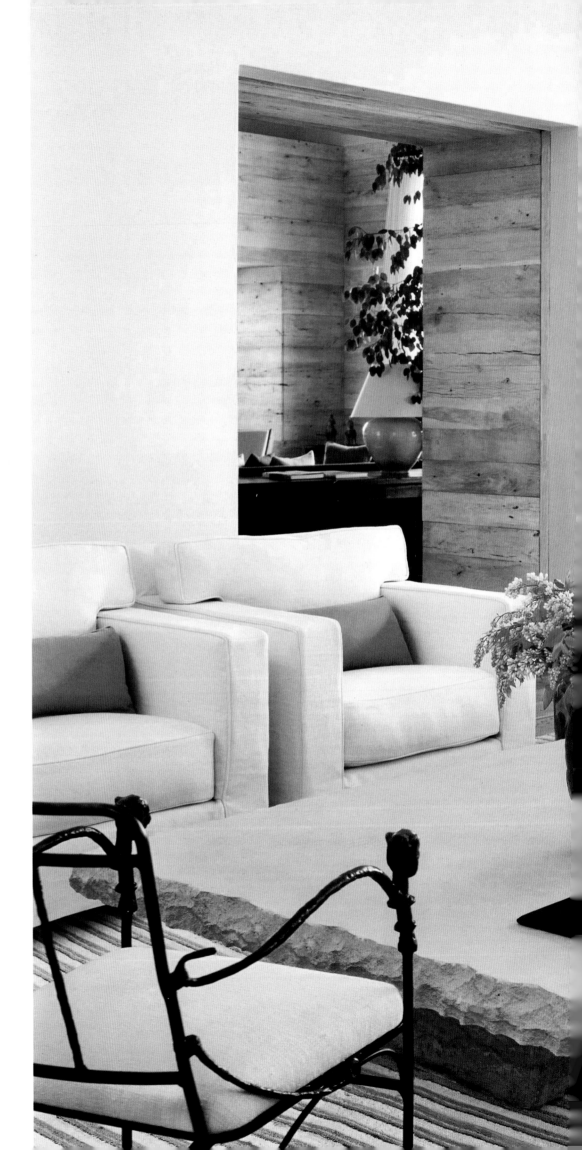

The absence of color in the living room means texture plays a leading role. It varies from rough—a custom limestone slab coffee table, the hammered arms of a bronze chair by Giacometti—to soft, seen in the linen on a custom sofa and armchairs and in the cushy Art Deco rug underfoot. The lamp on the console table was made from a Ming vase.

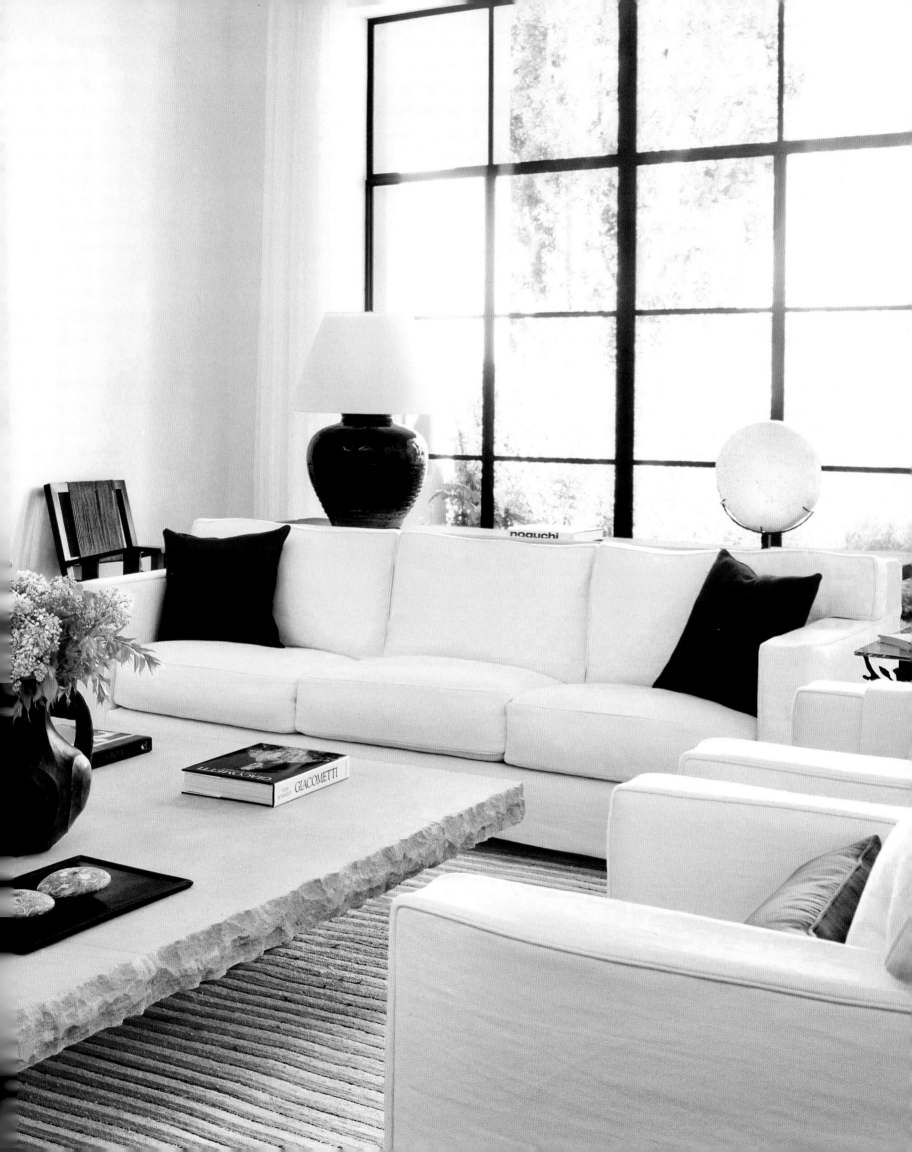

ABOVE: A pergola shelters a dining area in the garden, which was designed by Robert E. Truskowski. OPPOSITE: A George III cabinet looks surprisingly modern in the spare and sober environs of the dining room. The English trestle table, also an antique, is paired with custom chairs covered in antique linen. FOLLOWING PAGES: One of the house's few pops of color appears on the custom sectional in the family room, which opens onto the garden. The painting is by Milton Avery.

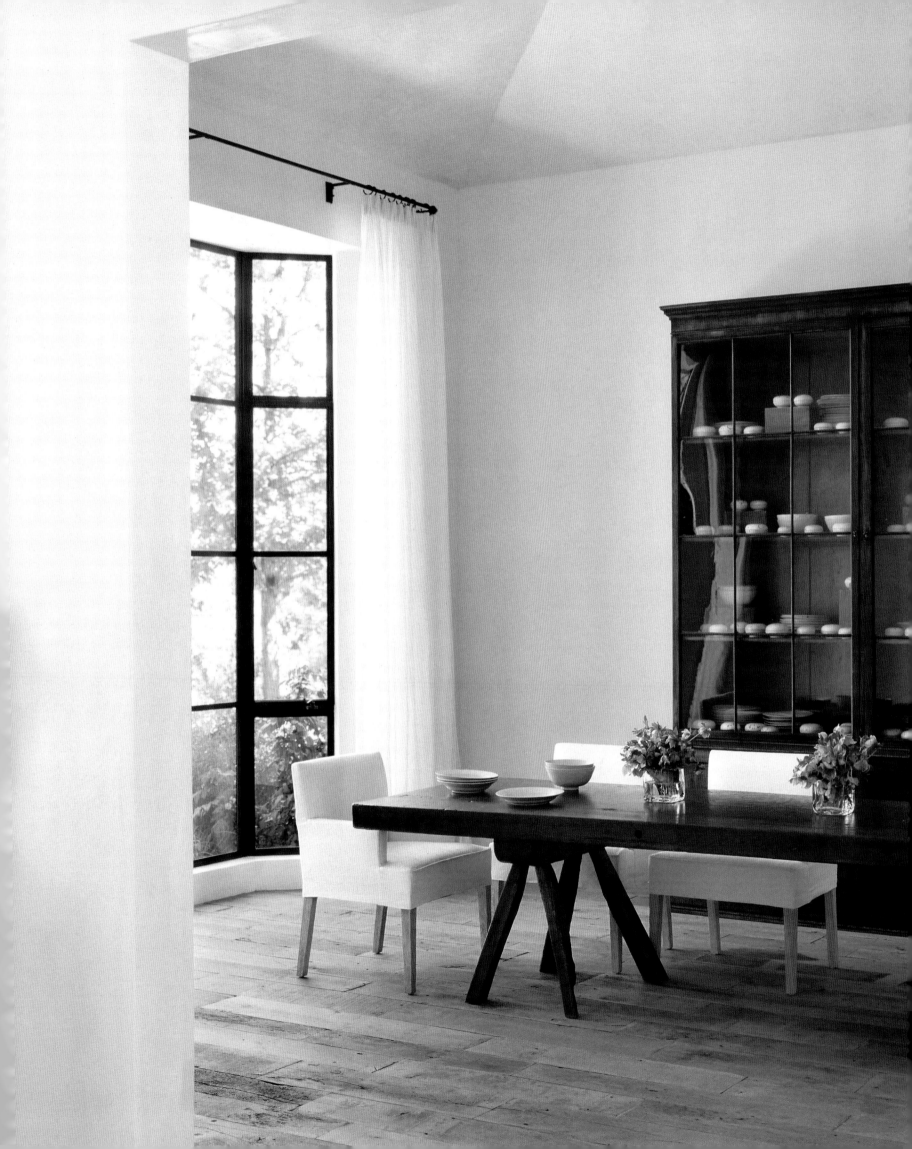

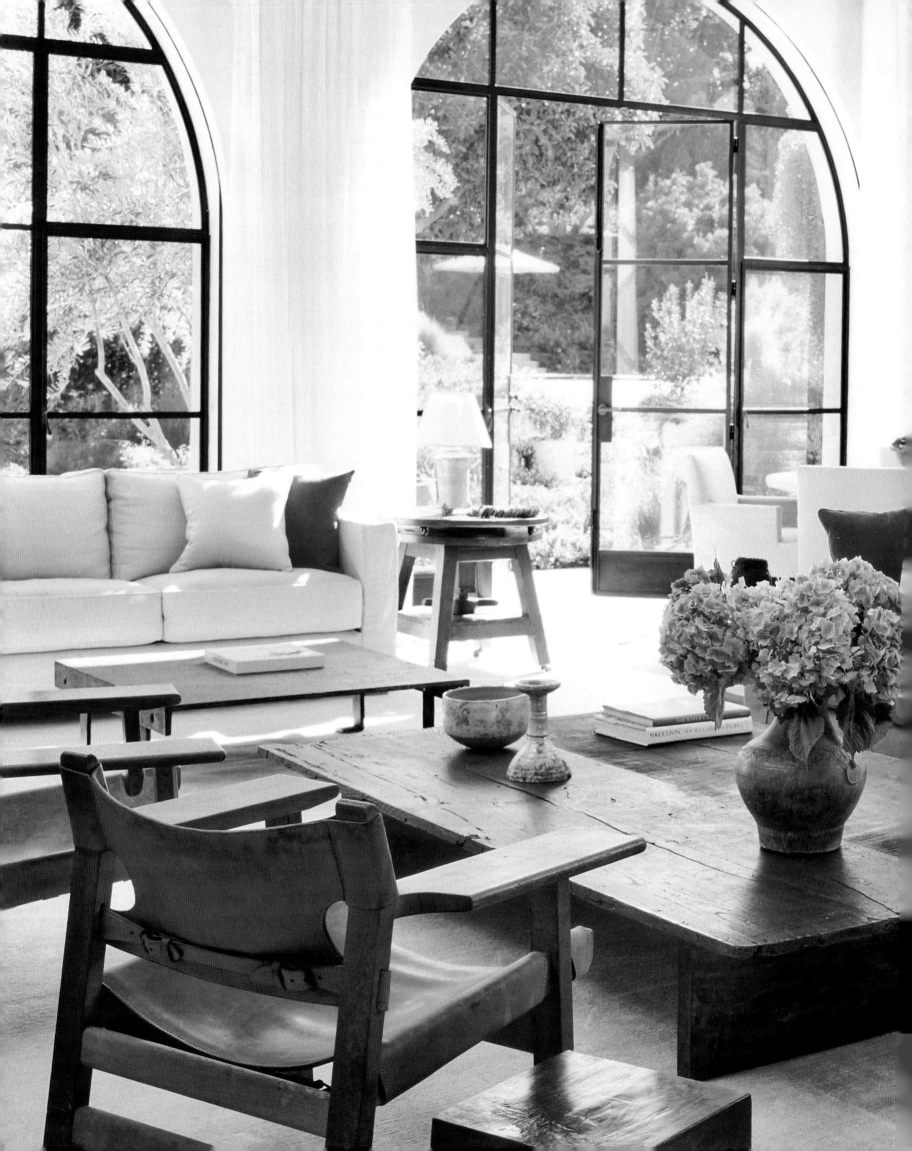

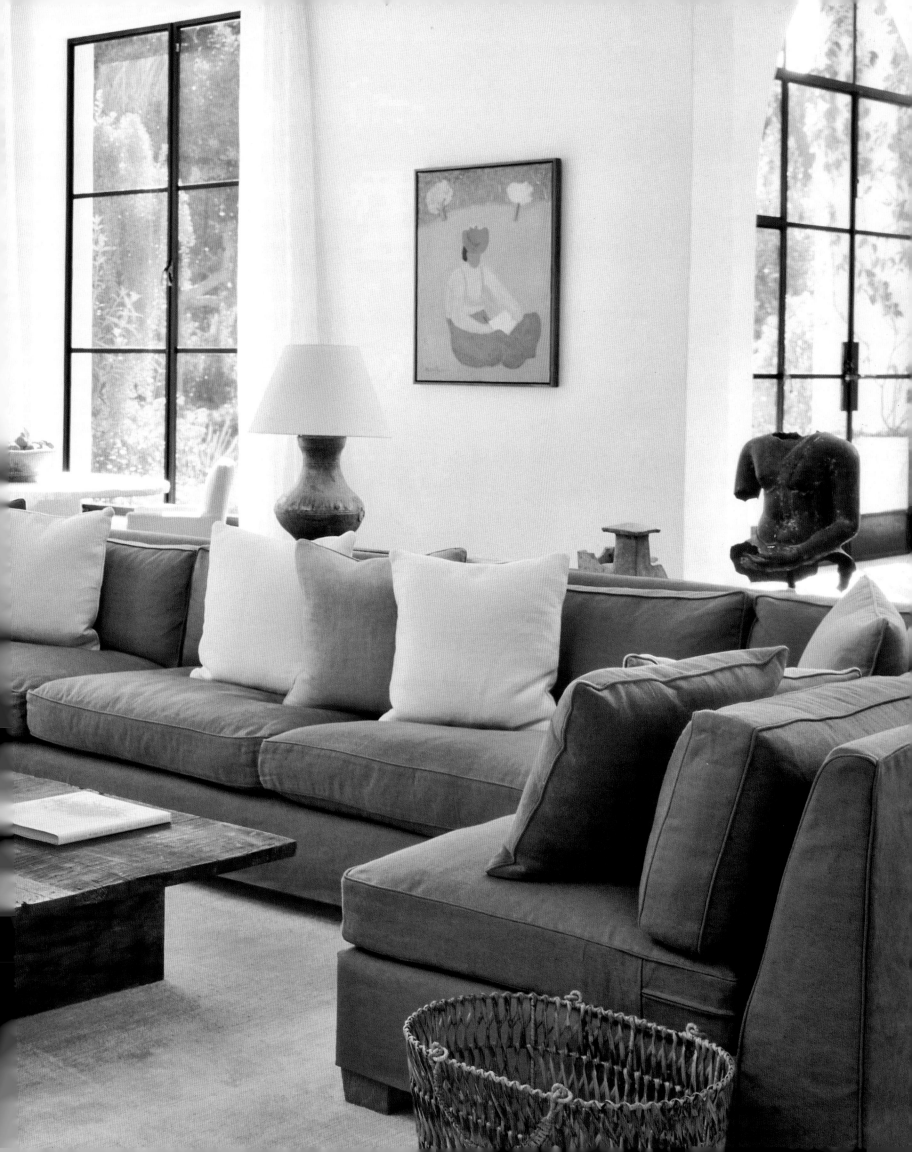

ABOVE: The master bathroom acknowledges an indoor-outdoor lifestyle with stone pavers that ease the transition to the patio. OPPOSITE: Planks of French oak, seen in the master bedroom's built-in bookcase, appear as a unifying element throughout the house. Subtly colored cashmere covers the armchair.

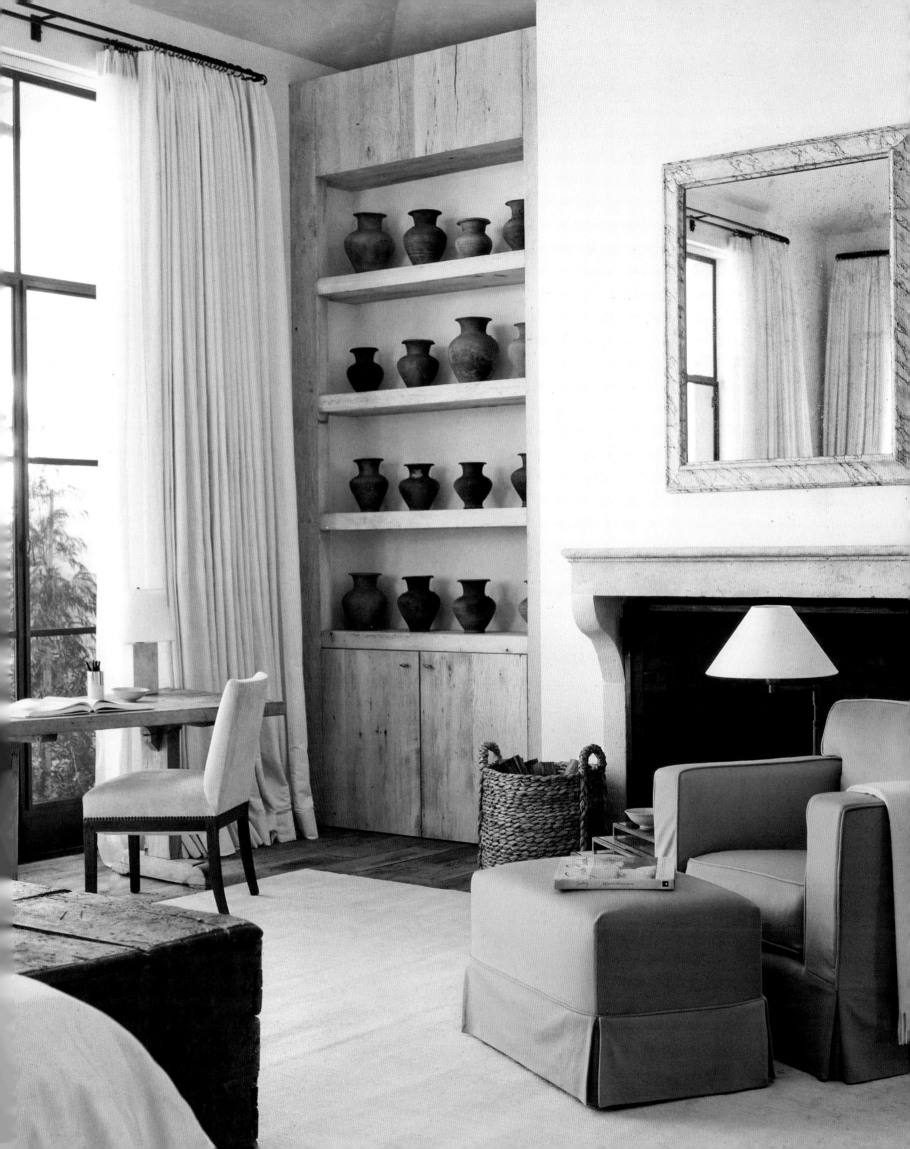

CURATED FOR COMFORT

It's possible to live easefully with a museum-quality collection of contemporary art.

For fifteen years, the estate caught designer Richard Hallberg's eye every time he drove past. "It stood out because you rarely see a Spanish Deco house from the 1930s in Los Angeles," he says. So when owners Marc and Jane Nathanson asked him to renovate the property—attributed to Lloyd Wright, eldest son of Frank Lloyd Wright—Hallberg was thrilled. "I'd always wondered what details unfolded inside."

One of the highest priorities was integrating the couple's expanding collection of twentieth-century art into the interior architecture while also making sure the rooms felt comfortable and informal. Despite the great names—Picasso, Warhol, Calder—the works don't take over. "The art speaks for itself," says Hallberg. "So the rooms themselves demanded restraint. They had to be elegant but livable." Quality was essential. The furniture and accessories needed to have the same integrity as the masterpieces. "We wanted the range of furnishings to feel as collected as the art," says Hallberg. The pieces run the gamut from tables of rustic stone and stacked selenite to an ornate Italian console and an antique rock-crystal chandelier. Also integral was a neutral palette—to showcase the colors and textures of the paintings and sculptures, and to provide the requisite breathing space for such prominent artists. And lest the scheme become too static, Hallberg threaded through graphic black accents that add dramatic contrast to all that white. Gestures such as ebonized walnut floors, cushion piping and woven leather pillows help to punctuate interior spaces.

Outside, tall hedges surround the garden, while knee-high hedges trimmed into simple shapes flank the seating areas. The garden's focal point is a monumental Calder sculpture, reflected in the shimmering pool. Like the residence itself, the scene is distinctly Californian but charged with universal appeal. "Here we are in the heart of L.A.," Hallberg says, "but we could be anywhere in the world."

Richard Hallberg renovated Jane and Marc Nathanson's Los Angeles house, which includes an impressive collection of contemporary art, including this work by Ellsworth Kelly. Hallberg strove to combine furnishings that would set off important works of art while still making the spaces feel comfortable.

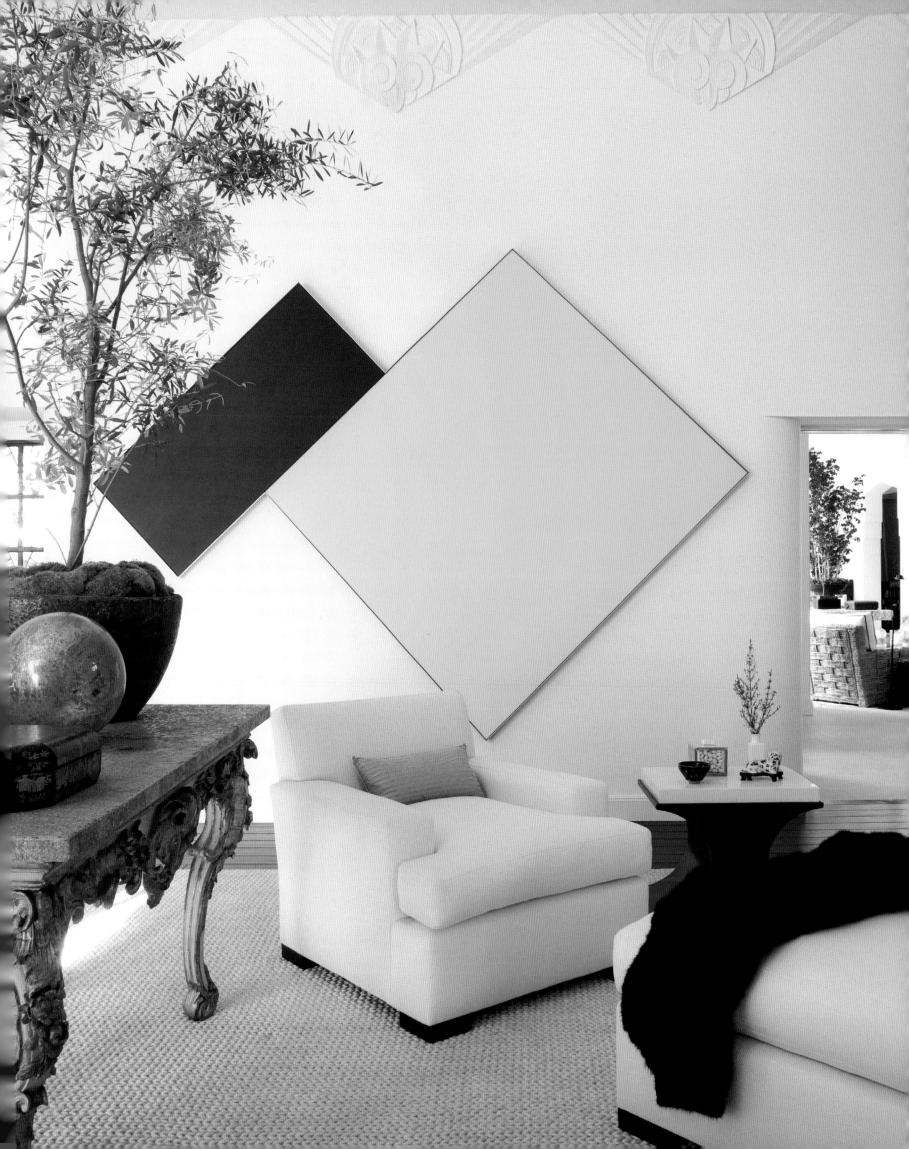

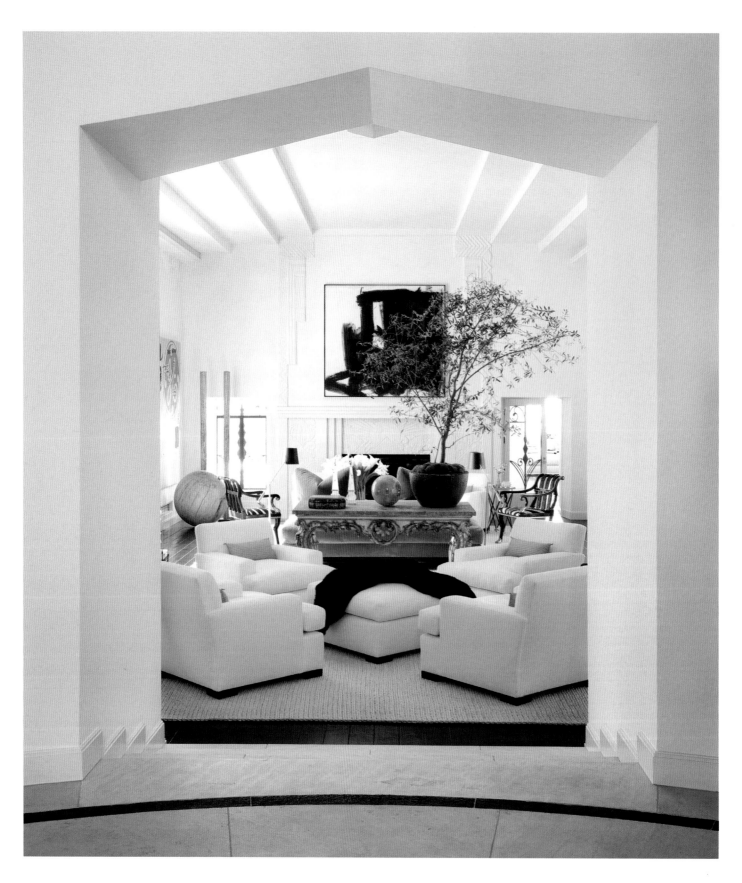

Hallberg accentuated existing Art Deco plasterwork without being too slavish. It delineates
ceilings, doorways and fireplaces throughout the house. ABOVE: An archway leads to the living room
and accentuates the Franz Kline painting over the mantel. OPPOSITE: A stepped doorway leads to
the dining room, which includes a granite table and an ornate Italian chandelier.

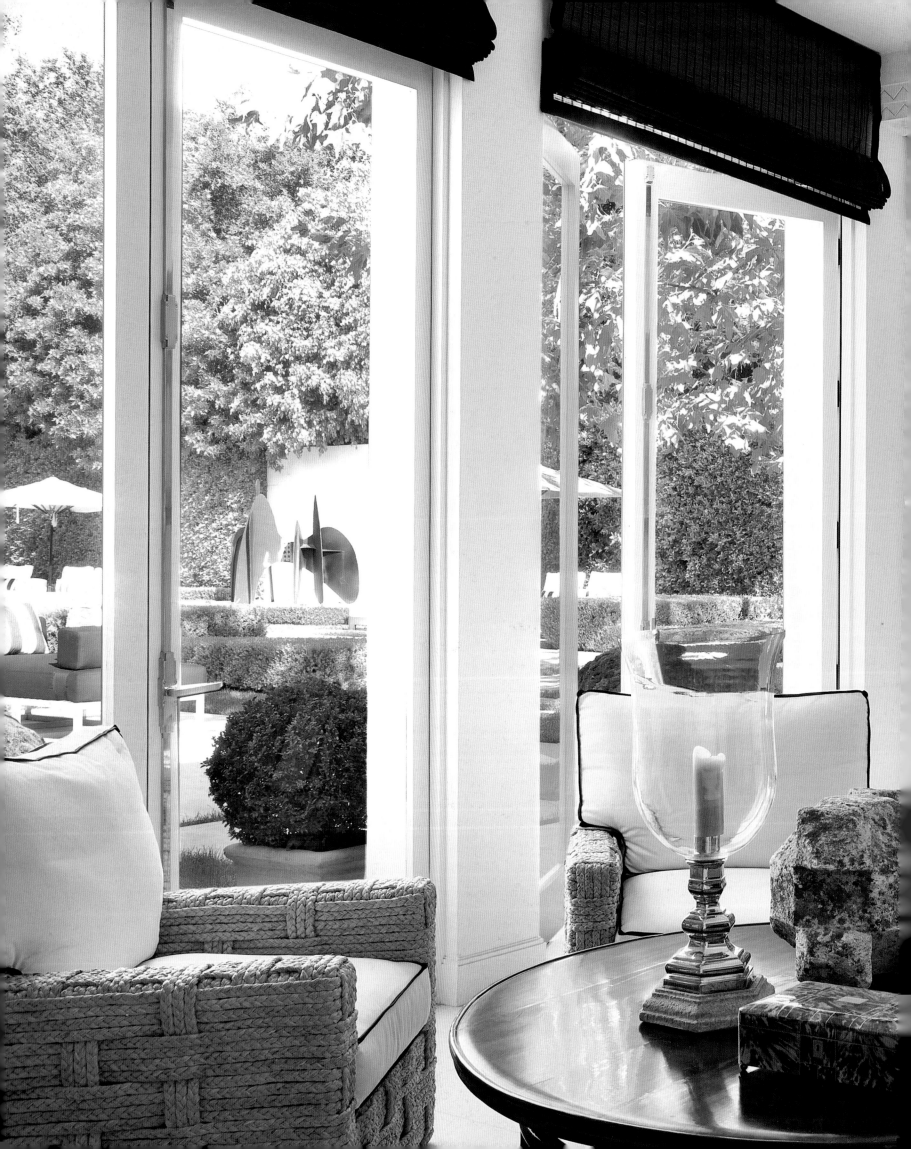

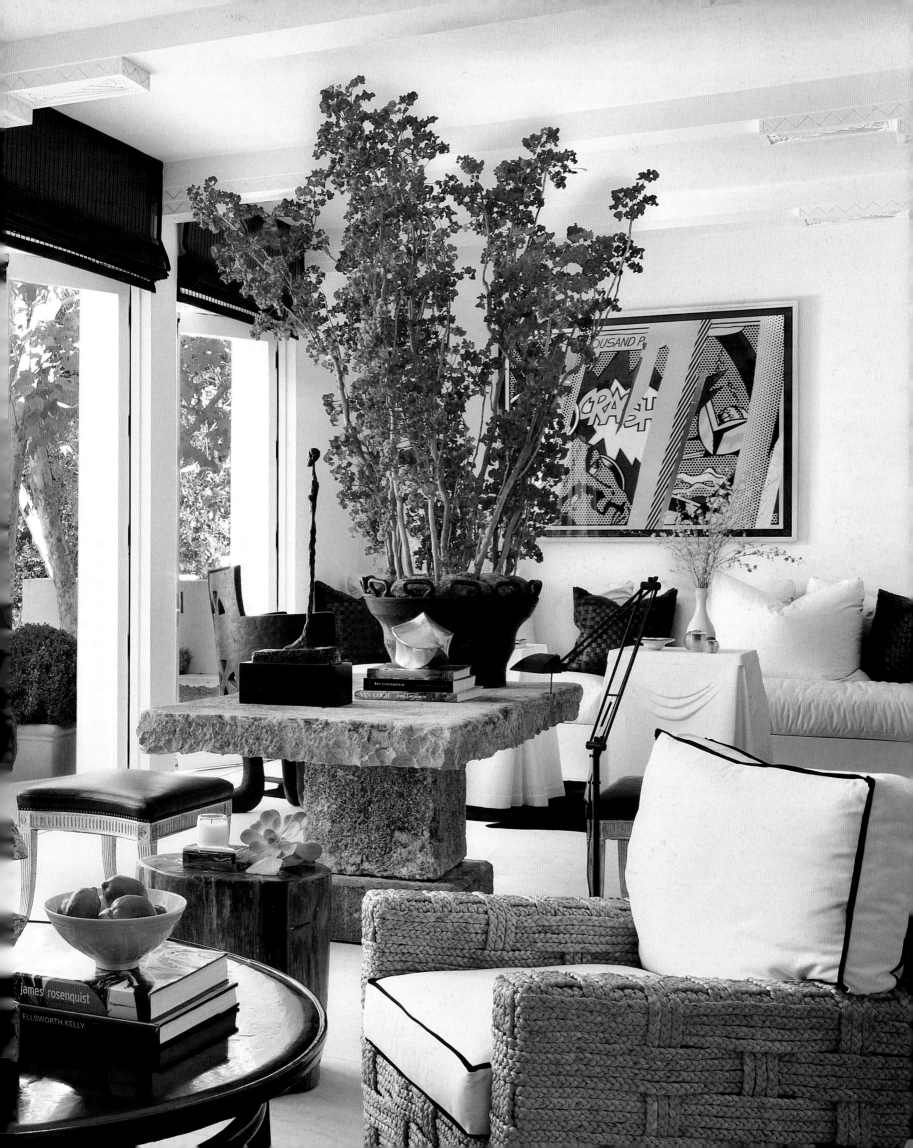

The focal point of the redesigned garden and pool is a sculpture by Alexander Calder. Chaises and daybeds conform to the house's palette, making the transition from indoors to outdoors seamless. PRECEDING PAGES: Hallberg remodeled the sunroom, adding French doors to open up the house to a view. The wall art is by Roy Lichtenstein.

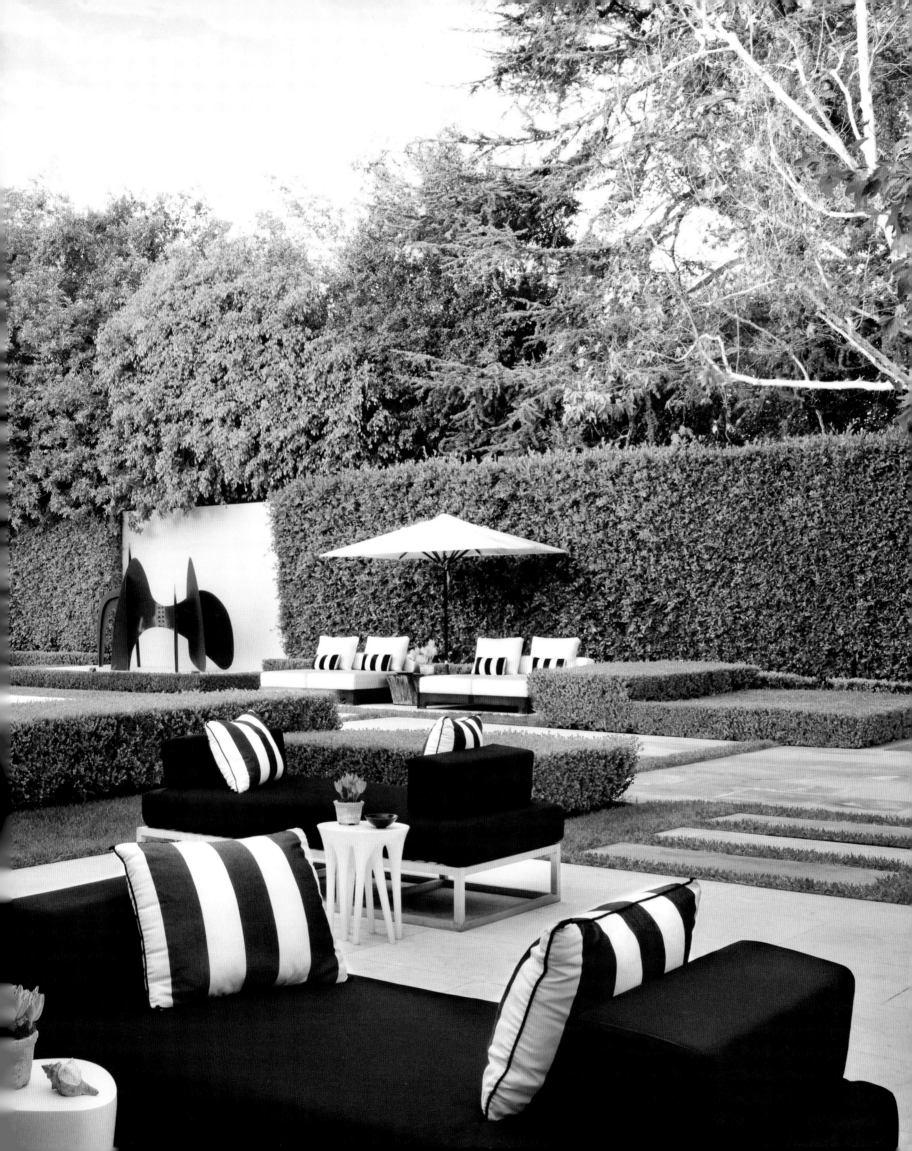

A STUDY IN SERENITY

A sober palette calms and unifies a connoisseur's eclectic collections.

"**M**y house is all khaki. It's all plain colors. Even my dogs are white and brown," says interior designer Barbara Wiseley of her 1930 Santa Barbara residence, designed by noted architect Lutah Maria Riggs.

She's painted every interior wall a dusty ecru, used natural unbleached linen for curtains and upholstery, and even refinished the plank floors in a woodsy shade of beige. The subdued, tone-on-tone envelope brings cohesion to a diverse collection of art, artifacts and antiques. "I'm a collector of so many things, and I love mixing them together." On the entry hall table alone, notable objects include Han dynasty lions, an Etruscan carved stone bird, a Roman statue fragment, amethyst stone pieces and eighteenth-century parchment books. Beneath the living room's beamed cathedral ceiling, there's an artful miscellany of elegant but not overly polished antiques: a worn, cream-colored eighteenth-century Chinese garden stool, an eighteenth-century Portuguese armchair covered in scuffed leather. Accessories such as a cowhide rug and a throw pillow made from an antique tapestry introduce another appealing layer of texture.

The only consistent color counterpoint is a sprightly green, which arrives in the guise of bonsai and a variety of other houseplants. A feathery Japanese maple stands guard in the entry hall; olive shrubs sprout from moss-covered pots in the dining room. Outside, Wiseley, an avid gardener, plotted a scheme on the one-acre grounds that reverses the hierarchy of hue. Here oaks, boxwoods, ferns and rosemary shrubs dominate the five-tiered landscape, and accents come from touches including a limestone slab table and an antique Spanish console aged to the color of driftwood. Plush daybeds and cushy armchairs provide opportunities to recline and enjoy the scenery, and of course even here, they are covered in outdoor fabrics conforming to Wiseley's favorite taupe color: "It's soothing," she says.

The dining room of Barbara Wiseley's Santa Barbara house strikes an artful balance between comfort and sophistication. An 18th-century carved urn, an antique Italian candlestick and a pair of 2nd-century stylized Roman dogs adorn a limestone table with an iron base.

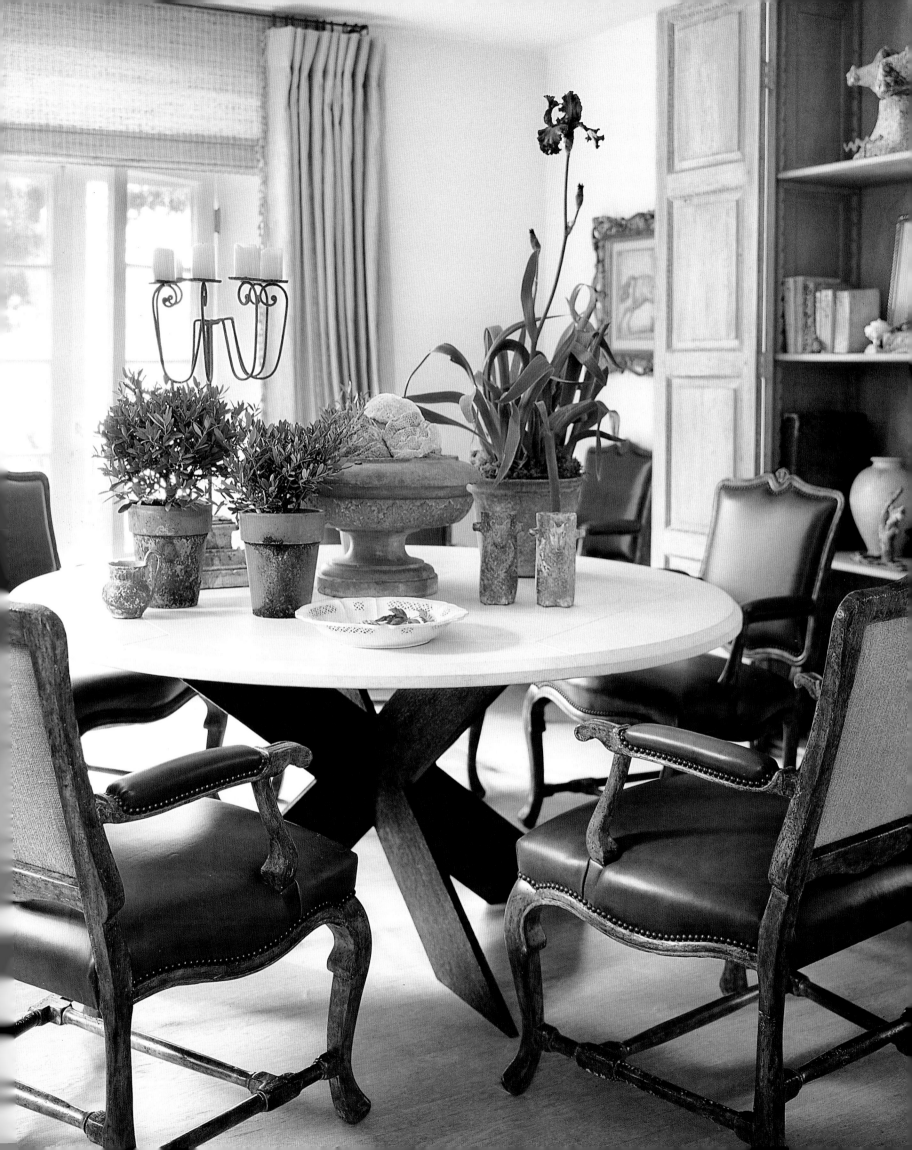

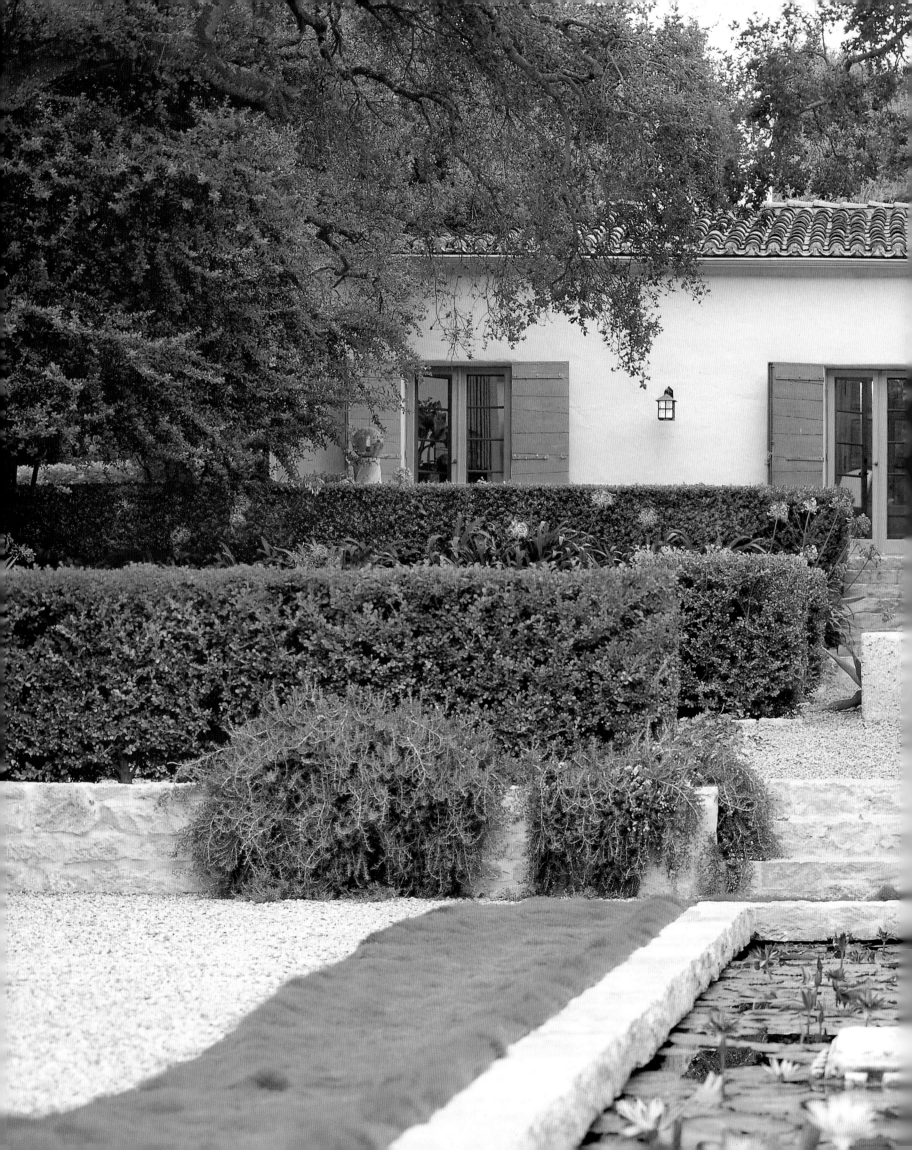

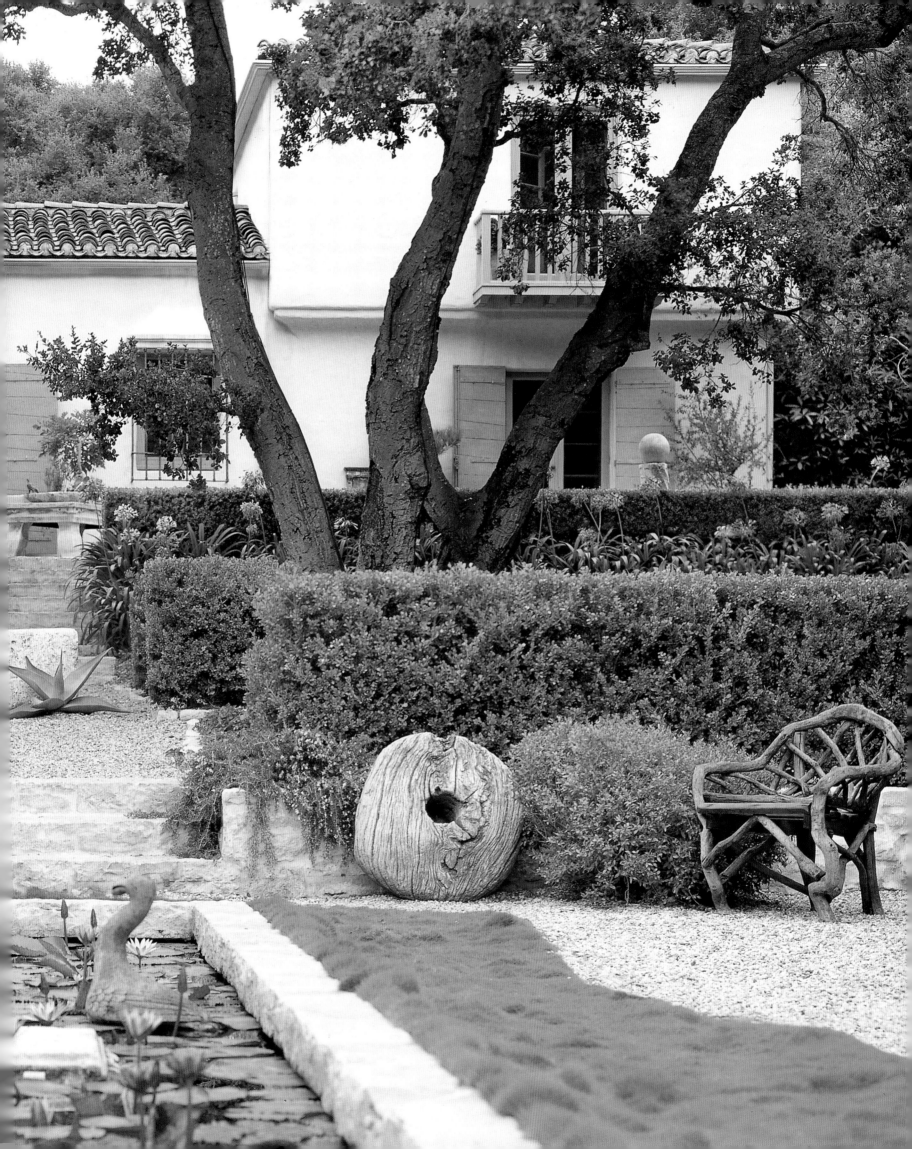

The foyer combines a varied set of influences. A collection of framed 18th-century botanicals hangs over an iron-studded antique Portuguese trunk. The quilted leather bench is Spanish. Above the 17th-century Italian turned-leg hall table is a Picasso drawing in an ebonized dentil frame. The mounted sculpture is an antique silver headdress. The studded coffer is also antique. PRECEDING PAGES: The garden features agapanthus, a pond with water lilies, and agave plantings connected by gravel paths. The shutters on the facade are antique. FOLLOWING PAGES: The living room is a study in scale.

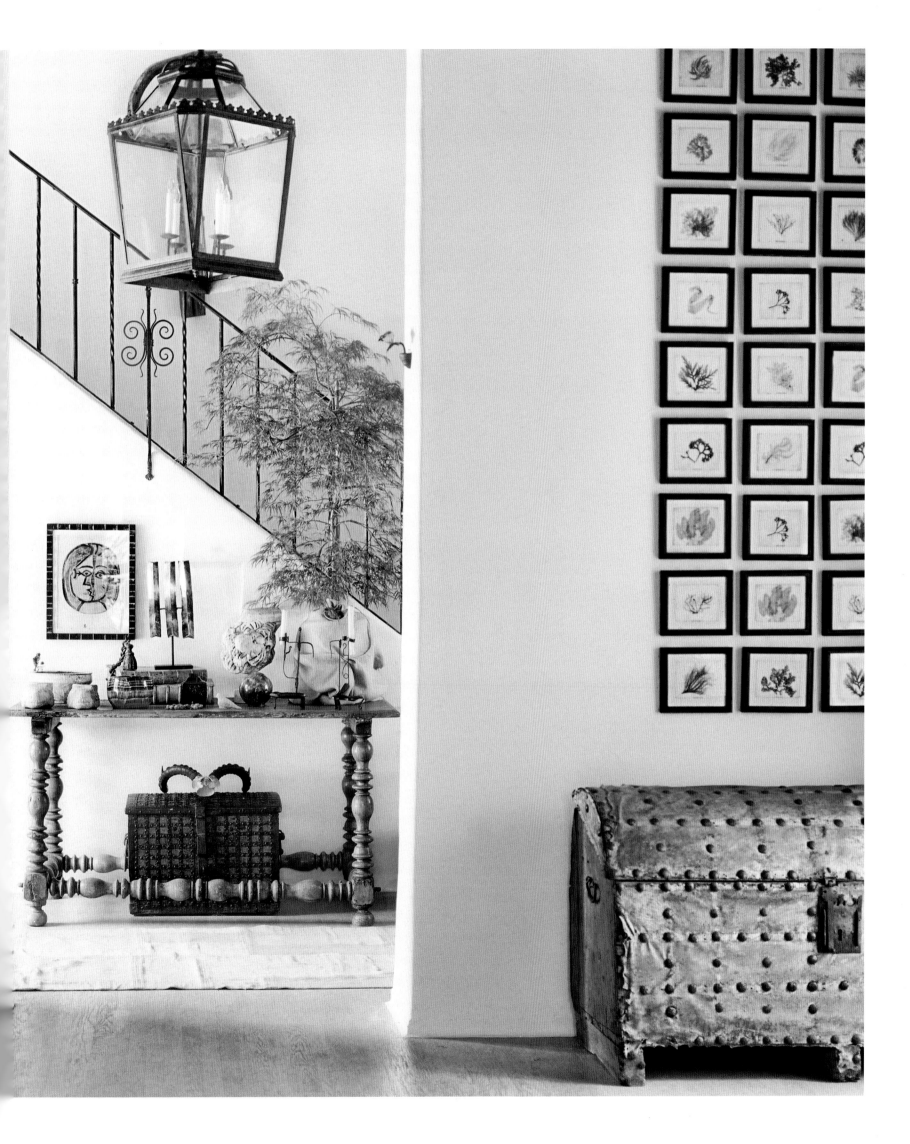

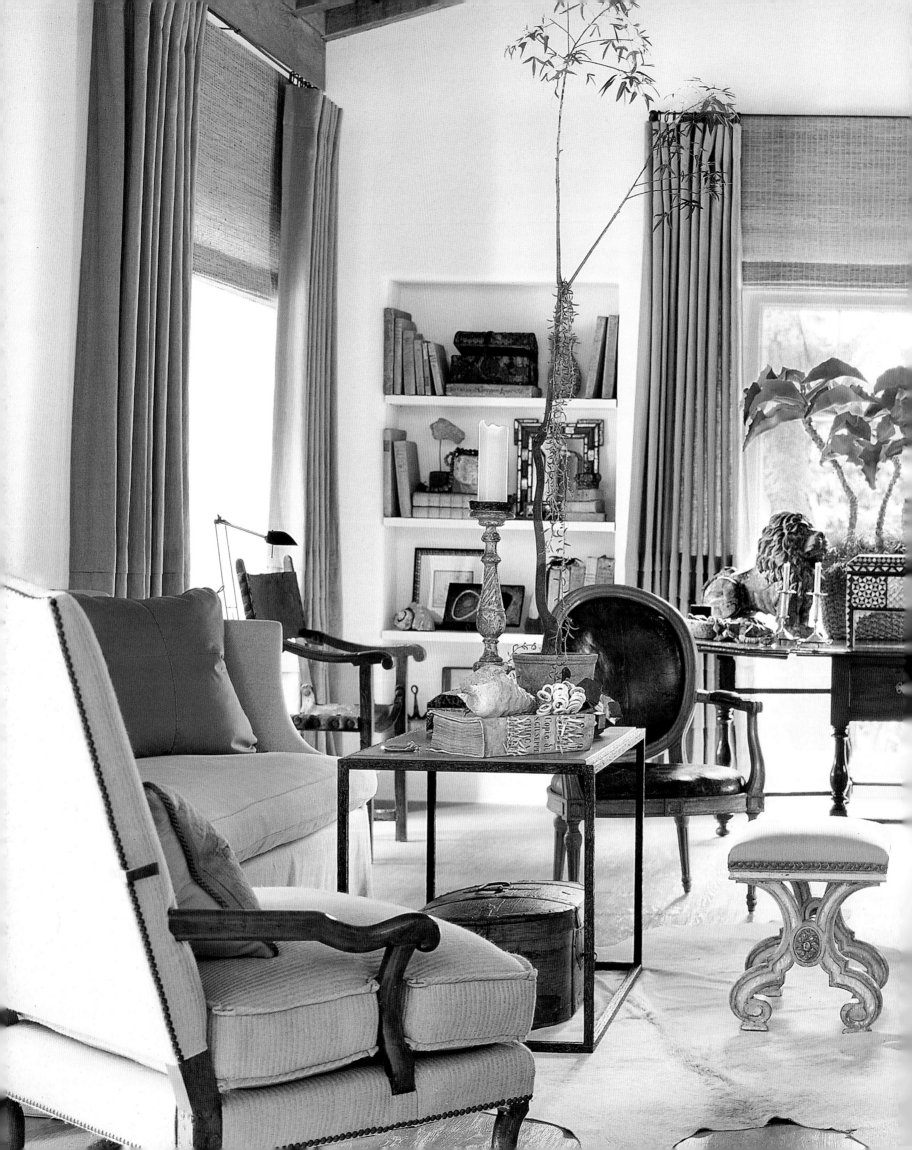

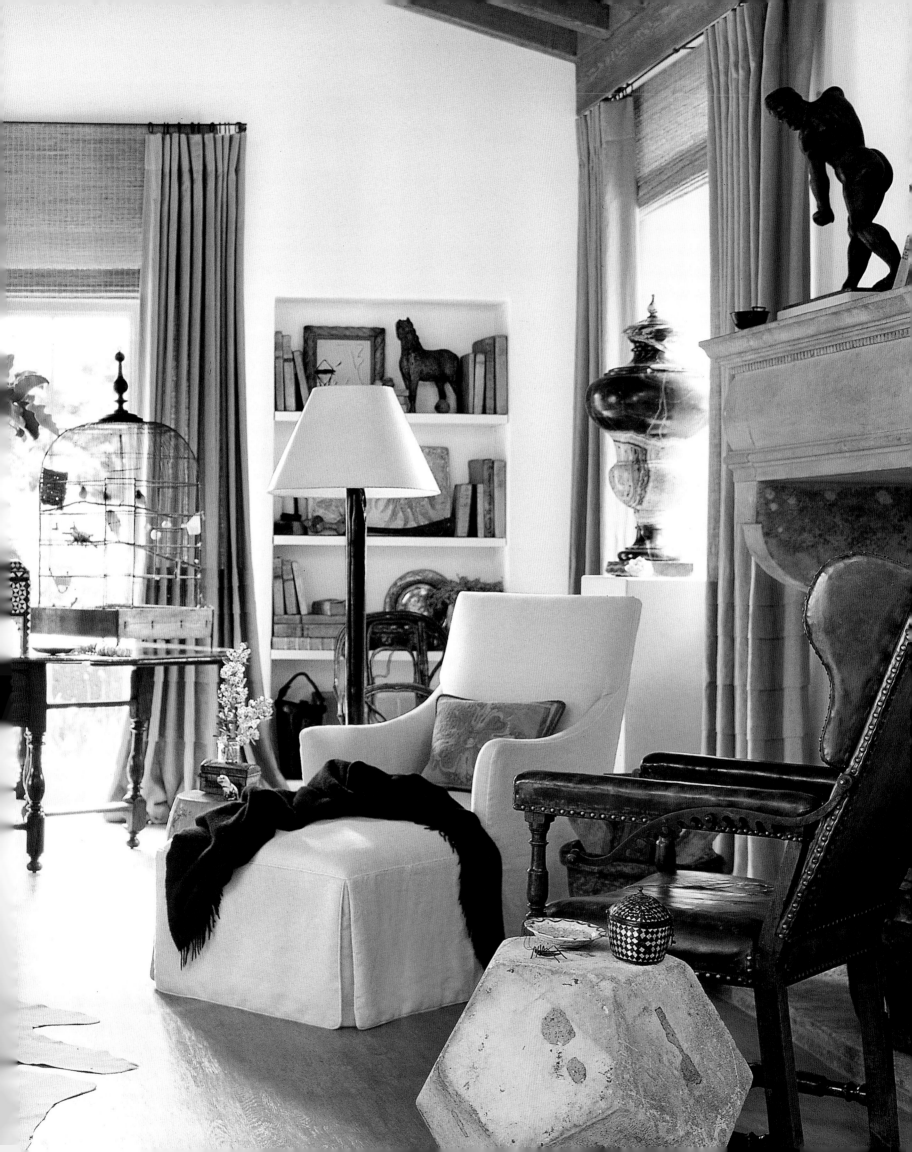

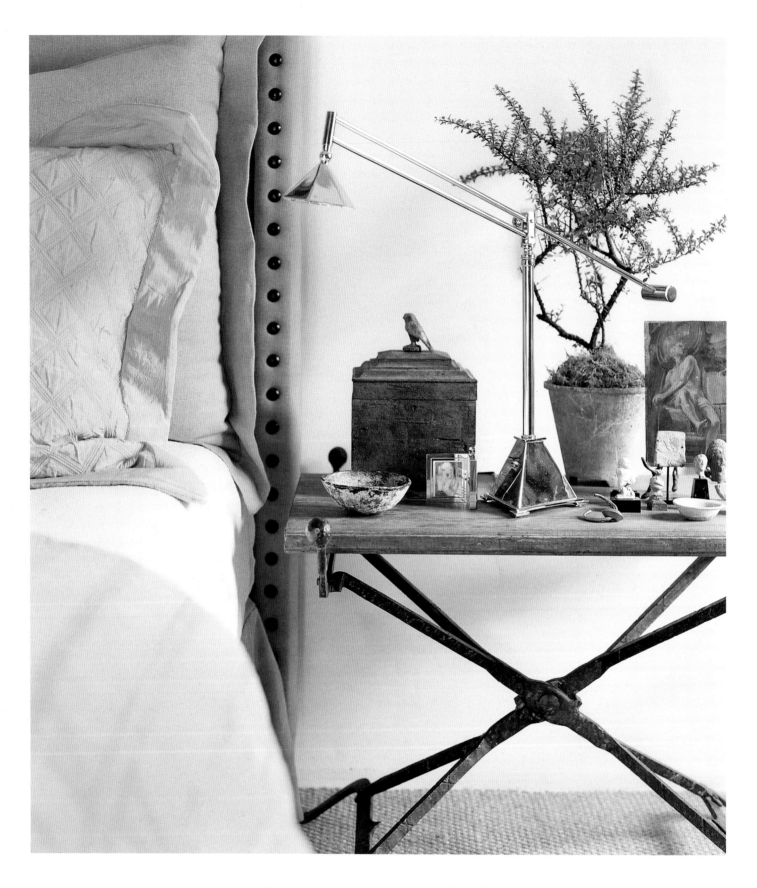

Bedroom vignettes are a microcosm of Wiseley's aesthetic. ABOVE: A custom headboard in unbleached linen has oversized nailhead trim. A pharmacy lamp illuminates a collection of "smalls." OPPOSITE: A contemporary work by Robert Kingston is displayed with a custom coffee table, an 18th-century Swedish box and an antique Italian stool covered in horsehair.

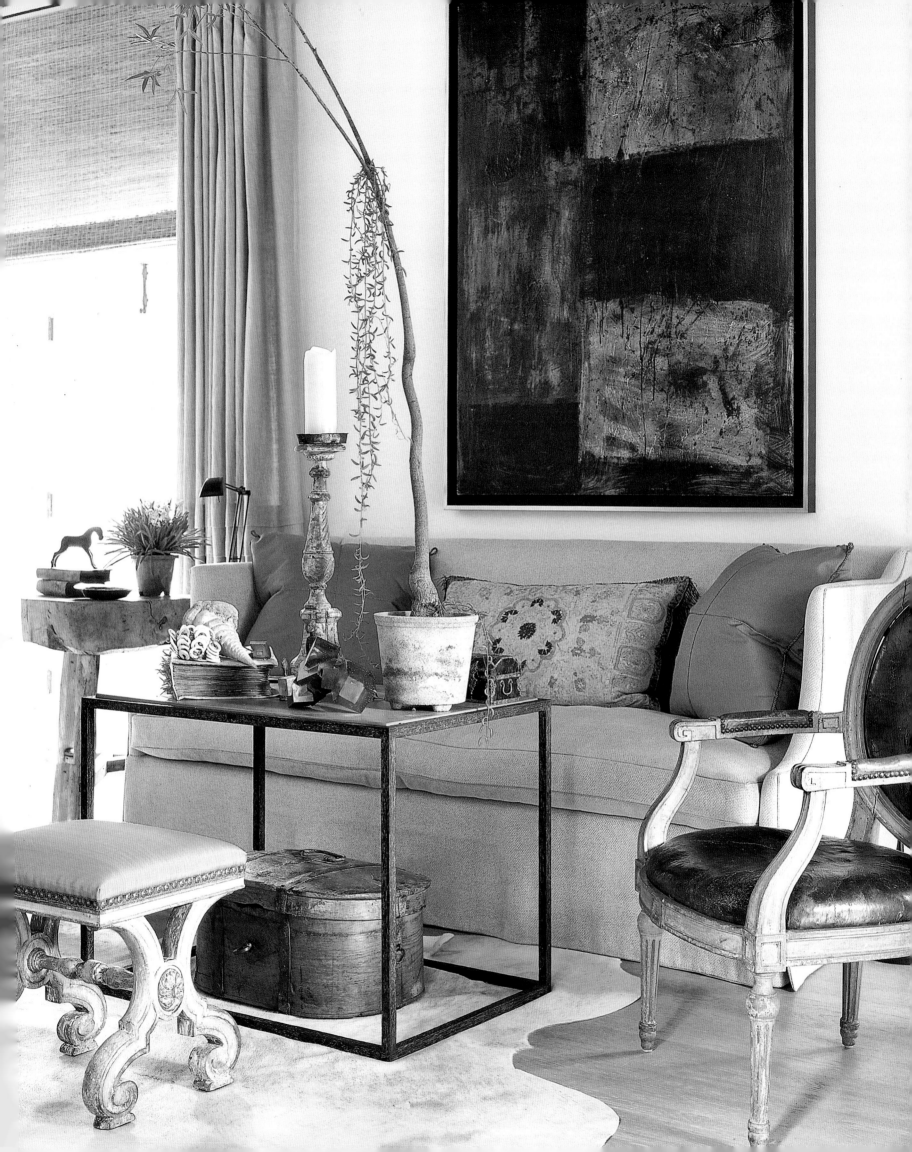

SOFTENING THE EDGES
Architectural minimalism is buoyed by a whimsical sense of humor.

L ike the house around it, the sweetgrass basket on the living room wall is a work of art. Nancy Braithwaite had it created specifically for her vacation retreat on South Carolina's Kiawah Island. "I fell in love with the strength and craft of Mary's work," Braithwaite says of local master weaver Mary A. Jackson, a recent MacArthur "genius" award winner. "She spent over a year on that basket."

The same rigor and devotion to detail are on display in the design of Braithwaite's house itself, a radical departure from her tradition-steeped Atlanta residence. "Designers need to experiment," says Braithwaite. At Kiawah, she envisioned a twenty-first-century abode heroic in scale, minimalist in decor and spacious enough to accommodate her husband, Jim, and their two daughters, sons-in-law and grandchildren. Together, the Braithwaites and architect Jim Choate devised a dwelling with three cedar-clad "pavilions" connected by generous, stone-paved hallways. High vaulted ceilings and expanses of windows make it airy and flood it with light.

For the look of the rooms, Braithwaite kept things simple with repetition. She used the same Indian flagstone for certain walls, floors and a fireplace, and identical textiles reappear in different colorways. When she couldn't find furniture in the right scale, she had pieces custom-made. From the slab-like dining table to the modern beds, clean lines and sharp angles echo and enhance the architecture.

The decor is balanced and utterly clutter-free—so pulled together that it might even have come off as a little severe, but for a bit of whimsy. When Braithwaite saw giant copper toads and snails by the artist Robert Kuo, she had to have them. The creatures literally climb the walls in a bathroom and a stairwell, introducing a hefty dose of levity and a bit of poetry. "They're as sculptural as the house," she says.

Three cedar-clad "pavilions" compose Nancy and Jim Braithwaite's modernist retreat on Kiawah Island, designed by architect Jim Choate and towering above a landscape the includes beach dunes and a salt marsh. FOLLOWING PAGES: A basket by Mary A. Jackson is the focal point of the living room.

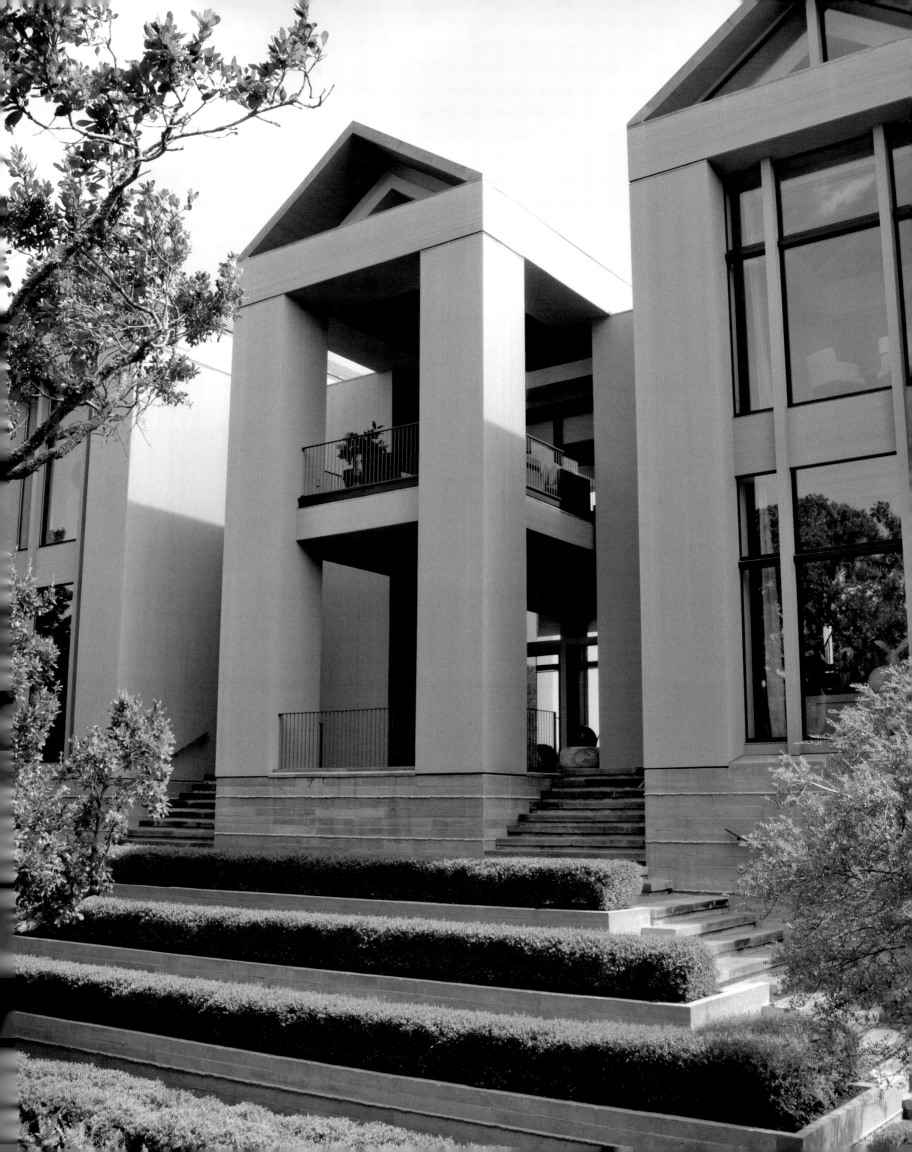

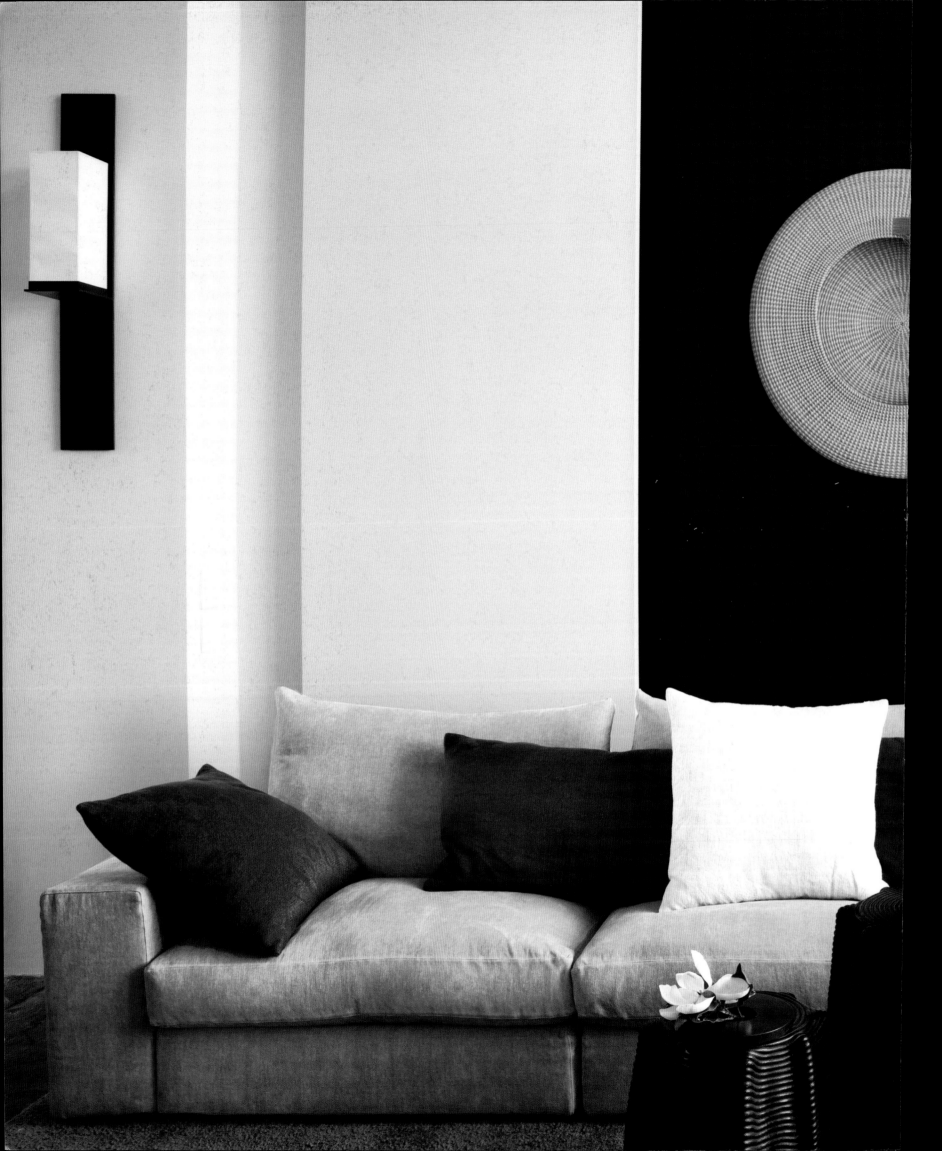

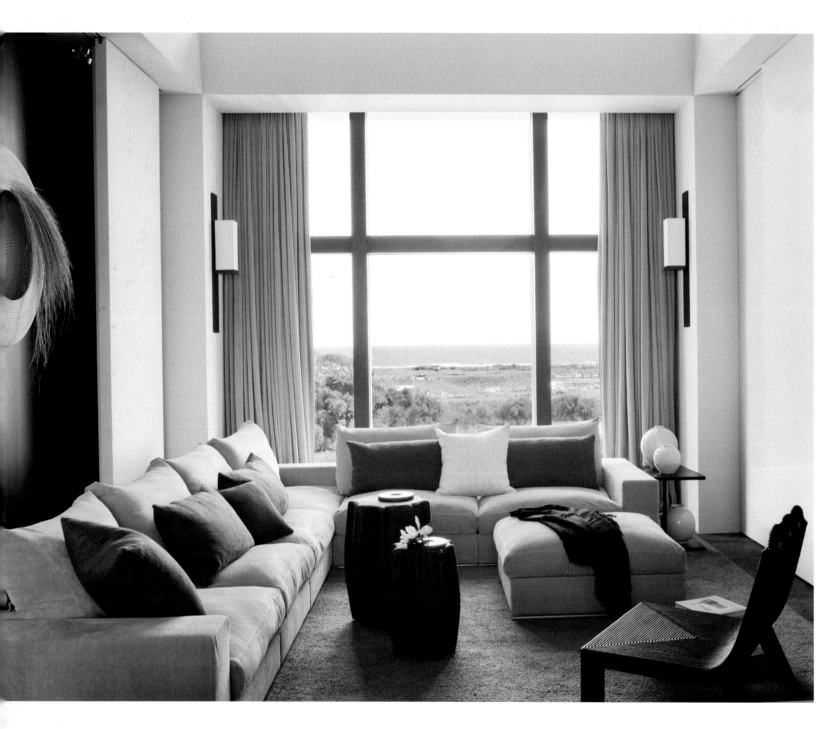

Repetition and a neutral palette give the interiors cohesion. Braithwaite settled on a few basic fabrics and used them throughout the house, selecting different colorways where appropriate. ABOVE: In the living room, the curtain fabric matches the sofa's upholstery. OPPOSITE: The custom chairs and dining table, which holds a striking arrangement of cecropia leaves, mirror the sharp-lined geometry of the architecture. The same flagstone tiles were used for the fireplace and the floors.

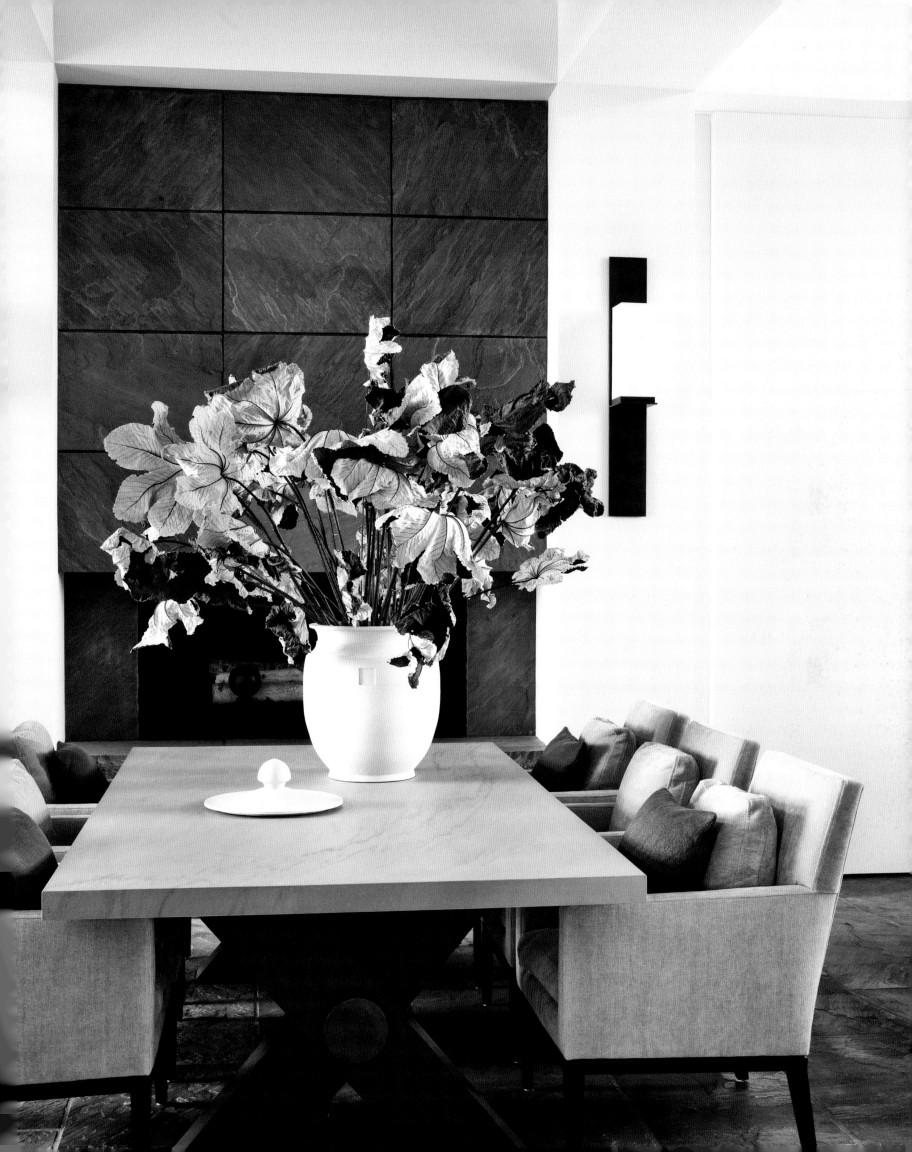

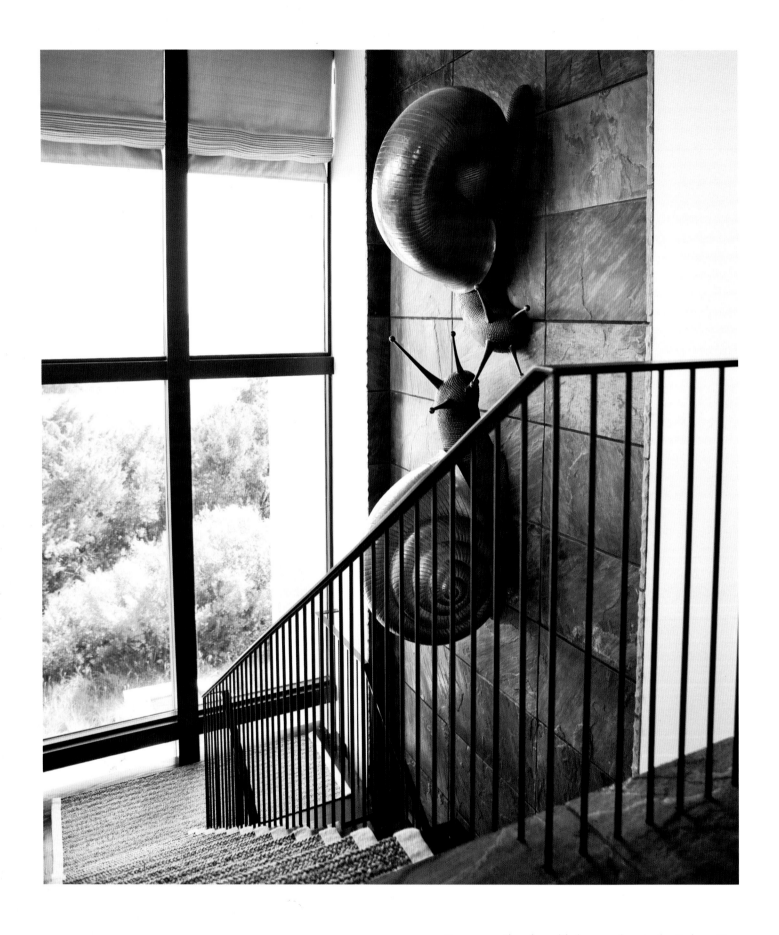

ABOVE AND OPPOSITE: Copper snail and marble hare sculptures by Robert Kuo
decorate the flagstone walls of a stairwell and surround the swimming pool.

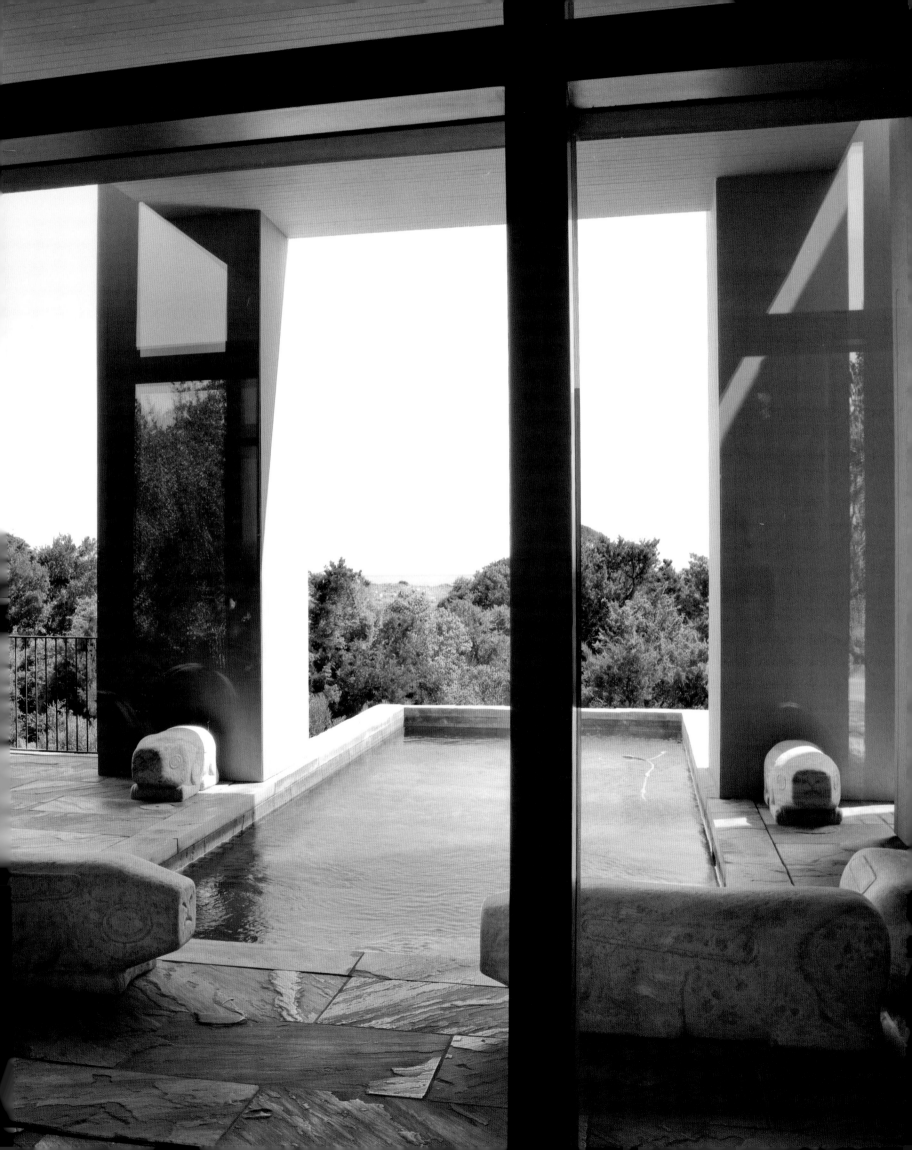

ABOVE: Soft textures in beige and a black and white stripe soften the clean edges of a canopy bed in a guest room. OPPOSITE: A stool covered in terry cloth is resistant to splashes. Copper toads by Robert Kuo climb the walls.

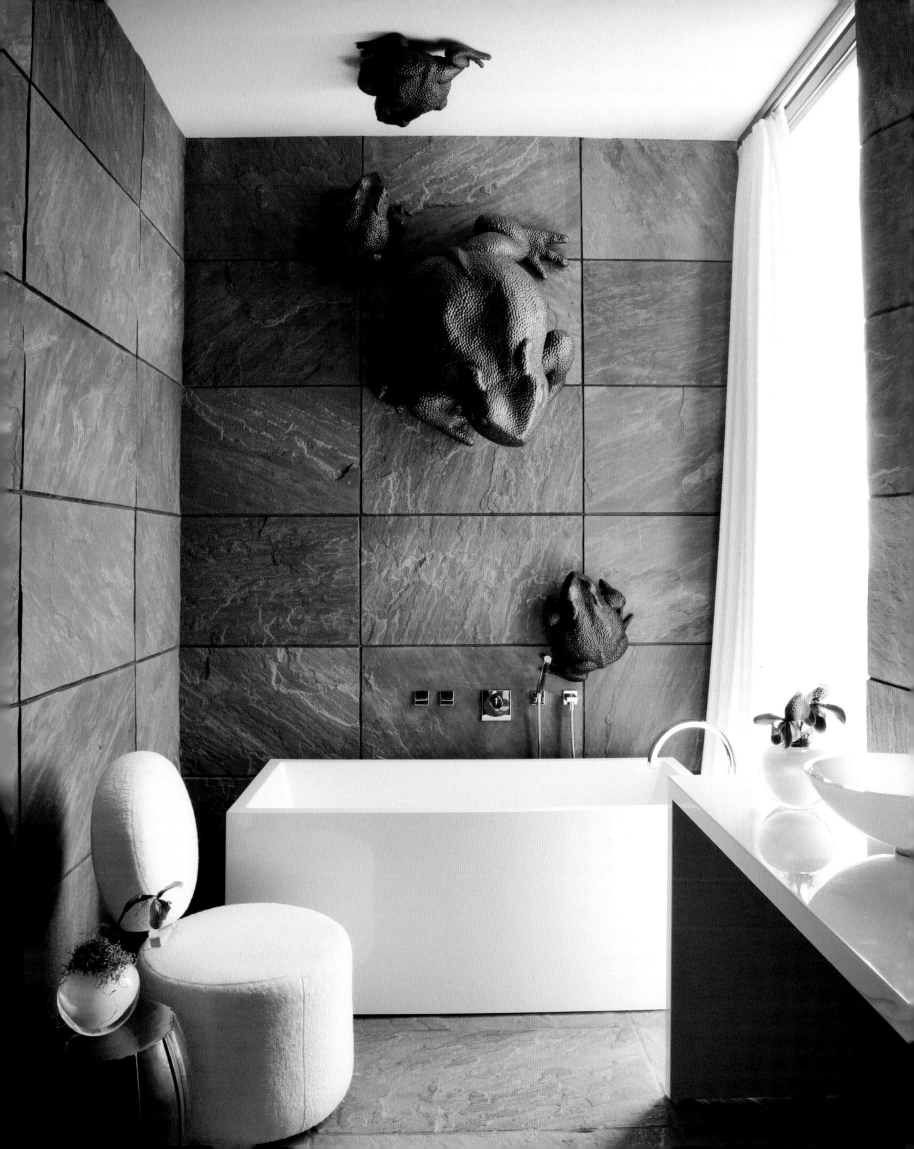

THAT BEACHY GLOW

An easygoing floor plan glimmers in a soft, seaside-inspired palette.

When Julie and Kent Stewart decided to build a Rosemary Beach vacation house for their family, they brought a lifetime of memories from summers spent in Florida to bear on the project, coupled with a desire for the usual things that draw people to the shore: the views, the rhythm of the tide and the light. But it was one of these features in particular that played a defining role in the retreat that designer Susan Ferrier and architects Bobby McAlpine and Greg Tankersley eventually delivered to the couple and their teenagers, Tanner and Taylor.

"You have to pay attention to the color of the light coming inside the house," says Ferrier. "It's very strong. But instead of fighting it, we just went with it, using the entire beach palette." Soft hues of blue, green, taupe and stone catch the sunshine that streams through the windows—the quality of which is both intense and sometimes overpowering. To complement and filter that glare, Ferrier used curtains with a gauzy feel. On the ground floor, richer versions of the predominating hues fittingly set the stage. The master suite on the third floor, decorated in shades of sand and shell and including touches such as sloped ceilings and dormer windows, has a tree-house atmosphere. It's on the middle level that Ferrier's approach gets its fullest expression. The large living room and salon is laid out like a loft, with no interior walls. Large steel-framed French windows and doors, some left bare, flood the space with light. Reclaimed antique oak planks on the floors are treated with a reflective coating and pack an inviting glow. A custom concrete-topped table shimmers and gleams. It's all cleverly modulated. "It's calm because it's balanced," says Ferrier.

In the salon of a Rosemary Beach retreat, Susan Ferrier's design accommodates a variety of functions. Coffered ceilings of pecky cypress provide an appealing texture in the newly constructed house, designed by architects Bobby McAlpine and Greg Tankersley.

Exterior eaves soften the sunshine,
allowing diffuse light to penetrate
the French windows, which were
left unadorned. Velvets and linens
cover the cushions and pillows on the
armchairs and the custom sofa. The
weathered industrial coffee table,
an antique, is a counterpoint to the
polished materials. The klismos chair
was treated with silver gilt.

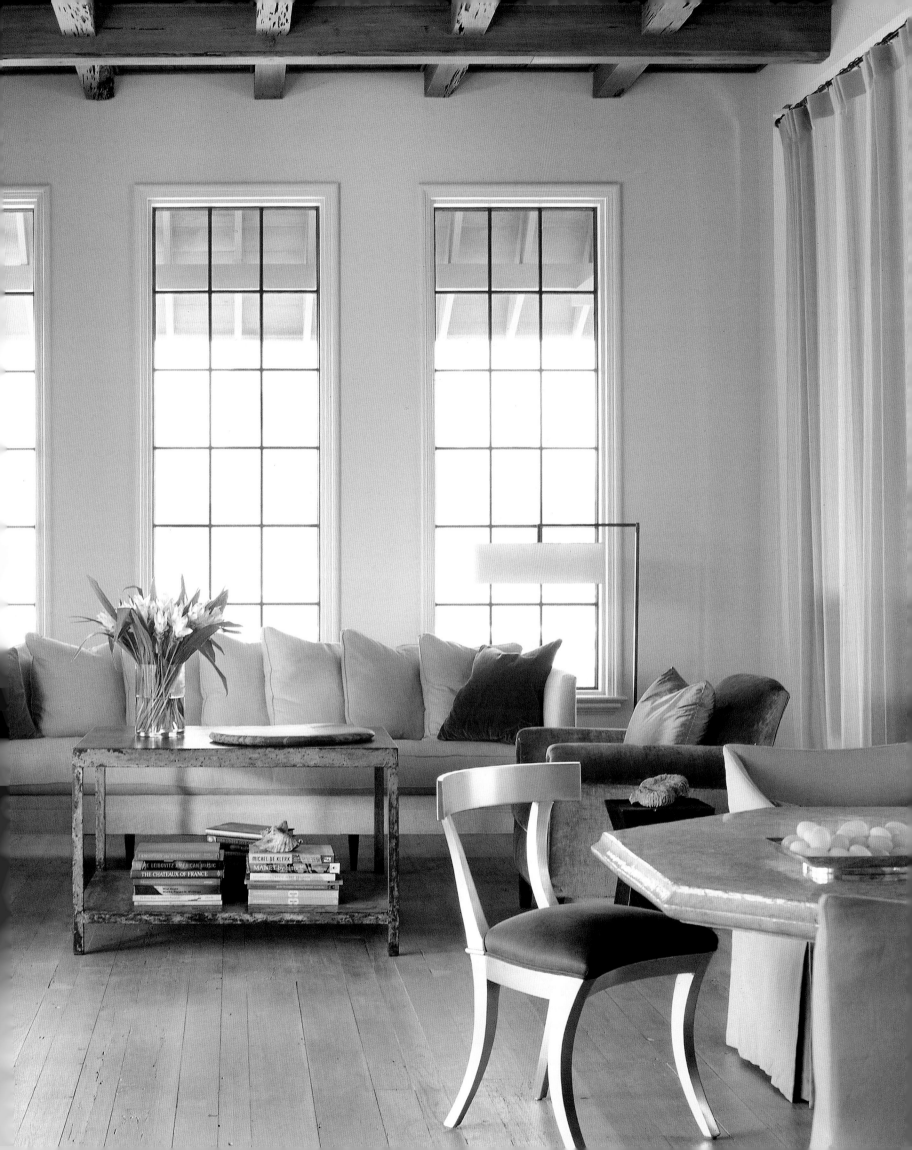

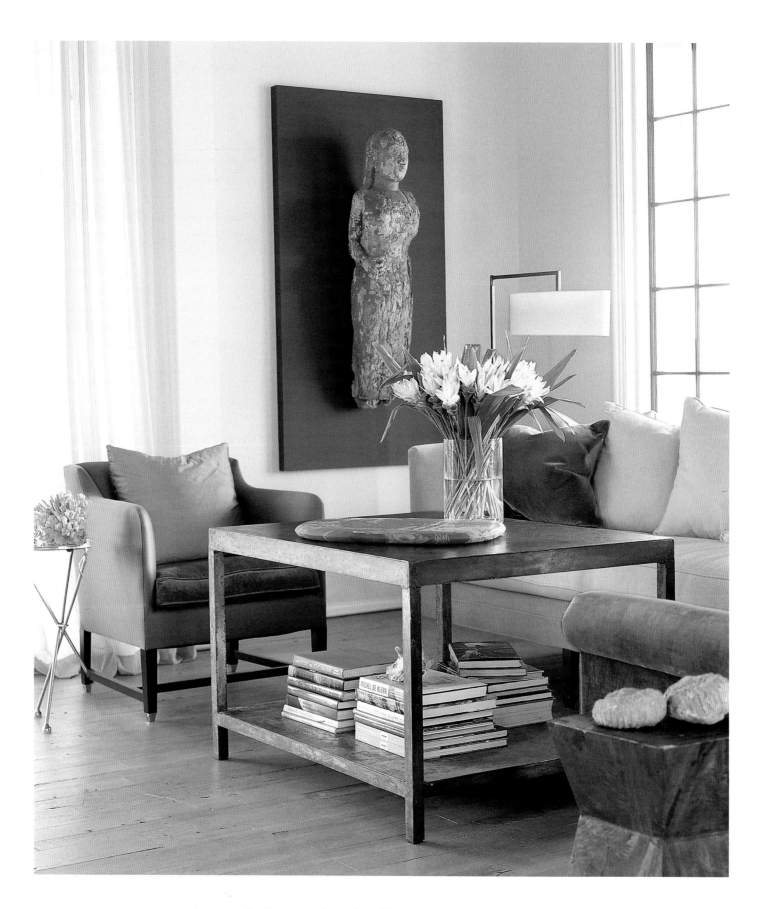

Matte and reflective surfaces play off each other throughout the house. ABOVE: Coral is displayed on a silver-plated tray table. The mounted Asian angel is antique. OPPOSITE: In the stairwell, a huge sheer scrim diffuses the light. The geometry of the stair rail is echoed in the shape of the hanging lantern.

FRENCH INFLECTION
An updated Art Deco sensibility is infused with a charming Gallic vibe.

I n this Park Avenue apartment, designer David Kleinberg and architect Peter Pennoyer have channeled Paris circa 1925, distilling from it a beguiling Art Deco style and combining it with a contemporary perspective to ground the home in the current day and age.

The renovation of the residence was commissioned by a young family who wanted to strike a balance between old and new. "We needed a timeless space that reflected our modern sensibilities," says the wife. She envisioned an updated version of a classic Parisian apartment in muted tones. Pennoyer complied with a lofty foyer and a rearrangement of the spaces into a grand enfilade, from the library to the living and dining rooms.

As to the decorating, Kleinberg went about subtly interpreting that Gallic *je ne sais quoi*. He invokes Jean-Michel Frank in his use of oak, limed and pickled in the herringbone floors and cerused in the paneling of the masculine library. Massive pocket doors, a Pennoyer-Kleinberg design, are ebonized and inlaid with a nickel motif that's like something off the SS *Normandie*. And the iced petit four of a dining room is splashed in a pale blue lacquer and sheathed in millwork that curves at the corners so the room feels oval.

Other details keep the interior from reading as a set piece. The herringbone parquet is wildly overscaled. In the dining room, the table has clean edges, and it sits under a sculptural chandelier with twiggy bronze arms that dangle with enormous rock-crystal teardrops. Displayed throughout is a striking collection of contemporary works by artists such as Gerhard Richter and Antony Gormley. "There's a lot of push-pull going on," explains Kleinberg. "But it's precisely that tension that keeps everything balanced and current."

A contemporary photograph by Candida Höfer hangs in the gallery of a Park Avenue apartment renovated and decorated by designer David Kleinberg and architect Peter Pennoyer. FOLLOWING PAGES: The living room, part of an enfilade that stretches from the library to the dining room, keeps to a creamy color scheme. Floor-to-ceiling windows augment the airy proportions.

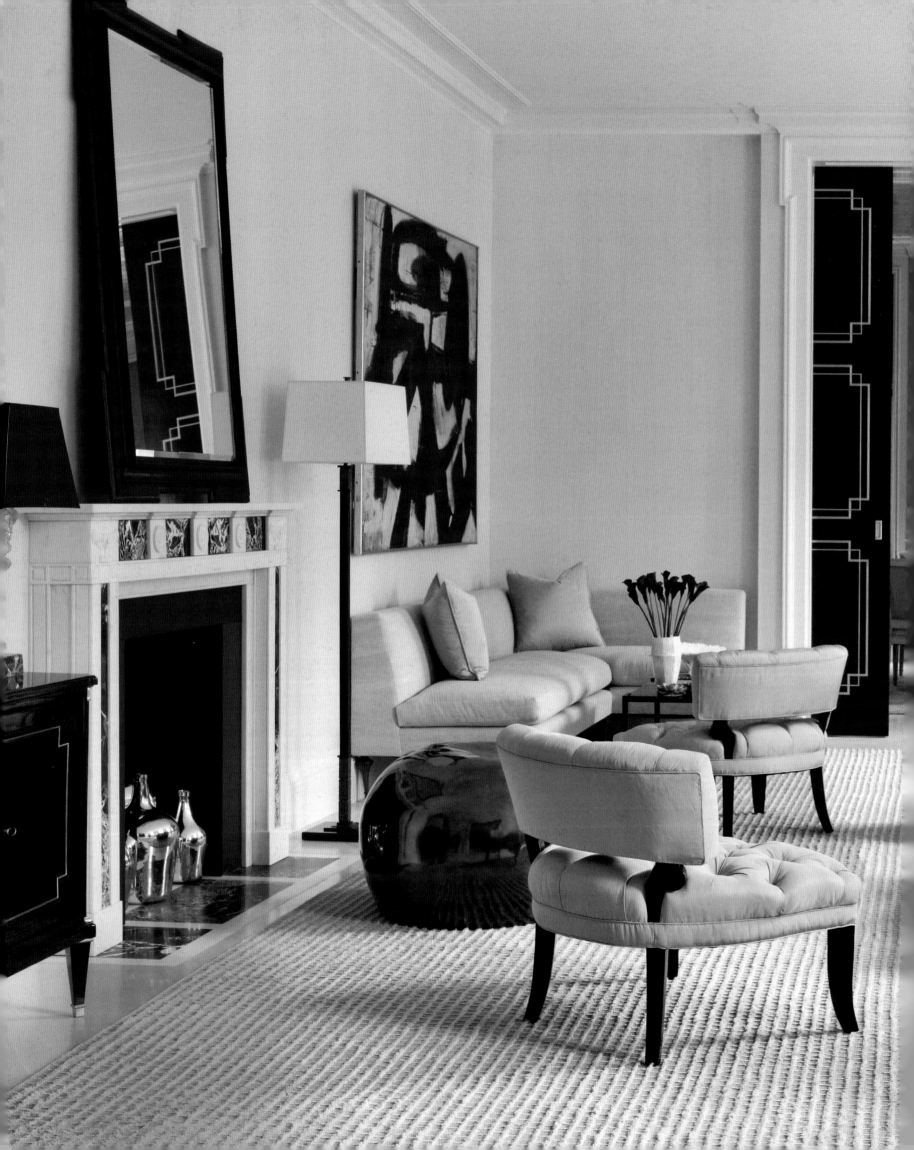

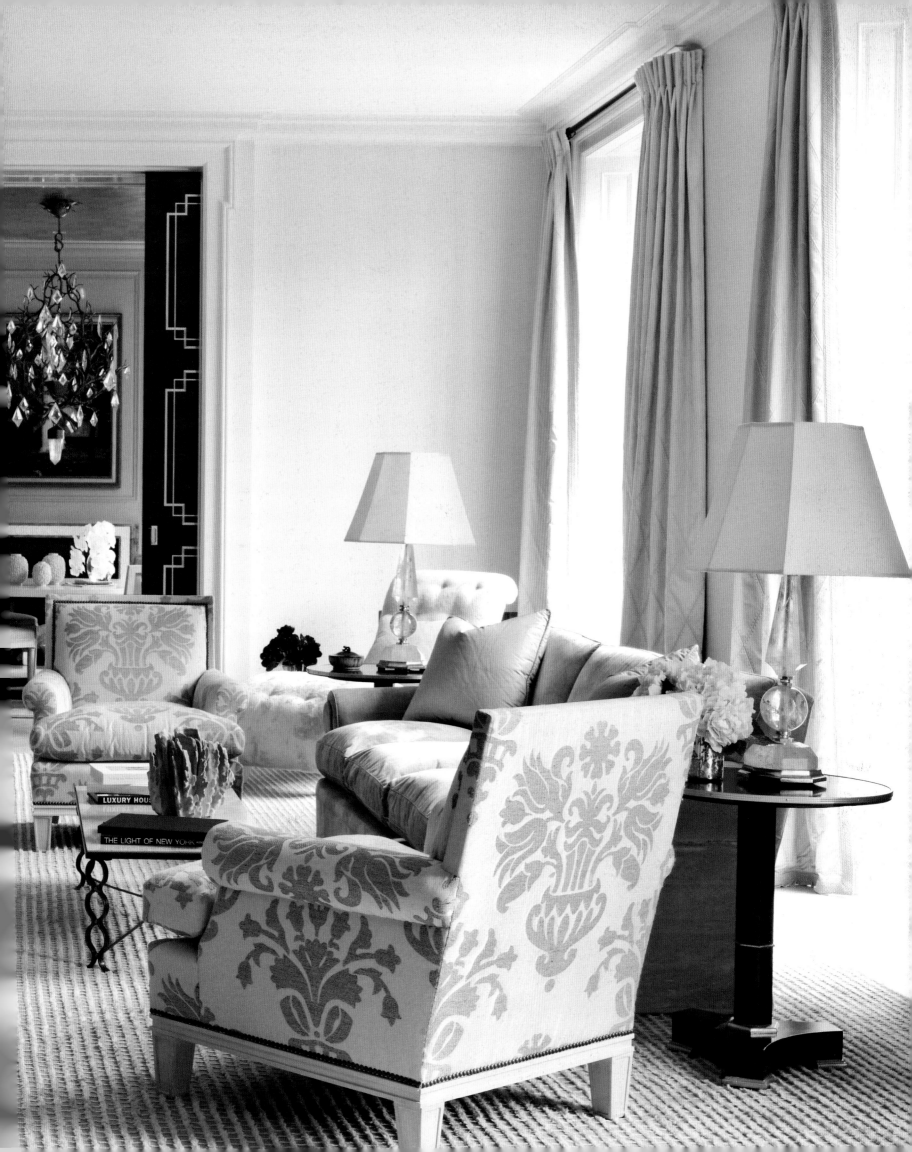

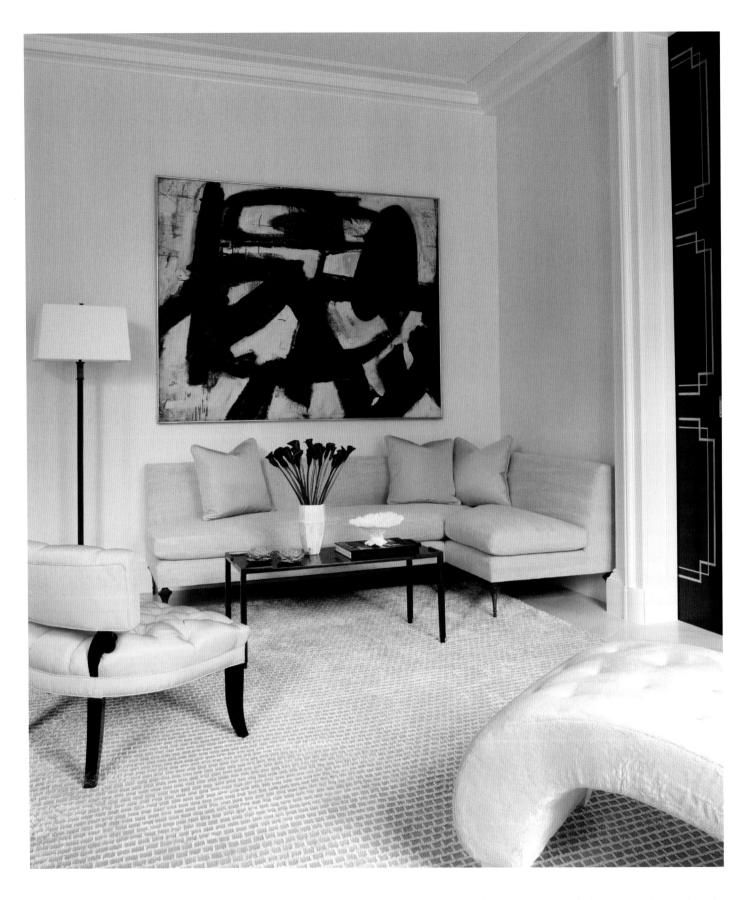

ABOVE AND OPPOSITE: Art by Franz Kline in the living room and elements such as a shapely, oversized chandelier by Hervé Van der Straeten in the dining room give the Art Deco–inspired spaces a modern sensibility. The mahogany pocket doors have a geometric inlay of nickel.

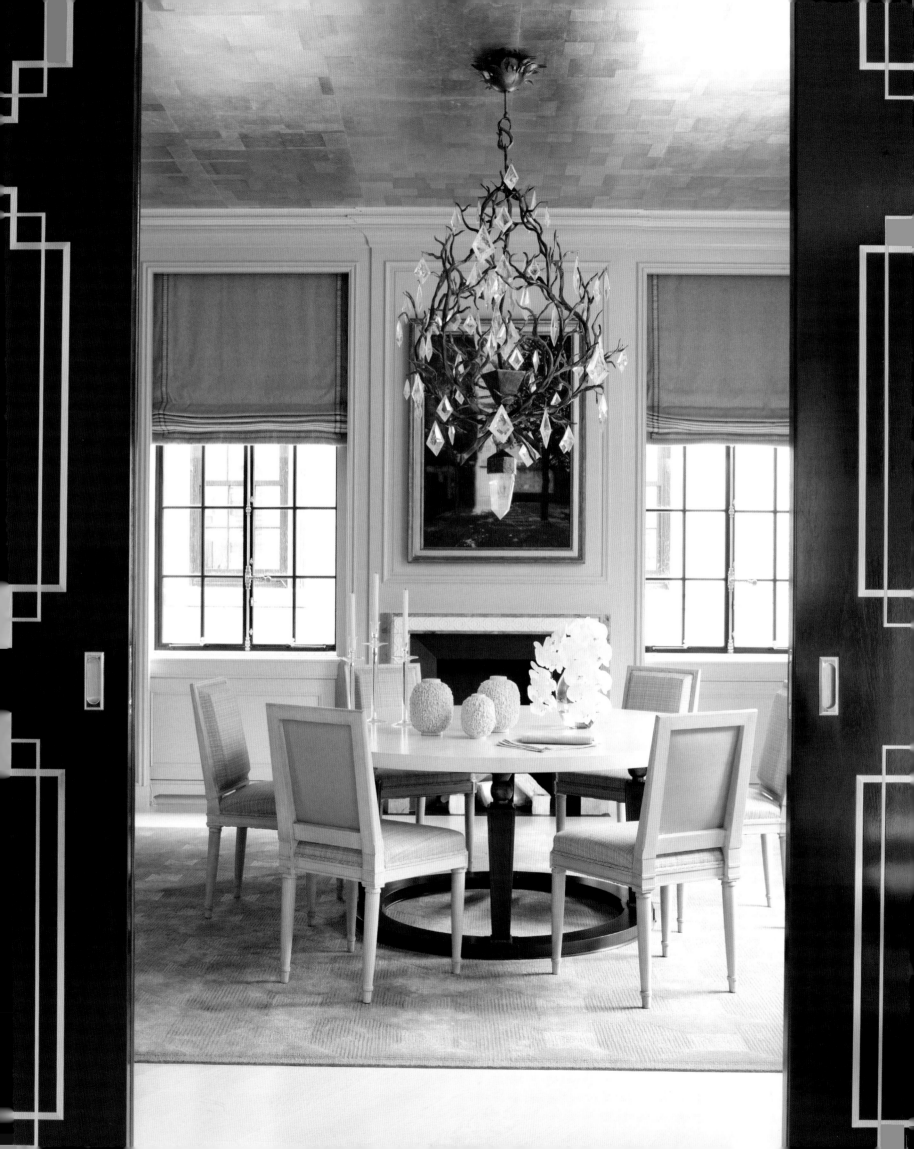

In a departure from public areas, the master bedroom features bold shots of a coral tone. To keep the color from becoming overwhelming, Kleinberg limited its use in the custom curtains, crafted from two different silk taffetas, to the height of the windowsill. The framed work above the bed is a photograph by Cindy Sherman.

3.
A romantic room charms and beguiles. It's about atmosphere and a feminine touch in spaces that will make you swoon.

Romantic Houses

Edit a decorating magazine for any length of time, and you learn a simple truth that explains millions of real estate transactions in a way statistics never will: People fall in love with houses. It happens all the time. Every home, it seems, is someone's version of happily ever after.

Romance, unsurprisingly, plays a huge role in an interior's allure. Romantic rooms have always loomed large in VERANDA. Such spaces are often so captivating because they exert an emotional pull—evoking a graceful and cultivated way of life in the curves of a wooden frame that gleams with gilt, or the chalky finish of an antique limestone mantel. These spaces hearken to the past. They revere craft. They cosset, they connect, they comfort. In the whisper of a pinch-pleat linen curtain, in the flourish of a ruffled sofa skirt, in the arc of a Louis XV chair leg, they adhere to the idea that a home is a refuge that should charm our hearts if it's truly to be a sanctuary.

As with so much in decoration, however, moderation is key. The best romantic rooms know when to say when. Pour on the frills with too heavy a hand, and you wind up with something so sweet it might give you a toothache. A well-practiced designer is nothing if not a good editor, and that's especially true when mining a romantic look. It's a balancing act. You temper the gilding with bare floors. You undercut the glimmer of a crystal chandelier with a flaking, centuries-old console table that proudly shows its age. You counteract silk tassel trim with a crumbling stone statuary remnant. Patina and texture become pinch-hit players that totally save the day.

Achieve the right mix, and the results will take your breath away. One look at Pam Pierce's Houston house and you'll agree. Her use of texture alone—dust ruffles in burlap, braided planters made from thickly corded sea grass—is genius, to say nothing of her knack for scale and light. In California, Madeline Stuart conjures romance from a well-placed chandelier here and an elaborately carved lamp there—knowing just when to reign it all in, as she does in a stunning kitchen that lets the magnificent coastal scenery speak for itself. From an impressive collection of rather feminine neoclassical antiques, Babs Watkins creates interiors you could almost call minimalist in a grand Houston house that reinvents the genre. Designer Ray Booth and architects Bobby McAlpine and Greg Tankersley have more than lived up to their sterling reputations with a Nashville estate that matches inspiration from Italian seventeenth-century architecture with an industrial aesthetic. It sounds ludicrous until you take one look at that sumptuous bathroom—the stately carved paneling, the intricate steel mirror, the carved stone vanity, a bathtub to soak all your troubles away. Here's fair warning: Get ready to fall in love.

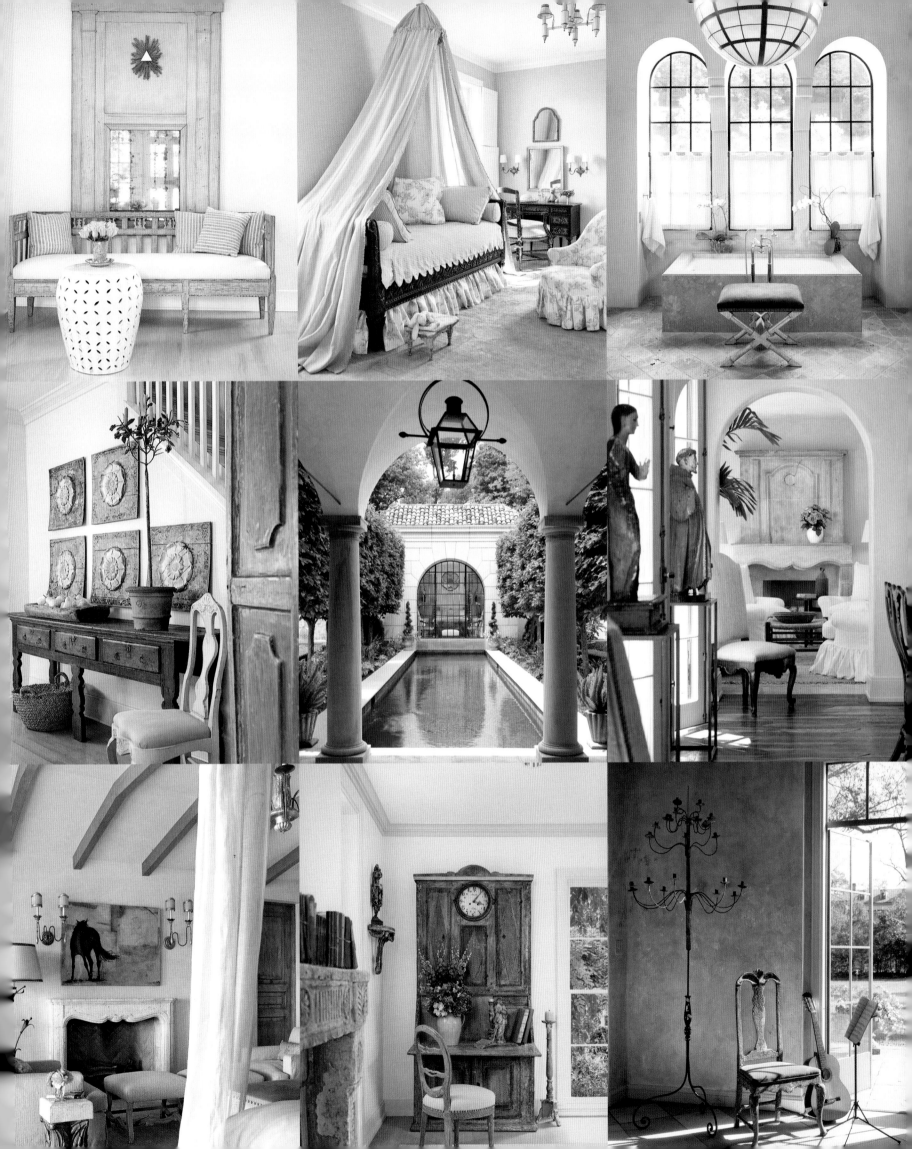

ELEGANT RESTRAINT
Classic decorative standbys deployed with care
create an artfully serene space.

I t can be difficult to make large rooms feel intimate and comfortable, and harder still to make them feel

intimate, comfortable *and stylish*. But that's exactly what designer Babs Watkins accomplished in this

capacious château-style house in the River Oaks area of Houston.

Watkins is the grande dame of Texas decorating, and over the years VERANDA has featured many of

her projects. No two are exactly alike, but all of them reflect her considerable talent. Watkins is well versed

in each and every design style and can execute them like no other. She is also a genius when it comes to scale

and an expert with color, and it's these skills that she puts to dazzling effect here.

In this house, you won't find raft-size sofas or great slab dining tables that can accommodate an army.

Counterintuitively, it's mostly small pieces that fill the lofty great room and the wide and ample living

room: delicate wrought-iron tables, gracious Louis XVI side chairs, a swirling Italian torchère with tendril-

thin arms. They are gathered in multiple arrangements so that any given space offers a variety of options

for curling up with a cup of tea or settling down with a guest for lunch. And though there is plenty of

space left over, the effect—even amidst such exalted elements as a 1940s crystal chandelier—is delightfully

minimalist. This is partly because most of the walls are bare, save for the luscious tones of pale blue-gray

and the warmer shell hues with which they've been painted by artisan Jay Iarussi.

It's an environment that becomes almost gallery-like in its simple expression of light, color and shape.

Though there isn't much art, there are hits of personality in the placement of the homeowner's keepsakes—a

rhinestone tiara on a side chair, a crystal orb on a tea table—so you don't really miss it. Besides, in the right

kind of space, the positioning of the furniture is art enough.

Bare wood floors and graphic metal accents such as a wrought-iron stair rail temper
the feminine furnishings in Babs Watkins' interiors for a Houston home renovated by
architect Patton Brooks. The arms on the crystal chandelier echo recurring
curling shapes. The damask-covered settee gets a flourish in a complementary fringe trim.

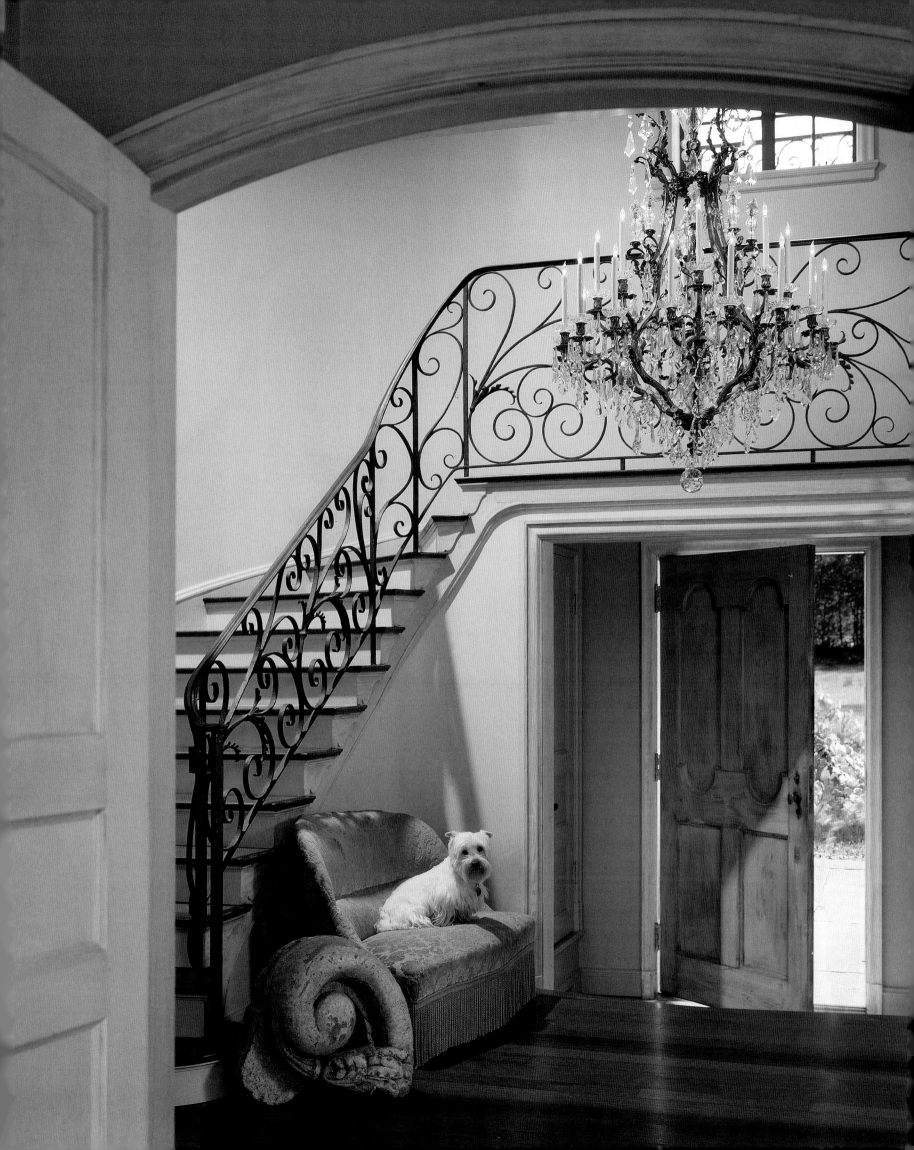

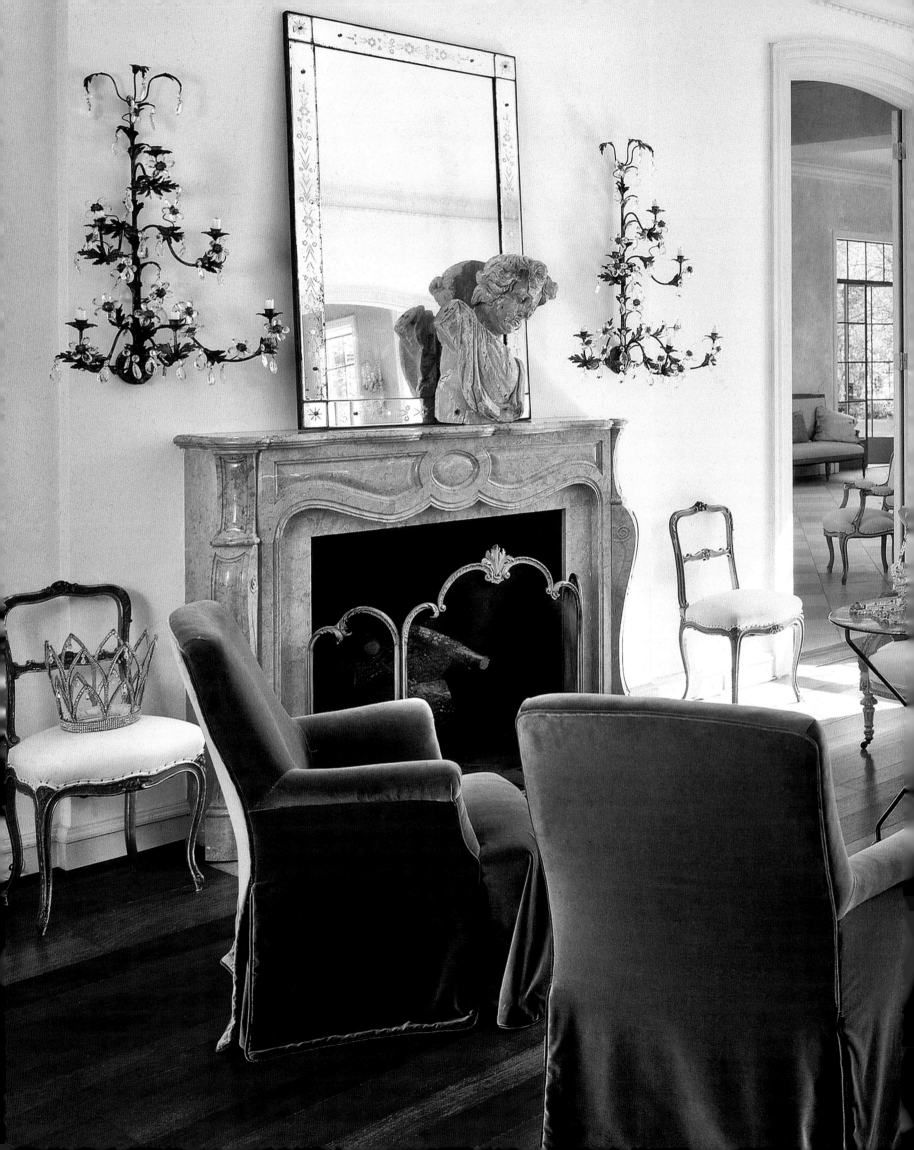

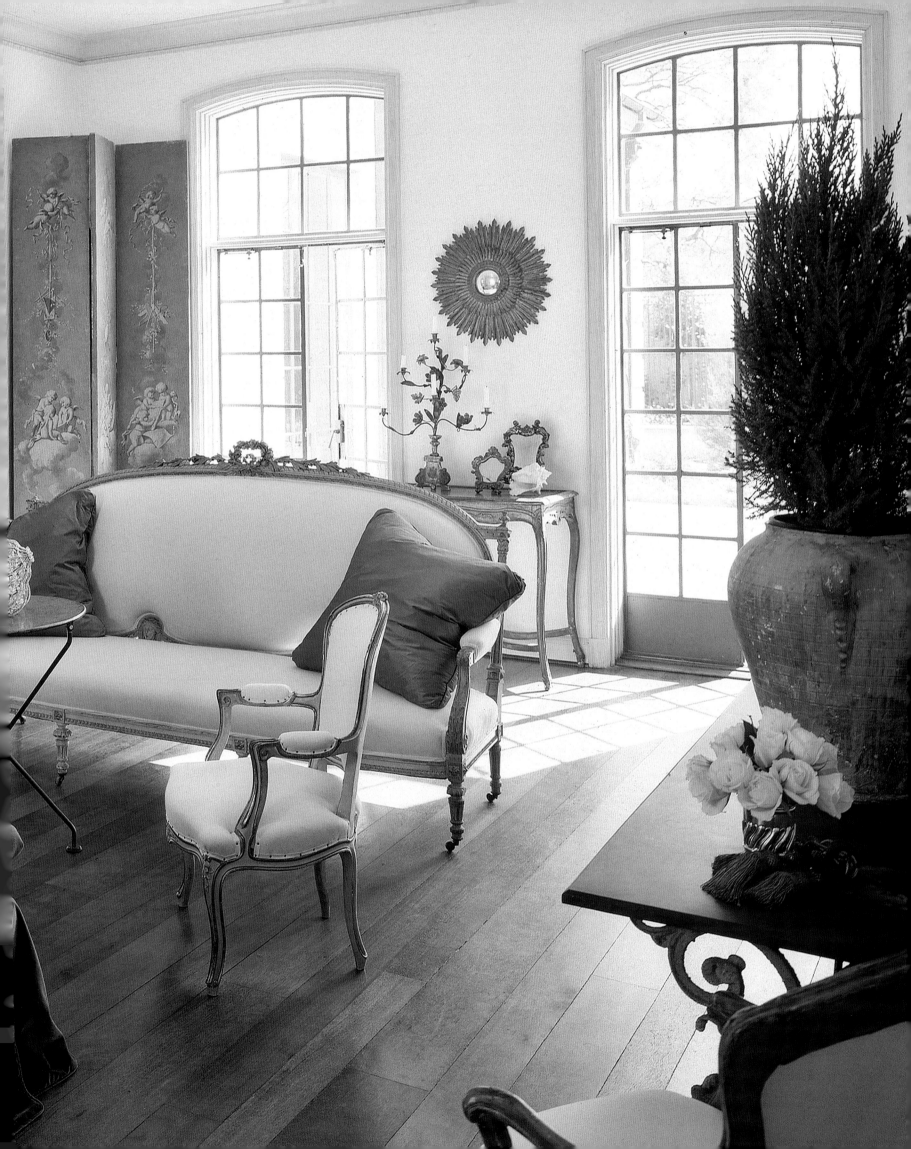

A gauzy linen tablecloth shades but does not completely obscure the prominent lines of the iron dining table. Neoclassical-style chairs conform to a strict geometry. The delicate Murano glass chandelier keeps the scheme in balance. PRECEDING PAGES: The Venetian mirror on the mantel is simple, a counterpoint to refined objects such as 1940s French crystal and wrought-iron sconces, armchairs slipcovered in velvet and an 18th-century painted screen.

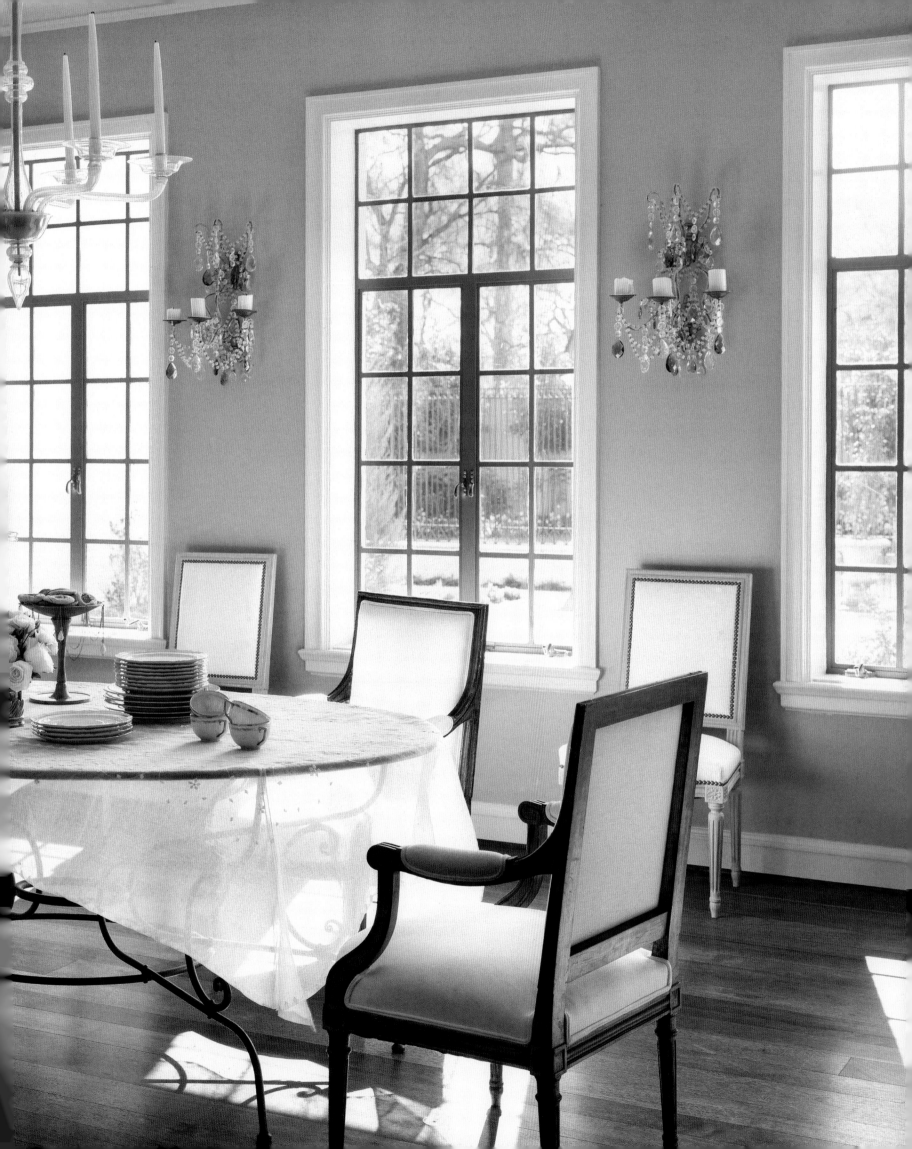

ABOVE: A breakfast nook can be opened to the elements for casual dining that is
practically alfresco. "We have several dining areas because we follow the sun," says the homeowner.
OPPOSITE: A vignette offers a close-up look at Jay Iarussi's nuanced paint technique.

SWEDISH SIMPLICITY

Gustavian elements give a delightful family house a laid-back grace.

Back in the mid-1990s, before the rage for all things Gustavian caught fire in design circles and made eighteenth-century Swedish antiques hotly coveted commodities, it was still possible to find top-drawer examples even at flea markets. It was at the Saint-Ouen *marché aux puces* in Paris, for example, that Shannon Newsom found many of the pieces that fill the Texas house she shares with her husband, Andrew, and their two young children, Cooper and Susanna.

The Newsoms were ahead of the curve in more ways than one. Not only did Shannon's shopping habits foresee one of the biggest decorating trends of the past twenty years, the way the couple deployed those treasures in a 1940s shingle-style house on a tree-lined Dallas street was irreverent and stylistically prescient, too. Scandinavian furniture, pale and often painted, was originally conceived as a humbler version of the neoclassical Louis XVI style, and it's frequently paired with cheery ginghams. The understated, chipping and misty-toned bergères, armchairs and consoles that the Newsoms collect are elegant without being stuffy, and they're versatile as well, seamlessly fitting into even twentieth-century structures while lending an air of soothing, unstudied grace. In this light-flooded house—reconfigured by architect Frank Ryburn with ivory walls, simple green-gray moldings and bleached oak floors—they look positively stellar.

Of course Shannon and Andrew didn't come to these design revelations all on their own. Aside from Ryburn, they had plenty of help, and a rich design legacy to draw upon. Shannon's mother and shopping buddy is the Houston-based antiques dealer and designer Jane Moore, whom they enlisted to assist with the interiors. And as the son of Lisa Newsom, Andrew practically grew up with VERANDA, watching it grow from its very inception. To boot, Andrew and Shannon own *Wisteria*, a catalog and website of refined home furnishings with a worldly point of view. Quite simply, good decorating is in their blood.

The collaboration between designer Jane Moore and architect Frank Ryburn showcases 18th-century Swedish antiques in a 20th-century Dallas residence. A collection of Gustavian pieces makes for a serene arrangement in a corner of the living room.

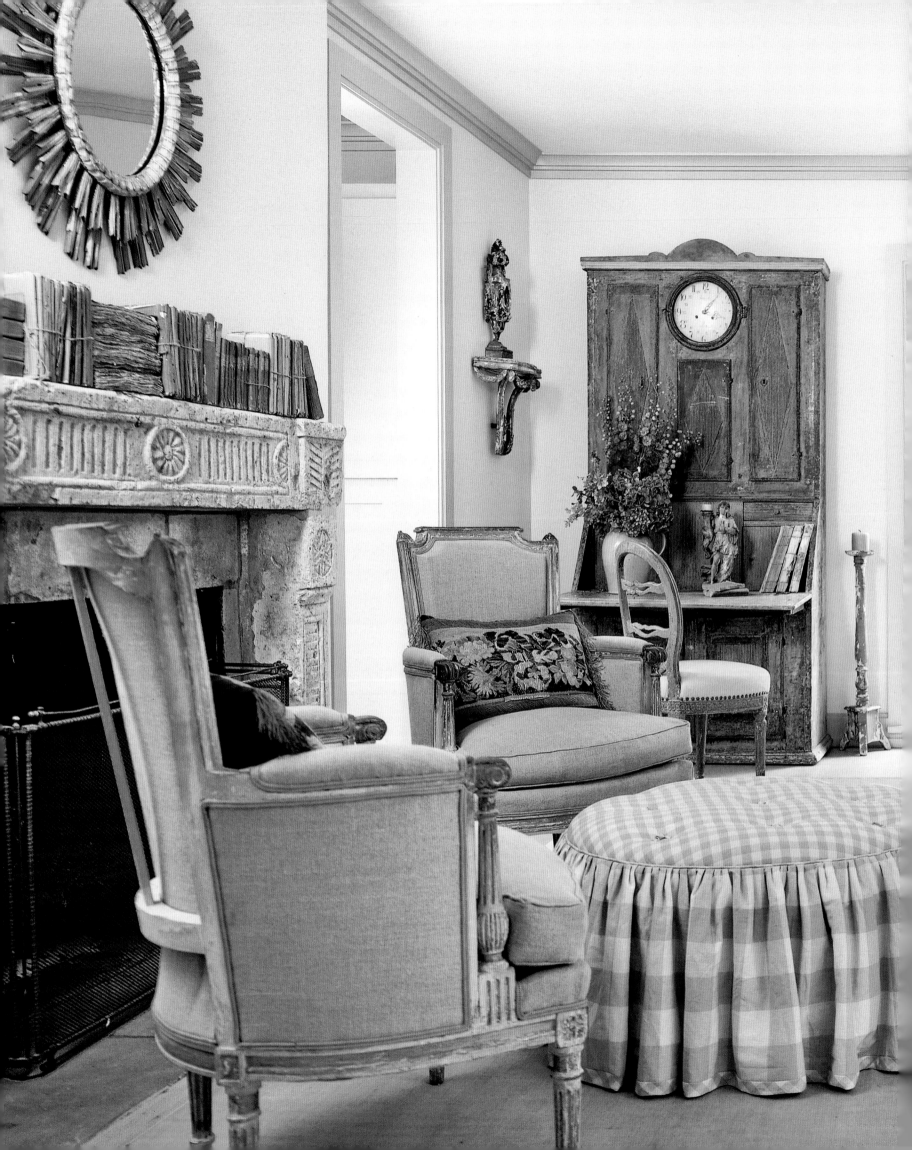

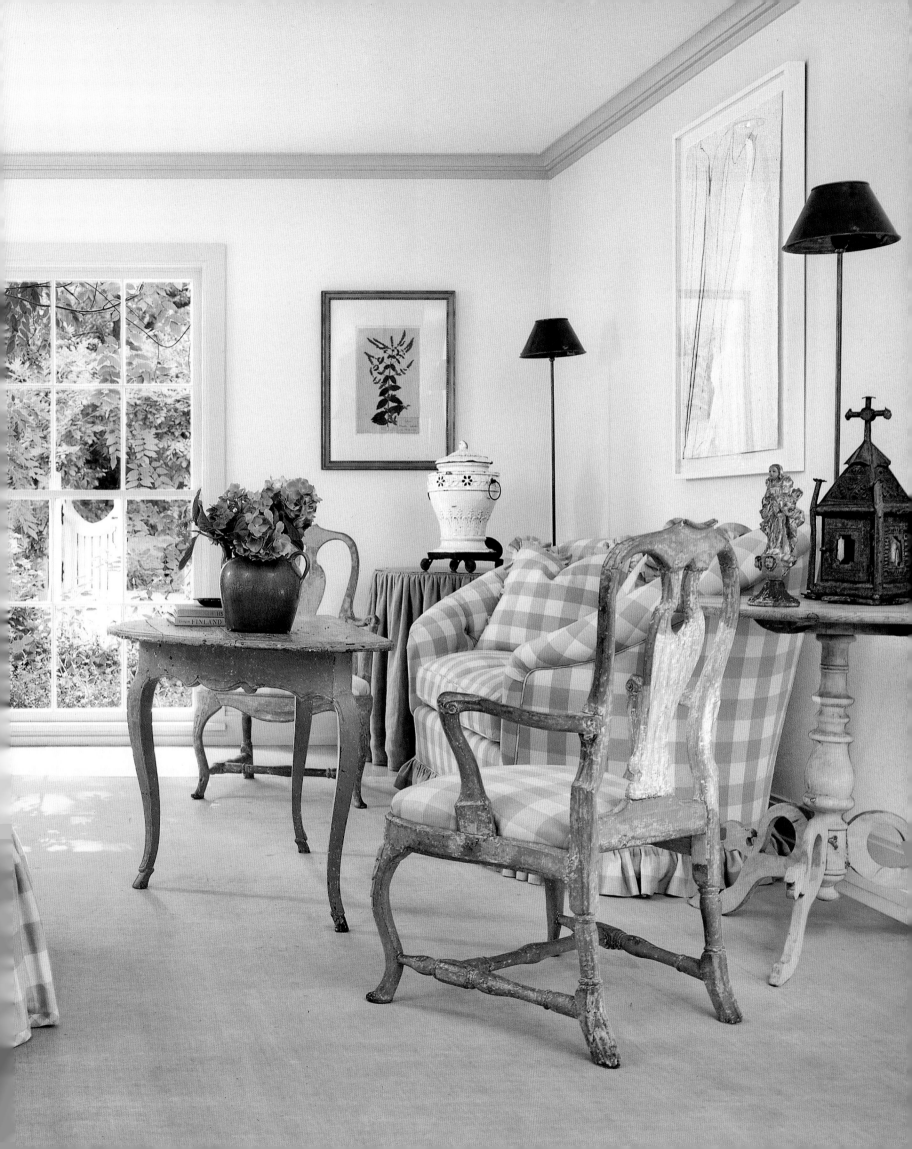

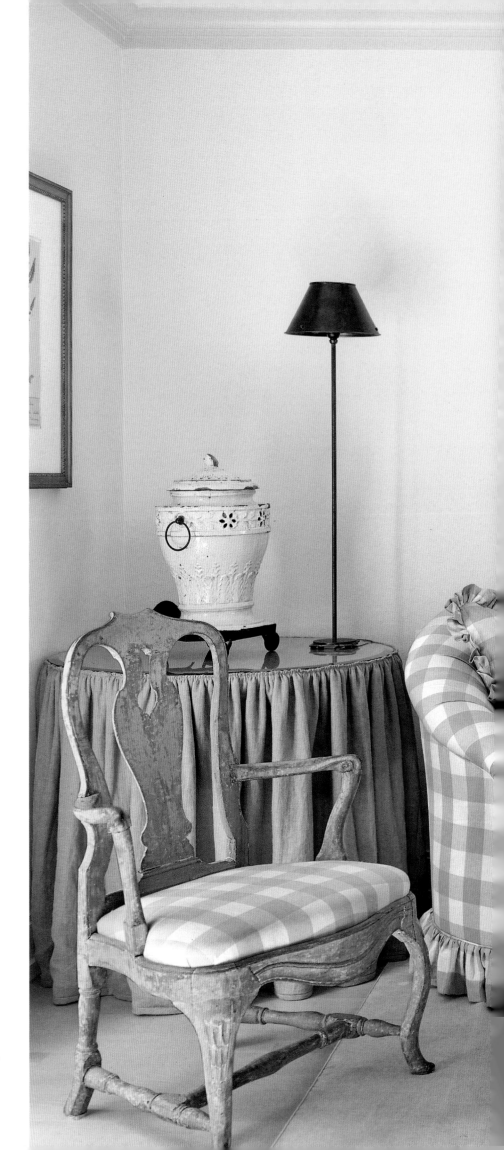

Architecture, pattern and subtle color keep a room filled with antiques from becoming saccharine. An overscaled, dusty blue check updates a classic pairing—gingham and Gustavian—and matches the flaking paint on the armchairs. In the corner is a chipped, creamy French ceramic coal burner made in the 18th century. PRECEDING PAGES: French bergères from the 19th century flank a weathered stone mantel of the same provenance. The ruffled skirts on the ottoman and settee strike a charming note.

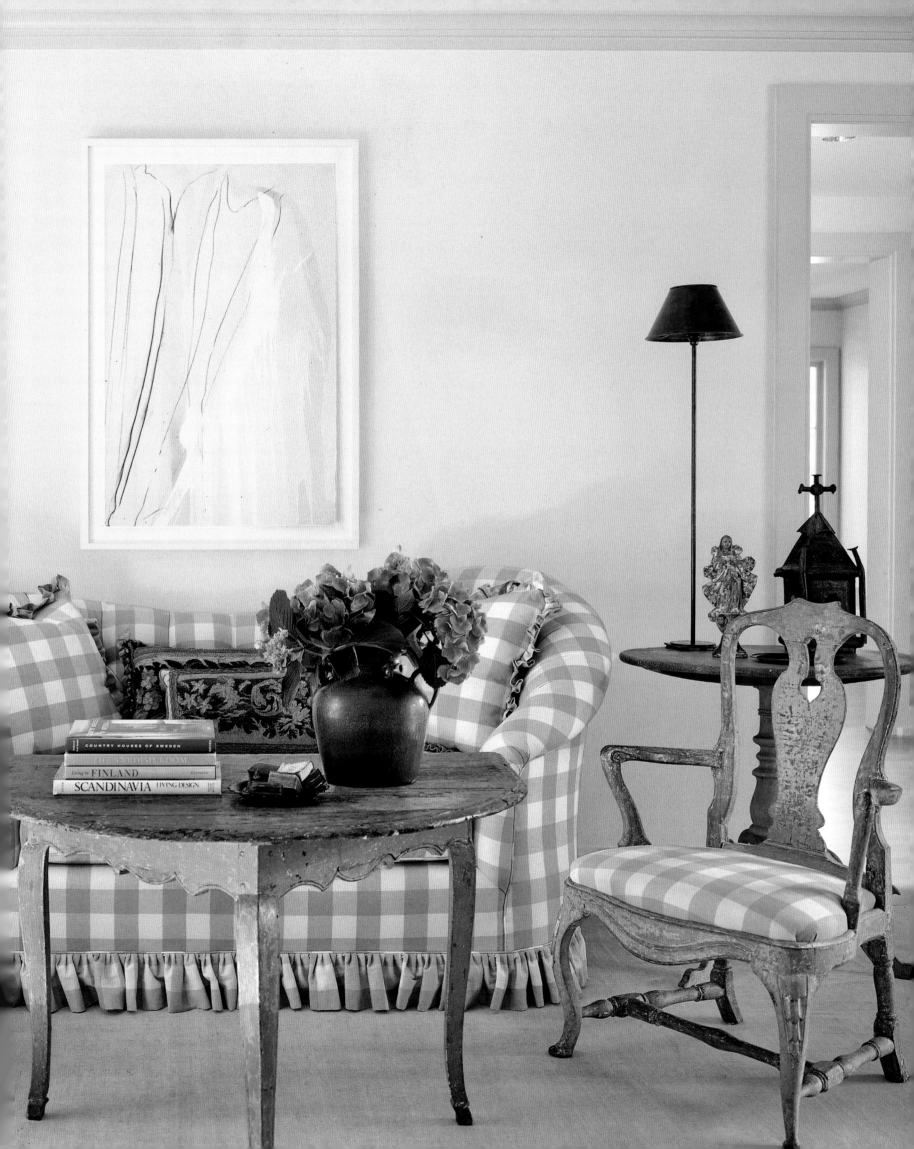

COUNTRY HOUSES OF SWEDEN

THE SWEDISH ROOM

Living in FINLAND

SCANDINAVIA LIVING DESIGN

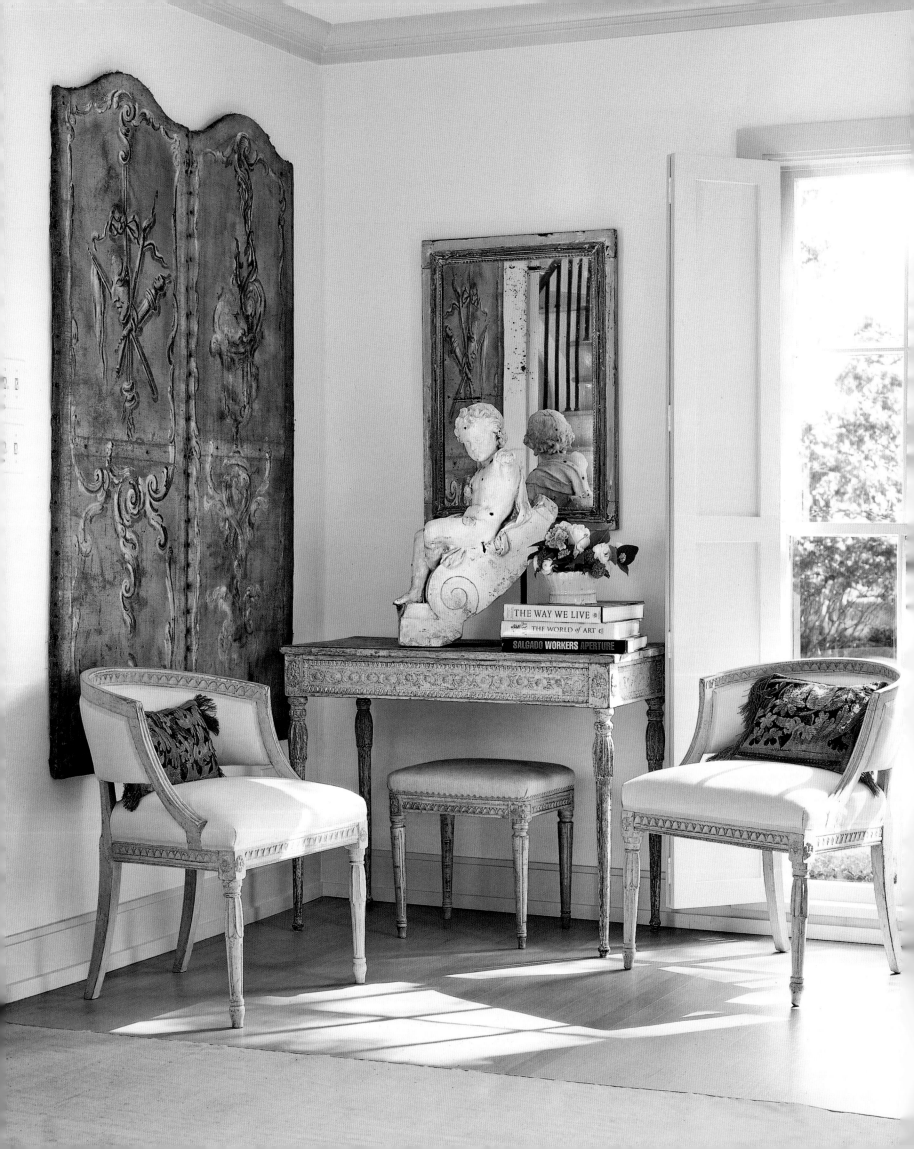

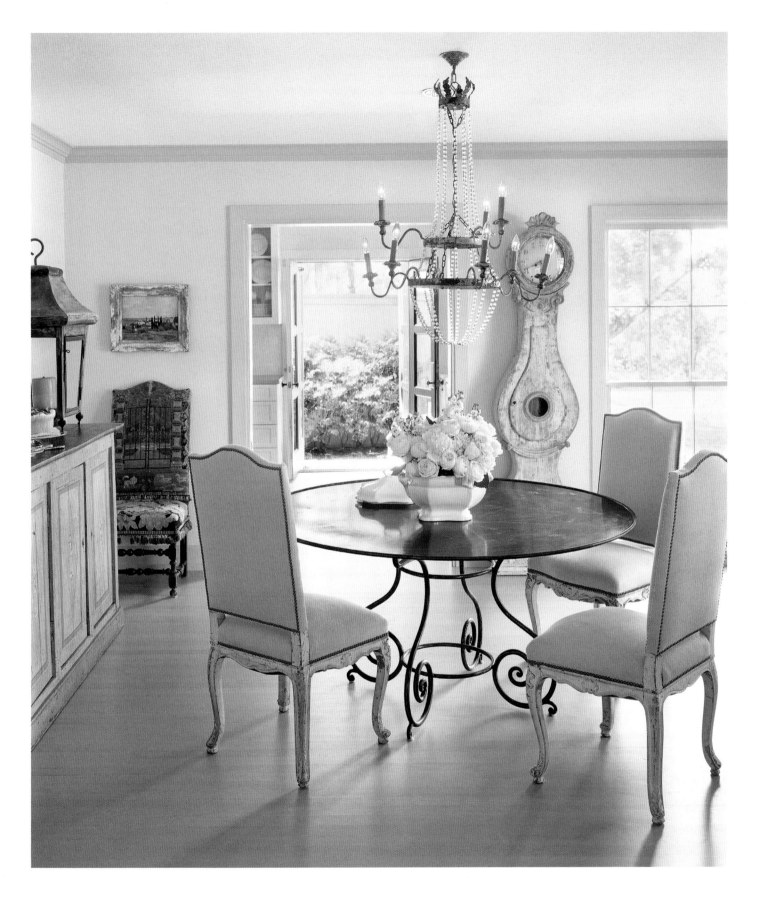

The dining room glints with glass, steel and mirrored surfaces that reflect light, offsetting the chalky finishes on the Gustavian clock and the Directoire buffet. A steel table purchased in Paris is surrounded by 19th-century chairs in linen. OPPOSITE: In a corner of the living room, a console, tub chairs and a stool, all Gustavian, join a period-appropriate French screen and mirror.

Designer Jane Moore, Shannon's mother, helped the couple with the interiors. The structure itself was remodeled by architect Frank Ryburn. ABOVE: A Régence armchair is upholstered in an understated linen. OPPOSITE: A French 18th-century demilune serves as a nightstand.

THE GOLDEN MEAN

A hybrid of the Old World and the Industrial Age
strikes a stunning balance.

For a husband and wife who appreciate an old-world look but also wanted a sense of openness for their new house in Nashville, designer Ray Booth and architects Bobby McAlpine and Greg Tankersley imagined an unusual hybrid: an elegant seventeenth-century Italian pavilion fused with a 1930s American factory. Diametric design? McAlpine, who loves unexpected juxtapositions, doesn't think so. "A lot of factories of the modern era had unprecedented amounts of loft-like bright space. That's why they've been rediscovered in all these urban redevelopment loft projects. I wanted that kind of airiness and freedom for this house."

The hillside structure combines a stucco and slather stone facade with delicate steel-framed windows custom-made in England. Restoration glass in industrial grids lends a molten-light quality to the interior. The two-story house is never more than one room deep, and the main salon, which includes an entry, living room, dining room, kitchen and lounge, has no interior walls or doors to diminish the abundant sunshine or views of a garden, creek, meadow and woods. Almost every room has a complementary outdoor space: An ivy-wreathed aerie is a perfect perch for an alfresco meal; a shady loggia offers refuge from the heat.

Inside, the expanse is partitioned with fabric. "We used curtains as portières that divide space to create a bit of rhythm and to give a sense of scale and height," says Booth. "In fact, we used them for anything except windows. We didn't want anything to obscure an inch of those vistas." The color scheme draws those vistas indoors, with the silver-gray of tree trunks echoed in the greige tones of stone floors, nubby linen upholstery and off-white plaster. "At first pass, many people think of this palette as monochromatic, which it is, but gradual variations of each specific color create harmony. Nothing is exactly the same shade. It vibrates ever so slightly."

Interiors designed by Ray Booth include the guest suite of a home by architects
Bobby McAlpine and Greg Tankersley in Nashville. By a reflecting pool, pleached
Parrotia persica acts as a hedge on stilts. Perennials provide ground cover.

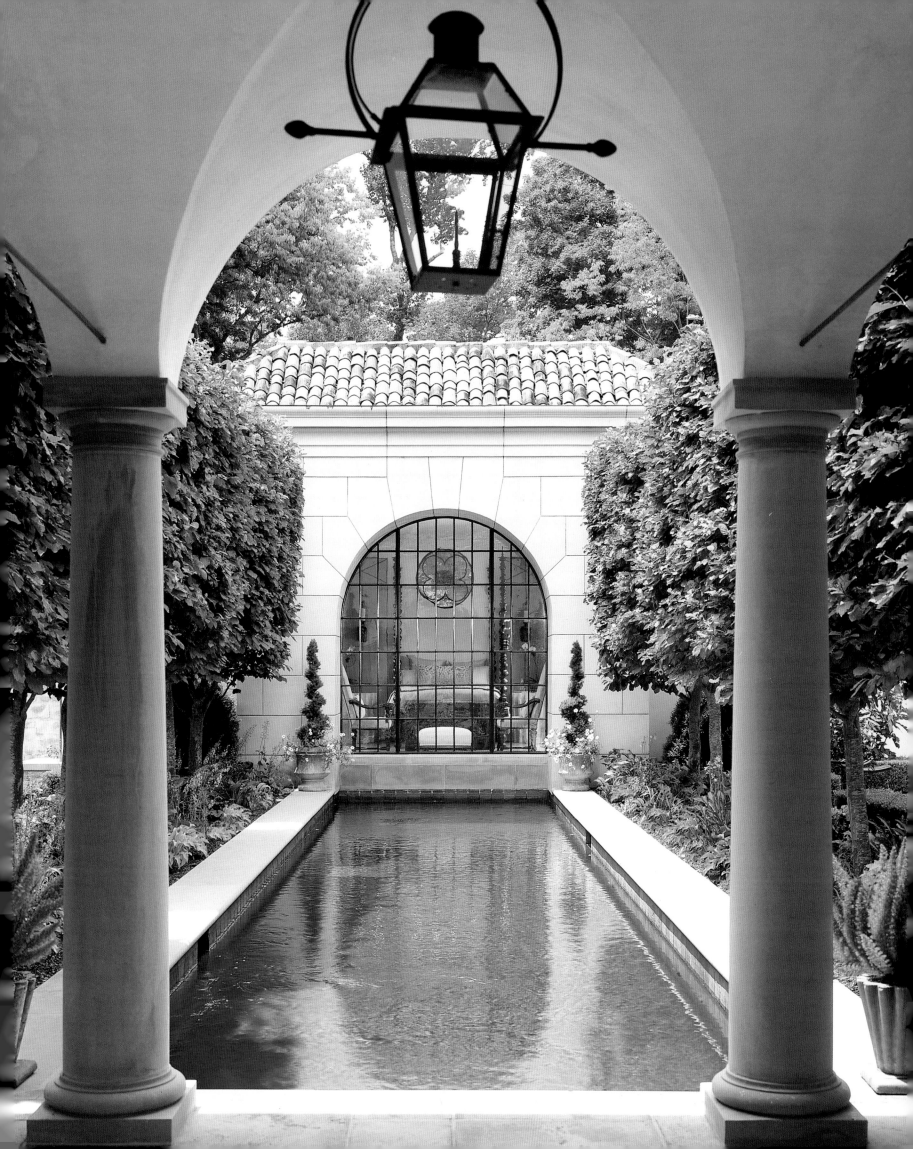

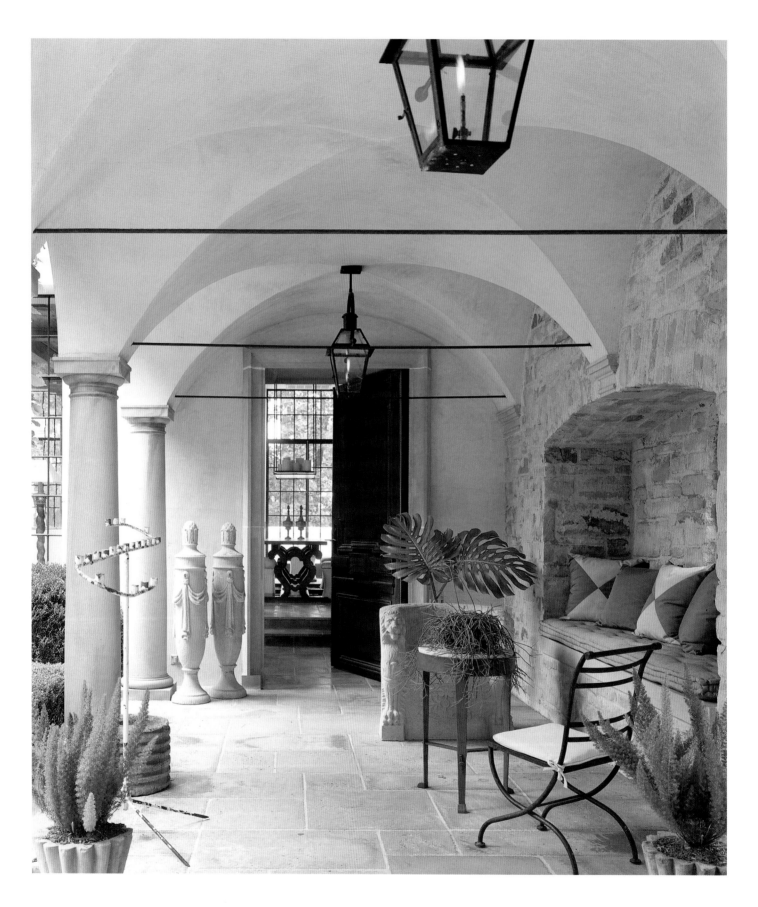

Stone floors continue through to the interior, bringing the outdoors inside. ABOVE: In the loggia, a garden and a composite stone chair compose a sitting area with a cushioned built-in niche. OPPOSITE: In the dining area, Alabama artist David Keith Braly created a family crest above the mantel as part of a pencil mural. A candle tray fixture by Kevin Reilly is suspended over an 18th-century Italian refectory table.

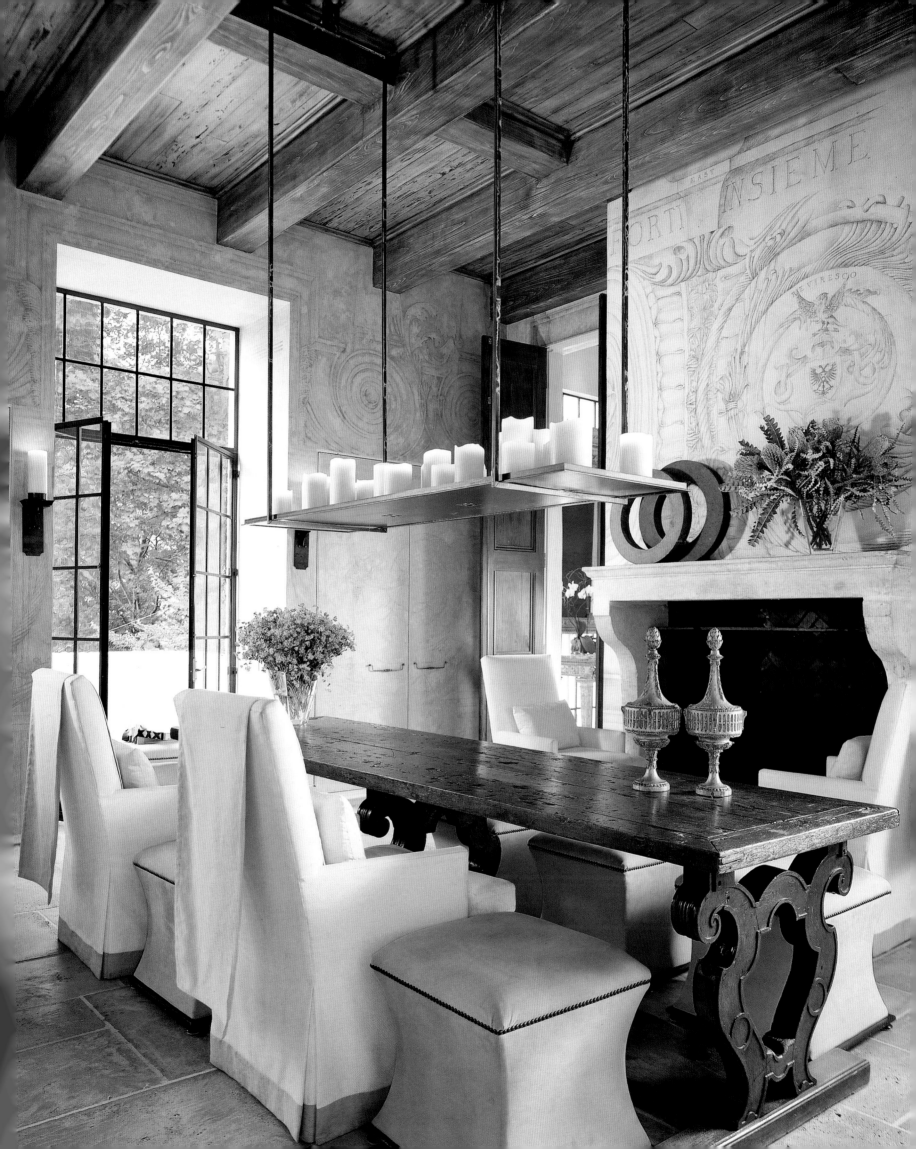

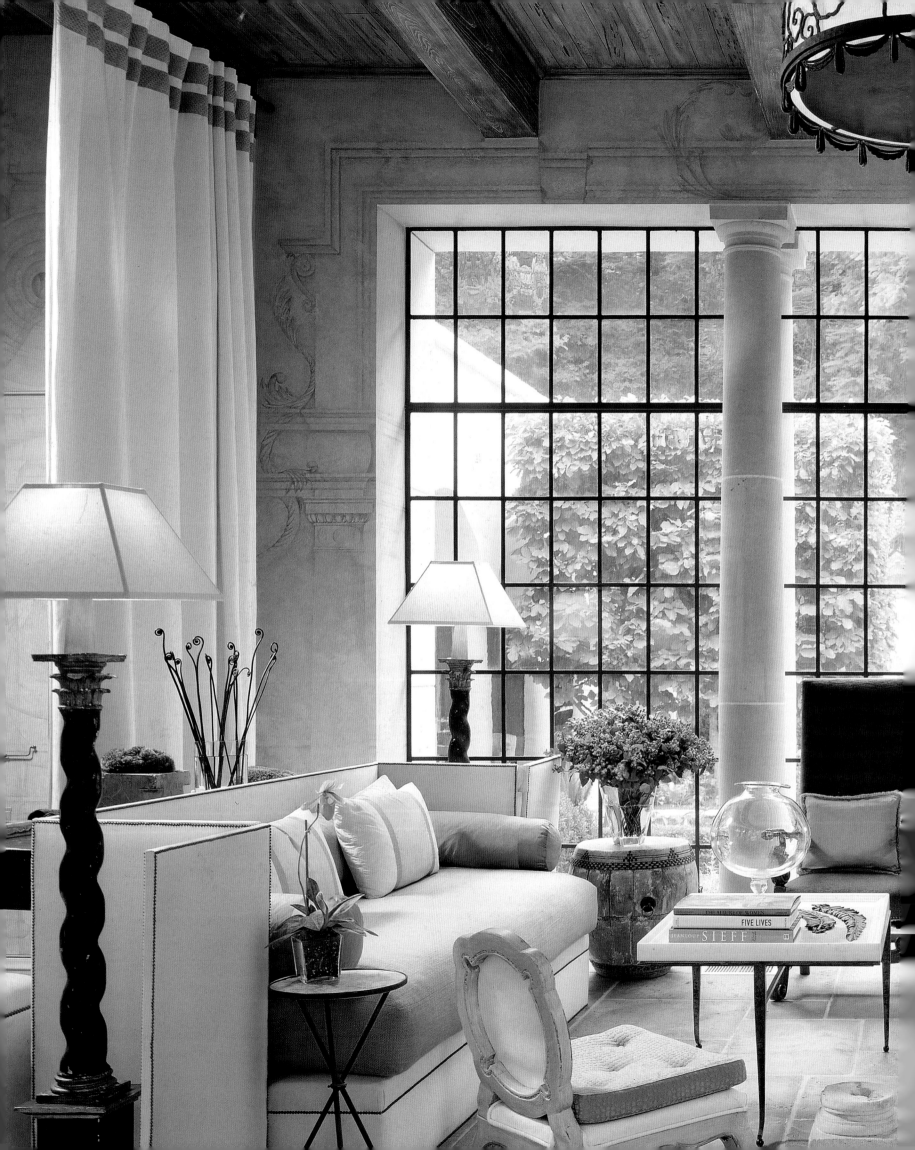

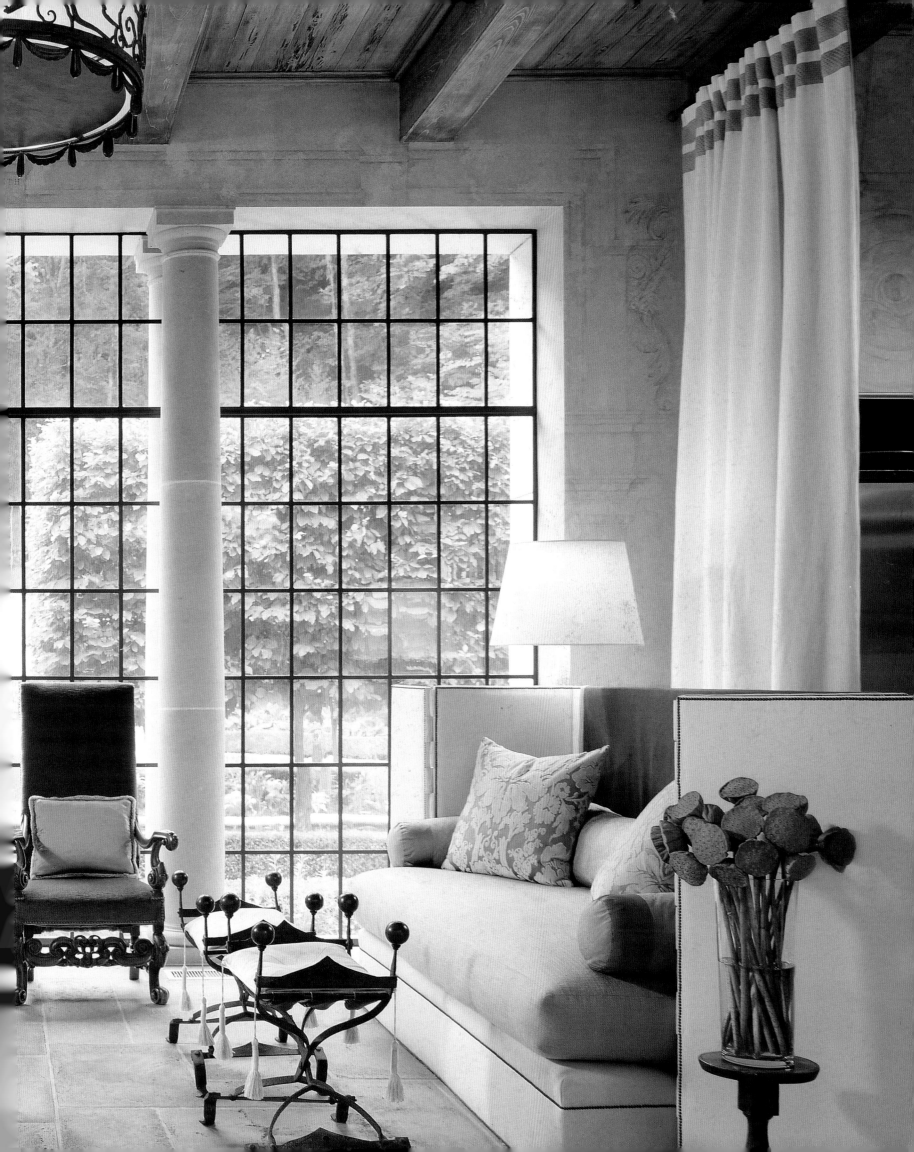

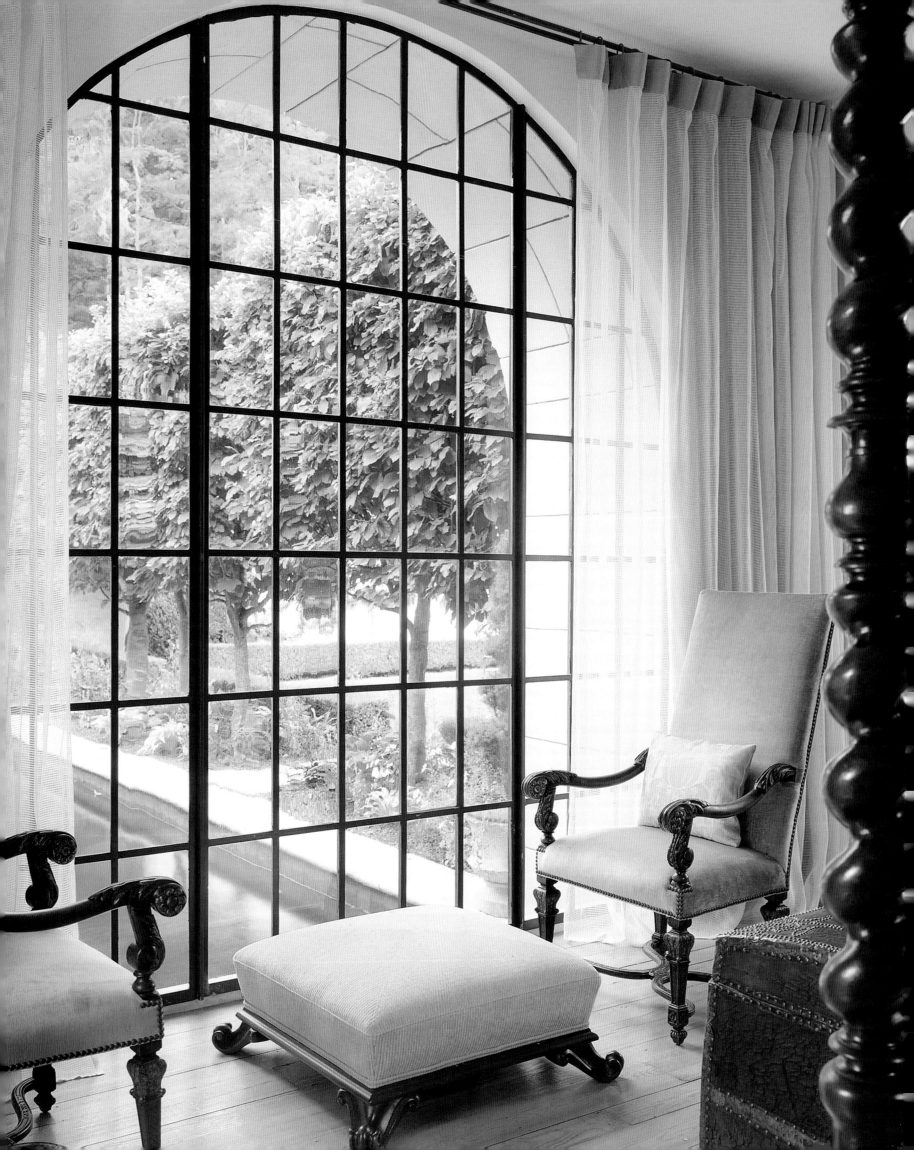

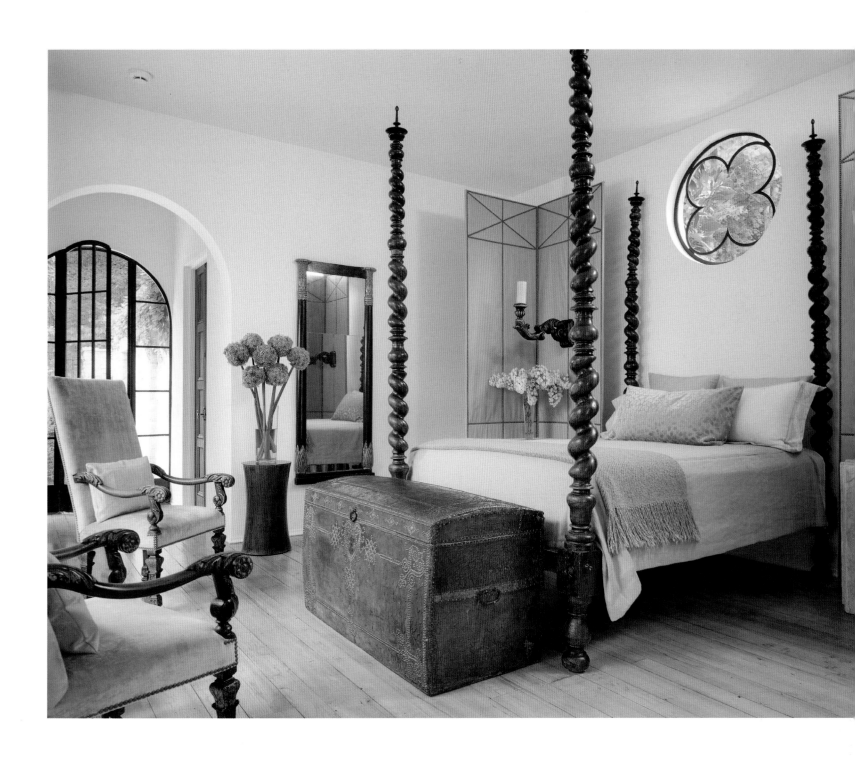

ABOVE AND OPPOSITE: Vertical elements accentuate the guest suite's height. The Majorcan walnut bed dates from the 17th century. An oculus features a quatrefoil motif. PRECEDING PAGES: Custom linen-covered sofas face each other to create an intimate seating area in the open-plan interior. FOLLOWING PAGES: Cypress paneling offsets an asymmetrically hung Italian mirror and a custom cast-stone vanity in the master bath. A large steel-and-glass chandelier is another prominent touch.

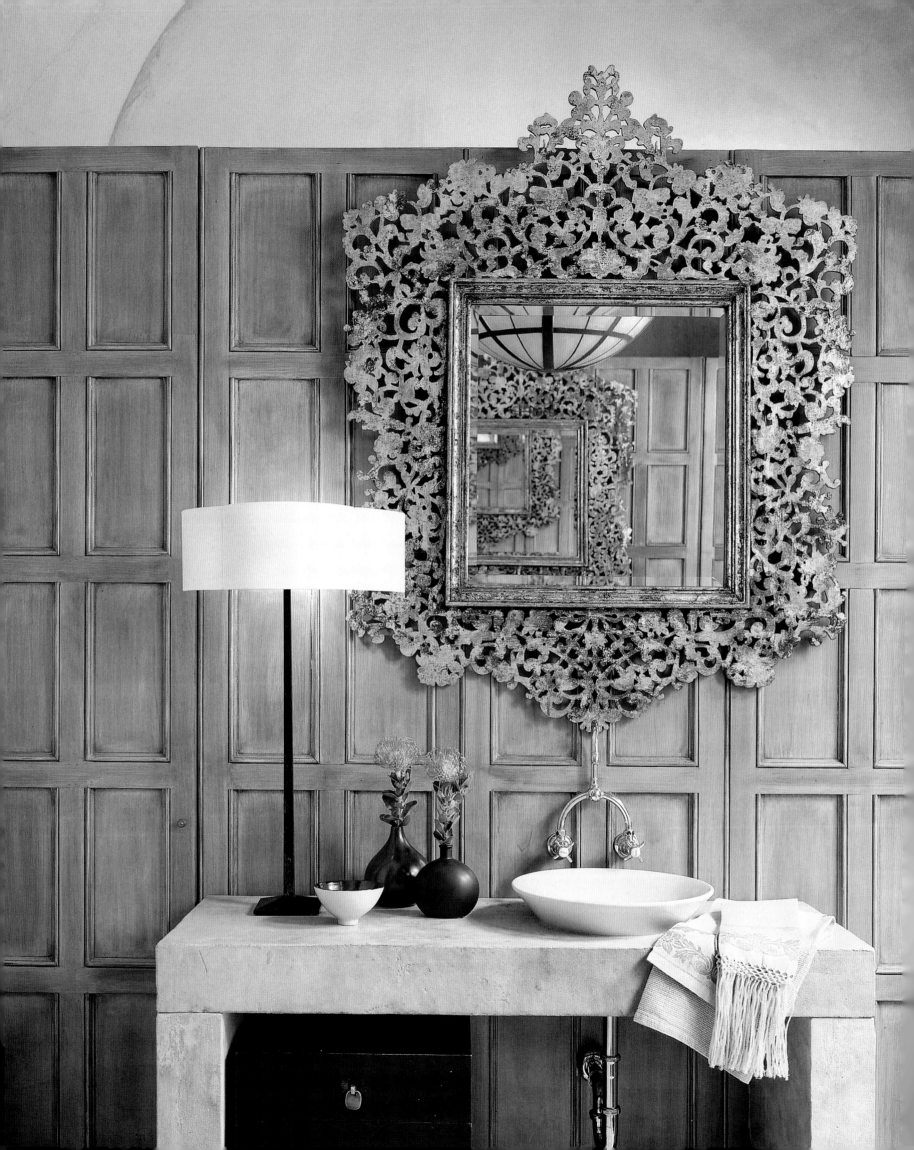

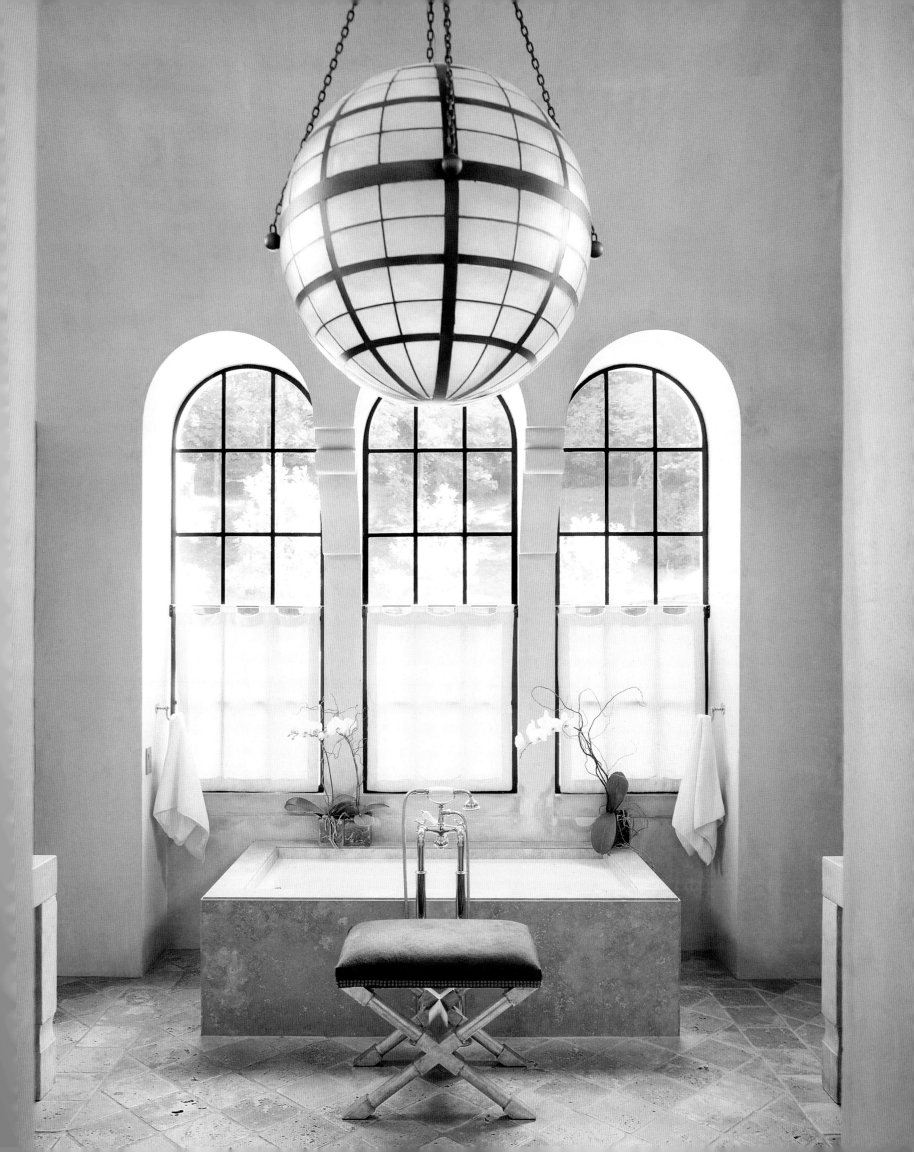

LAYERS OF BEAUTY
Striking a beguiling balance between rough and refined elements.

The instant designer Pamela Pierce stepped inside this French Mediterranean–style house in Houston's museum district, she fell in love. She wasn't deterred by unfortunate decorative choices such as mirrored walls, which had made skin-deep scars since the residence was built in the 1920s. The superior quality and integrity of its architecture was still strong enough to shine through. She promised her husband, Jesse, to add nothing more than paint to rid it of its excesses—and eventually embarked on what became rather extensive renovations.

"We really did intend to just paint," she says. "But then the plaster had to be redone, and then we decided that adding interior arches would create the illusion of ceiling height, and by then we had found fabulous antique floors to install, and, well, one thing just led to another and another." She and Jesse lived only on the third floor for eighteen months. During another round of work, they lived without a kitchen. But when they were finally done, they had restored the residence to its original glory, complete with antique architectural elements installed with such sensitivity that they seem as if they'd been there from the very beginning.

In the kitchen and breakfast room, floors of eighteenth-century Italian cathedral stone glow with a storied patina, while chestnut and walnut floors from the same time period in the living and dining rooms provide warmth and substance. As to the furnishings, a sense of peacefulness pervades. In rooms where uncurtained windows allow for plenty of oak-filtered light, overscaled, comfy pieces are covered simply, in plain materials such as handwoven French linen. There's no clutter anywhere. "If a piece speaks to me, I know I can always find a place for it," says Pierce. "But I am also very good at moving things out when they no longer seem to fit in here."

Throughout her restored 1920s house in Houston, designer Pamela Pierce installed 17th-century
French limestone mantels to create focal points and anchor spaces with strong—though
subtle—doses of character. Armchairs wear simple linen slipcovers; the sisal rug tempers their ruffles.

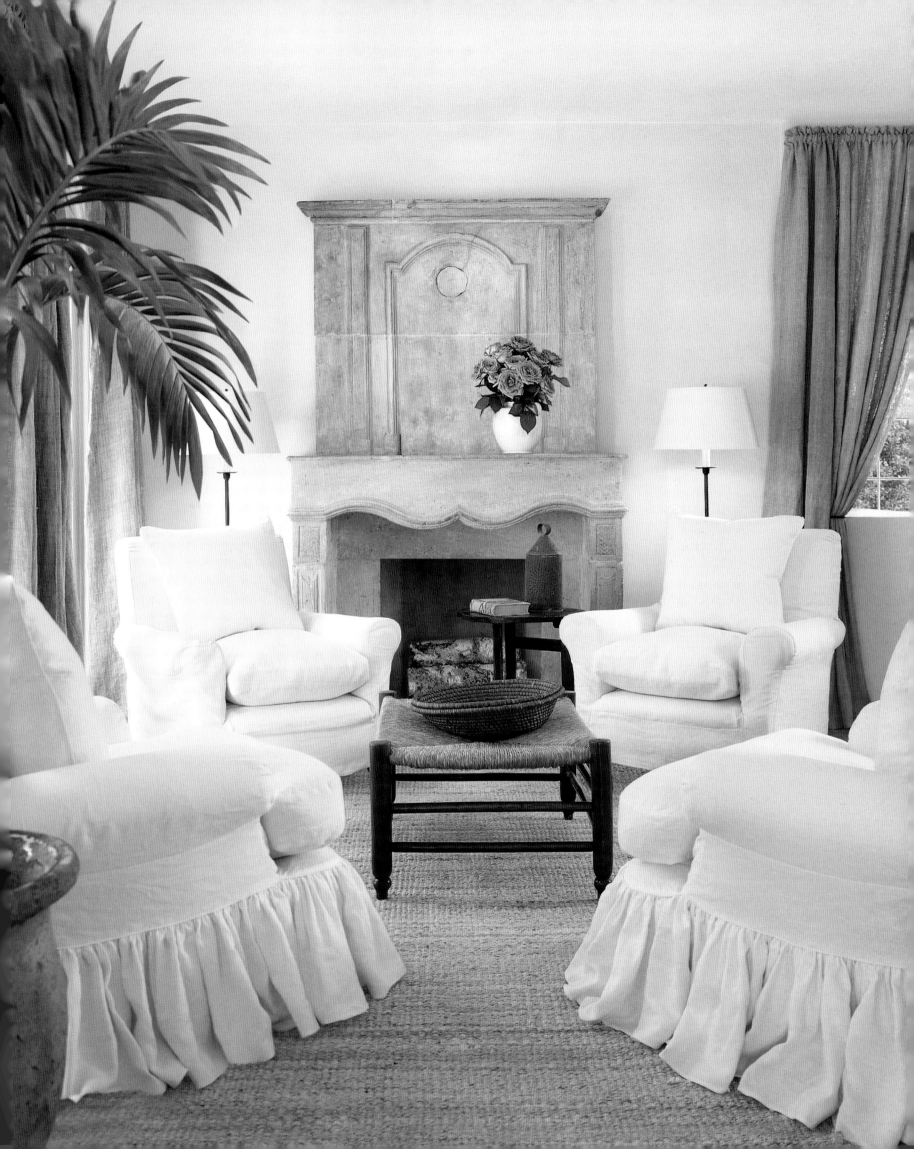

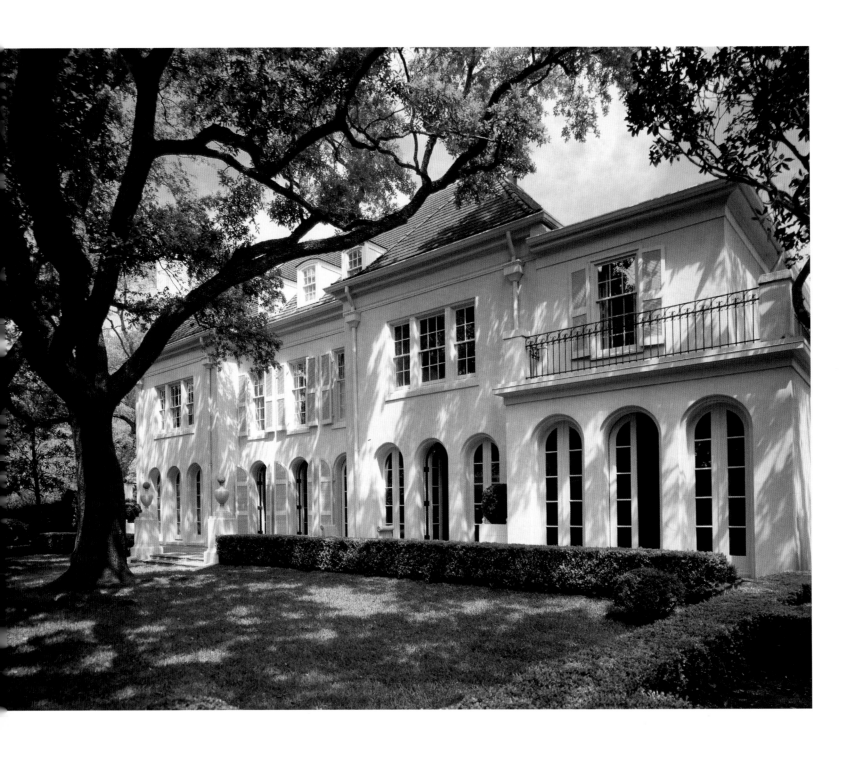

French windows and doors lead to grounds designed by Danny McNair. ABOVE: An oak shades a lawn bordered by boxwood. OPPOSITE: The custom daybed is upholstered and skirted in a rough-hewn hemp. The sea-grass planters add another layer of interest. FOLLOWING PAGES: In the living room, an 18th-century Italian table is used as a writing desk.

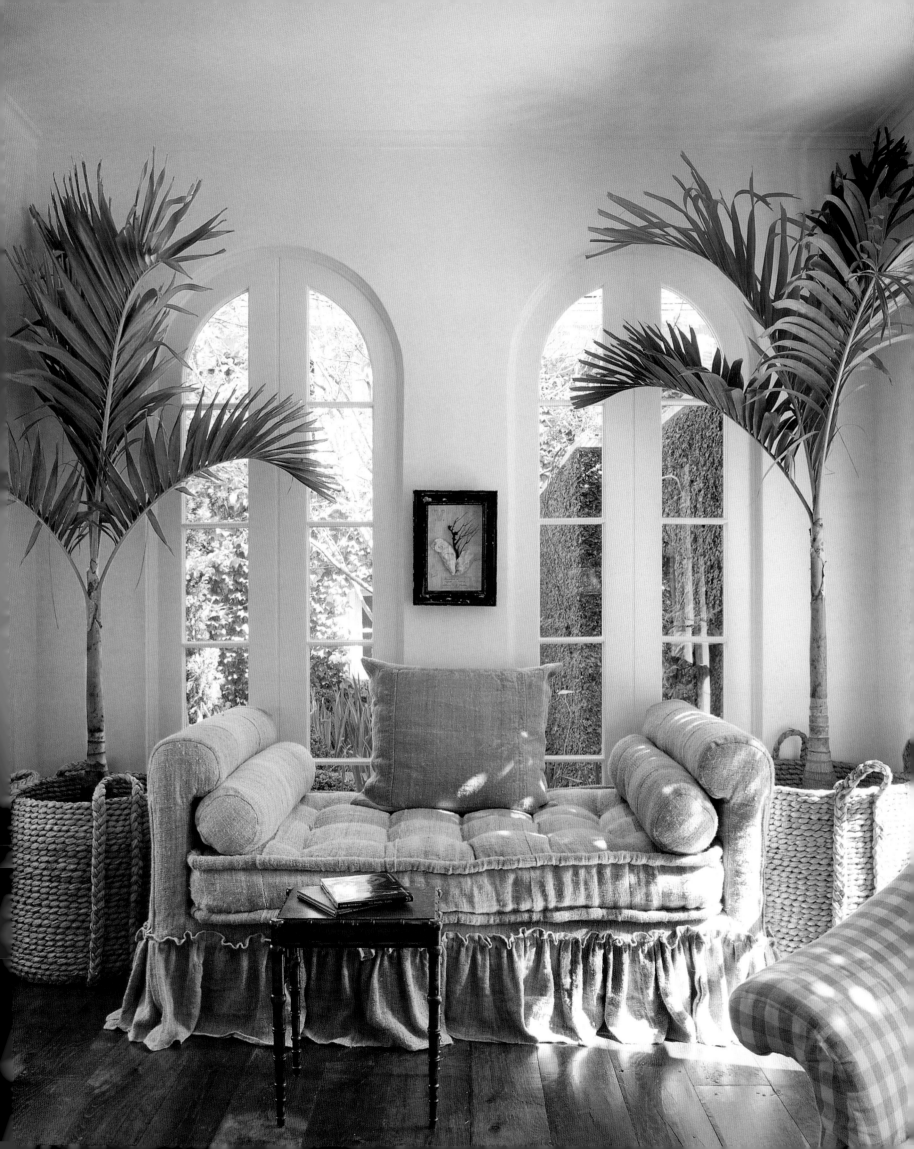

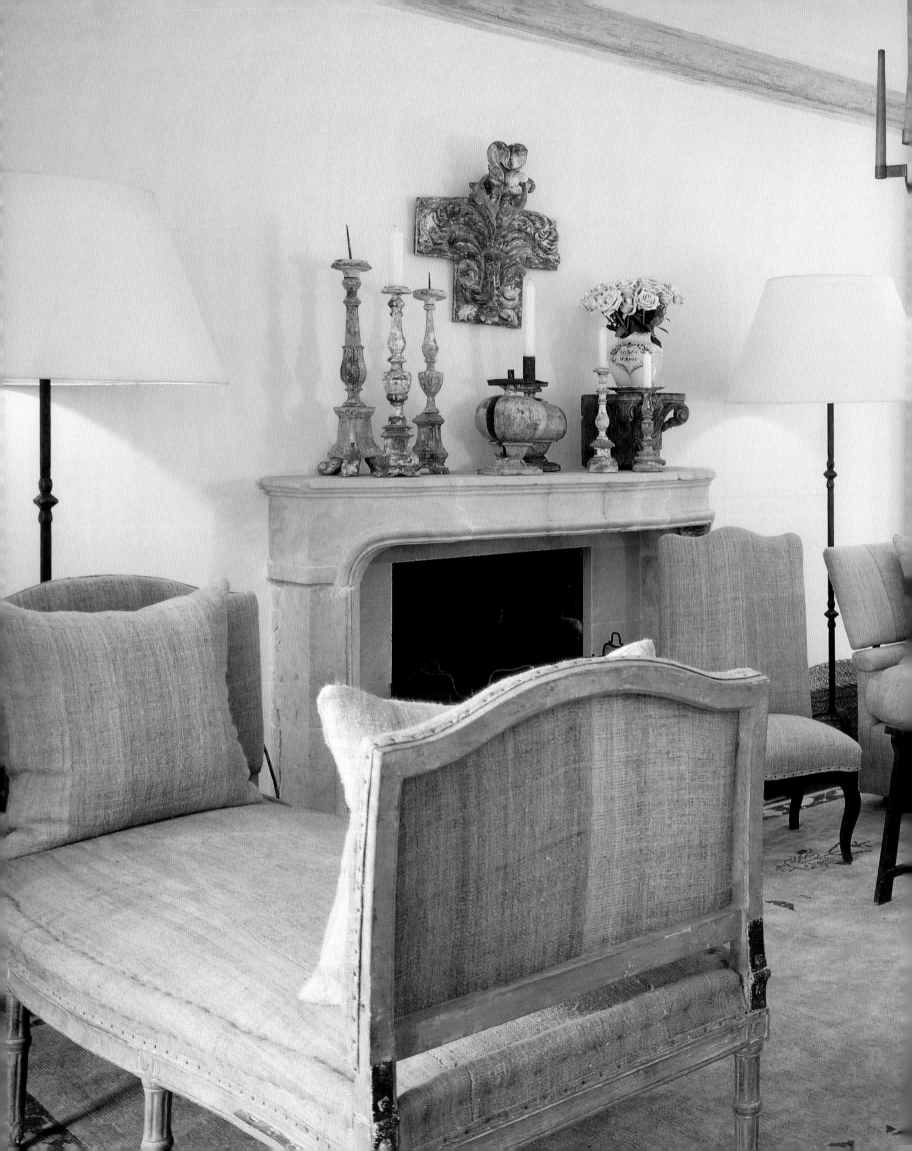

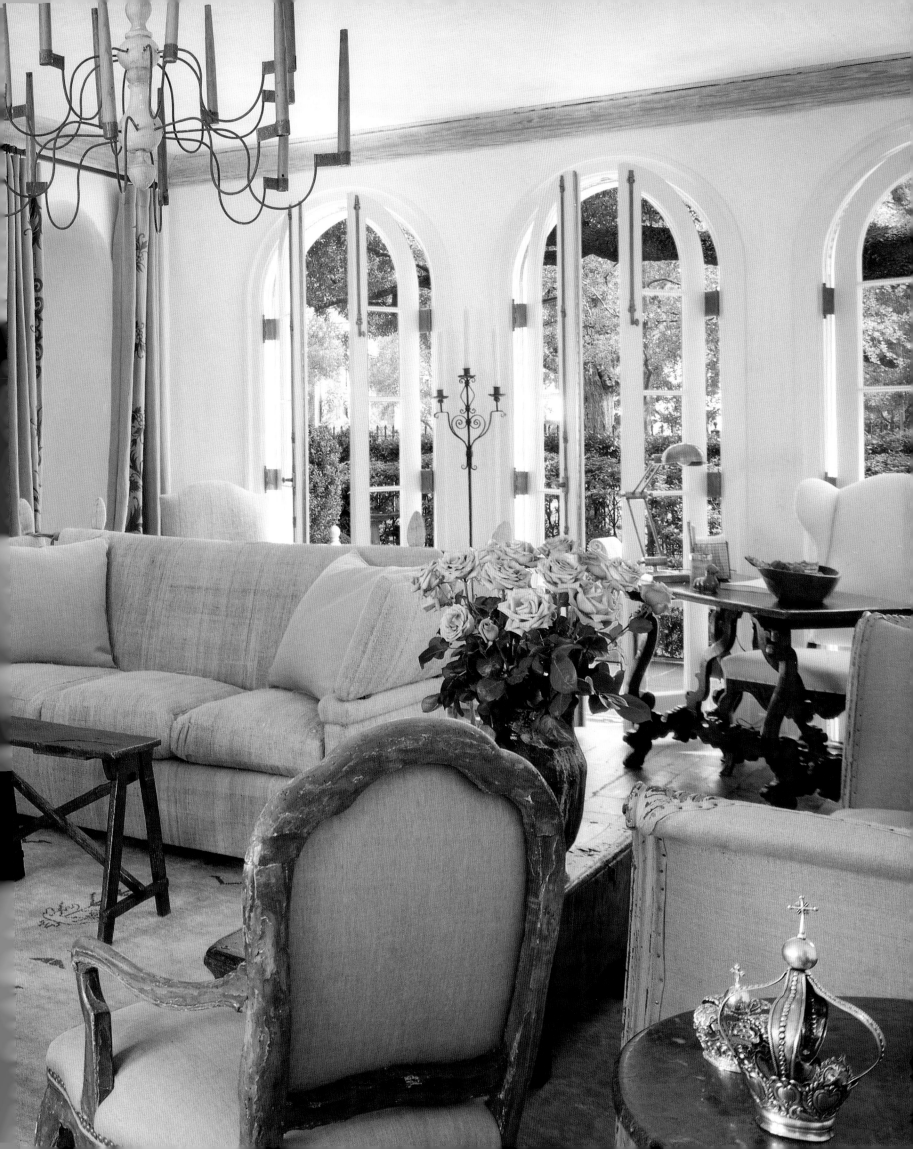

Evergreen plantings beckon outdoors. ABOVE: The crushed limestone pathway is bordered by Japanese yew. OPPOSITE: An 18th-century Swedish secretary complements a Gustavian canapé and an Oushak rug. FOLLOWING PAGES: A custom skirted bench pairs with an 18th-century Italian trestle table and a Queen Anne settee.

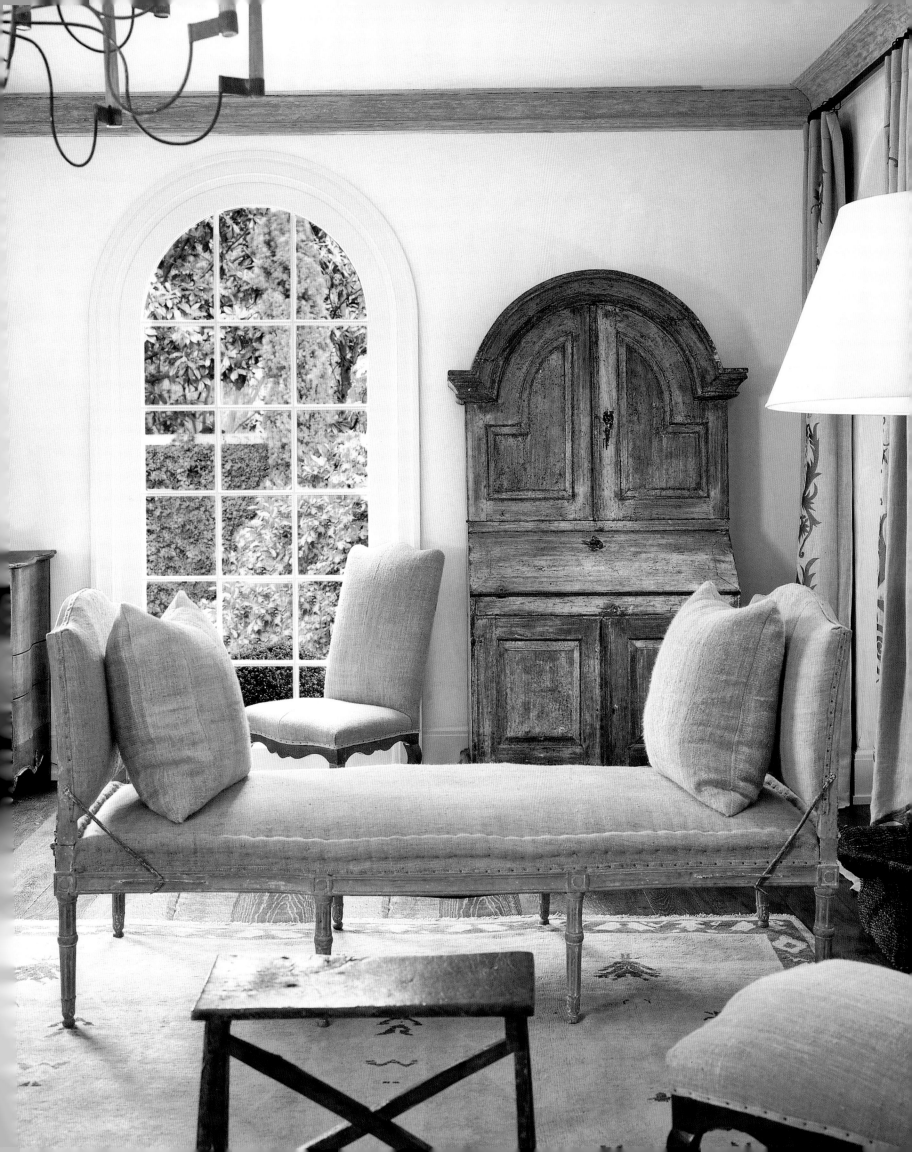

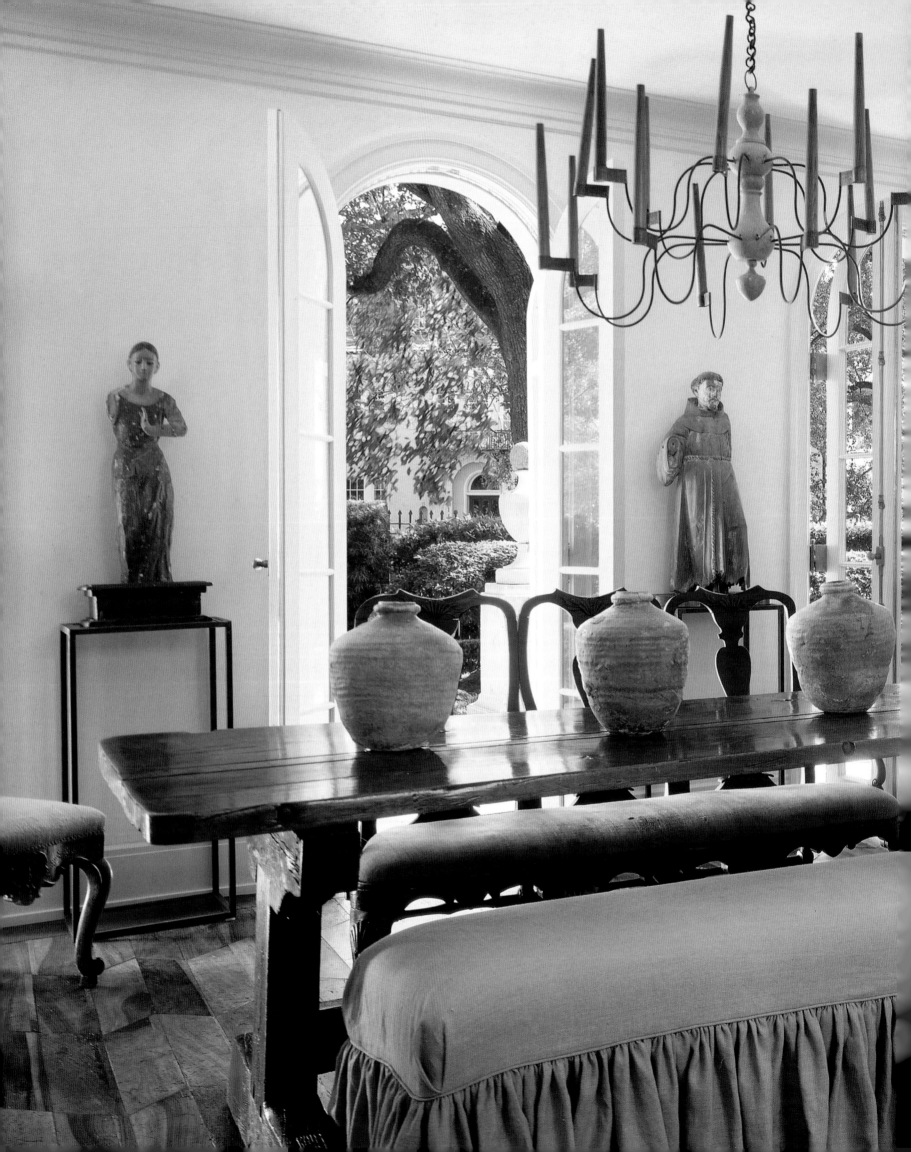

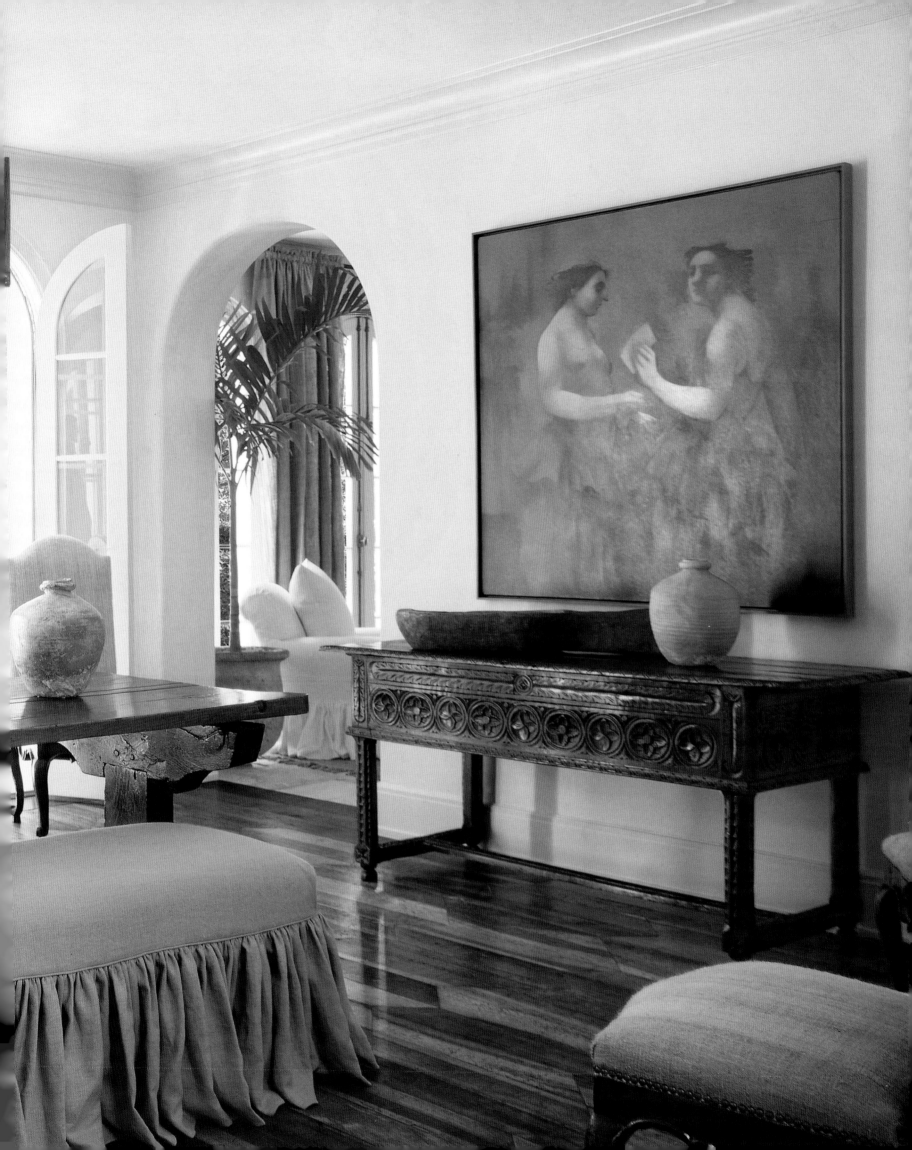

Arrangements reflect a curator's eye. ABOVE: A Napoleon III lantern floats above a Louis XV–style mantel. OPPOSITE: The kitchen features a Napoleon III butcher-shop table and a 19th-century zinc cow's head.

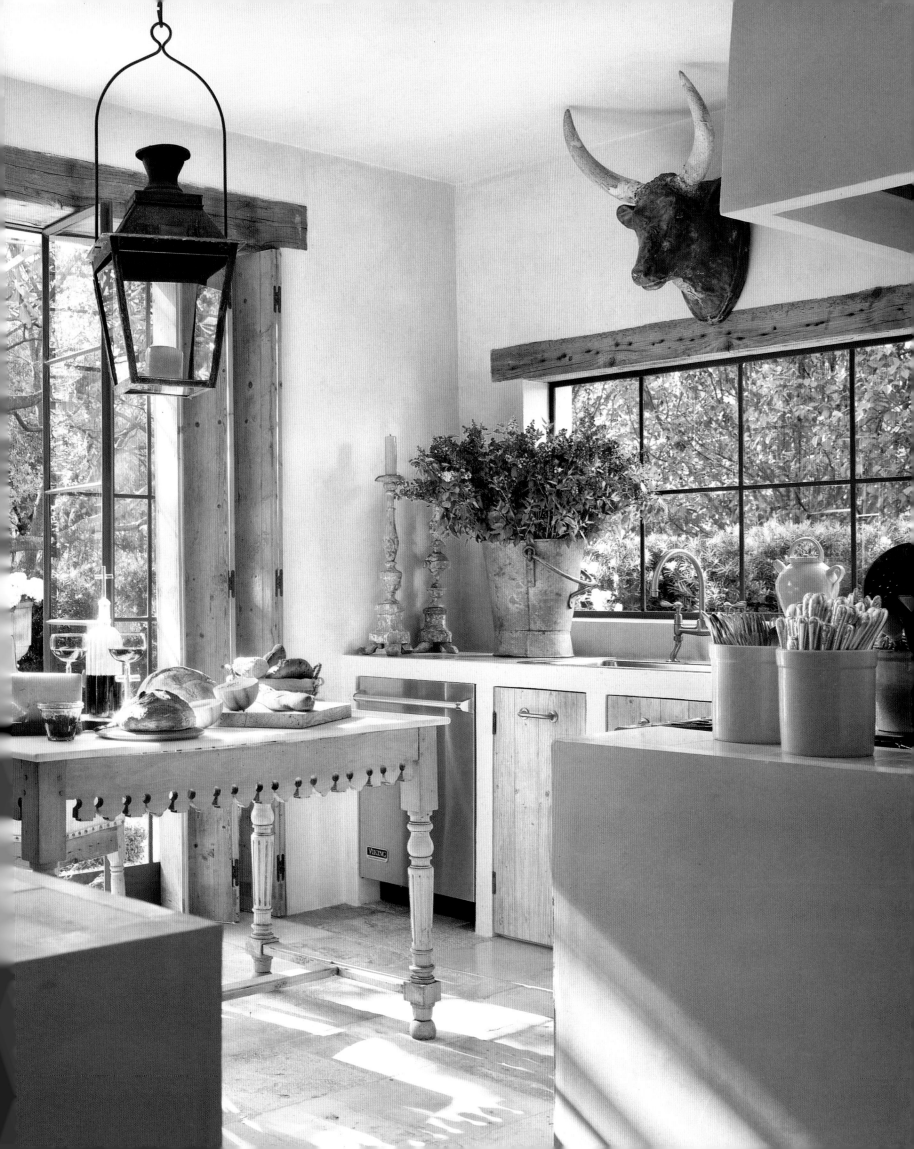

CALIFORNIA LIVING
A quiet blend of color and form makes the most of majestic coastal landscapes.

Dan and Luana Romanelli began with a rare find: six acres of land overlooking the Pacific on the Malibu coast. "It was such a phenomenon to find an undeveloped piece of property out here," says Luana, a horsewoman with a passion for riding. It took five years, however, to prepare the land and complete the four-bedroom house, designed by architect Stephen Giannetti. The finished property, which includes stables for six horses and riding trails leading down to the Pacific Coast Highway, was a long time coming but worth every day the Romanellis were made to wait. "There are so many problems when you acquire a raw piece of land," says Dan, a former Warner Bros. executive. "But we made something we are all proud of. It's a jewel that was honed and shaped."

That "we" includes Los Angeles–based designer Madeline Stuart, who let the stunning surroundings set the scheme. Almost every room features French doors that open onto breathtaking ocean views. "Let's face it," says Stuart. "What are you going to do to the interiors that's more compelling than the majestic beauty of nature outside of the house? The decor defers to the oceanfront site." The subdued rooms in powdery shades combine elements both raw and refined: coarse linen curtains and abaca rugs with shimmering crystal chandeliers, hand-scraped oak floors with velvets and silk upholstery that sparkles with a subtle sheen. In the master bedroom, a side table with a chunky limestone top and a gracefully carved and gilded wooden base perfectly illustrates the house's unpretentious charm.

In fact, the residence incorporates some quintessential elements of the California lifestyle: It's a space that's easy and sophisticated at once, with the great outdoors ever present. The winningest testament is how the Romanellis revel in it all. Says Stuart, "I've never seen two homeowners, four dogs and six horses so happy in one place."

Luana Romanelli leads one of her horses, Argento, across the drive of the Malibu estate she shares with husband Dan. The house, by designer Madeline Stuart and architect Stephen Giannetti, was inspired by traditional estates in the South of France.

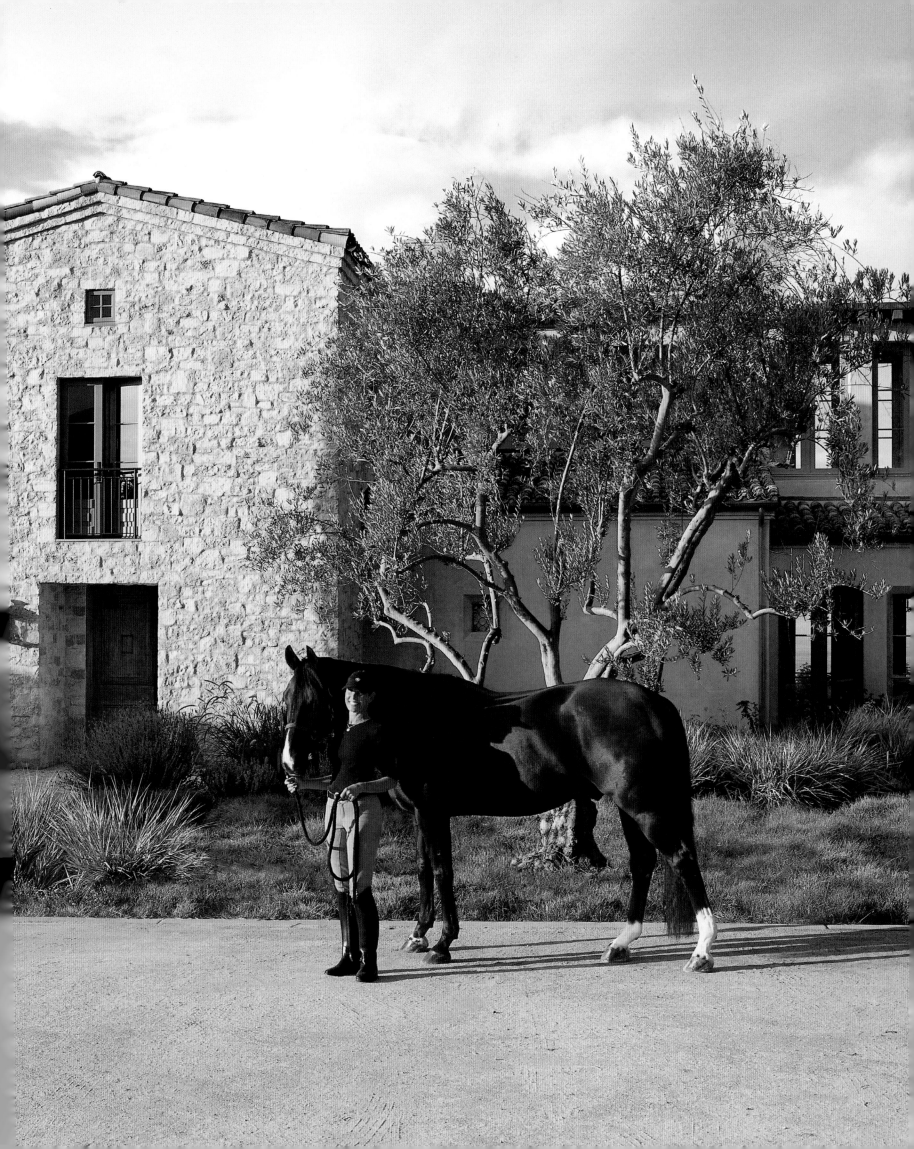

Unexpected elements display an outside-the-box approach. The chandelier was refashioned from the crown of an antique canopy bed. An antique French gym bench, covered in scuffed and weathered leather, is repurposed as a cocktail table. Custom armchairs have linen-covered cushions and backs in pale blue silk. The limestone mantel is antique, and the custom fire screen is made of nickel. The art is by Ashley Collins.

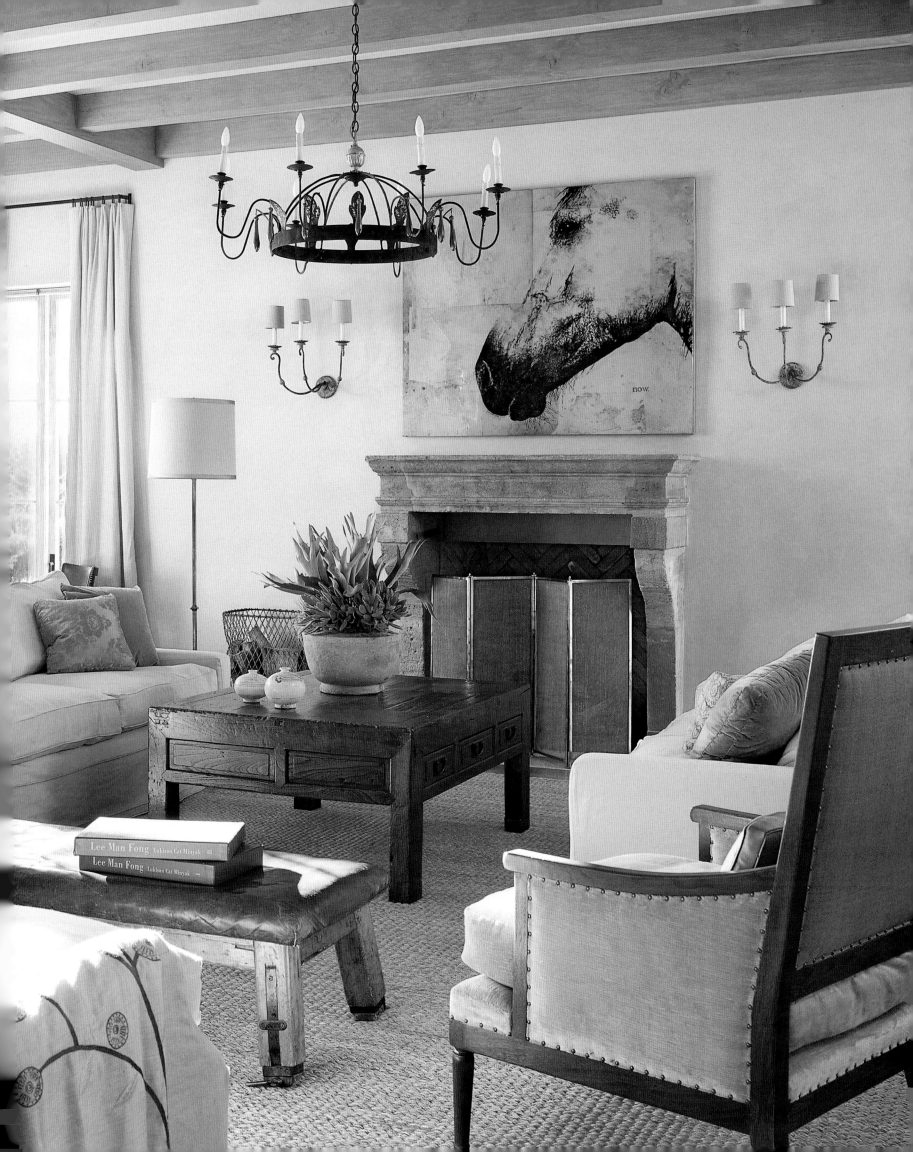

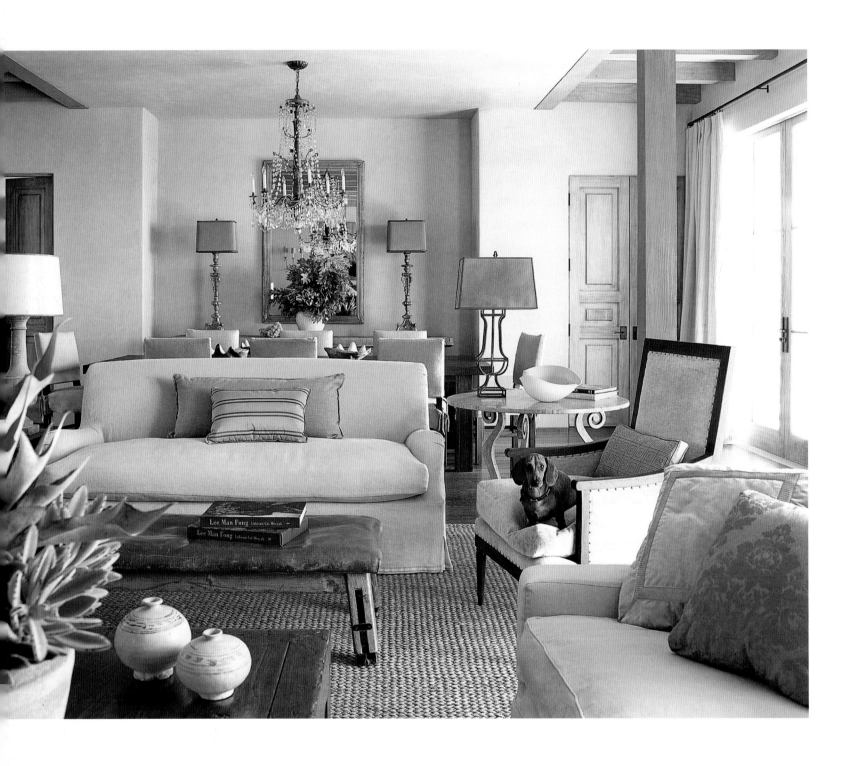

The living room blends into the dining area for ease. ABOVE: Custom sofas are covered in linen. The 1940s table is Italian. OPPOSITE: The 18th-century Italian sideboard gets a lift from custom-cut stones. The lamps were made from antique altar candlesticks.

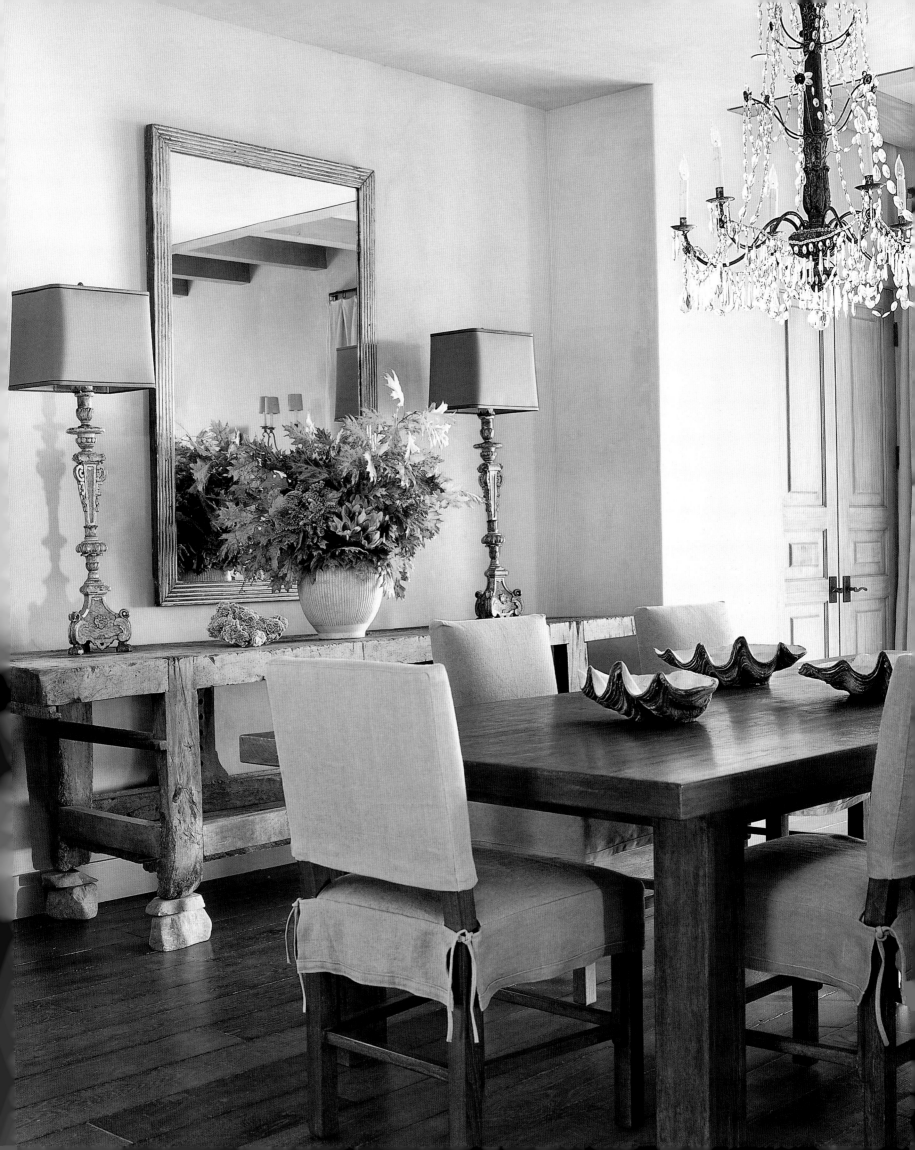

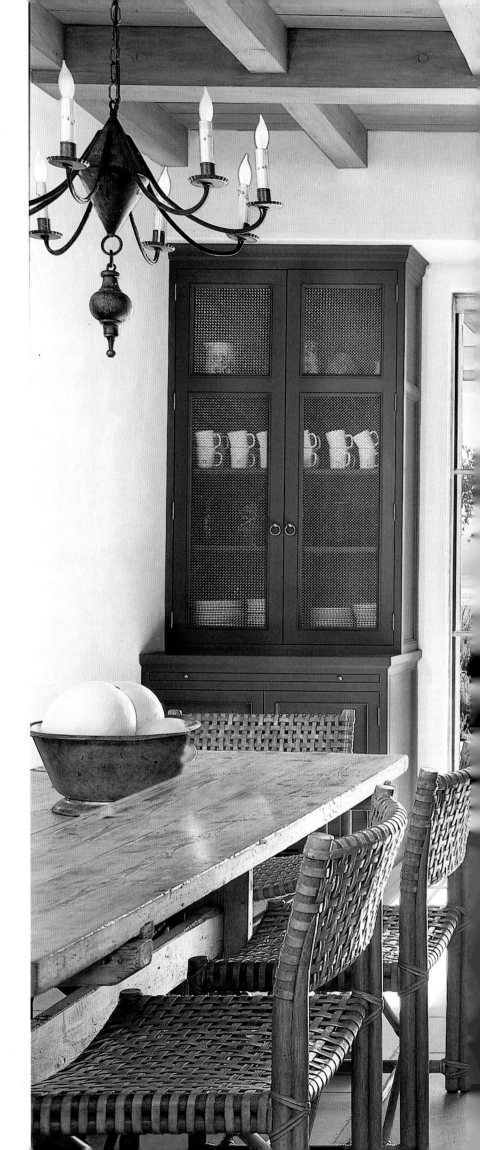

The kitchen opens directly onto expansive Pacific views and a garden planted with olive and coral trees, salvia, rosemary and Spanish lavender. The floor tiles are Santa Barbara sandstone. The custom limestone countertop harbors midcentury modern mahogany slat stools. Chairs with seats and backs of laced cowhide surround a 19th-century Swedish farm trestle table.

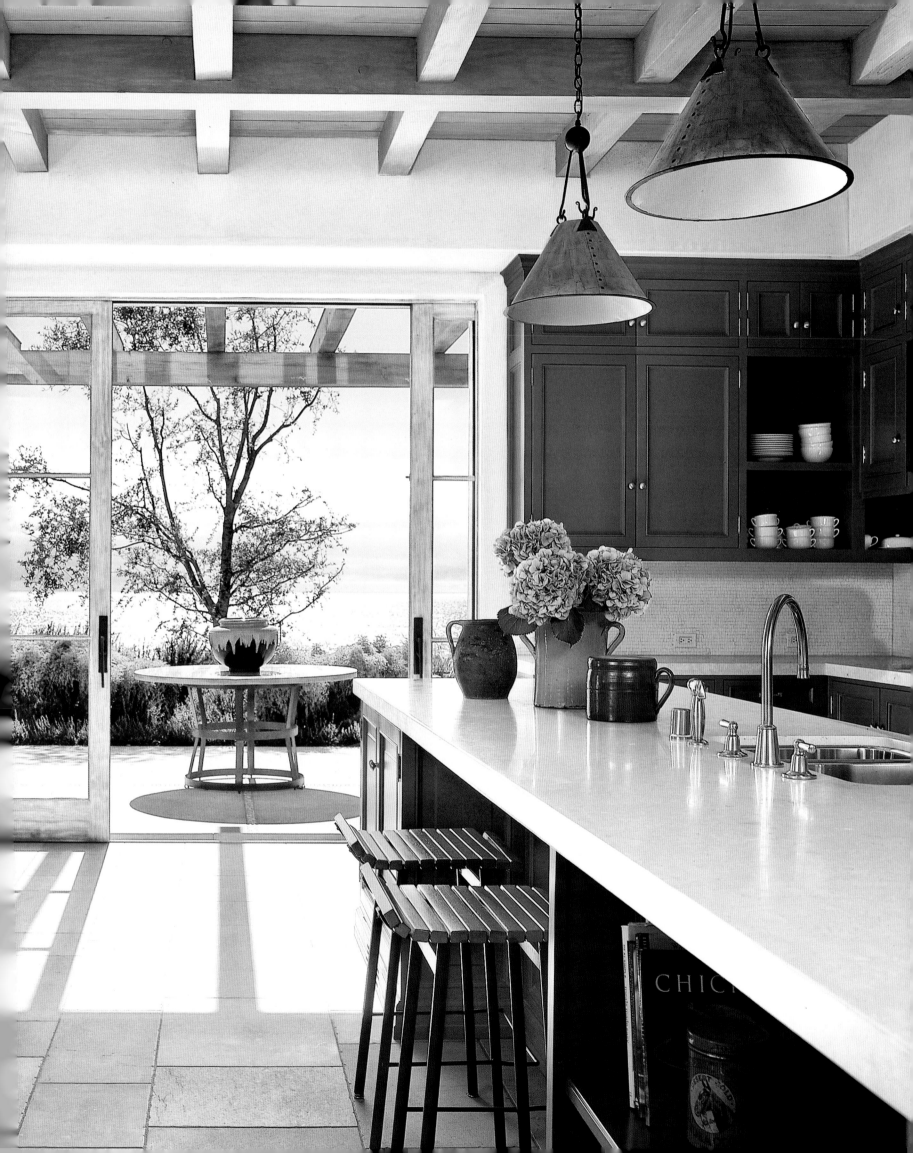

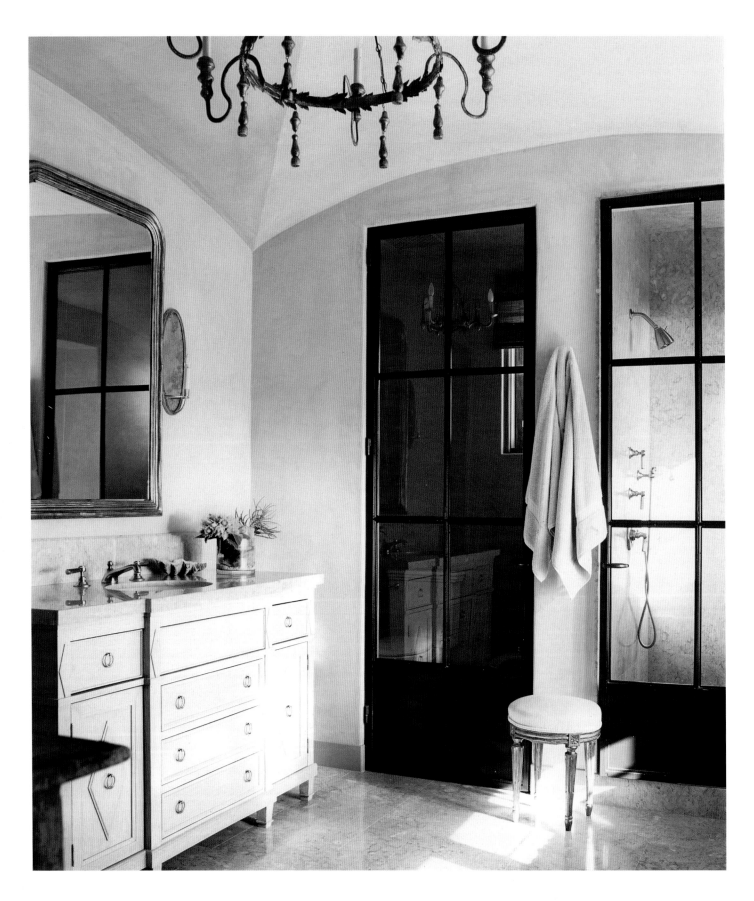

The master suite is an elegant refuge. ABOVE: Custom steel doors provide a graphic silhouette in the neutral space. The 18th-century chandelier is Italian. OPPOSITE: The custom canopy bed is hung with ethereal linen panels. The 19th-century ottoman is French.

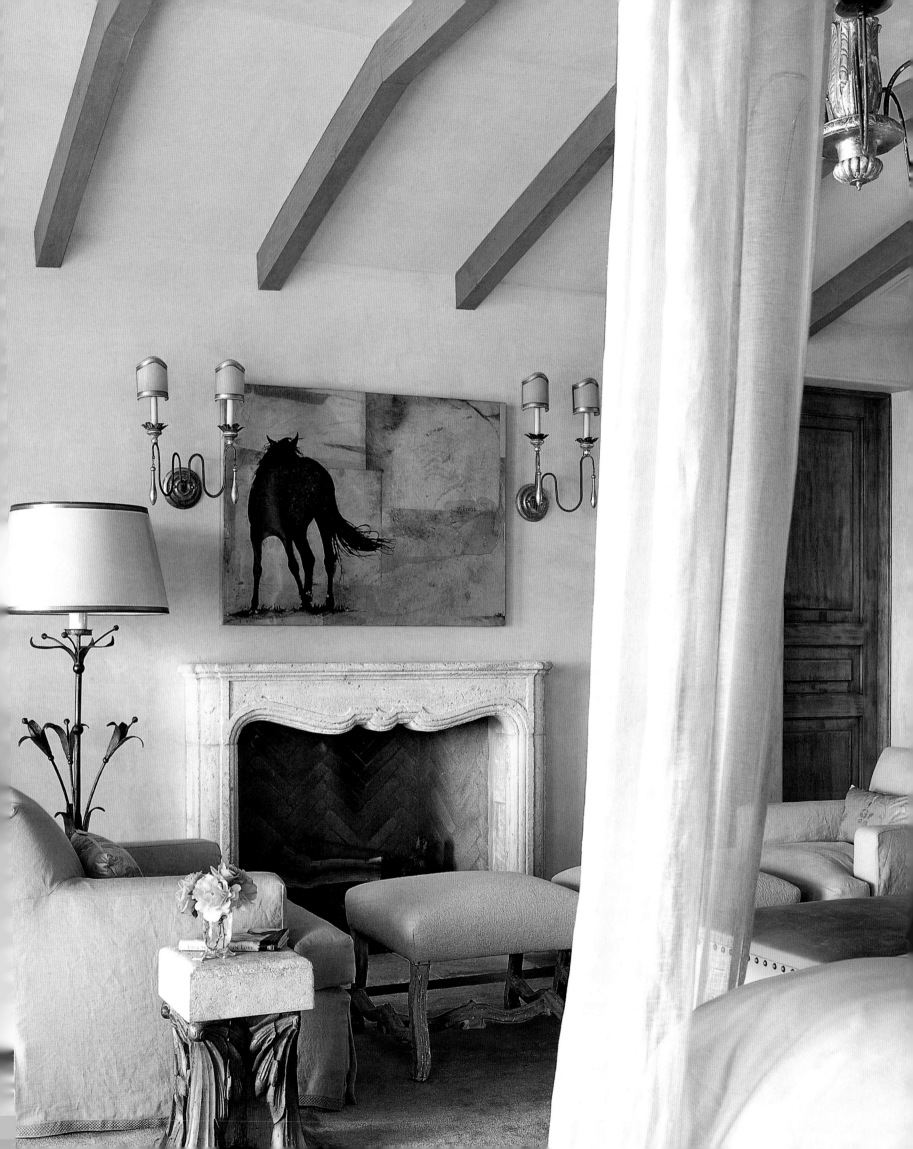

SWEDISH PALETTE
A casual approach to antiques marks a breezy
and welcoming family house.

J udging from these pictures, you'd never believe Shannon Bowers' two-story Georgian house in Dallas was once gloomy. "It was mauve with dark wood floors, and it had mini blinds blocking out the sun," she says. "I wanted more natural light, airiness and a fresh new look."

What became a haven of pale furnishings dipped in sunshine took its cues from the soft hues and understated elegance of painted Swedish furniture. They prompted Bowers, daughter of designer Pamela Pierce, to choose a linen with a "petit blue" undertone that dictated the predominant shade of the rooms: "The color of the paint on the walls is a derivative of that fabric." For accents, Bowers looked to the outdoors. "I'm a purist," she says. "For me, colors found in nature—like robin's-egg blue, light sand and the lavender of hydrangeas—are soothing." Those tones appear in fresh striped cotton dhurries, the linen on seat cushions and the creamy glaze on a porcelain garden stool.

Numerous French antiques pair well with the flaking Gustavian pieces, exuding a similar aesthetic. "Most of them are from the Directoire period, so the lines are clean and work well with Swedish neoclassical proportions." A Gustavian library table with fading paint happily weds a pair of gently shimmering gilt fauteuils.

And since she and husband Dan have a growing family, Bowers wanted more than anything to take a friendly approach, creating functional spaces that would be sophisticated but could also handle a little wear and tear. She made ample use of slipcovers, which can easily be cleaned or replaced, as can those cotton dhurries, which are also reversible. Antiques show up in the living spaces as well as in the children's rooms. "I want to share them with my whole family," she says. "I want my house to look beautiful, but more important, I believe it should be a warm and comfortable place."

Shannon Bowers has light, sunshine-enhancing floors at her Georgian house in
Dallas. A linen cushion and pillows in a striped French muslin
complement a Gustavian settee. The trumeau is from the 19th century.

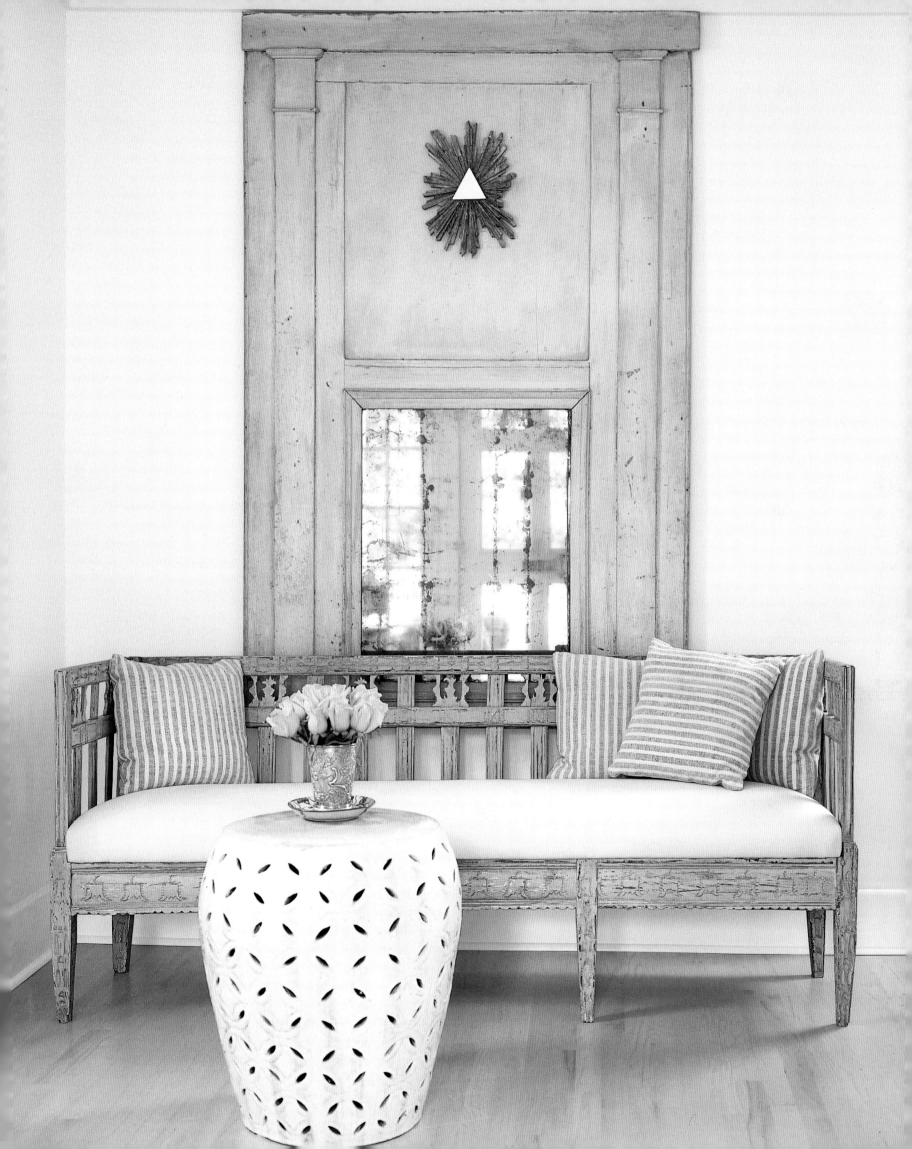

French and Swedish pieces create a serene setting. Swedish chairs with linen seats surround a pair of 19th-century Swedish demilunes used as a table. PRECEDING PAGES: A Gustavian sofa and a 19th-century Swedish cabinet and horse share the living room with a Louis XVI chair and a Louis XV limestone mantel. The French bistro tables are antique. The lamps were made from 18th-century columns.

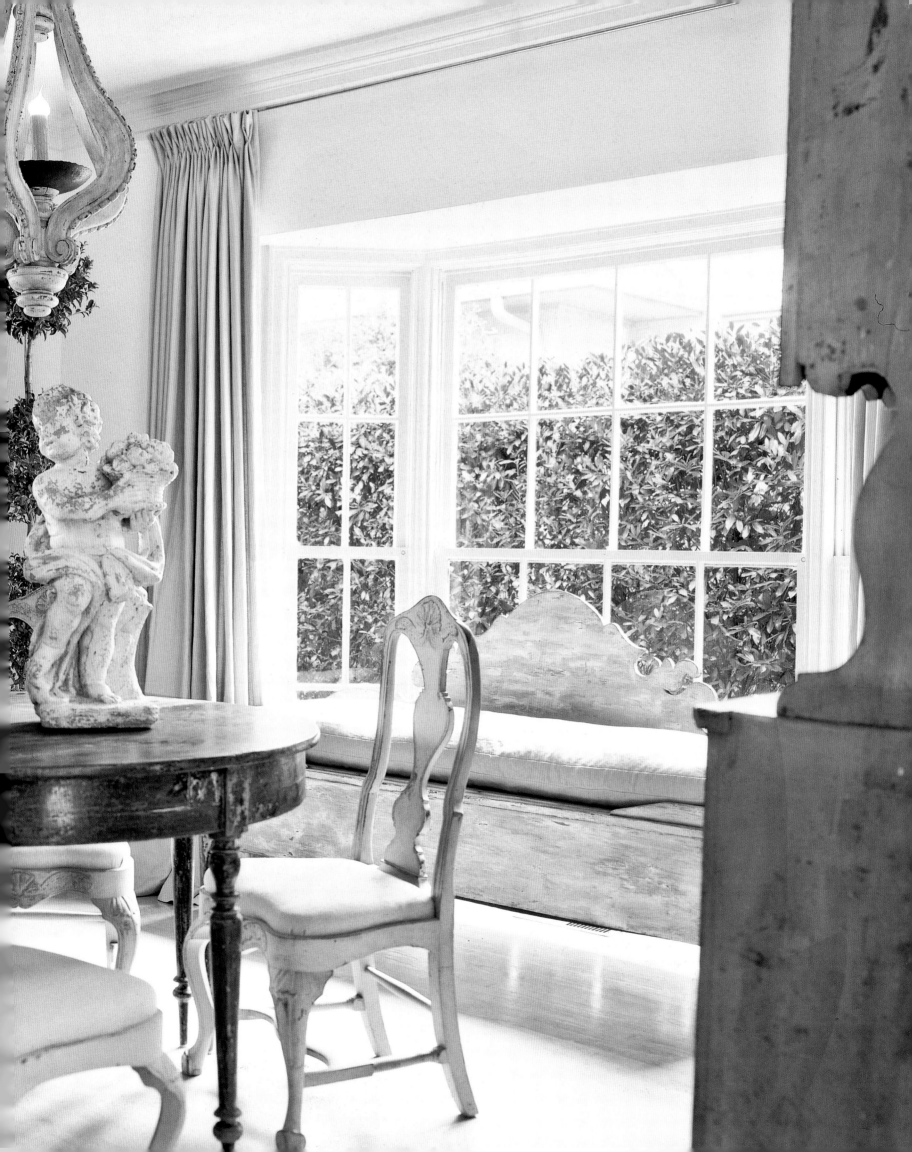

The kitchen combines function with charm. Open shelving places everything within reach, while ruffles of French linen and plain wooden finishes add flourish and levity. Belgian chairs from the 19th century are pulled up to an iron table with a marble top. The French charcuterie table, lantern and overdoor carving above the window are all 19th-century antiques.

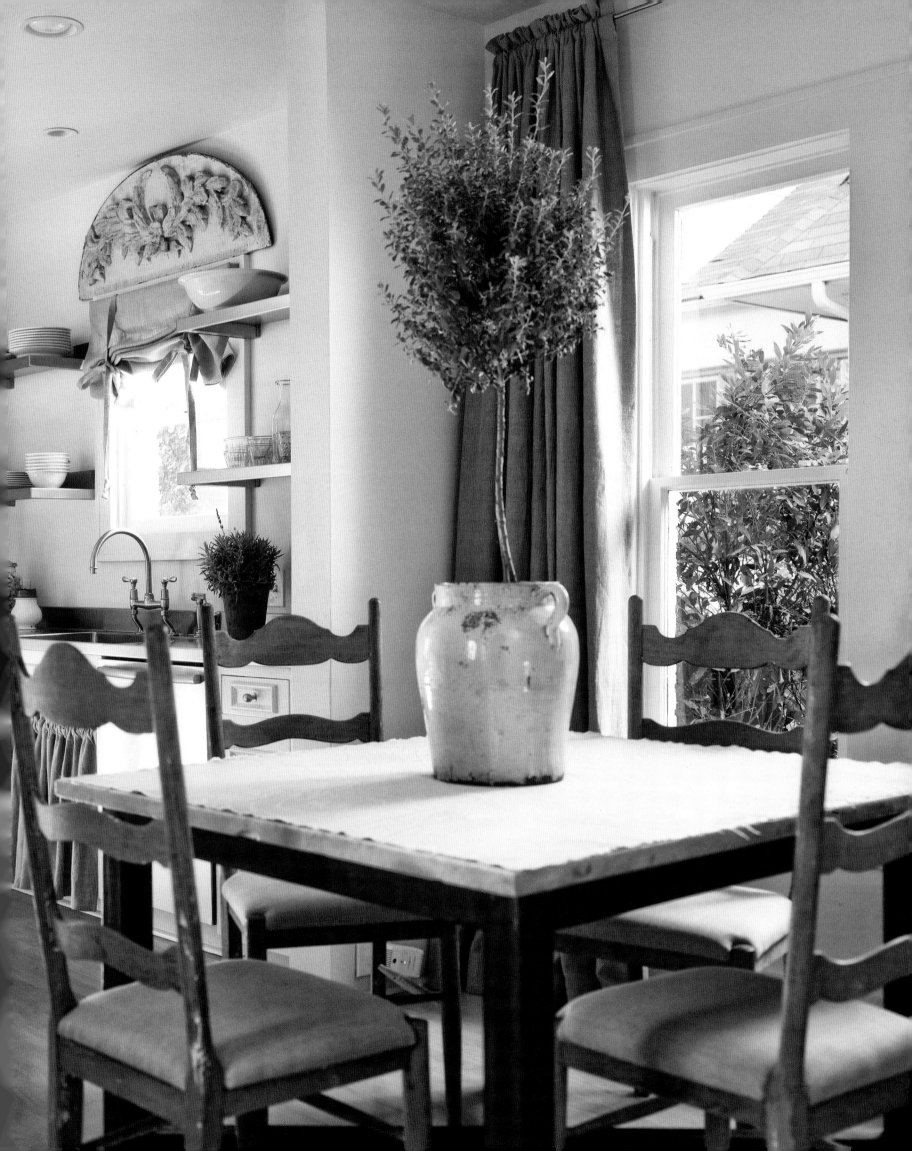

4.

A house can be a
holiday, an escape
from the norm,
a perch for relaxation
and serenity.

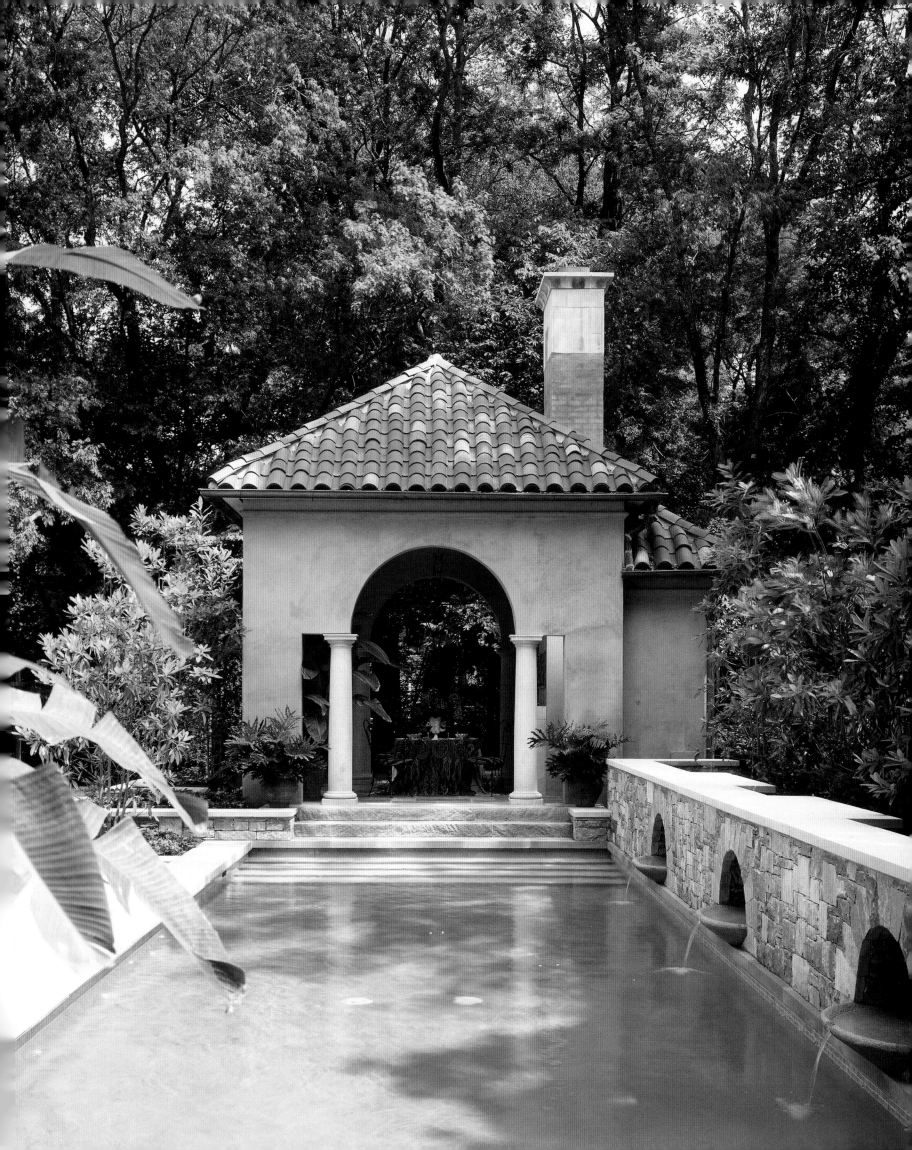

Artful Retreats

Decoratively speaking, a second home is the ultimate second chance. It's a staging ground for the kind of choices you might not want to live with every day. If your main house is traditional and a tad buttoned up, maybe the beach house is refreshingly simple, with slipcovers and wicker and painted pine floors that don't need much in the way of embellishment—on the weekend, that's exactly the way you like it. On the other hand, maybe your retreat represents the chance to regroup with friends and family. Perhaps the main objective is to comfort and coddle, to make everyone walking through the front door feel like they've been swept away to a glamorous new world where the cares of everyday life simply don't apply.

Whatever the case, because of our lush format and layouts—where photography has always had a chance to really shine—vacation retreats have always struck a strong chord in the pages of VERANDA. Readers have told me time and again that they feel transported when they browse through the magazine, that the experience of turning the pages feels like an escape, like a holiday they take without ever leaving the comfort of their armchair or sofa. This is never more true than with the vacation houses we've featured. In one fell swoop, they allow you to travel the globe and soak in a wide array of influences and perspectives.

The houses gathered here are archetypes. They range wildly in style. What they have in common is a reverence for comfort and a certain amount of ease. They are made for swimsuits and bare feet, for ski boots and curling up by the fire. In them, found objects take on the significance of art. Seashells and bamboo and stone slabs become part of the decor. Almost without exception, they are also family houses, spots where the extended clan gathers to recharge and relax. In this way, they represent a spirit of generosity unique to vacation homes: They are getaways where one is meant to host, to welcome with open arms the ones we love.

That sort of generosity carries magic. It is nothing short of magic, for instance, that infuses the spare, raw wood walls of the Vervoordt family's Alpine retreat—only a special brand of sorcery could make something so minimalist also feel so cozy. There is enchantment as well in the Jamaican hillside villa that Charles Faudree outfitted in corals and ikats and a whelk-studded chandelier for an Oklahoma family. The seemingly effortless way Adrienne Vittadini was able to weave together a cosmopolitan sensibility with a wonderfully laid-back energy at her Sarasota escape is spellbinding. In their North Carolina mountaintop aerie, antiques dealers and businessmen Hal Ainsworth and Winton Noah used the tools of their trade to conjure a singularly elegant haven in what appears to be a barn. It combines so many fine elements in a way that's unstudied, unforced and totally carefree. Completely bewitching.

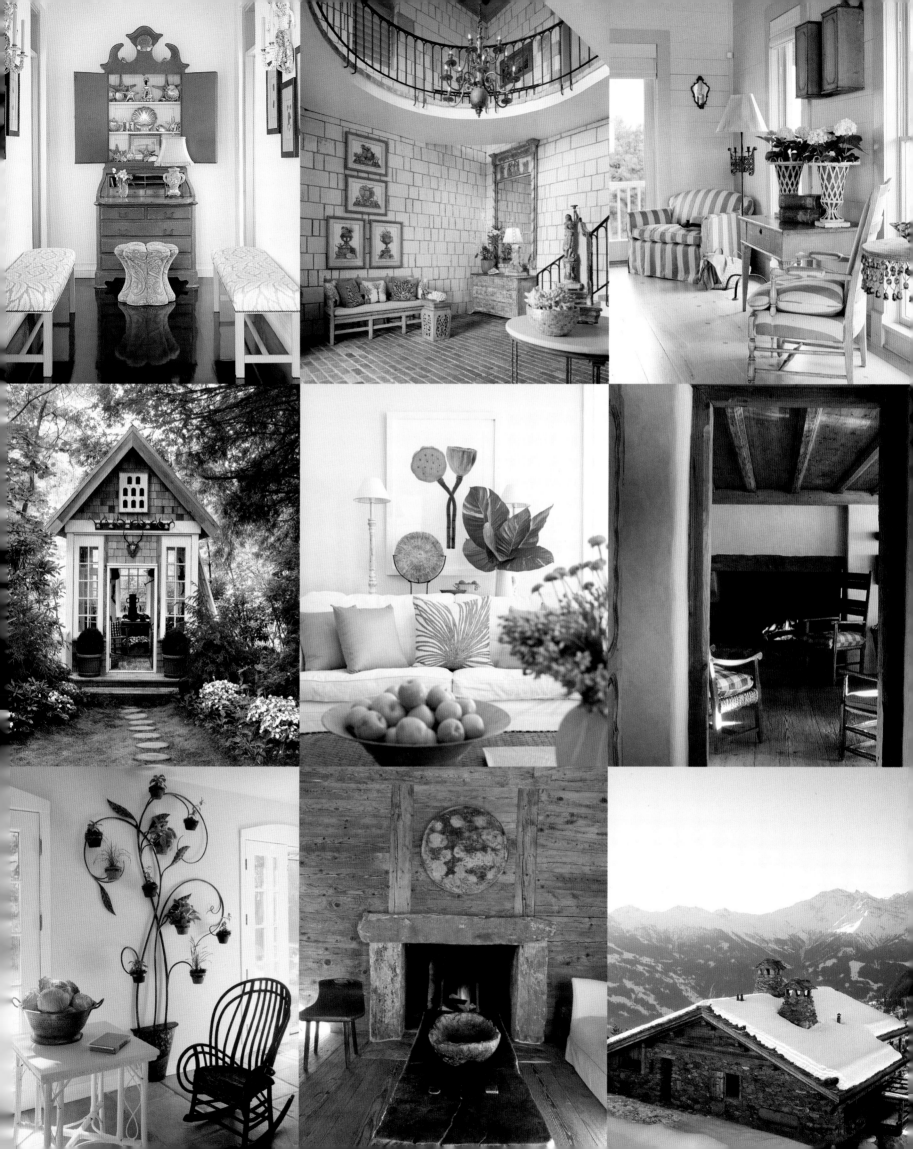

A CHARMING GETAWAY
Refined basics pair with a simple scheme in an unpretentious getaway.

I t takes a large Houston-based family less than an hour's drive to reach this Galveston Island beach house, but it might as well be a world away—or maybe just a continent. Decorated by Babs Watkins, the pretty, unpretentious retreat has a cottage-like feel and a serious French vibe, with a marine-inspired palette that wouldn't be out of place in Brittany or Île de Ré but looks right at home in Texas.

The bones of the place are easy and carefree and particularly suited to the seaside setting. There are wraparound porches, large sun-guzzling windows and wide-plank painted pine floors that have been distressed through a washing process to appear slightly faded and weathered—all the more welcoming to sandy feet and dripping swimsuits. Beamed ceilings and walls paneled horizontally with more planks— these are whitewashed—round out the casual vibe in an informal arrangement of rooms that flow from one to the other with ease.

In this breezy environment, Watkins arranged furniture and objects with a generous dose of *je ne sais quoi* and the nuanced sense of color for which she is well known. A tufted sofa covered in a seafoam green fabric shares space in the living room with a slipper chair upholstered in a complementary toile de Jouy; a painted Louis XVI trumeau gleams from the mantel. The ocean tones are offset here and there by patches of taupe, such as the beige awning stripe on dining chair cushions. Textures from a wealth of materials continue the beachy theme: sea-grass rugs, a wicker chaise, a flaking painted cane-back settee. And lest anyone take things too seriously, room has also been made for whimsy, with touches such as vintage pink flamingo garden statues and petite children's Windsor chairs lending a note of breezy nonchalance. *Quel charme!*

In the pool house of a Galveston Island beach getaway designed by
Babs Watkins for a Houston family, a pair of large celadon-glazed pots with
arrangements of bamboo flank an 18th-century Italian painted settee.

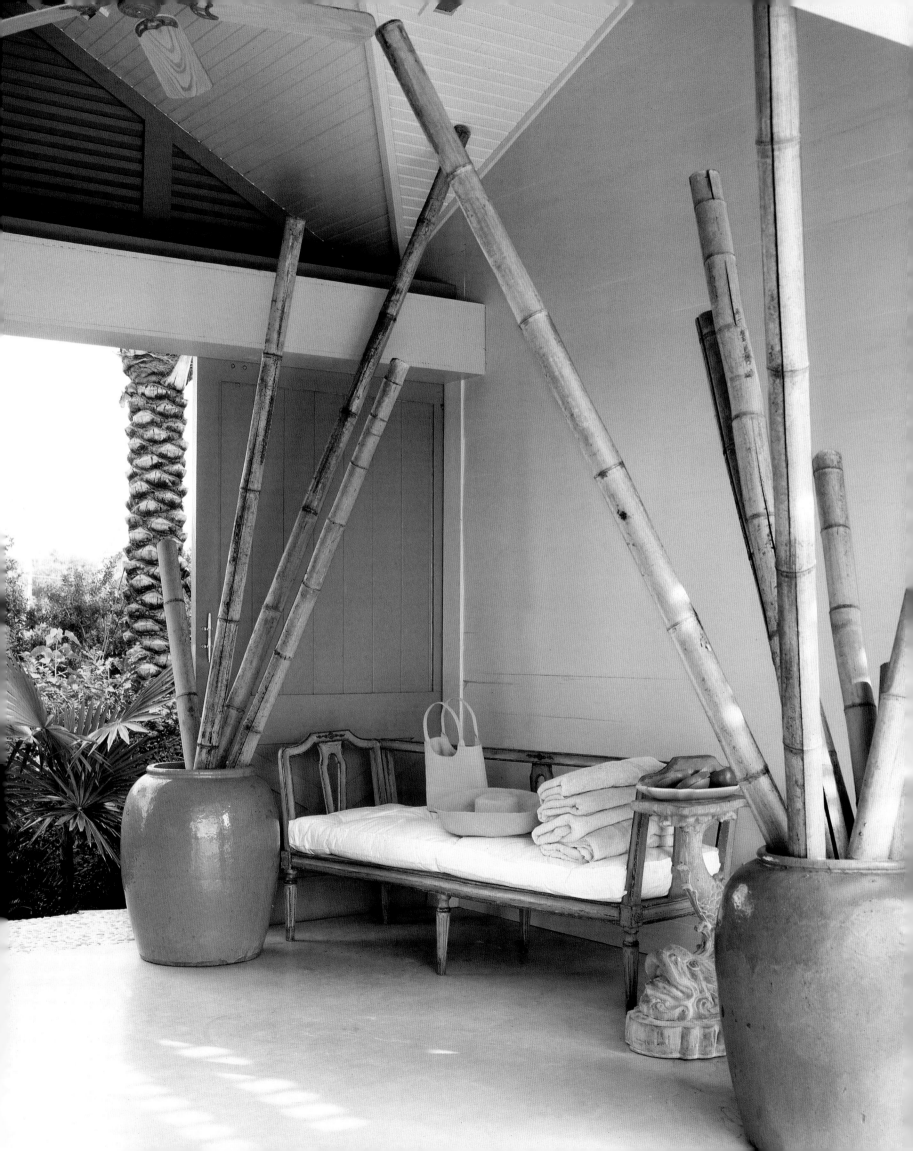

In the living room, frilly accents such
as an antique tufted sofa with caryatid
legs and a glass-topped coffee table with
twirling brass legs are modulated by
simple or striking furnishings, like the
clean-lined limestone mantel and the
giant faux whelks in the hearth.
Adding to the balancing act, windows
wear simple Roman shades.

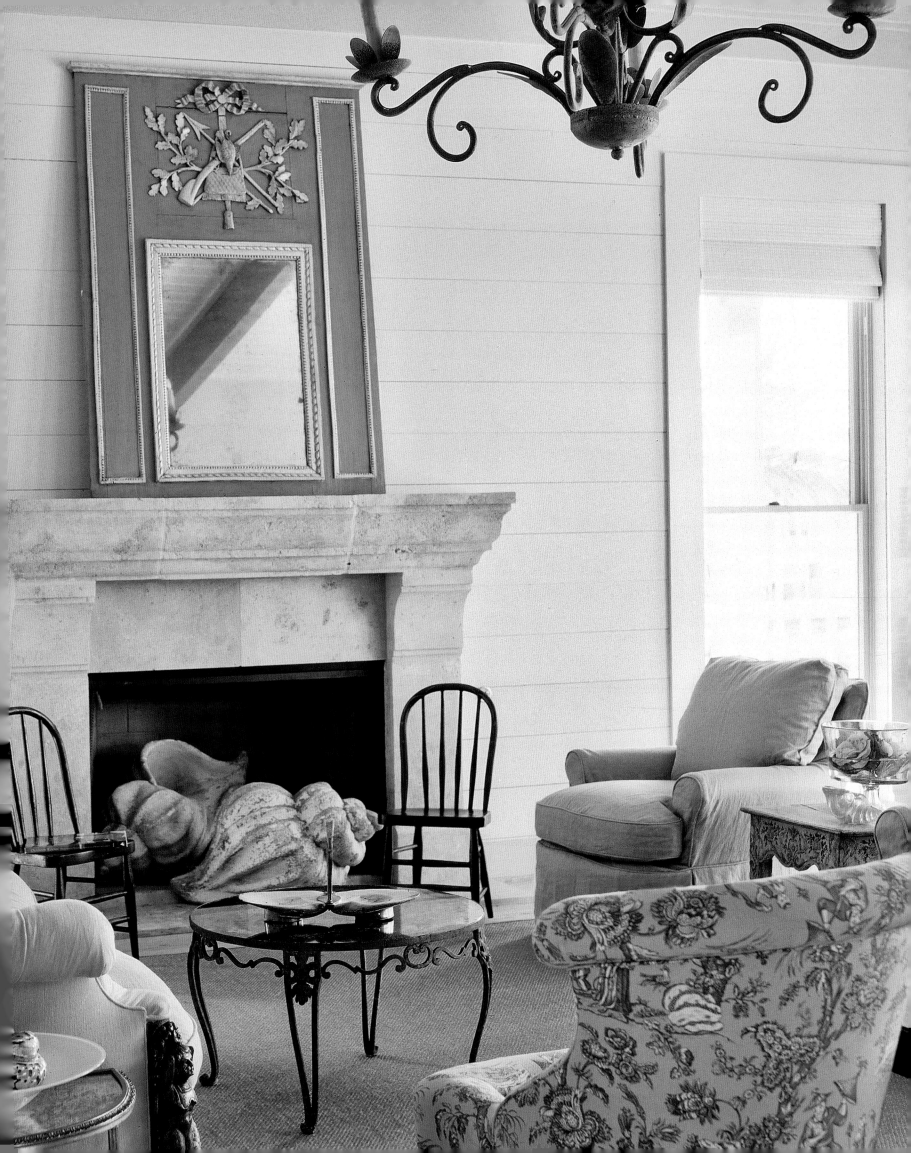

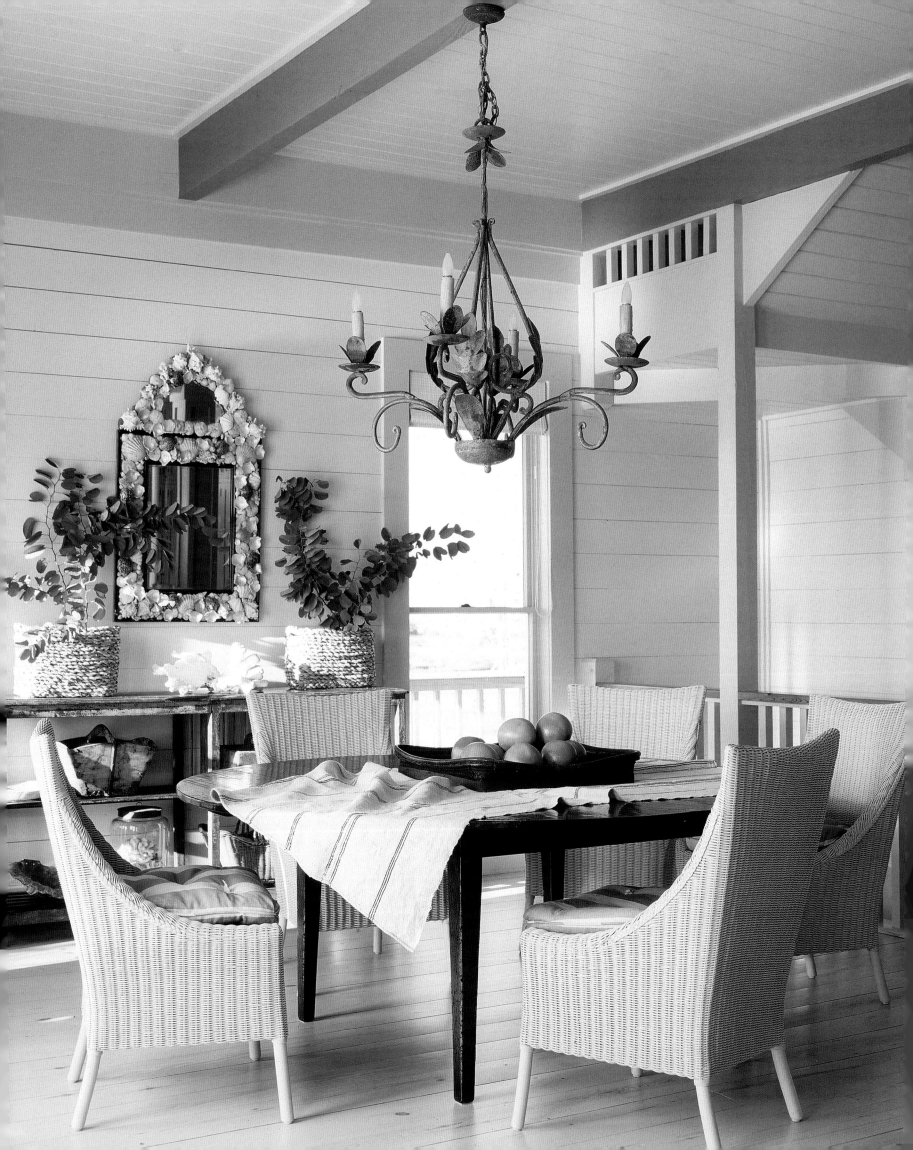

Separate seating areas provide distinct nooks for curling up or casual dining. ABOVE: A tufted chaise has a frilly pompon fringe. OPPOSITE: Wicker dining chairs and a sideboard with open shelving make for laid-back family meals.

Pops of bright color break up the cottage's dominant hues. ABOVE: Folding French iron campaign beds are dressed in a lively pink paisley. OPPOSITE: French tole-and-crystal sconces provide elegant contrast to a Louis XV cane-back settee with chipping paint and a tufted toile de Jouy cushion.

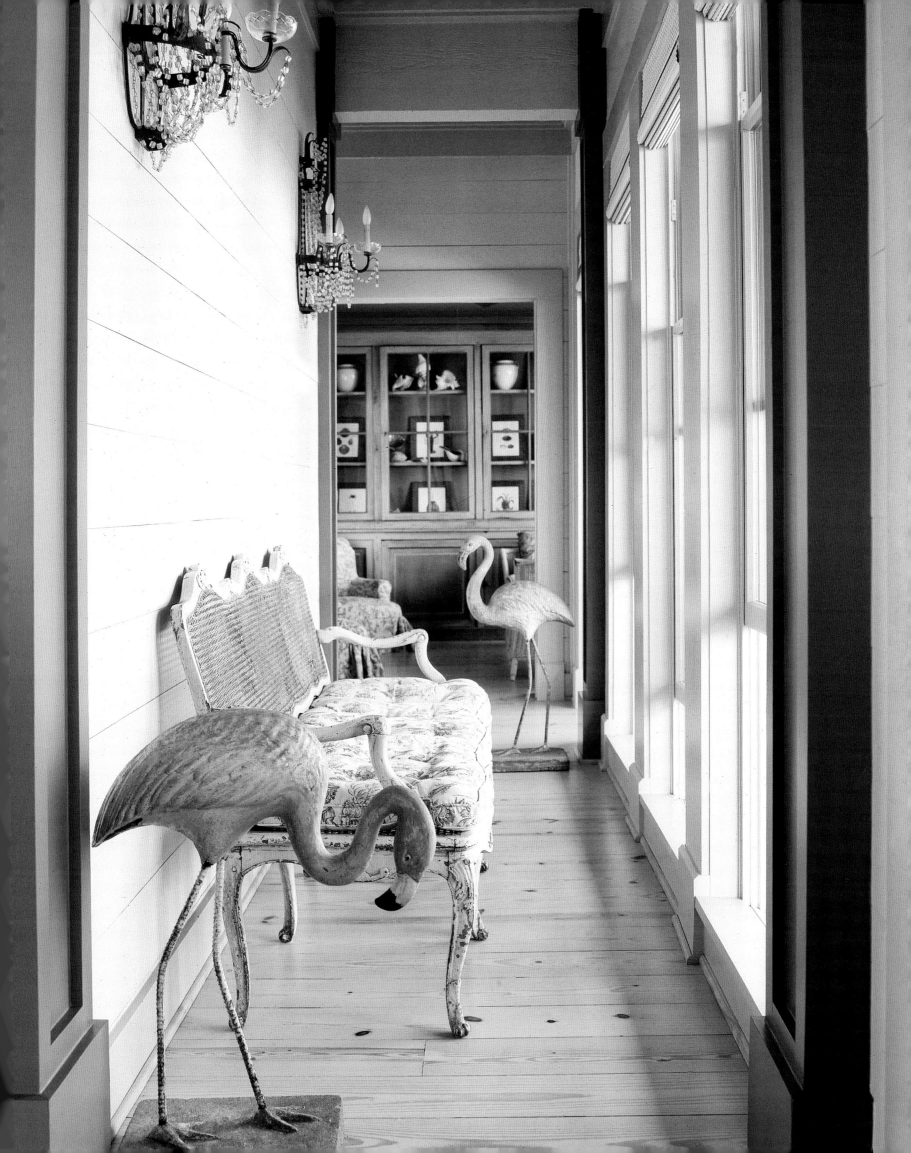

WORLDLY ÉLAN
A masterful eye crafts a cultivated and cosmopolitan Florida home.

I n the '80s and '90s, Hungarian-born Adrienne Vittadini headed her own women's apparel company in New York, winning a Coty Award and opening signature boutiques across the country. After selling her fashion empire in 1996 and licensing her namesake stores, she gradually switched to home design, reveling in a natural talent for decor. "Before I sold my company, when I was also designing shoes and luggage and swimwear, I couldn't wait to design the sheets and home accessories," she says. "I always loved interiors without realizing it." Vittadini has since renovated or built and then decorated about twenty houses in New York and Florida. This one, on Lido Key in Sarasota, is a vacation escape she shares with her Italian-born husband, Gianluigi. It draws upon the same Euro-American sophistication that characterized her clothing line and faces sunsets over an inland waterway and the Gulf of Mexico—matching striking interiors with striking views.

The living room is anchored by a black and white kilim that prompted the room's colors. "I knew I wanted earth tones with black accents and linen-white walls," she says. "I already had the zebra rug." Elsewhere in the house, her abundant use of ivory tones allows her to splash a single color, in accents such as pillows and artworks, to dramatic effect. In a sitting area abutting the kitchen, a verdant hue takes the starring role, appearing in a print of a lotus pod, in a botanical pattern that undulates across silk pillows and in an insouciant arrangement of tropical leaves. "I use different tonalities, from yellow-green to bottle green, from chartreuse to kelly green." The subtle use of shades ensures that rooms have life but don't detract from the impressive surroundings, which are front and center in nearly every space, thanks to plenty of French doors and windows. "We wanted to maximize the natural light and views of the azure water."

Comfort and an easy, cosmopolitan élan characterize the vacation escape that Adrienne Vittadini shares with husband Gianluigi in Sarasota, Florida. FOLLOWING PAGES: Vittadini gives a modern look some soul by adding in clean-lined antiques, such as Regency side tables.

Light floors provide a perfect foundation in breezy seaside rooms. ABOVE: An antique English table and Delft enhance a breakfast nook. OPPOSITE: Mirrored panels in the master bedroom reflect scenic views. FOLLOWING PAGES: A poolside loggia reflects Palladian influences in its symmetrical proportions and Doric columns and pilasters.

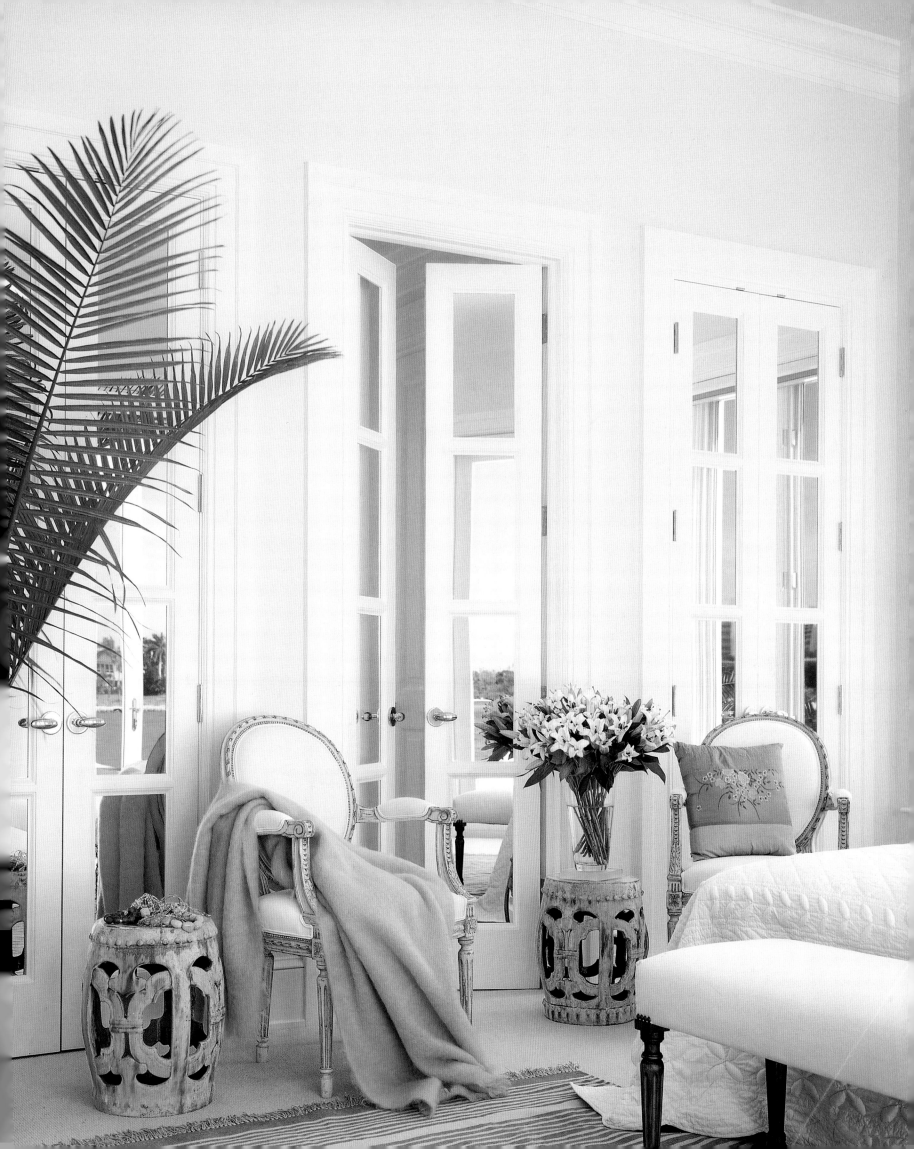

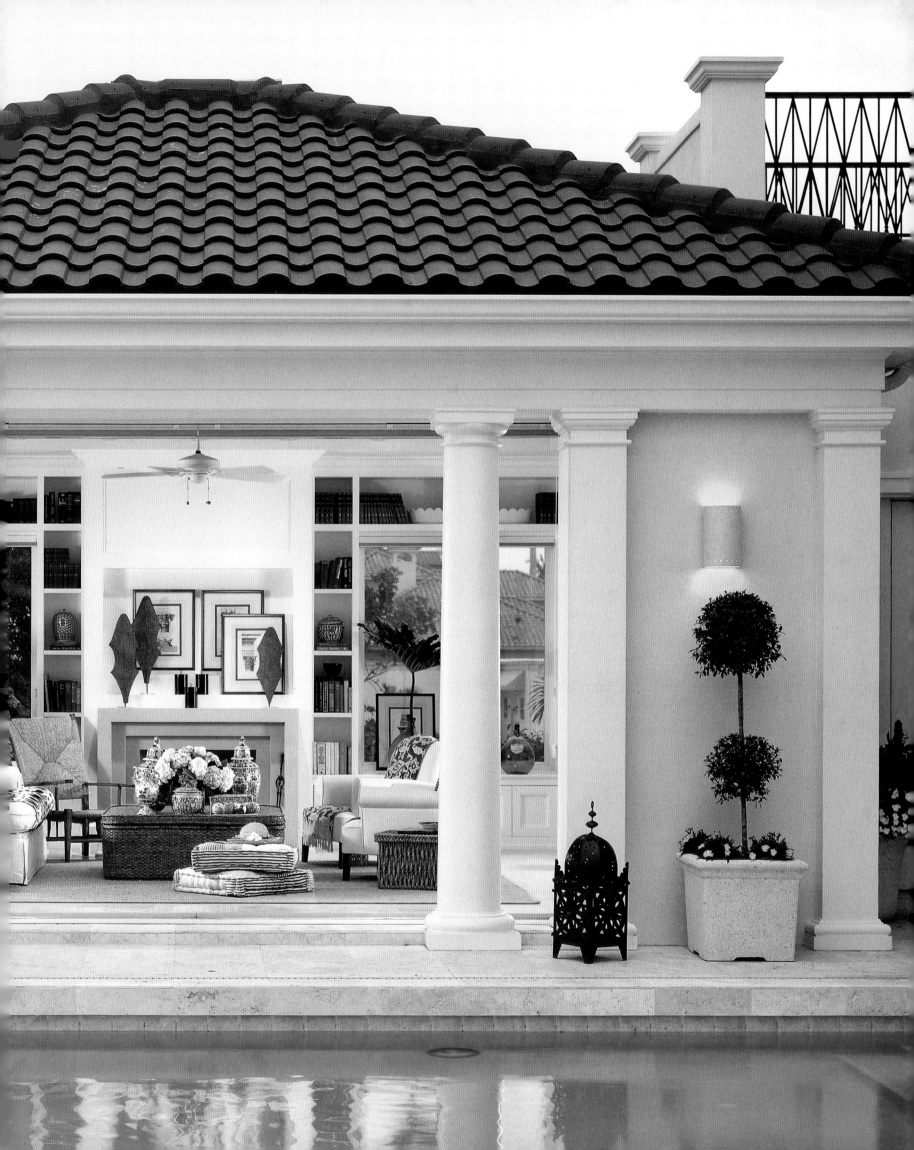

PALE PERFECTION
Soft ivory hues give a revamped weekend house a genteel brand of glamour.

"I've been doing houses for what seems like a hundred years," says Chicago-based designer Lynn Hummer. "But few intrigued me like this one. I had an instant affinity for it." The residence in question is an outbuilding by architect Howard Van Doren Shaw, noted for his work in the Midwestern city in the early twentieth century. The structure was originally meant to serve as servants' quarters, but what it lacked in grandeur it more than made up for in charm—a winning quality for Hummer's clients, a couple looking for a weekend escape.

The house is in an idyllic setting, complete with its own pond. It had good lines and proportions but nevertheless needed a makeover. Working with architect Peter Witmer, Hummer reconfigured the floor plan to create four large rooms. Porches were also added, and a garage became a guesthouse. Outdoors, a garden was wrought from the overgrowth.

The light-filled spaces now have high ceilings and a streamlined look. Soft neutrals are energized with just the right amount of prints, but nothing is too busy or fussy. And there is a faint but distinct whisper of Stockholm: "I was definitely going through a Swedish period," Hummer says. "I suggested white floors, all painted furniture and no brown wood." Dusky cane-back dining chairs wear vivid kelly green seat cushions. An elegant table with a delicate carved lattice pattern is artfully aged and weathered. Undercutting these genteel elements is scrolling metalwork—in a chandelier, the legs of marble-topped consoles—that adds a graphic visual note. The overall effect is a clean simplicity that's ethereal and serene. There's an airiness about the place that defies one to feel weighed down by anything—it's the perfect kind of perch for a stressless getaway. "I spend the day surrounded by stuff," says the wife, who owns a multi-dealer antiques market. "So I love getting to our weekend house and having just a few things around."

An Illinois weekend retreat renovated by designer Lynn Hummer and architect Peter Witmer incorporates living and dining areas into one large space, tempering a somewhat formal scheme with a casual floor plan ideal for easy weekend living.

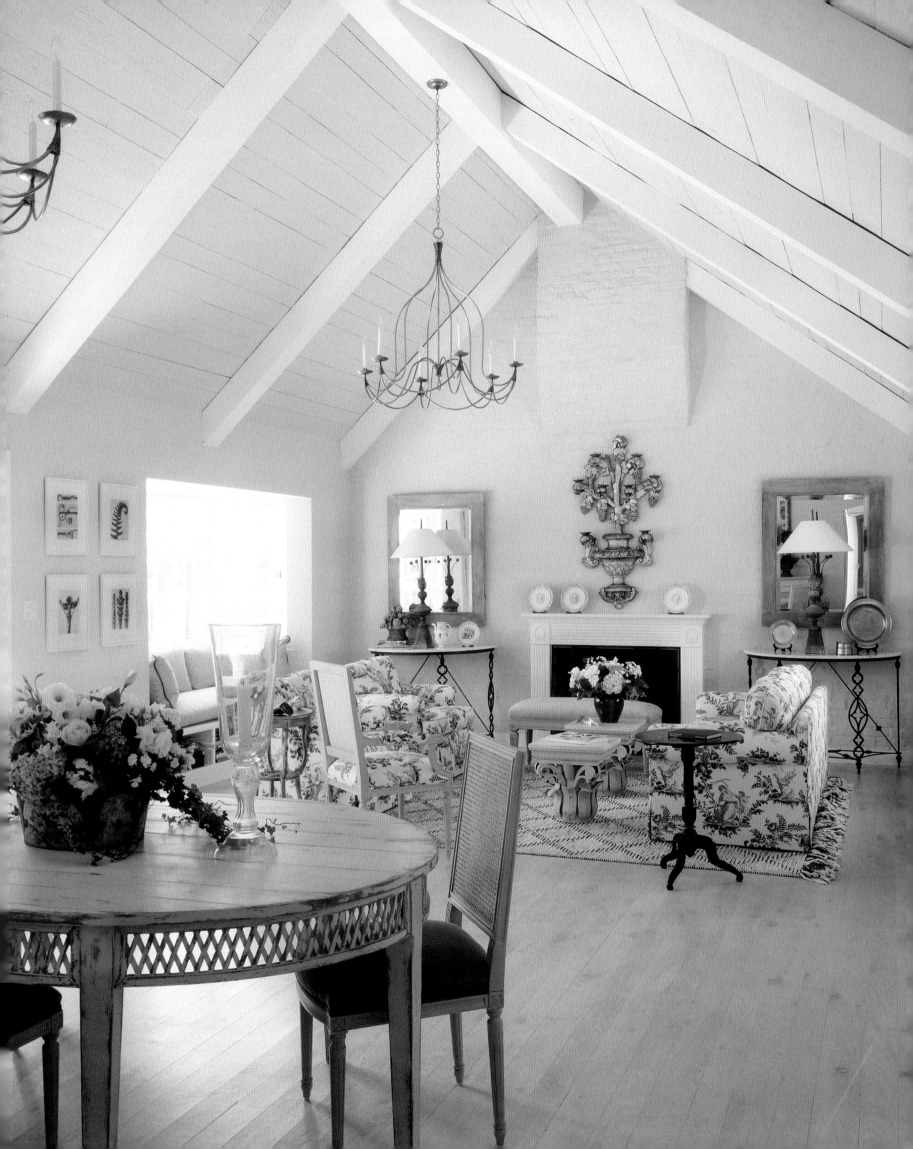

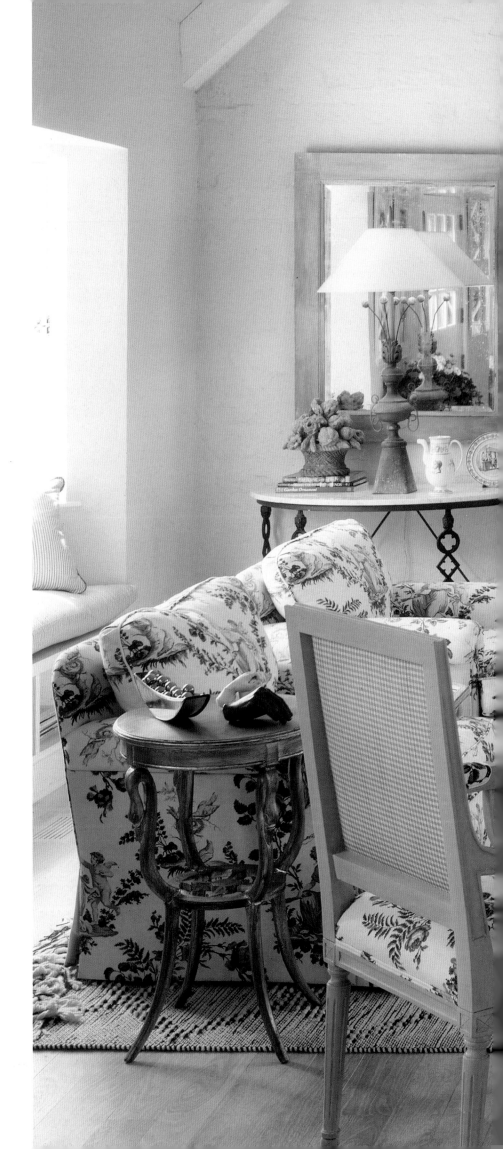

A small rug anchors a seating arrangement. Bare floors throughout much of the rest of the house offset feminine touches. A 19th-century Italian carved and gilt torchère acts as a focal point above the mantel. A cheery toile covers the sofas and seat cushions. The lamps were recast from French tole finials. A collection of 19th-century Creil plates strikes a refined note. The 1930s French table beside the sofa on the left features a swan motif.

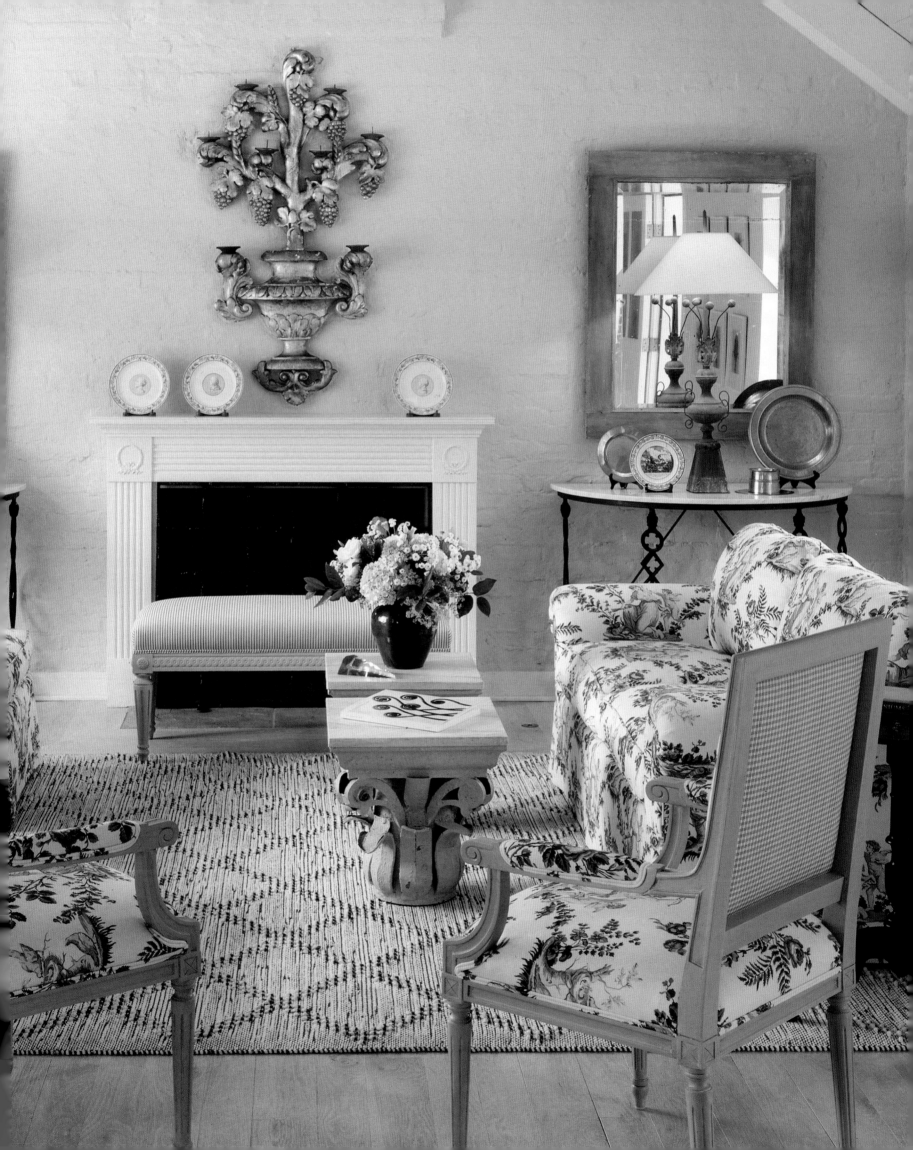

Artful shapes provide scale and proportion. ABOVE: In the kitchen, a tree-shaped iron jardinière holds herbs. The willow rocker echoes its profile. OPPOSITE: A tall bistro mirror positioned above the French sideboard reflects lofty vaulted ceilings. The zinc cachepots are American antiques.

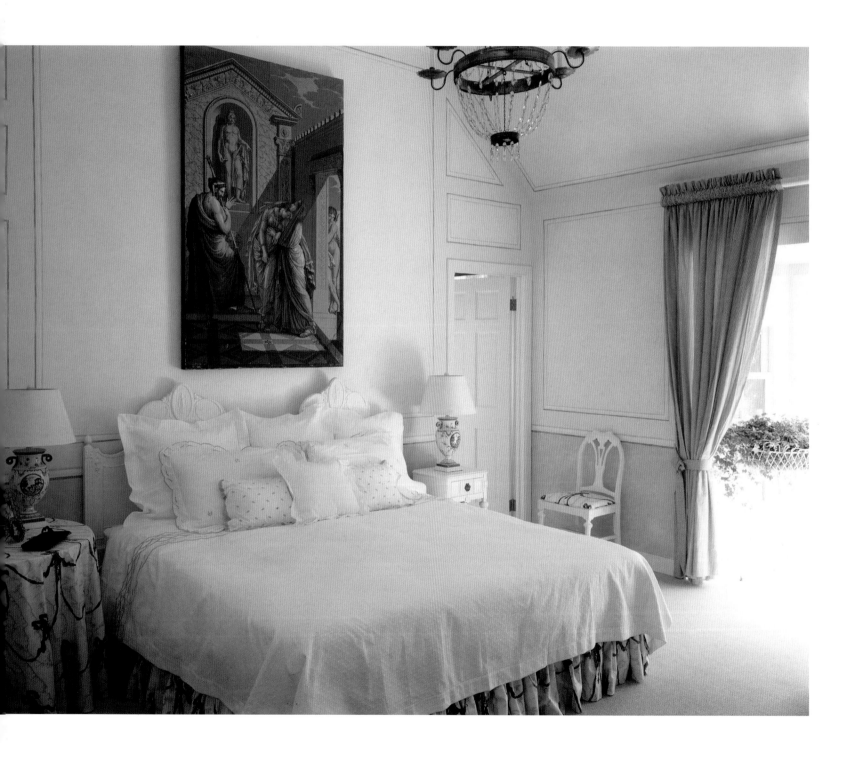

Curated objects become art. ABOVE: A 19th-century Zuber grisaille wallpaper panel becomes a focal point when hung above the bed in the master bedroom. OPPOSITE: Franco-Roman artifacts in the walled garden are scattered across the gravel to look like ruins.

THE GREAT ESCAPE
Continental touches accentuate the European
allure of a grand Jamaican villa.

"When I first saw the house, it blew my socks off," says Charles Faudree, the Tulsa-based designer known for his interpretations of country French style, who redecorated this Jamaican escape for an Oklahoma couple. "It looked more like an Italian villa than a traditional Jamaican house, yet it had the spacious rooms, indoor-outdoor pavilions and tall, conical, wood-beamed roofs typical of Jamaican homes. The palette was perfect for blending old-world elegance with new-world comforts."

Drawing on the history of the estate, known as Bambu Villa—it was built by a British architect in the 1960s for an American family that had a fascination with Italy—Faudree set out to preserve its Continental charms while updating them with a comfortable brand of sophistication. To accomplish this, he and associate April Faudree Moore and the homeowner embarked on buying trips through galleries and flea markets in Paris and the South of France, yielding two shipping containers of treasure. Their efforts afforded Bambu Villa an engaging mix of Italian, French and Swedish antiques that maintain its stately air. As a counterbalance, Faudree added a plethora of custom upholstered sofas and chairs, providing cushy perches in rooms meant to welcome friends and a large growing family. "Although my first love is country French, I'm not a purist," says Faudree. "I like blending diverse time periods, styles, fabrics, patterns and colors to provide some excitement and magic." Limestone entry walls, cedar jalousies and teak floors complete the vision, which casts a distinct spell. Says the homeowner, "We get goose bumps every time we walk in the door."

Charles Faudree redecorated Bambu Villa, a historic estate perched above Montego Bay in Jamaica, originally built in the 1960s by architect Robert Hartley for Philadelphia society couple Douglas James Cooper and Deana Pitcairn. Faudree incorporated many of the estate's original elements, such as the iron railings and a 19th-century Dutch brass chandelier. FOLLOWING PAGES: Ikats, animal prints, florals and deep-toned solid fabrics in the living room reference the blues of the sea, visible through arched doorways.

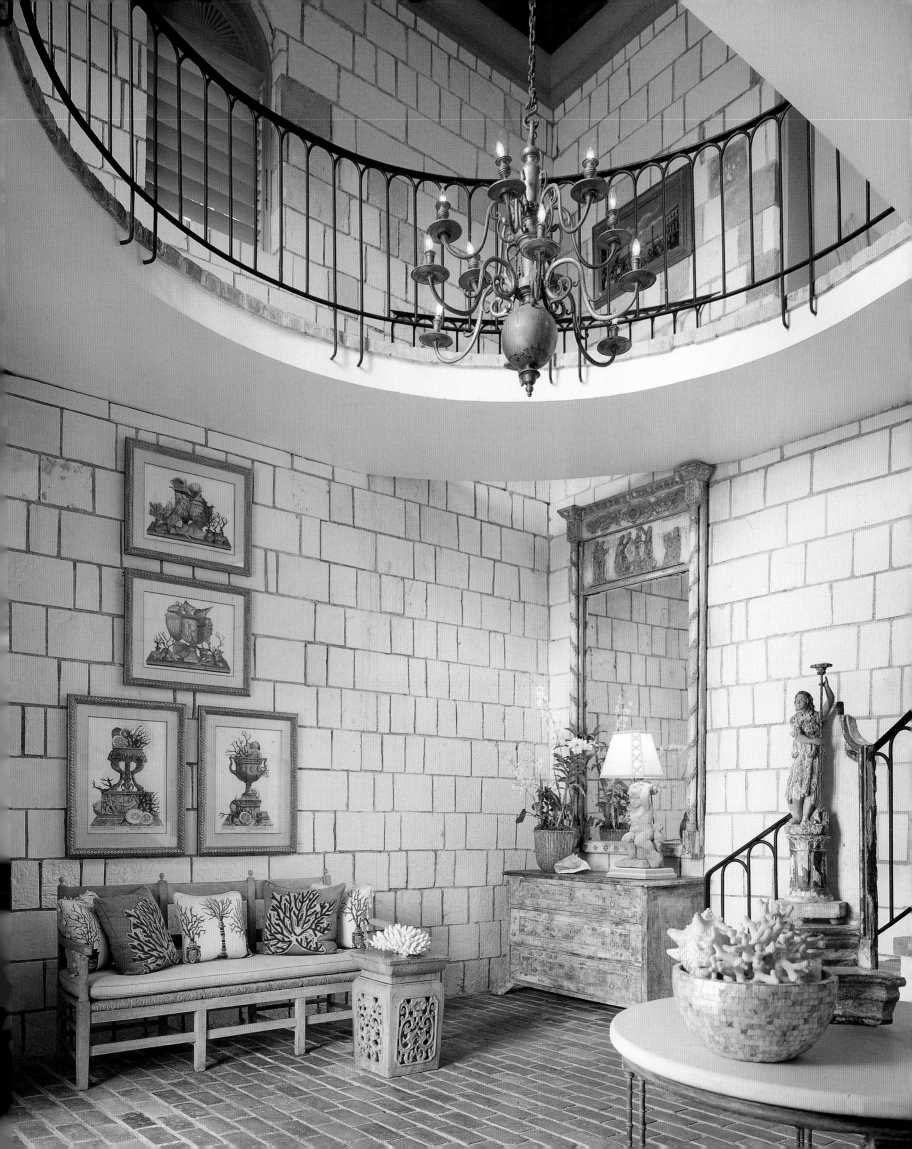

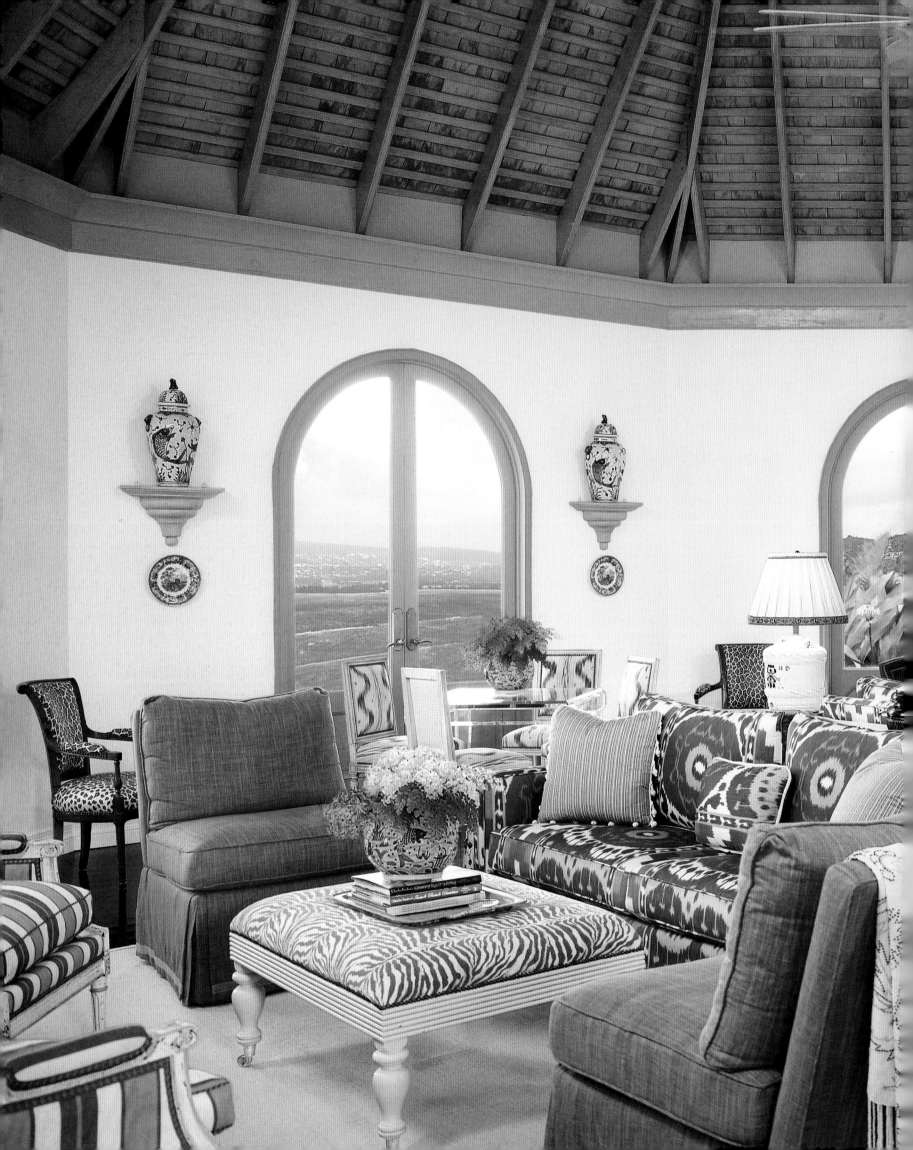

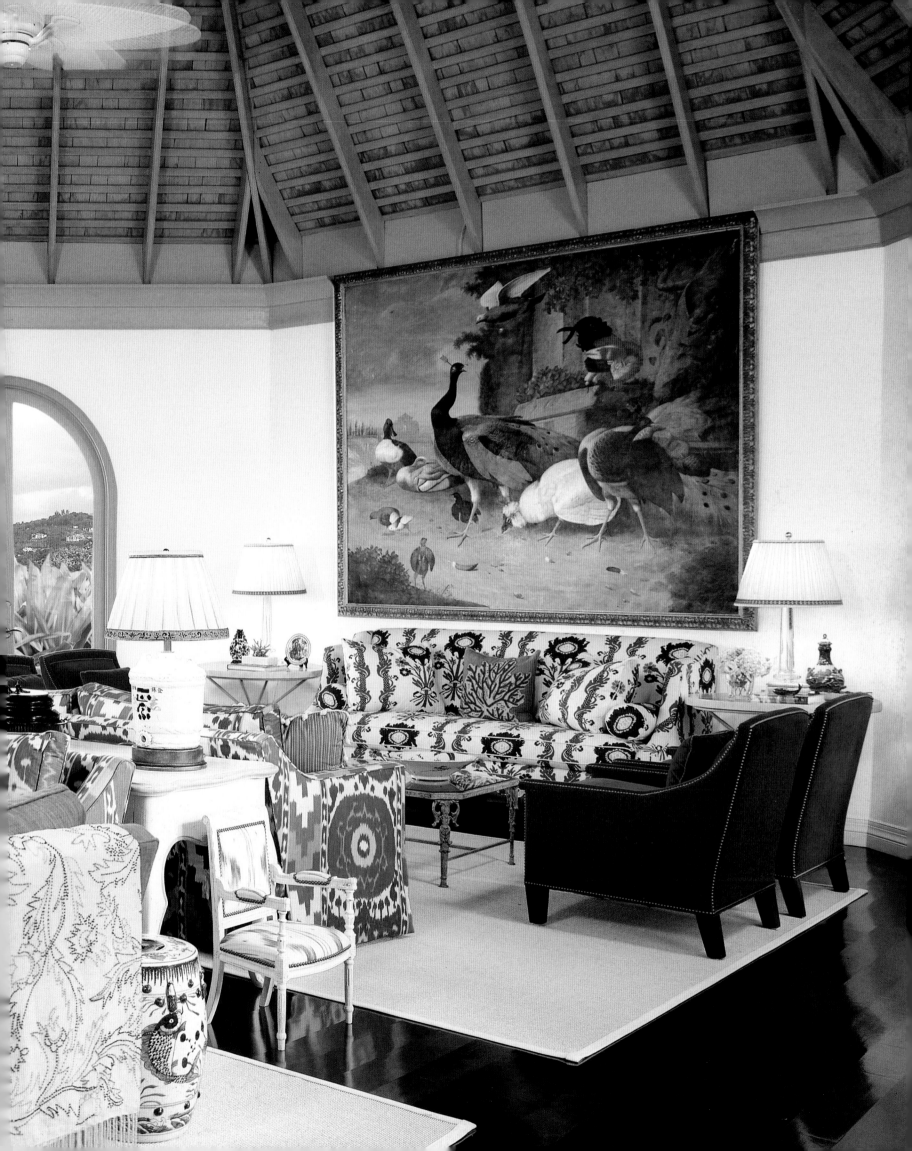

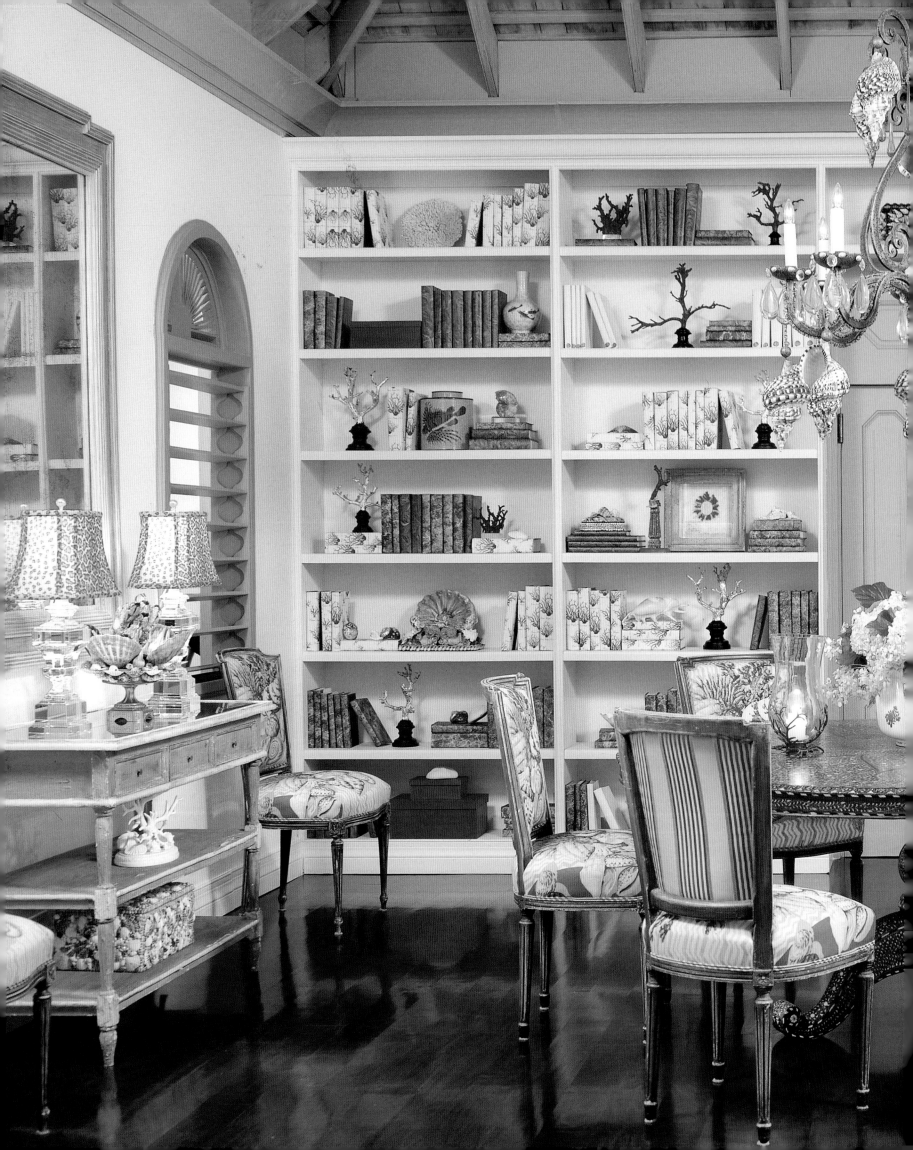

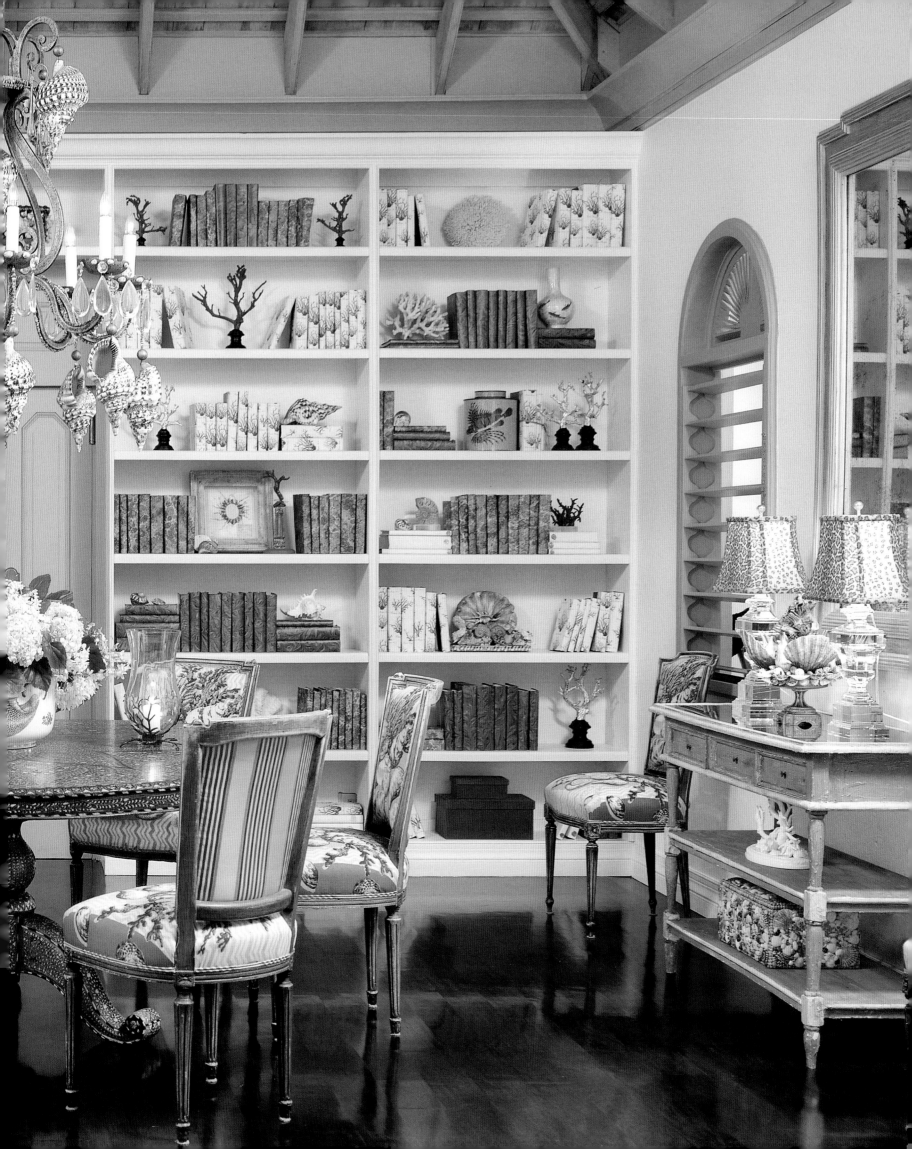

An oil painting by Deana Pitcairn, the original owner, stands out in a lofty bedroom, complemented by the dusty celadon shades in woodwork, furniture and fabrics. The antique desk, stool and tables are French. PRECEDING PAGES: The dining room pairs an inlaid Syrian table with an ornate chandelier dripping with whelks. "A touch of whimsy is something every house should have," says Faudree. Coral, mounted on shelves and printed across seat cushion fabrics, reinforces the nautical theme. FOLLOWING PAGES: The original pool area was inspired by the Maritime Theater at Hadrian's Villa at Tivoli. Antique Roman statues, purchased by the Coopers in London, decorate the colonnade. Loggias enclose alfresco dining pavilions that command expansive views of Montego Bay.

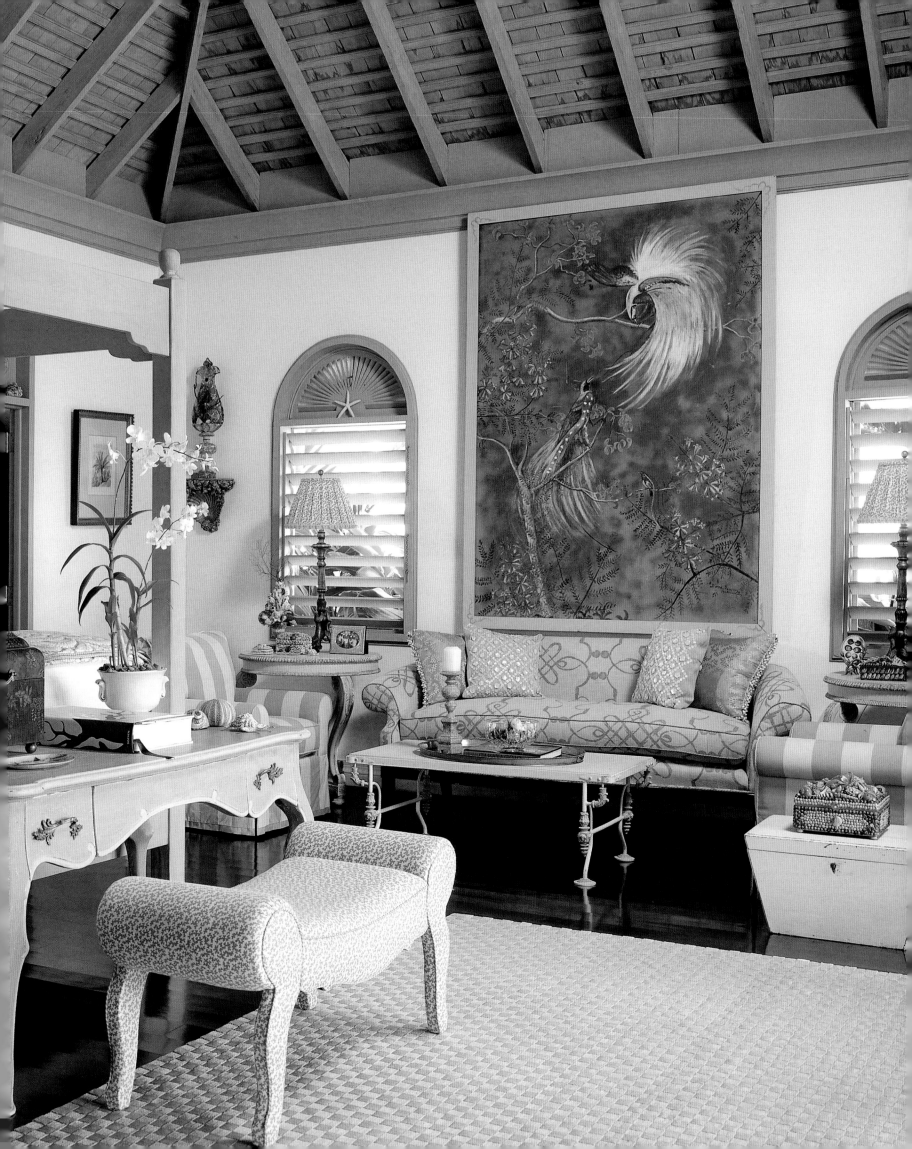

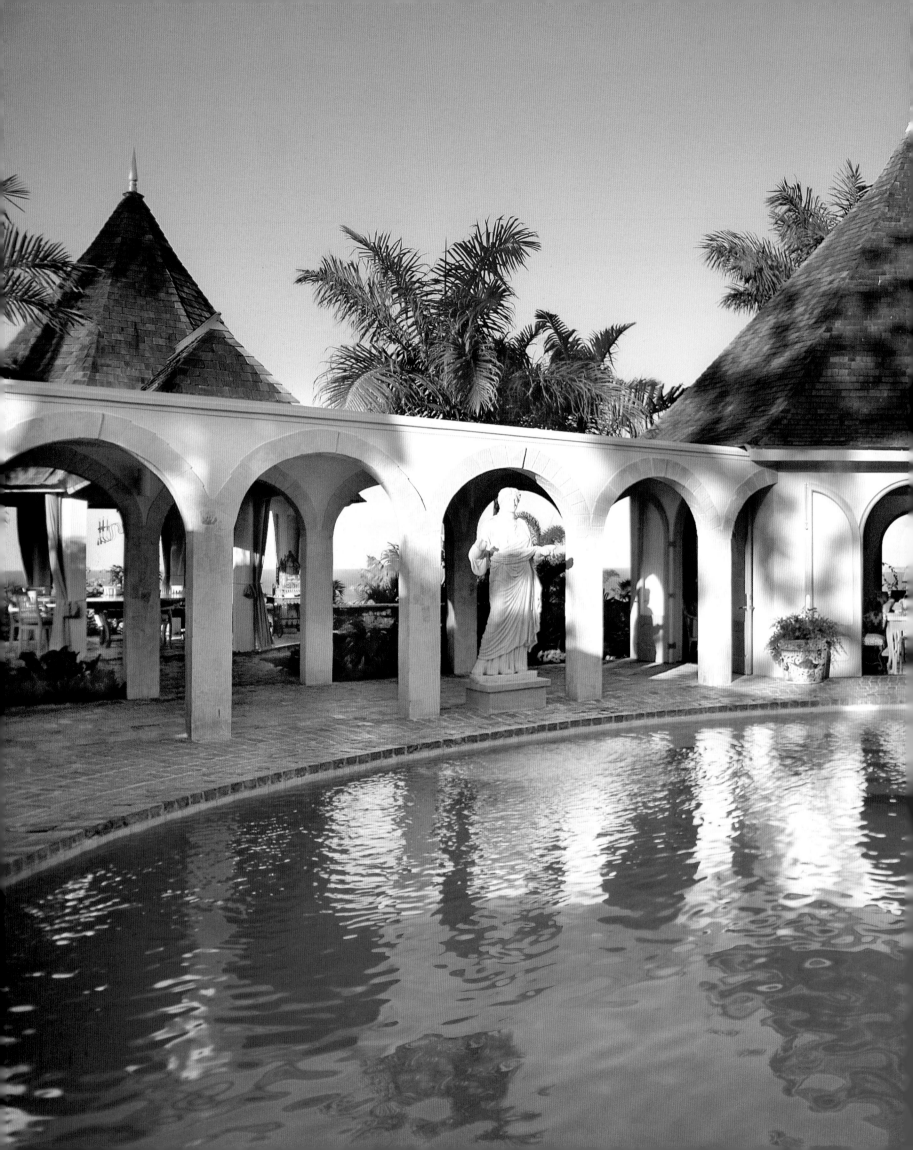

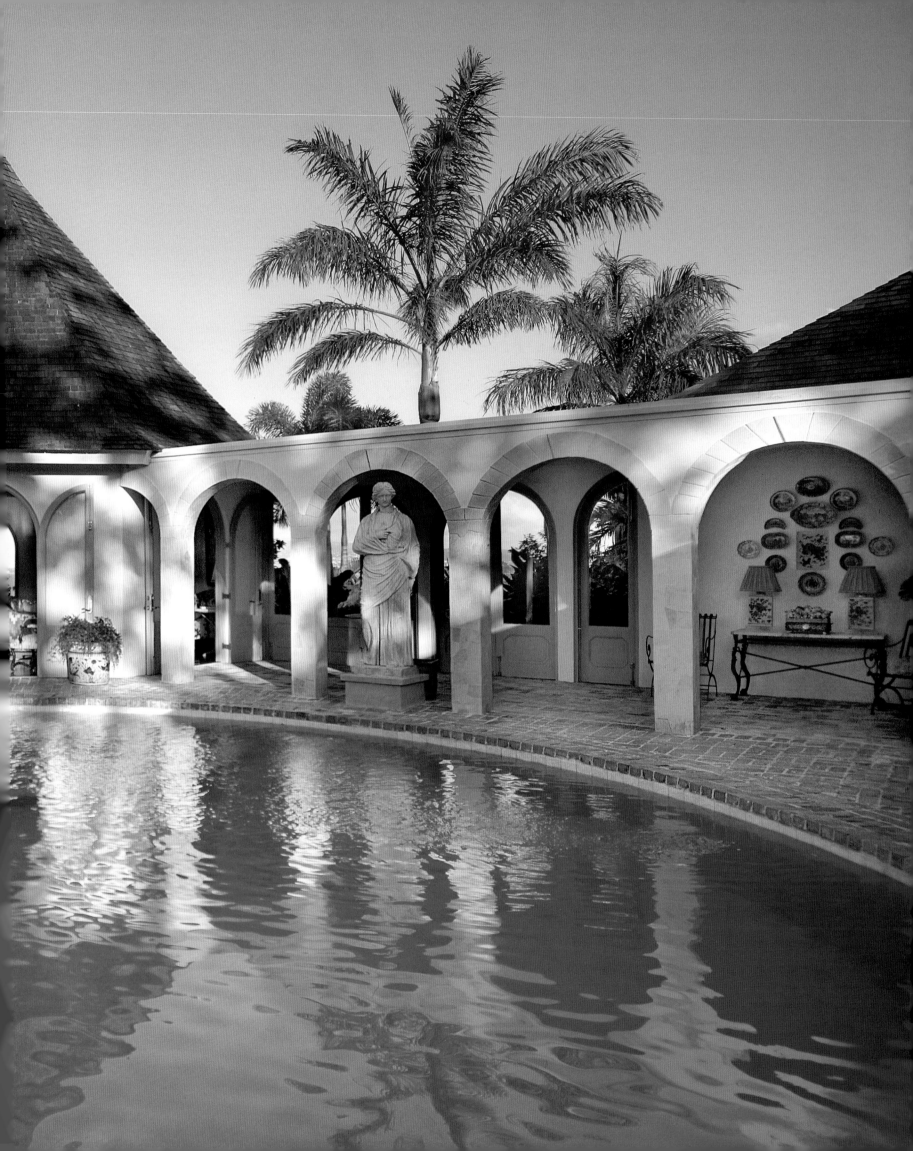

THE SEA INSIDE
The distinctive color of the ocean dictates the interiors of a Florida beach haven.

Occasionally a single element in a house's scheme dominates the interiors and provides the focal point of all the rooms and spaces. In this case, that element happens to be water, specifically its color, and the particular shade it takes on as it laps the sandy shores of a planned Florida community on the Gulf of Mexico—a town fittingly named WaterColor.

The vacation retreat was created by Atlanta-based designer Toby West and architect Thomas Christ for a couple with a burgeoning family. With its Bahamas shutters, double porches and hipped metal roof, the cottage is exemplary of what has become known as the Seaside style, a reference to WaterColor's older and higher-profile neighbor, which Christ helped to develop in the 1980s. (He had a hand in several of Seaside's public structures and more than sixty of its private residences.)

West specifically matched the color that would play a starring role inside the house to the water around a submerged sandbar in front of the house. The shade washes over every room and can be difficult to define—depending on the weather and the time of day, it can appear an ethereal blue-green, a milky turquoise or a pale, luminescent celadon. Complementing the distinctive palette are furnishings that are West signatures: painted English furniture, bound sisal rugs, tailored curtains and pleated lampshades. He deliberately kept the look low-key. Nearly all the chairs are upholstered wicker, and fabrics such as an overscaled gingham and a subtle floral print provide nuanced depth.

For West, who along with partner Tom Hayes has an antiques shop in Atlanta renowned for its regal selection of Continental pieces, the project is not so much a departure as it is a reflection of his range. "There's this great energy at the beach," he says. "It's looser, so from a decorating standpoint, you can do more things. And for me that's a breath of fresh air. I get to go out on another limb."

The interior walls in a beach house by designer Toby West and architect Thomas Christ are paneled entirely in wide planks. A salvaged oculus on an upstairs landing is repurposed as a distinctive mirror.

Black-and-white photographs of sailboats serve as a prominent accessory throughout the house, in keeping with the prevailing scheme. ABOVE: A double-height stairway is flooded with light. OPPOSITE: A counter makes the kitchen accessible to the dining area. FOLLOWING PAGES: A mounted sailfish trophy strikes a whimsical note in the living room.

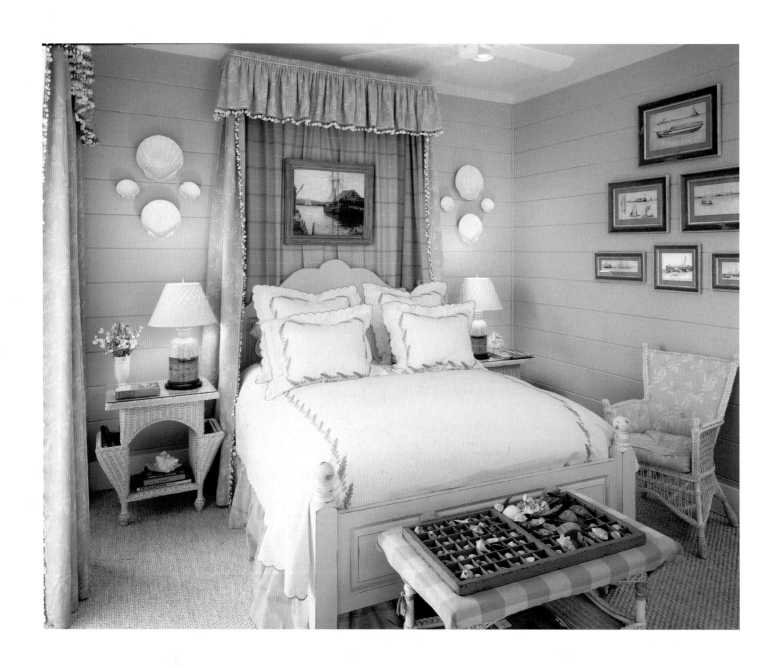

Shells add another grace note. ABOVE: In the master bedroom, shells trim the canopy, curtains and valances. OPPOSITE: A shell-encrusted mirror is central to a vignette with a painted chest of drawers.

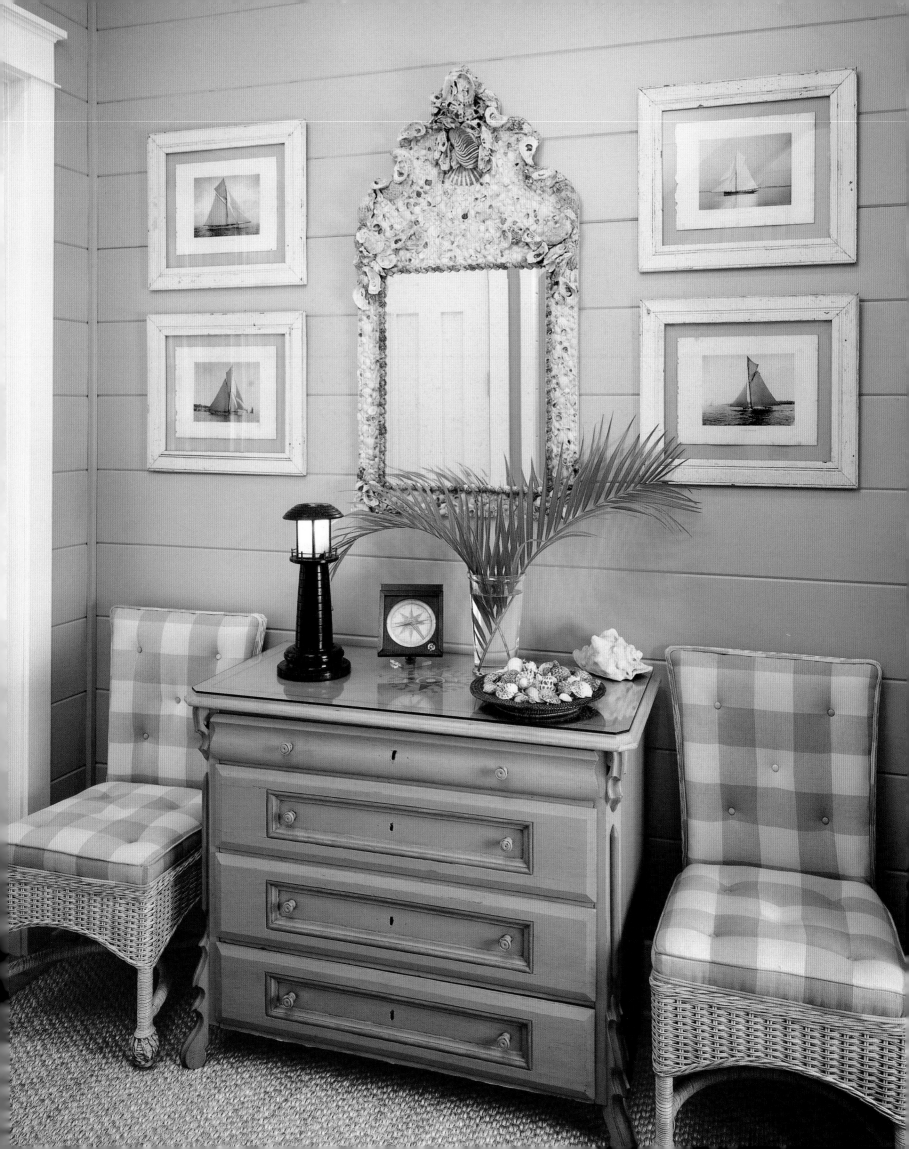

THE POWER OF PATINA
A desert house employs salvaged materials
to create a storied atmosphere.

For nearly twenty years, Michael S. Smith's seamless blend of modern practicality and old-world elegance has attracted a roster of high-profile clients, including Cindy Crawford, Steven Spielberg and, most recently, Michelle Obama, who hired Smith to redecorate the private quarters of the White House. "I try to strike a balance," Smith explains, "between rooms that are beautiful and ones that are really functional." Which is precisely what he's done to great effect in this six-bedroom house near Camelback Mountain in Paradise Valley, Arizona.

Built in a rural Mediterranean style by Scottsdale-based architect Don Ziebell, the new structure exudes the ageless appeal of a European estate, thanks to a shopping trip in Provence on which Ziebell and his clients bought forty oak doors, nine marble fireplaces, reclaimed wood and limestone flooring, and furnishings.

Indoors, Smith gave the house an airy lightness that transcends the stereotype of the country French interior. "I wanted to capture the voice of Arizona," he says. He plotted a decor with a slight "frontier feel," which he tempered with sophisticated elements and a natural, handcrafted sensibility. In the sun-filled living room, "faded, bluey-red tones" in the curtain fabric—handwoven in Guatemala—"cool off" the flood of light. Slipcovers and classically shaped upholstered pieces provide a relaxed atmosphere. Smith kept things sculptural, allowing the furniture to hold its own against the architecture.

Each space has a distinct identity. "A room has to have its own voice," Smith says, "but the house has to flow together and be cohesive." Smith avoided hitting an explicit style on the nose, instead providing a mix that reflects a sense of place. In the master bedroom, a Portuguese-style bed and French-inspired mirror keep company with an antique English desk. "It's about building in the flexibility to grow as a family changes, and making big spaces homey and beautiful."

OPPOSITE: A Khotan rug is paired with an antique Italian table in the entry hall of a house by designer Michael S. Smith and architect Don Ziebell in Paradise Valley, Arizona. FOLLOWING PAGES: The new house appears to have history, thanks to walls made from regional stone.

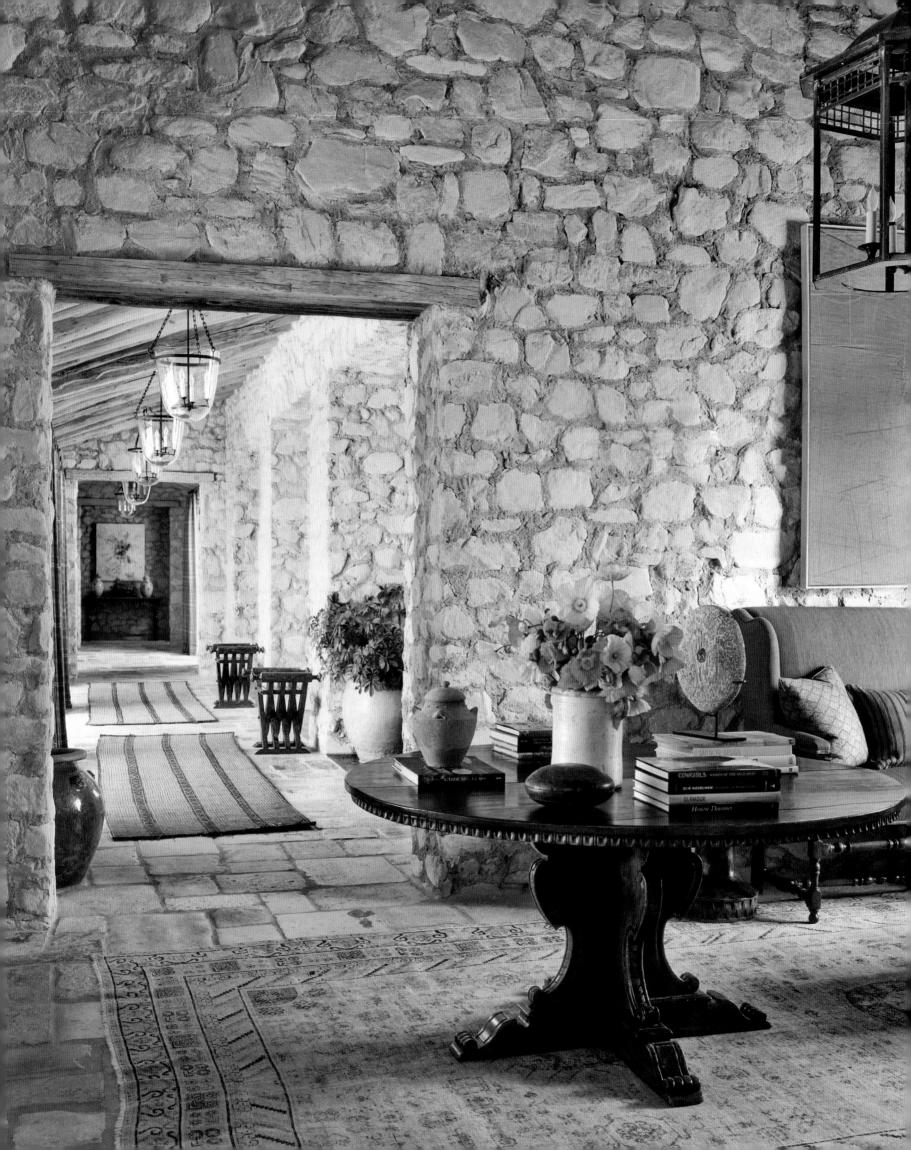

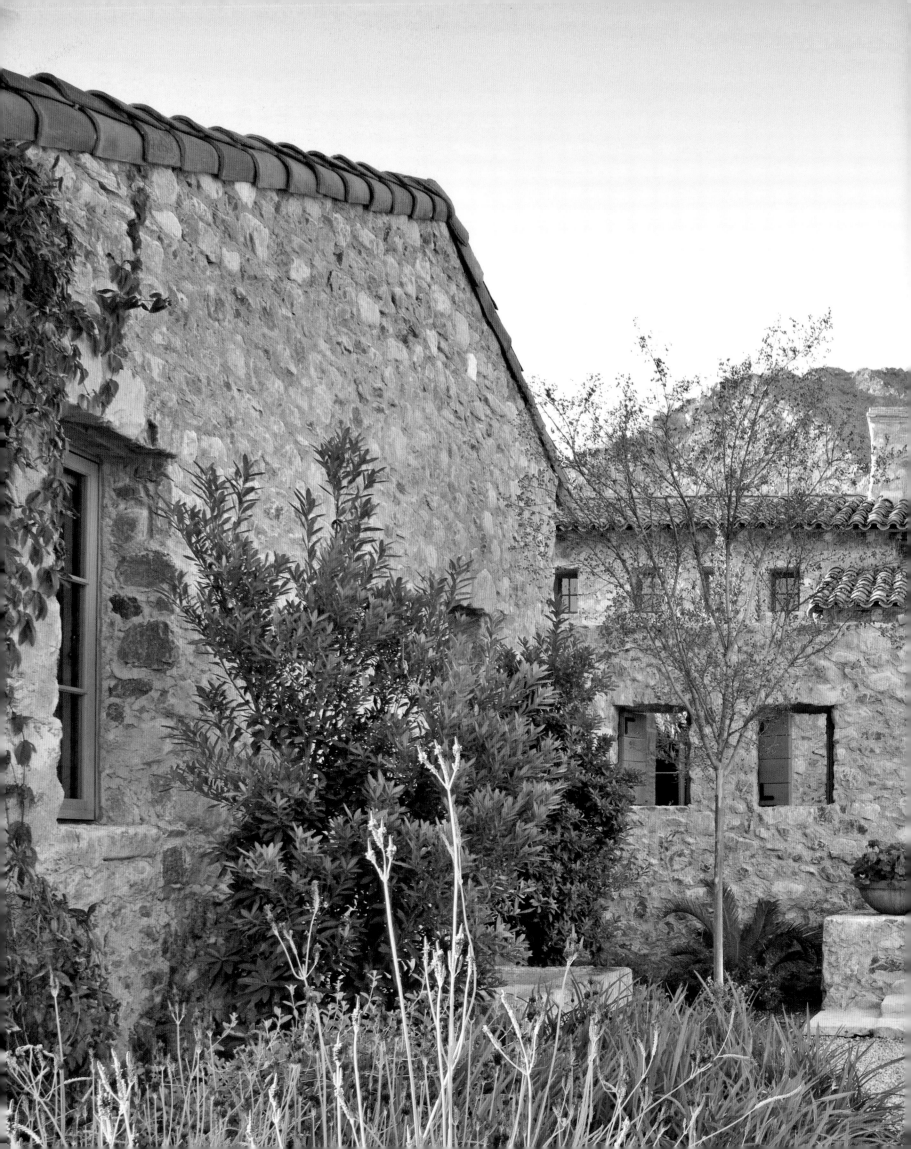

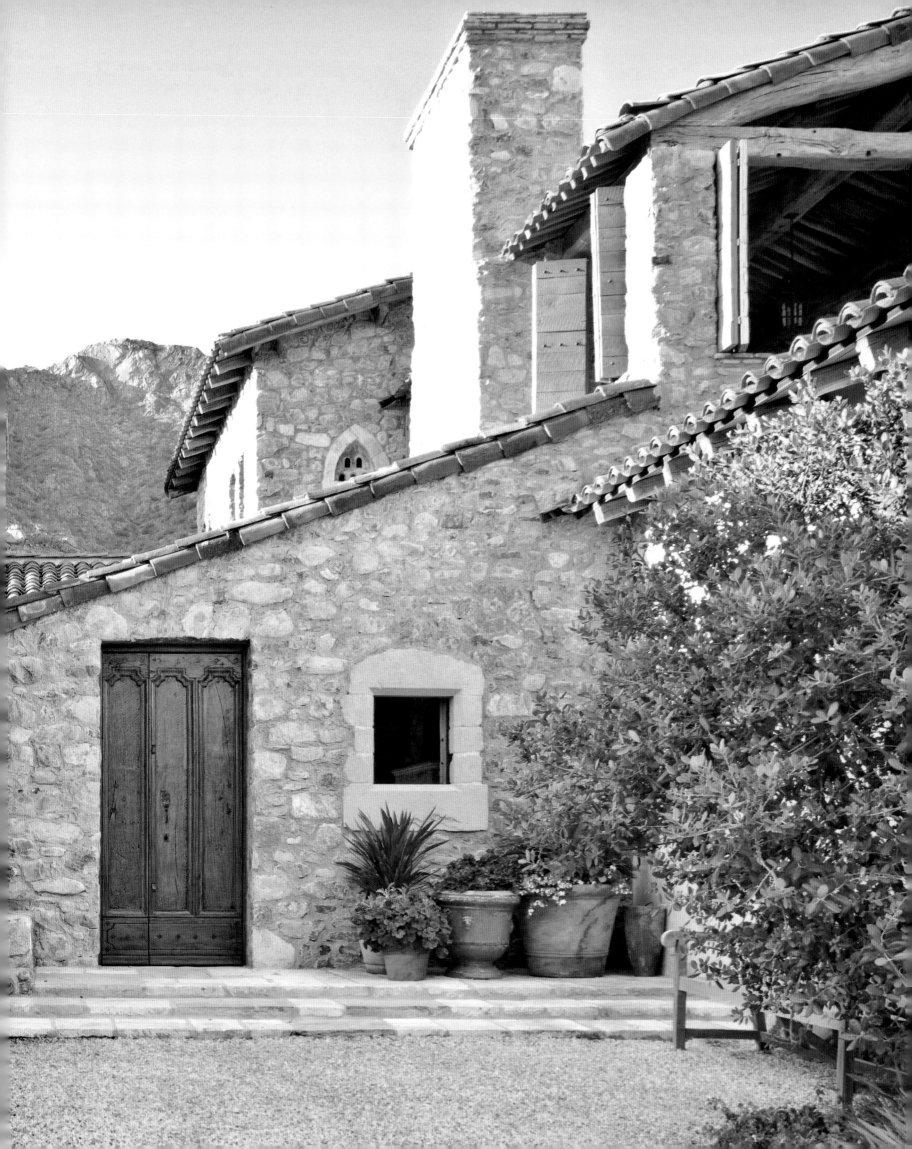

Smith coated exposed rock on
interior walls with a lime wash to
"give it a clean, scrubbed look
that's easier to live with." The
custom chair and sofa are covered
in a light linen stripe. Antique
Italian Baroque-style side chairs
and an inlaid Syrian side table add
interest. Hung high above the
window frames, the curtains
further accentuate the height of
the room. Iron-framed chandeliers
have sculptural profiles.

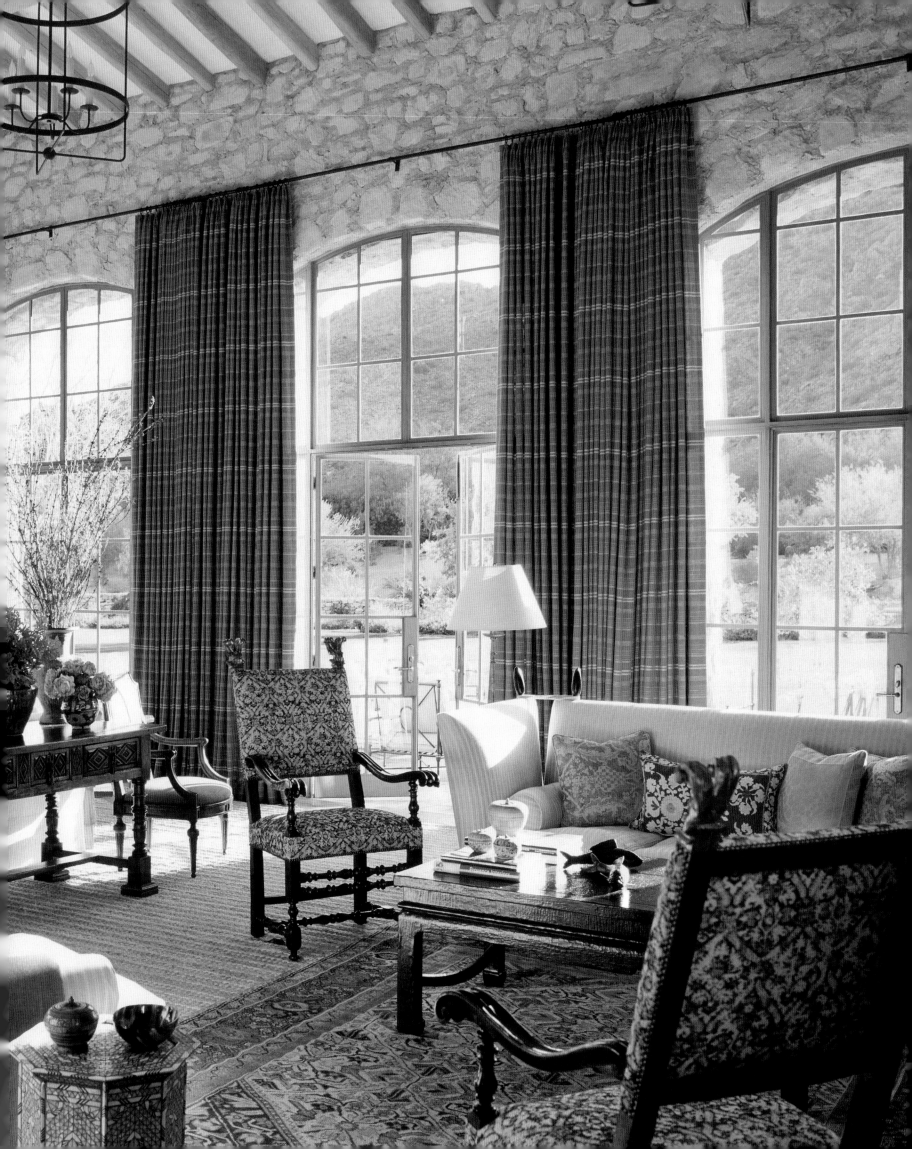

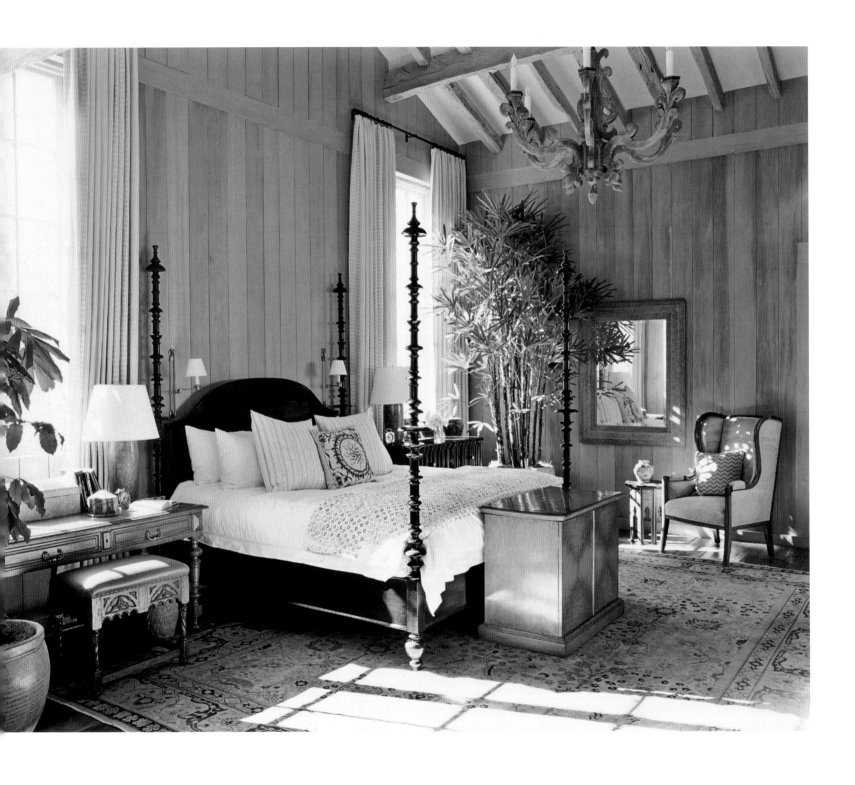

An antique-filled master bedroom is lightened by cedar planks that were wire brushed and stained a subtle shade. An English desk and stool meet a Portuguese-style four-poster. OPPOSITE: The master bath opens onto a terrace.

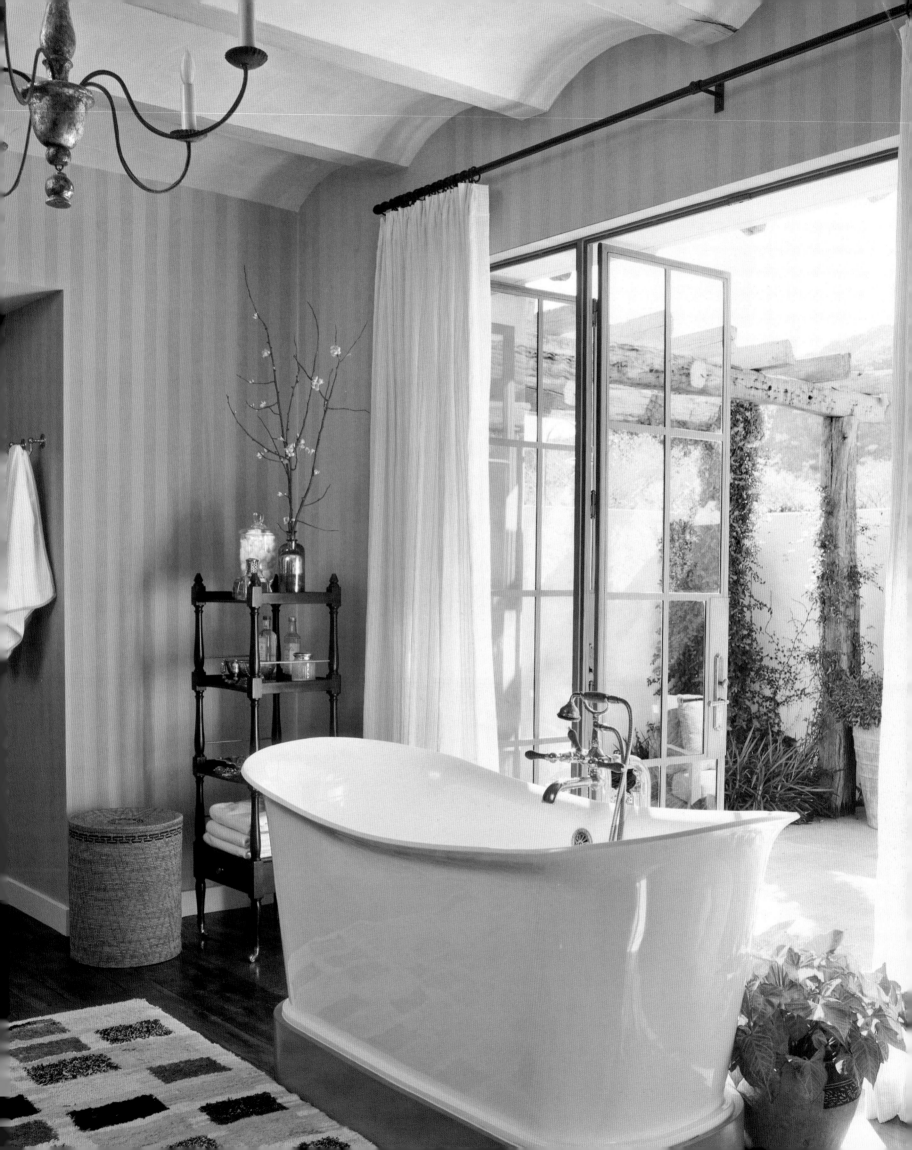

MOUNTAIN SANCTUARY
Two experts fill their country refuge with an impressive array of antiques.

In the late 1970s, Hal Ainsworth and Winton Noah both arrived in Atlanta from small Southern towns. They became business partners, leased a shop on Peachtree Road and took to the highway to hunt down unusual antiques. Soon the store became a mecca for interior designers intrigued by the country pieces the duo unearthed and the sophisticated way in which they were displayed. Eventually, Ainsworth-Noah relocated to the Atlanta Decorative Arts Center, where the showroom has catered to the design trade since 1979, expanding its purview to include European antiques and blue-chip firms such as de Gournay and Rose Tarlow Melrose House.

The appealing blend of country simplicity and luxurious formality that has become their hallmark is illustrated vividly in the retreat they built in North Carolina in the mid-'90s. From the outside, the house looks like a plain barn clad in cedar shingles. But walk inside, and you're confronted by a living room with soaring twenty-six-foot ceilings and a rock fireplace that equals their height, as well as a mix of elegant furniture covered in rich textiles. To match the room's scale, Ainsworth designed an extra-long, extra-deep sofa for the space and flanked it with a pair of Régence fauteuils with five-foot backs. Since most coffee tables would look puny in comparison, he found a stately oak dining table and trimmed the legs to coffee table height.

Elsewhere, the decor relies on the colors and patterns of nature: Earth browns and forest greens dominate, and printed fabrics mimic trailing leaves or exotic animal skins. A large, multi-branch antler chandelier illuminates the living room and reappears as a motif in accessories, such as a pair of horns mounted above the mantel. The effect inhabits a middle ground between down-home and château—a French hunting lodge by way of the Appalachians.

At a North Carolina escape designed by Hal Ainsworth and Winton Noah, a summerhouse in the garden has tall French windows that capture mountain breezes and views of the lake. "It's a great place to read," says Noah.

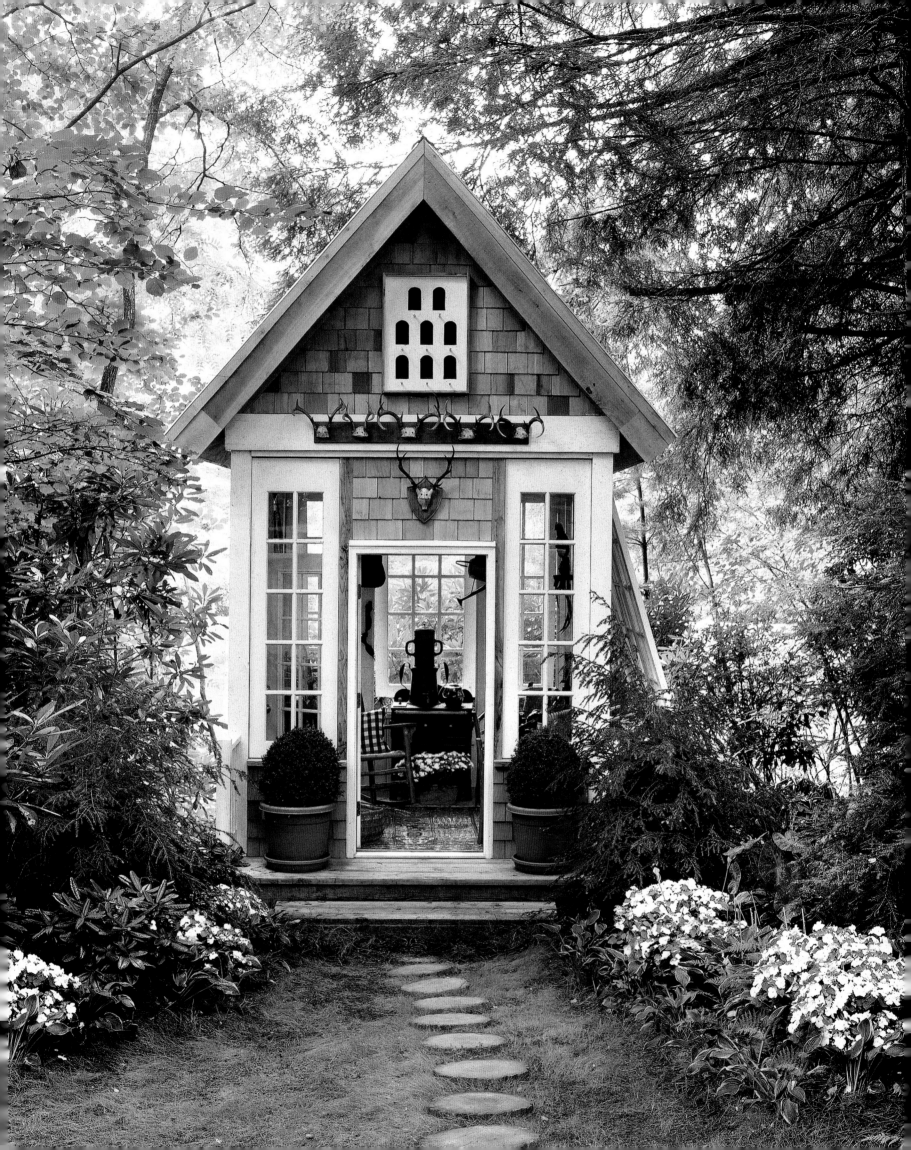

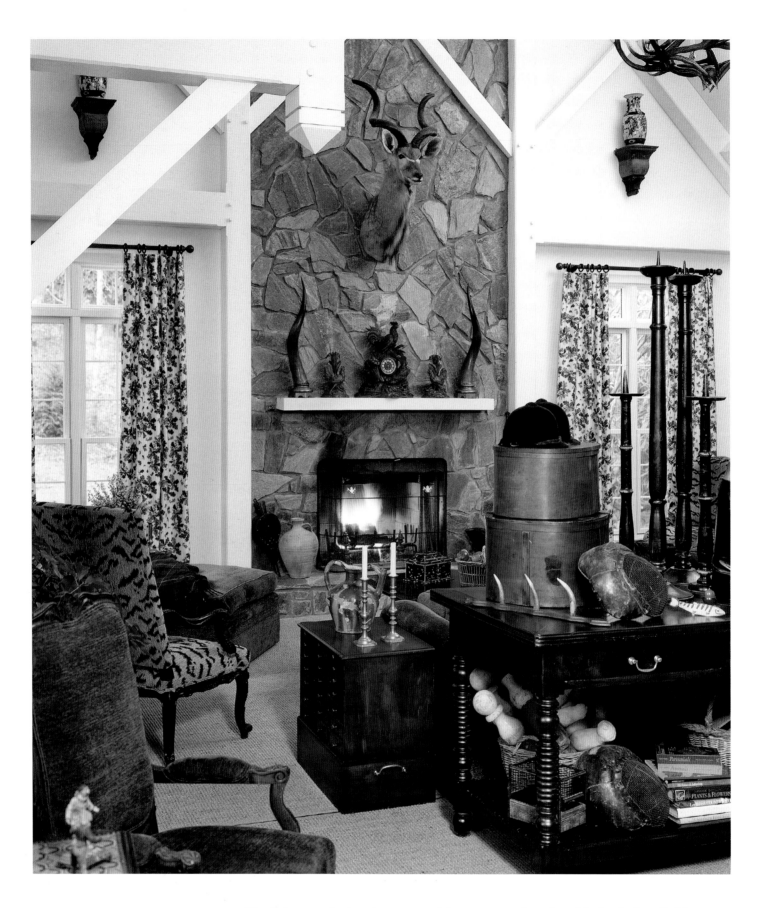

The living room's gigantic trusses weigh 3,200 pounds each and had to be installed by crane.
ABOVE: Ainsworth and Noah found the fauteuil's tiger-patterned velvet in Paris.
OPPOSITE: The chest beneath the painting was custom-built to accommodate antique doors and drawers.

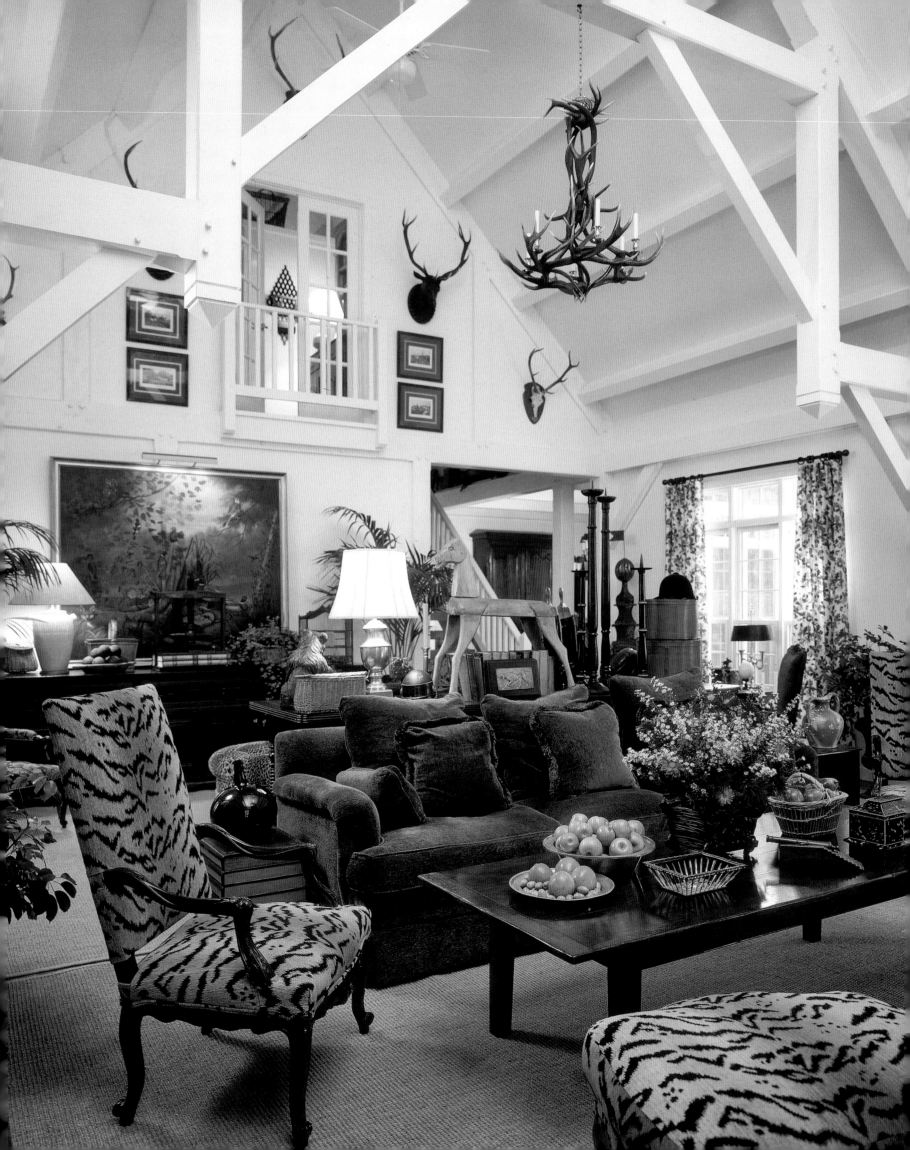

Gilt details in the dining room—in the tole chandelier and the convex mirror—are an elegant counterpoint to the simple table and chairs. The console was made from an antique balcony railing. FOLLOWING PAGES: A toile-and-ticking canopy crowns Ainsworth's bed. Noah's bed was crafted from tree trunks. All of the furniture on the screened porch was made in North Carolina.

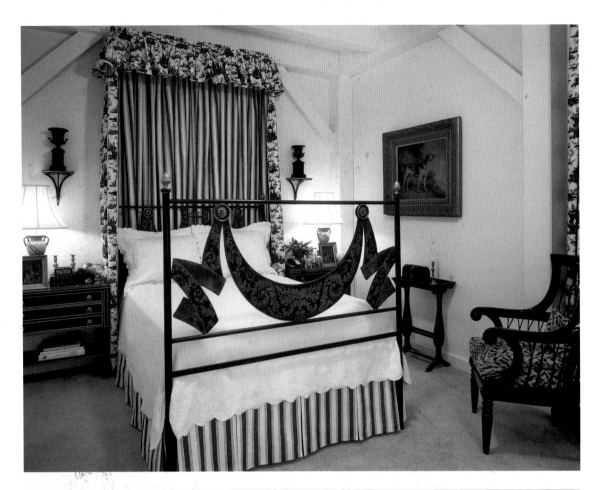

LESS IS MORE

A spare Alpine retreat takes handcrafted objects and finishes to gorgeous heights.

When Axel Vervoordt and his wife, May, decided to build a ski chalet in Switzerland, every detail of the rustic structure had to be executed according to plan. Before starting to build, Vervoordt made a list of requirements for his ideal site: It had to command beautiful views all day long, include vistas of the sun rising and setting, and be close enough to an airport to be convenient for the couple and their two sons, Boris and Richard, who all journey to the Alps several times a year "for skiing, for nature and for family life." Miraculously, the Vervoordts found such a site perched above the jet-set enclave of Verbier, at a height of 5,500 feet.

The couple designed the three-level stone-and-wood house themselves, and it bears their unique blend of unstudied elegance. "All of the wood is without carving," says Vervoordt. "I was looking for a kind of minimalism, a way of thinking as well as a way of reusing the old." Inside, walls and floors are covered in wide and splintered knotty planks. Fireplaces are crafted from rough-hewn slabs of rock and have the presence of sculpture. Most of the furniture is what Vervoordt calls *montagnard*—rustic pieces, both antique and new, made by mountain dwellers. "All of the people who make it have a great respect for wood and a great sense of joinery that enables them to make pieces that last for generations." Simple plank benches are studded with doweled legs whose joints show through their surfaces. Matching that aesthetic is furniture of Vervoordt's own design, such as his now-iconic deep-seated sofa, and chestnut dining chairs made from twigs. The ambience is timeless and serene, in tune with the family's sensibility. "Everything in the house is very real and very simple," says Vervoordt.

Axel and May Vervoordt's Alpine ski chalet overhangs the resort town of Verbier in the Swiss Alps. FOLLOWING PAGES: In the living room, an 18th-century tabletop is the only decoration above the mantel. The child's chair by the hearth is a Welsh antique.

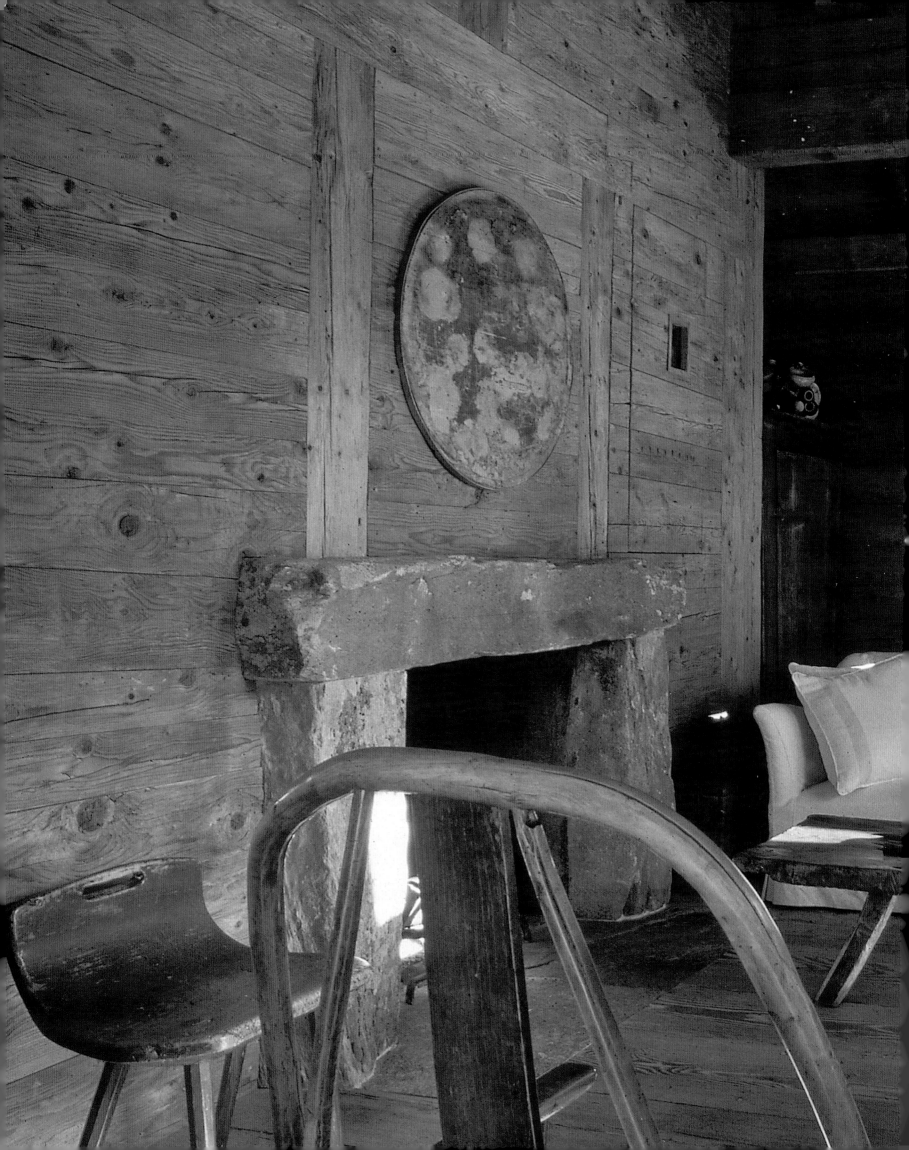

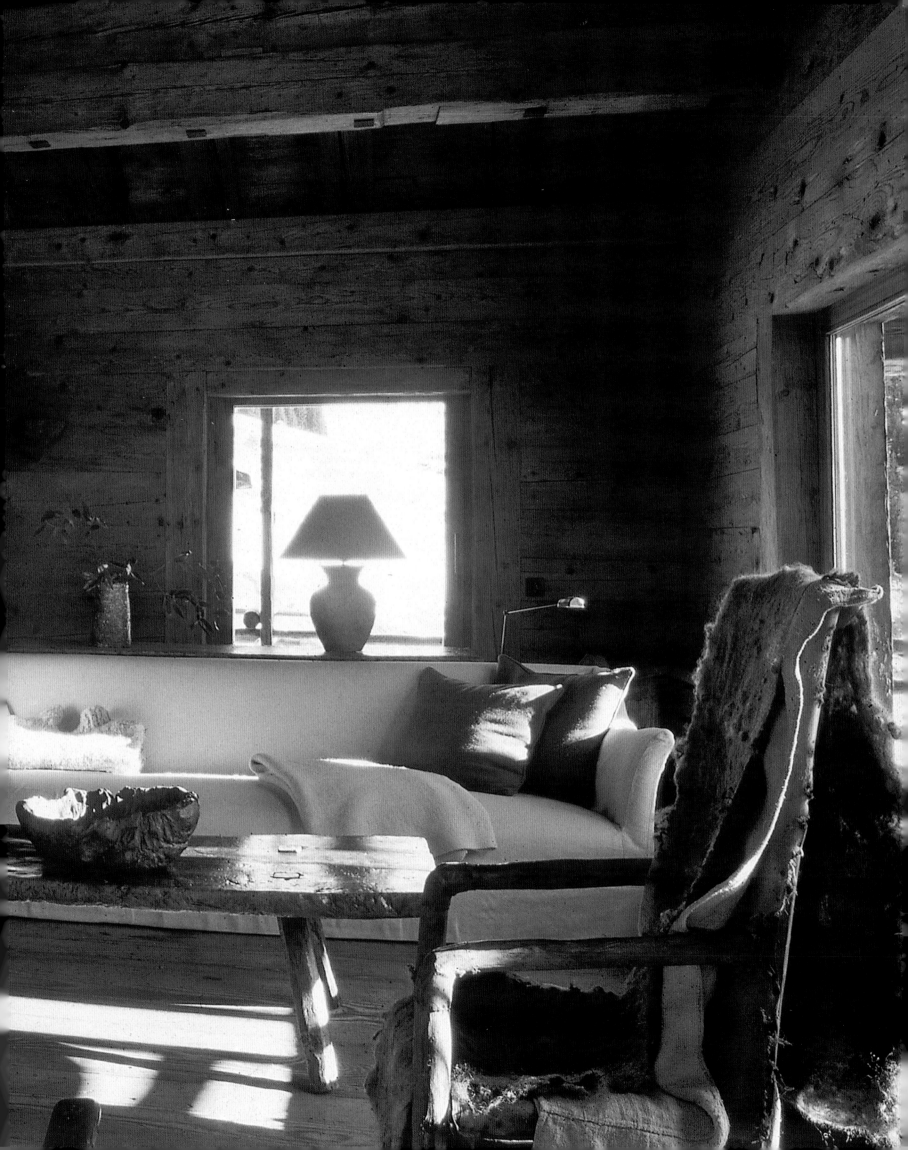

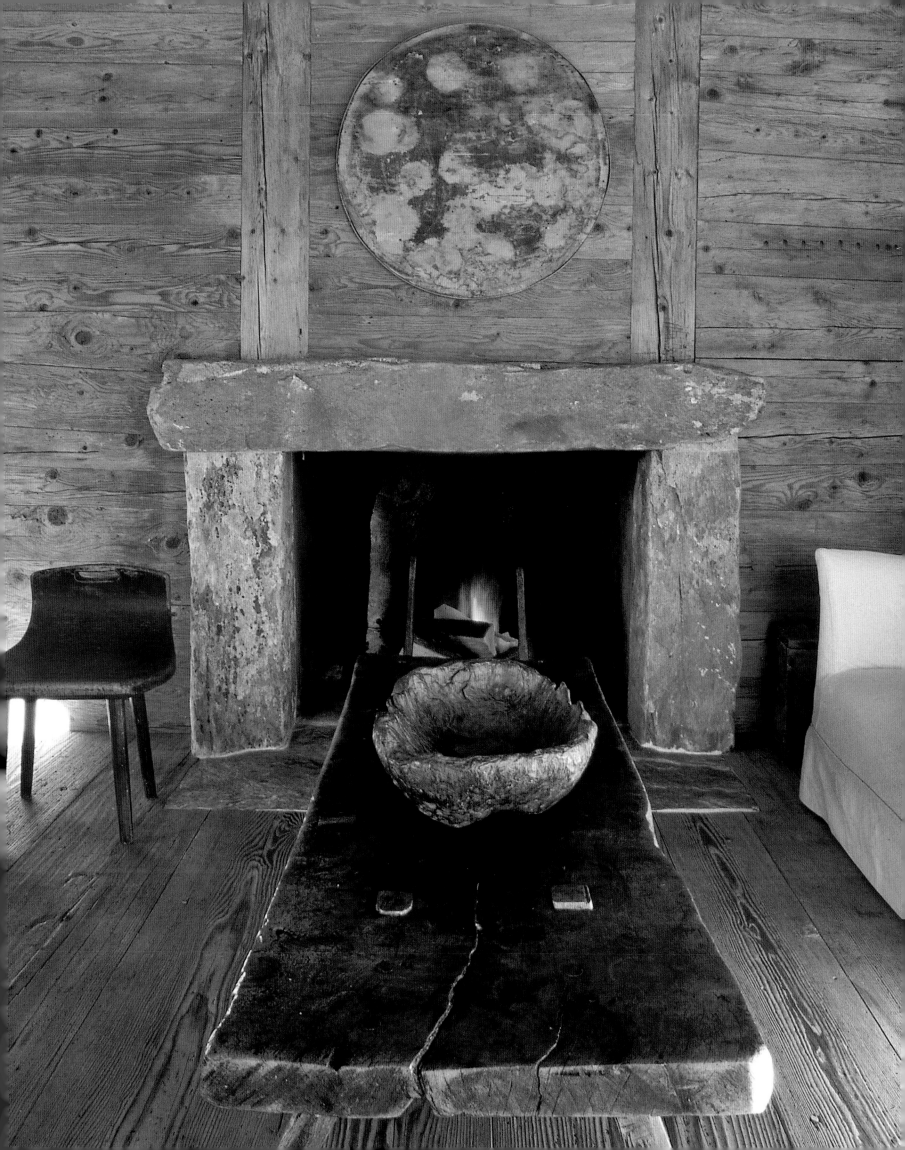

Decorative elements are raw but refined. ABOVE: In the master bedroom, an elm tripod table holds a lamp made from a 16th-century Khmer vase. OPPOSITE: Beds in the guest quarters were built into alcoves. PRECEDING PAGES: The dining room and small kitchen open onto each other, in keeping with the casual way the Vervoordts entertain. A *montagnard* bench harbors snow boots. A Chinese burr-wood bowl is another living room focal point.

This book is dedicated to the memory
of my dear husband, Neal. Also, my wonderful children
and their spouses: Bradley and Brigitte, Leslie and
Chris, Andrew and Shannon, and Ansley and Deane.
And to my adored grandchildren: Christopher, Cooper, Brooke,
Susanna, Caroline, Tatum, Berkeley, Rhys, and Bryce.
And to my parents, Nora and Alvie Beckwith,
and siblings, Nora and Rudy, George and Nancy,
Irene and Jack, and Ken and Aurora.

ACKNOWLEDGMENTS

There are many individuals to whom I owe a debt of gratitude for their support and contributions to VERANDA and to this book. My heartfelt thanks to:

All the homeowners who graciously opened their homes to VERANDA, and to the designers and architects who shared their projects with our readers.

Chuck Ross, art director and friend, who helped me create VERANDA. Without him, the magazine would have remained a dream.

Sims Bray, our former publisher, who contributed greatly to the growth and success of VERANDA.

Dedicated staff and contributors who made it all possible: Rich Michels, Carolyn Englefield, Linda Sherbert, Deborah Sanders, Leslie Newsom Rascoe, Mary Jane Ryburn, Jim Lewis, Steve Ransom, Sarah Bloesch, Jill Brown, Charlotte DuPre, Catherine Lee Davis, Eugenia Santiesteban Soto, Kate Bolick, Linda Rye, Catherine Dennis, Jim Pixley, Meg Evans, Mary Miller, Carly Stewart, Mickey Thomas, Mindy Duncan, Ansley Newsom Kreitler, Marda Burton, Marilou Taylor, Nancy Perot Mulford, Jan Magids, Mary Lide Kehoe, Gannon Hunt Turner, Susan Keller Canmann, Pilar Crespi, Anne Foxley, Susan Gutfreund, Danielle Rollins, Tara Shaw, Julia Noran, Sarah Morse, Rosie D'Argenzio, Alessandra Mikic, Candace Braun, Victoria Druckman and Tori Jones.

Our faithful advertisers, from small shops to national and international companies, who embraced VERANDA from the beginning and continue to support us.

Our publisher, Jennifer Levene Bruno, and her amazing sales team: Lola Battle, Katie Brockman, Georgia Fleming, Steve Moser, Teresa Lowry, Liane Lane, Patty Palmer, Jan Levine, Jim Blazevich,

Cassie Rinker, Angela Jett Okenica, Steve Newman, Cheryl Kogut, Sue Todd, Danny Della Lana, Issy Drinkall, Laura Stubben, Marie Armande de Sparre, Daniella Angheben and Herb Moskowitz. Our director of marketing, Alexa Wilson. Former sales associates who made all the difference in the beginning: Penny Coppedge, Sarah McDaniel, Mark Adeszko and Luciano Bernardini de Pace.

The photographers—especially Peter Vitale, whose beautiful images make up half of this book. The writers, whose skillful prose captures the elegance of the interiors.

Hearst Communications, which acquired VERANDA in 2002 and gave the magazine the best home ever. The brilliant Frank Bennack, David Carey, Gil Maurer, Mark Miller, Michael Clinton, John Loughlin, Ellen Levine, Deb Shriver, Glenda Bailey, Thomas Chung, Curtis Darbasie, Steve Rodgers, Jack Rohan, Steve Gerbes, Rick Day, Jim Miller and Eliot Kaplan.

Cathie Black, former president of Hearst Magazines, who introduced Hearst to VERANDA and for whom I have the greatest admiration and gratitude. Also, to Victor Ganzi, former president of Hearst Communications, and Ruth Diem for their kindness and support.

Friends who have always been loyal to VERANDA: Hal Ainsworth, Winton Noah, Carolyne Roehm, Adrienne Vittadini, Mysty McLelland and everyone at the Atlanta Decorative Arts Center, Jerry Pair, Ryan Gainey, Jan Shoffner, Harry Greiner, Bob Crosland, Tom Hayes, Toby West, Jimmy Sellers, Babs Watkins, Jane Moore, Richard Norris, Marilynn Lahatte, Jane Marsden, Dottie Travis, Miguel Flores-Vianna, Jason Kontos, Walter Riley, Linda Clopton, Susan Lapelle, Stan Topol, John Oetgen, Carol S. Funk, Carolyn Malone, Carole Weaks, Jackye Lanham, Lee Phillips, David Schilling, Suzanne Kasler, Frances Schultz, Steve Christopher, Tim Revis, Bill Peace, Anita and Ed Rascoe, Julie Rascoe, Ana Johnson, Armando Gonzalez, Roy Moore, Rachel and Daryl Bristow, and Nancy and Carl Kreitler. My mentor, Walter Mitchell, for his constant encouragement.

To the memory of Jim Hooten, Chris King, Connie Nesbitt, Harvey Bourland and Derro Evans.

Doug Turshen, who, with David Huang, made this book a work of art.

Sharyn Rosart of powerHouse Packaging & Supply, who directed us with knowledge, diplomacy and compassion, and without whom we could not have made this book a reality.

Chris Thompson of Sterling Publishing for his constructive comments and helpful advice, and Martha Corcoran for her efficient tracking of images.

Mario López-Cordero, one of the finest wordsmiths I know, for contributing new text and for adapting the original articles.

Stephen Singerman for his thorough knowledge of grammar and punctuation, which he brought to bear in proofreading this book.

Jacqueline Deval, publisher of Hearst Books, for her commitment to this book.

Tom Woodham, who has been my friend, colleague and confidant from the very first issue. This book would not have been possible without him.

Dara Caponigro, VERANDA's editor-in-chief, whose lovely preface to the book is so appreciated and whose discerning taste and sense of style continue to inspire me.

CREDITS

NOTE: All of the homes in these pages originally appeared in stories written for VERANDA, and I would like to thank all the wonderful contributors whose work appeared in the magazine and laid the foundation for this book. —*LBN*

PAST PERFECT
Interior design by Edouard Vermeulen. Architectural restoration by Raymond Rombouts. Photographed by Francis Amiand. Produced by Miguel Flores-Vianna. Original text by Jean Bond Rafferty.

INSIDE STORY
Interior design by Dan Carithers. Architectural renovation by Peter Block. Landscape design by Edward Daugherty. Photographed by Peter Vitale. Produced by Lisa Newsom. Original text by Linda E. Clopton.

VISUAL SYMPHONY
Interior design by John Saladino. Landscape architecture by Kevin Grochau. Photographed by Max Kim-Bee. Produced by Carolyn Englefield. Original text by Linda O'Keeffe.

ANTIQUAIRE'S CASTLE
Interior design by Axel Vervoordt. Landscape design by Jacques Wirtz. Photographed by Jacques Dirand. Produced by Carolyn Englefield. Original text by Robert Shore.

ALL THAT GLITTERS
Interior and architectural design by Mary Douglas Drysdale. Photographed by Peter Vitale. Original text by Charles L. Ross.

PROVENÇAL SPLENDOR
Interior design by Ginny Magher. Architectural renovation by Bruno Lafourcade. Landscape design by Dominique Lafourcade. Photographed by Peter Vitale. Produced by Lisa Newsom. Original text by Frances Schultz.

SWEEPING GESTURES
Interior design by Landy Gardner. Architecture by Bobby McAlpine and Greg Tankersley. Landscape design by Ben Page. Photographed by Peter Vitale. Produced by Lisa Newsom. Original text by Elizabeth McMillian.

GLOBAL PERSPECTIVE
Interior design by Piero Castellini Baldissera. Photographed by Jacques Dirand. Produced by Carolyn Englefield. Original text by Ian Phillips.

WHAT'S OLD IS NEW
Interior design by Michael and Alexandra Misczynski. Architectural renovation by Marvin Herman with Drexel Patterson and Tony Crisafi. Landscape architecture by Robert E. Truskowski. Photographed by Jonn Coolidge. Produced by Carolyn Englefield. Original text by Degen Pener.

CURATED FOR COMFORT
Interior design and architectural renovation by Richard Hallberg. Original architecture attributed to Lloyd Wright. Landscape architecture by Nord Eriksson. Photographed by Miguel Flores-Vianna. Original text by Linda O'Keeffe.

A STUDY IN SERENITY
Interior and exterior design by Barbara Wiseley. Architecture by Lutah Maria Riggs. Photographed by Jonn Coolidge. Produced by Miguel Flores-Vianna. Original text by Degen Pener.

SOFTENING THE EDGES
Interior design by Nancy Braithwaite. Architecture by James Choate. Landscape architecture by Wertimer and Associates. Photographed by Melanie Acevedo. Original text by Wendy Moonan.

THAT BEACHY GLOW
Interior design by Susan Ferrier. Architecture by Bobby McAlpine and Greg Tankersley. Photographed by Tria Giovan. Produced by Richard Norris. Original text by Linda E. Clopton.

FRENCH INFLECTION
Interior design by David Kleinberg. Interior architecture by Peter Pennoyer Architects. Photographed by Simon Upton. Produced by Anne Foxley. Original text by Mario López-Cordero.

ELEGANT RESTRAINT
Interior design by Babs Watkins. Architectural renovation by Patton W. Brooks. Landscape design by Sarah W. Lake. Photographed by Peter Vitale. Produced by Chris King. Original text by Charles L. Ross.

SWEDISH SIMPLICITY
Interior design by Jane Moore. Architectural renovation by Frank S. Ryburn. Landscape architecture by Herbert Pickworth. Photographed by Peter Vitale. Produced by Mary Jane Ryburn. Original text by Nancy Perot Mulford.

THE GOLDEN MEAN
Interior design by Ray Booth and Bobby McAlpine. Architectural design by Bobby McAlpine and Greg Tankersley. Landscape architecture by Ben Page & Associates. Photographed by Peter Vitale. Original text by Linda E. Clopton.

LAYERS OF BEAUTY
Interior design by Pamela Pierce. Landscape design by Danny McNair. Photographed by Peter Vitale. Original text by Nancy Perot Mulford.

CALIFORNIA LIVING
Interior design by Madeline Stuart. Architecture by Stephen Giannetti. Landscape design by James Yoch. Photographed by Dominique Vorillon. Produced by Mary Jane Ryburn. Original text by Degen Pener.

SWEDISH PALETTE
Interior design by Shannon Bowers. Photographed by Peter Vitale. Original text by Nancy Wood.

A CHARMING GETAWAY
Interior design by Babs Watkins. Photographed by Tria Giovan. Produced by Mary Jane Ryburn. Original text by Nancy Perot Mulford.

WORLDLY ÉLAN
Interior design by Adrienne Vittadini. Architecture by Clifford M. Scholz Architects and Adrienne Vittadini. Landscape design by Hazeltine Nurseries. Photographed by Peter Vitale. Original text by Linda Sherbert.

PALE PERFECTION
Interior design by Lynn R. Hummer. Architectural renovation by Peter Witmer. Landscape design by Douglas Hoerr Landscape Architecture. Photographed by Casey Sills. Produced by Mary Jane Ryburn. Original text by Frances Schultz.

THE GREAT ESCAPE
Interior design by Charles Faudree and April Faudree Moore. Original architecture by Robert Hartley. Photographed by Peter Vitale. Original text by Dana Micucci.

THE SEA INSIDE
Interior design by Toby West. Architectural design by Thomas Christ. Photographed by Mick Hales. Produced by Lisa Newsom. Original text by Frances Schultz.

THE POWER OF PATINA
Interior design by Michael S. Smith. Architecture by Oz Architects. Landscape design by Arcadia Studio. Photographed by Grey Crawford. Produced by Carolyn Englefield. Original text by Ruth Altchek.

MOUNTAIN SANCTUARY
Interior design by Hal Ainsworth and Winton Noah of Ainsworth-Noah. Photographed by Peter Vitale. Original text by Agnes Sarah Clark.

LESS IS MORE
Interior design by Axel and May Vervoordt. Architectural execution by Raymond Bruchez and Marcel Fellay. Photographed by Jacques Dirand. Produced by Carolyn Englefield. Original text by Amy Page.

Front Cover: Francis Amiand
Inside Back Flap: Leslie Newsom Rascoe
Back Cover (clockwise from top left): Peter Vitale, Jonn Coolidge, Peter Vitale, Peter Vitale

Page 2: Interior design by Bert Tully and Ann Brown. Photographed by Mick Hales. Page 5: Interior design by John Saladino. Photographed by Antoine Bootz. Page 7: (top row, from left) Francis Amiand, Peter Vitale, Simon Upton; (middle row) Mick Hales, Tria Giovan, Peter Vitale; (bottom row) Francis Amiand, Grey Crawford, Peter Vitale. Page 9: Interior design by Axel and May Vervoordt. Photographed by Jacques Dirand. Page 11: Interior design by Adrienne Vittadini. Photographed by Peter Vitale. Page 13: Interior design by Ray Booth and Bobby McAlpine. Photographed by Peter Vitale. Page 15: Interior design by Ginny Magher. Photographed by Peter Vitale. Page 17: (top row) Peter Vitale; (middle row) Francis Amiand, Jacques Dirand, Peter Vitale; (bottom row) Peter Vitale, Max Kim-Bee, Jacques Dirand. Page 95: Jonn Coolidge. Page 97: (top row) Jonn Coolidge, Melanie Acevedo, Miguel Flores-Vianna; (middle row) Tria Giovan, Miguel Flores-Vianna, Jonn Coolidge; (bottom row) Jonn Coolidge, Jonn Coolidge, Melanie Acevedo. Page 151: Peter Vitale. Page 153: (top and middle rows) Peter Vitale; (bottom row) Dominique Vorillon, Peter Vitale, Peter Vitale. Page 213: Peter Vitale. Page 215: (top row) Peter Vitale, Peter Vitale, Tria Giovan; (middle row) Peter Vitale, Peter Vitale, Jacques Dirand; (bottom row) Casey Sills, Jacques Dirand, Jacques Dirand.

INDEX

NOTE: Page numbers in italics refer to photographs and their captions.

A

Ainsworth, Hal, interior design by, 266, *266–273*

Art collections, designing for, 108

Art Deco style, 108, *110–111*, 142

Avery, Milton, painting by, *102, 104–105*

B

Baurscheit, Jan Pieter van, *48–52*

Block, Peter, architecture by, 30

Booth, Ray, interior design by, 172, *172–181*

Bowers, Shannon, interior design by, 204, *204–211*

Braithwaite, Jim, 126

Braithwaite, Nancy, interior design by, 126, *126–135*

Braly, David Keith, mural by, *174–175*

C

Calder, Alexander, sculpture by, *114–115*

Carithers, Dan, interior design by, 30, *30–39*

Castellini Baldissera, Piero, interior design by, 84, *84–93*

Children, designing for, 204

Choate, Jim, architecture by, 126, *126–127*

Christ, Thomas, architecture by, *250–251*

Classic themes, designer interpretations of, 16–92; Carithers, 30, *30–39*; Castellini Baldissera, 84, *84–93*; Drysdale, 60, *60–65*; Gardner, 78, *78–83*; Magher, 66, *66–77*; Saladino, 40, *40–47*; Vermeulen, 18, *18–29*; Vervoordt, 48, *48–59*

Collins, Ashley, artwork by, *196–197*

Color schemes: beach hues, 136, 216, 250; bold accents, *148–149*, 224; cream, 142, *144–145*; for desert light, 40; for displaying art, 108; ivory–gold–yellow, 60; khaki, 116; in landscaping, 116; mahogany–oak, *82–83*; nature-inspired, 116, 172, 204, 266; neutral, 30, *36*, *100–101*, 108, *130–131*, 172; pale, 232; Scandinavian-inspired, 204; tone variation in, 172, 224; vibrant, *90–91*

D

Directoire style, 204

Drysdale, Mary Douglas, interior design by, 60, *60–65*

E

Editing, 40, 152

F

Farmhouse style, 66, 84

Faudree, Charles, interior design by, 240, *240–249*

Faudree Moore, April, 240

Ferrier, Susan, interior design by, 136, *136–141*

Finishes, *28–29*, *140*, 169

Floors, *130*, 136, *234–235*

Formality, offsetting, *22–23*, *36–37*

Frank, Jean-Michel, influence, 142

French Art Deco style, 142

Frey, Pierre, fabric and wall coverings by, *76–77*

G

Gainsborough, Thomas, painting by, *56, 58–59*

Gardner, Landy, interior design by, 78, *78–83*

Geometric shapes, 40, *64*, *140–141*

Giannetti, Stephen, architecture by, 194

Gustavian furniture, 162, 204

Cooper, Douglas James, *240*

Courtright, Robert, art by, *44–45*

Crisafi, Tony, architecture by, 98

Cross-cultural references, designers' use of: Castellini Baldissera, 84, *84, 86–87*; Vermeulen, 18, *18–19, 24–25*; Vervoordt, 48, *54–55*; Wiseley, 116, *120–121, 124–125*

H

Hallberg, Richard, interior design by, 108, *108–115*

Hartley, Robert, architecture of, *240–241*

Herman, Marvin, architecture by, 98

Historicism, in modern context, 18, 48, *52–55*

Höfer, Candida, photography by, *142–143*

Hummer, Lynn, interior design by, 232, *232–239*

I

Iarussi, Jay, paint treatments by, 154, *160–161*

Industrial Age style, 172

J

Jackson, Mary A., basket by, 126, *126, 128–129*

K

Kelly, Ellsworth, contemporary art by, *108–109*

Kingston, Robert, contemporary art by, *124–125*

Kleinberg, David, interior design by, 142, *142–149*

Kline, Franz, paintings by, *110, 146*

Kuo, Robert, sculpture by, 126, *132–135*

L

Lafourcade, Bruno, architecture by, *66*

Lafourcade, Dominique, garden design by, *66, 68–69*

Lichtenstein, Roy, artwork by, *112–114*

Light: color of, 136; "cooling" textiles, 258; diffusing, 136, *138–141*; from restoration glass, 172; texture–tone interplay with, *46–47*

M

Magher, Craig, 66

Magher, Ginny, interior design by, 66, *66–77*

Marot, Daniel, cabinetry by, *54–55*

McAlpine, Bobby, architecture by, 78, *78–79*, 136, 172, *172–173*

McNair, Danny, landscape design by, *184*

Mediterranean style, 78, *78–79*, 258

Minimalism, 126, 154

Misczynski, Alexandra, interior design by, 98, *98–107*

Misczynski, Michael, interior design by, 98, *98–107*

Moderation, in romantic style, 152

Modern themes, designer interpretations of, 96–149; Braithwaite, 126, *126–135*; Ferrier, 136, *136–141*; Hallberg, 108, *108–115*; Kleinberg, 142, *142–149*; Misczynski and Misczynski, 98, *98–107*; Wiseley, 116, *116–125*

"Montagnard" furniture, 274

Moore, Jane, interior design by, 162, *162–171*

N

Nathanson, Jane and Marc, *108–109*

Newsom, Shannon and Andrew, interior design by, 162, *162–171*

Noah, Winton, interior design by, 266, *266–273*

O

old-world style, 172, *172–181*

P

Patterson, Drexel, architecture by, 98

Pennoyer, Peter, architecture by, 142, *142–143*

Pets, designing for, 30

Picasso, Pablo, drawing by, *120–121*

Pierce, Jesse, 182

Pierce, Pamela, interior design by, 182, *182–193*

Pitcairn, Deana, *240, 246–247*

"Portrait of the Daughter of George II" (Gainsborough), *56, 58–59*

Proportions, architectural: symmetry in, *60, 228, 230–231*; vaulted ceilings, *34–35*; window height, *142, 144–145*

Provençal style, 30, *32*, 66

R

Reilly, Kevin, light fixture by, *174–175*

Repetition: in modern interiors, 126, *130–131*; of shapes, *64, 140–141, 154–155*

Retreat themes, designer interpretations of, 214–281; Ainsworth, 266, *266–273*; Faudree, 240, *240–249*; Hummer, 232, *233–239*; Noah, 266, *266–273*; Smith, 258, *258–265*; Vervoordt, 274, *274–281*; Vittadini, 224, *224–231*; Watkins, 216, *216–223*; West, 250, *250–257*

Romanelli, Dan, 194

Romanelli, Luana, 194, *194–195*

Romantic themes, designer interpretations of, 152–211; Booth, 172, *172–181*; Bowers, 204, *204–211*; Moore, 162, *162–171*; Newsom and Newsom, 162, *162–171*; Pierce, 182, *182–193*; Stuart, 194, *194–203*; Watkins, 154, *154–161*

Rombouts, Raymond, architecture by, 18, *18, 20–21*

Ryburn, Frank, architecture by, 162, *162*

S

Saladino, John, interior design by, 40, *40–47*

Scale: humanizing large spaces, 40, *40–44, 62–65, 80–82*, 154; living room as study in, 120, *122–123*

Scandinavian antiques, 162, *162–163*, 204

Seguin, Jerome Abel, sculpture by, *40–41*

'S-Gravenwezel, 48, *48–59*

Shaw, Howard Van Doren, architecture by, 232

Sherman, Cindy, photography by, *148*

Sight lines, interior, 30

Simplicity, 18, 126

Smith, Michael S., interior design by, 258, *258–265*

Spanish Art Deco architecture, 108, *110–111*

Stewart, Julie and Kent, 136

Stone, lime wash on, *262–263*

Straeten, Hervé Van der, chandelier by, *146–147*

Stuart, Madeline, interior design by, 194, *194–203*

T

Tankersley, Greg, architecture by, 78, *78–79*, 136, 172, *172–173*

Tension, in modern interiors, 142

Texture, *46–47, 100–101*

Truskowski, Robert E., garden design by, *102*

Tuscan farmhouse style, 84

Twombly, Cy, artwork by, *46–47*

V

Vermeulen, Edouard, interior design by, 18, *18–29*

Vervoordt, Axel: architecture by, 274; furniture design by, 274; interior design by, 48, *48–59, 274, 274–281*

Vervoordt, May, 48; interior design by, 274, *274–281*

Vittadini, Adrienne, interior design by, 224, *224–231*

Vittadini, Gianluigi, 224

W

Wallpaper, art from, *72–73, 238*

Watkins, Babs, interior design by, 154, *154–161*, 216, *216–223*

West, Toby, interior design by, 250, *250–257*

Window treatments: absence of, 172; color in, *148*; and light quality, 136, *138–141*

Wirtz, Jacques, landscape design by, *50–52*

Wiseley, Barbara, interior design by, 116, *116–125*

Witmer, Peter, architecture by, 232, *232–233*

Z

Ziebell, Don, architecture by, 258, *258–261*